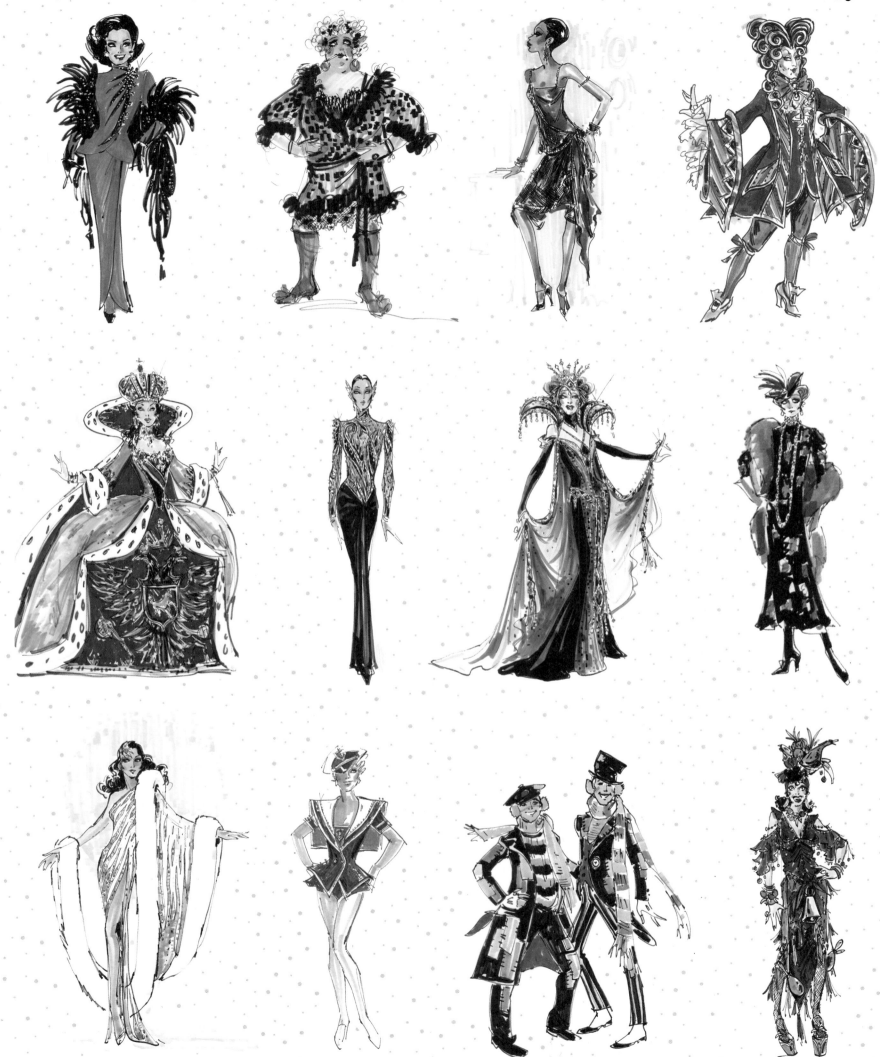

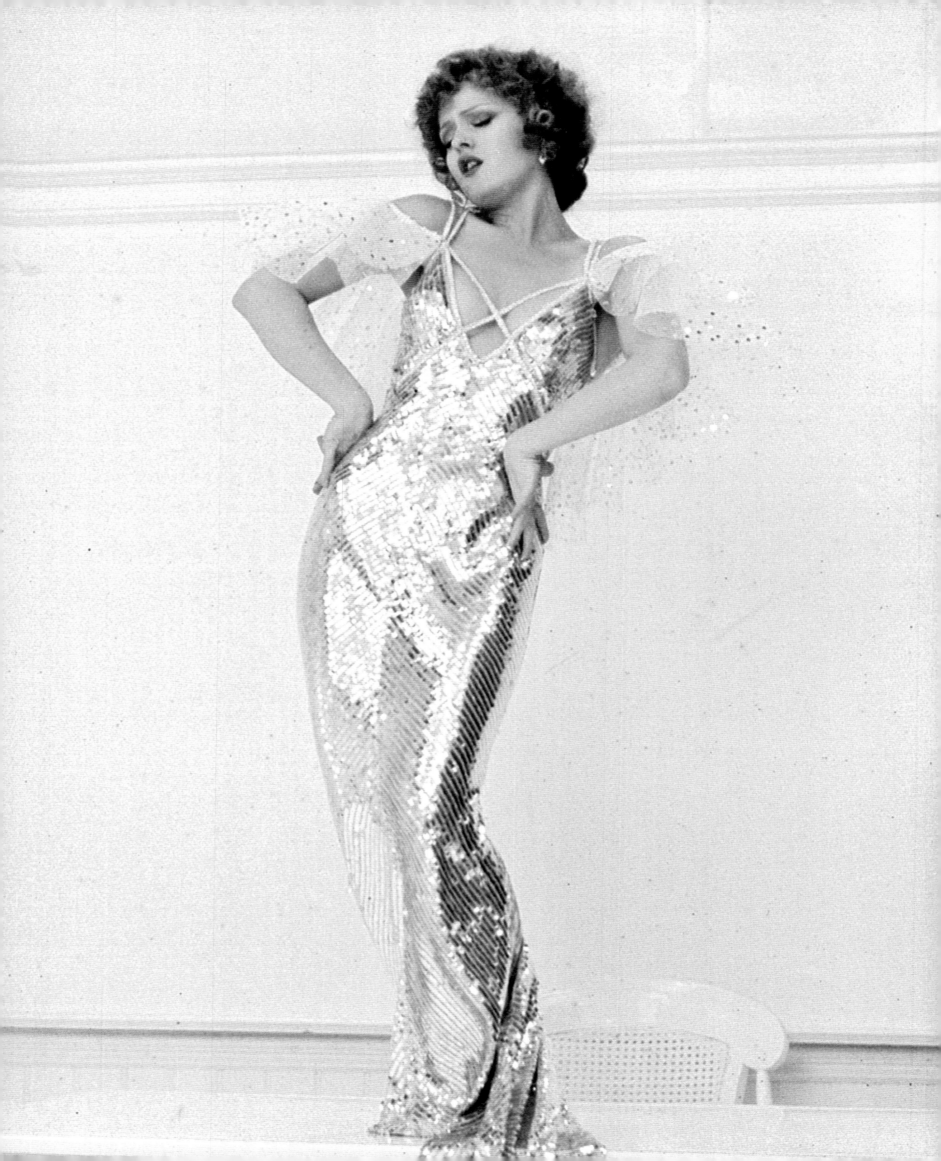

# The Art of
# BOB MACKIE

## Frank Vlastnik and Laura Ross

*Photographic Editor:* **Matt Tunia**

Simon & Schuster

New York   London   Toronto   Sydney   New Delhi

For Mary Brucker, who kept a roof
over my head while I wrote this book.

For Mary Vlastnik Armon, who was next
to me in front of the television every
Saturday night.

For Andy Kreiss, for keeping the flame.

*—Frank*

For Leslie and Liam.

*—Laura*

Simon & Schuster
1230 Avenue of the Americas
New York, NY 10020

First Simon & Schuster hardcover edition November 2021

SIMON & SCHUSTER and colophon are registered trademarks of Simon & Schuster, Inc.

For information about special discounts for bulk purchases, please contact
Simon & Schuster Special Sales at 1-866-506-1949 or business@simonandschuster.com.

The Simon & Schuster Speakers Bureau can bring authors to your live event.
For more information or to book an event, contact the Simon & Schuster Speakers
Bureau at 1-866-248-3049 or visit our website at www.simonspeakers.com.

Design concept: Jessica Musumeci, Works Well With Others, LLC
Book design: Jason Snyder

Manufactured in China

10 9 8 7 6 5 4 3 2 1

Library of Congress Cataloging-in-Publication Data has been applied for.

ISBN 978-1-9821-5211-6
ISBN 978-1-9821-5212-3 (ebook)

# CONTENTS

# WHAT CAN YOU SAY ABOUT A BRILLIANT & CLEVER GENIUS?

## *Plenty.*

**WHAT CAN YOU SAY ABOUT A BRILLIANT AND CLEVER** genius? Plenty. For my variety show, this man designed as many as sixty to seventy costumes *a week* for eleven years! Do the math. It averages out to around seventeen thousand costumes. He created looks for every character in every sketch, not to mention the musical numbers.

There were times when I didn't know how I was going to play a character in a certain sketch until I could see how I was going to look and what I was going to wear. Bob helped me create Eunice, in the "Family" scenes; Mrs. Wiggins, the dumb secretary; and all of the characters in the many movie takeoffs.

In 1967, we were in the process of hiring a staff for my upcoming comedy variety show. I first became aware of Bob when I watched the *Alice Through the Looking Glass* TV special . . . and then I saw Mitzi Gaynor's show. I marveled at the costumes. Not only were they beautiful, but when it was required, they were funny! In checking the credits, I discovered that Bob Mackie was the designer. We got in touch with him, and he came to my house for a meeting. The doorbell rang, I opened the door, and there was a handsome young lad (he looked like he was about twelve) claiming to be Bob Mackie. It turned out he was in his twenties. He was charming and funny and offered several clever ideas. He was hired on the spot!

Hiring Bob was one of the smartest things I ever did. Our beautiful friendship lasts to this day. I'm so glad we've had these times together, and I'm particularly pleased that his work—with me and so many others—is documented here for all time.

**—CAROL BURNETT**
**NOVEMBER 2021**

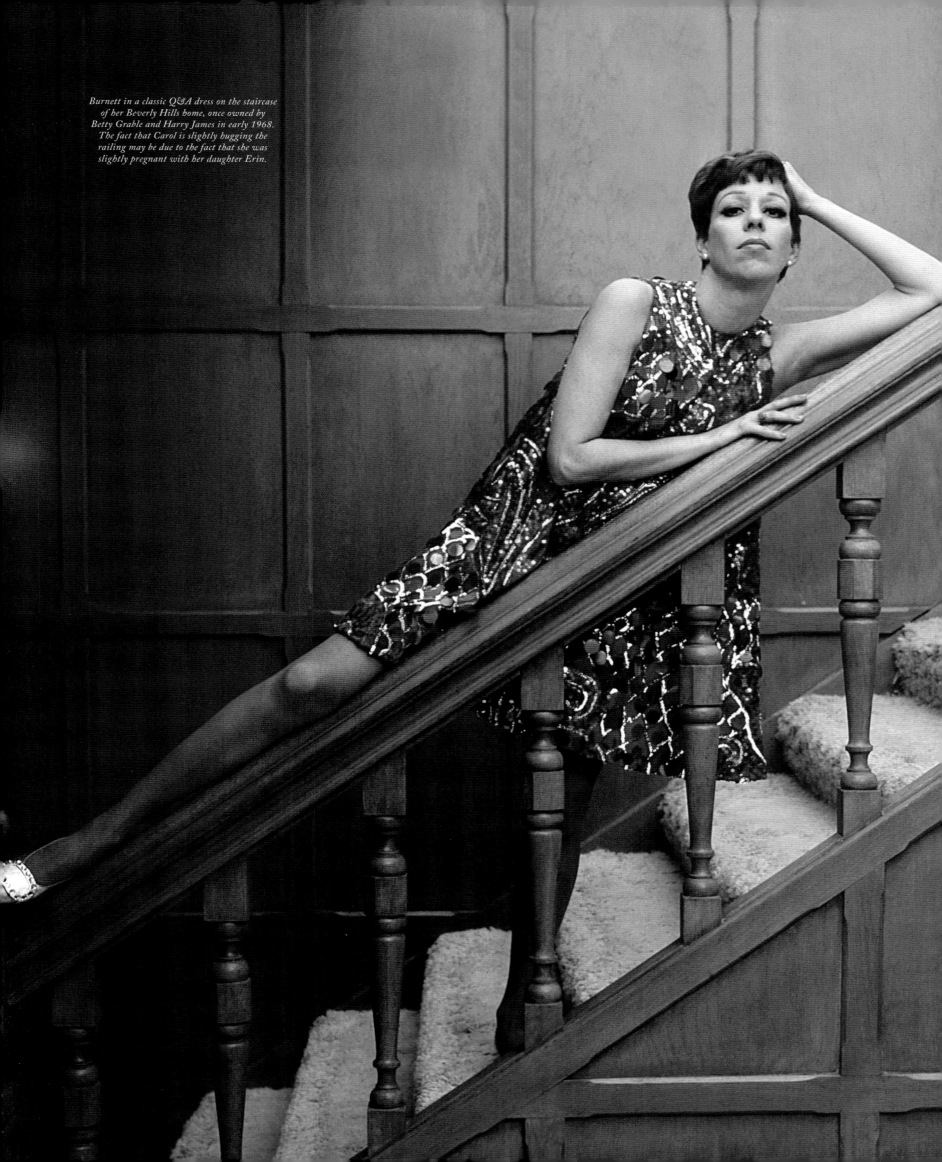

*Burnett in a classic Q&A dress on the staircase of her Beverly Hills home, once owned by Betty Grable and Harry James in early 1968. The fact that Carol is slightly hugging the railing may be due to the fact that she was slightly pregnant with her daughter Erin.*

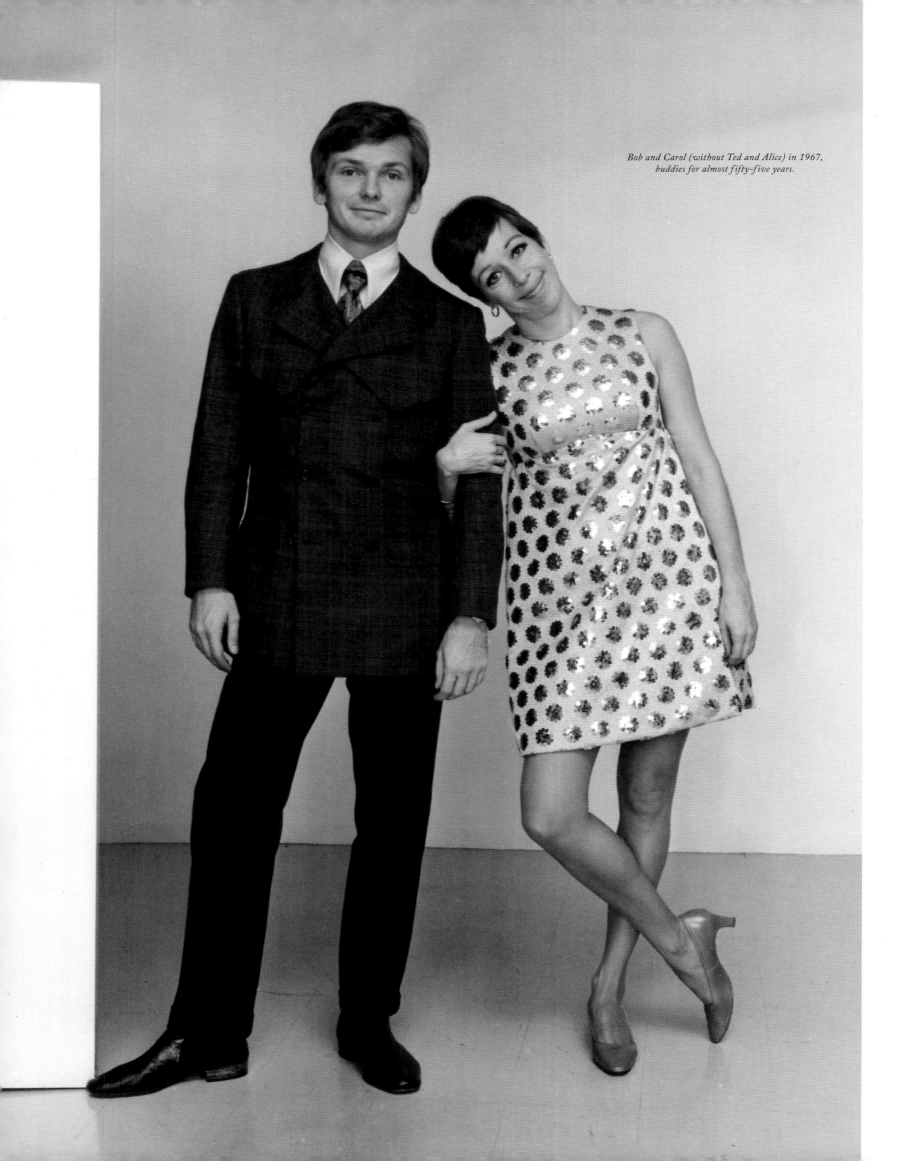

*Bob and Carol (without Ted and Alice) in 1967,*
*buddies for almost fifty-five years.*

*"He created looks for every character in every sketch, not to mention the musical numbers."*

# BEGINNINGS

**EVERY GREAT PRODUCTION HAS AN OPENING NUMBER, AND** Robert Gordon Mackie's is set in sunny Southern California. He was born in Monterey Park just before the outbreak of World War II. His parents divorced when he was young, and little Bobby went to live with his grandparents in Inglewood, where, as he recalls clearly, his relative solitude fostered a vivid imagination. "Radio was my biggest influence," he explained. "I could visualize the mysteries I listened to, but I also *loved* movies, especially musicals and adventures. Showgirls, pirates, Arabian Knights . . . I wanted so badly to live in a Technicolor world. I used to make stage sets on the top of my dresser and set flashlights, and then put a 45 record on. I'd say, 'One day *I'll* get to do this!' Basically, I was a nonstop daydreamer."

When he reached high school age, the budding theater artist went to live with his father, who worked at the Bank of America in Los Angeles. Mackie set about distinguishing himself as the Renaissance man of the school drama department, designing costumes and scenery for numerous productions, acting in them, and even doing the publicity.

"I soon discovered I was meant to be a costume designer. I wanted to move to New York and design sets and costumes for Broadway, but I was in California and poor, so here I stayed." Moving on to Pasadena Civic College, Mackie eventually scored a scholarship to the Chouinard Art Institute. "I had one teacher who had been an ex-dancer in movie musicals with Eleanor Powell, who said, 'Why don't we put a showgirl costume in the fashion show this year?,' knowing that no one else would be interested except me," he noted. "I submitted about twenty sketches and was selected; it was very encouraging. Years later, when I opened a show in Las Vegas, I made *sure* that teacher was there."

That's the kind of heart, gratitude, and sense of loyalty that have characterized the man to this day.

As you'll see.

---

*Robert Gordon Mackie in a salute to George M. Cohan at Rosemead High School in 1956. "Bobby" was responsible for sets, costumes, and choreography, as well as taking center stage. As his career progressed, he preferred to let his designs hold the spotlight.*

"I had one teacher who had been an ex-dancer in movie musicals with Eleanor Powell, who said, 'Why don't we put a showgirl costume in the fashion show this year?,' knowing that no one else would be interested except me. I submitted about twenty sketches and was selected; it was very encouraging. Years later, when I opened a show in Las Vegas, I made sure that teacher was there."

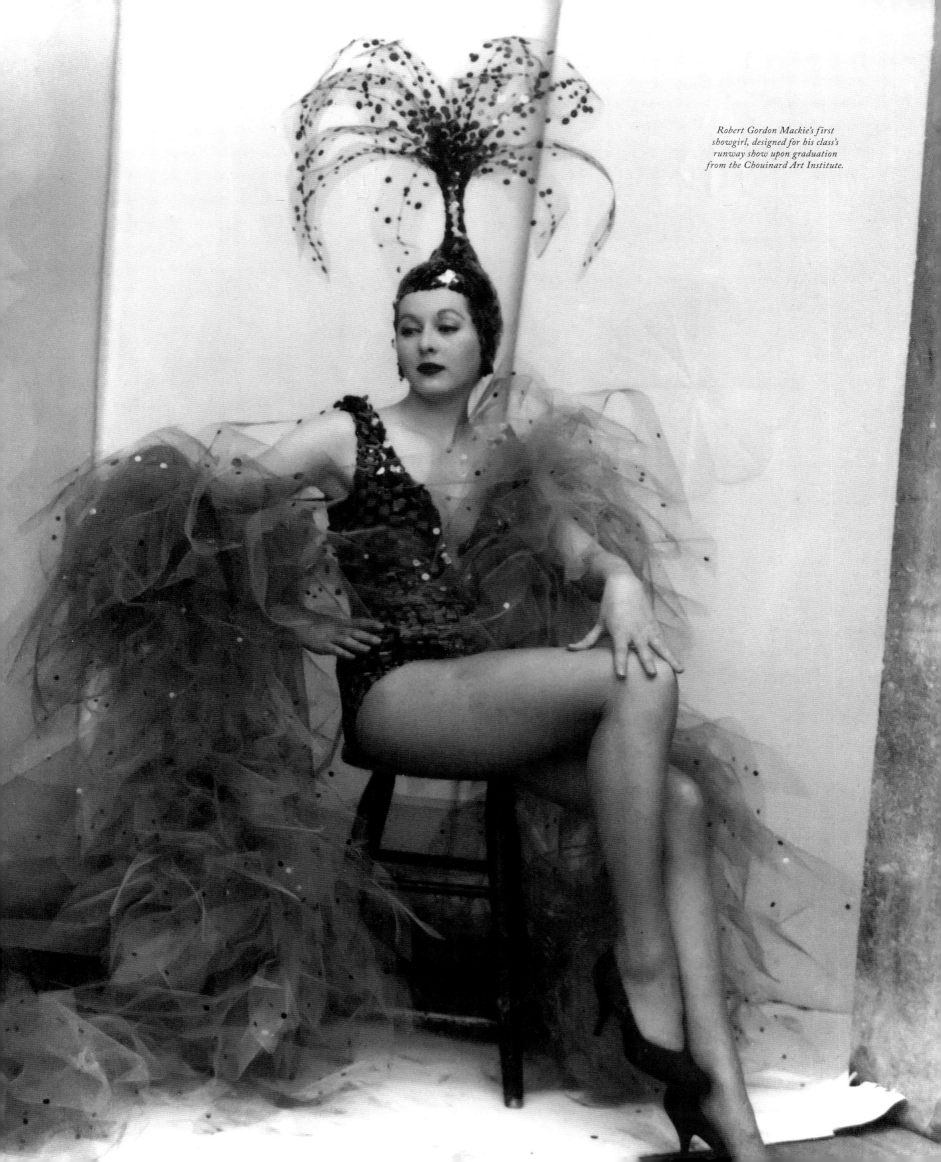

*Robert Gordon Mackie's first showgirl, designed for his class's runway show upon graduation from the Chouinard Art Institute.*

# Early
# *Influencers*

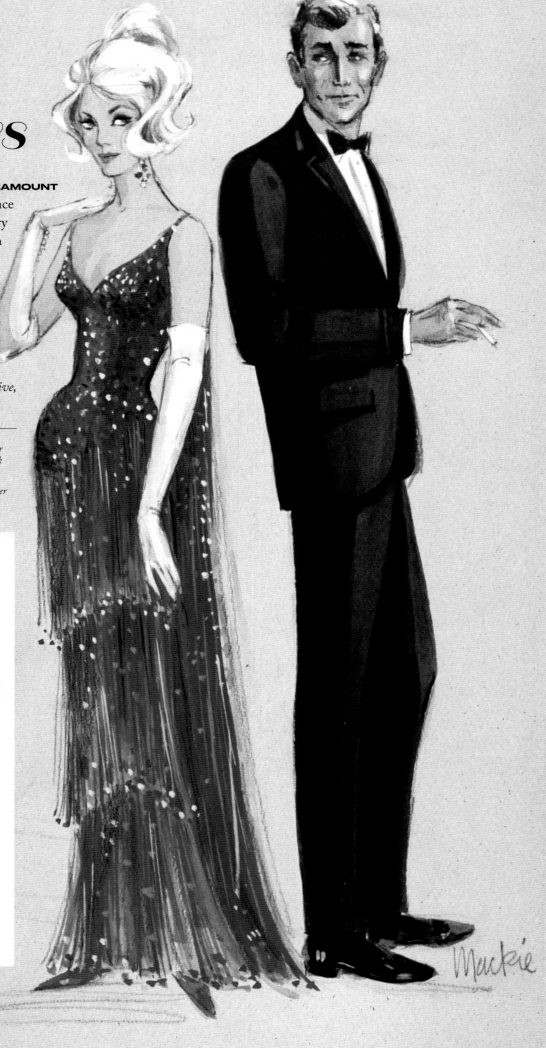

**MACKIE'S PORTFOLIO LANDED HIM AT PARAMOUNT**
Pictures in 1961, where he worked as a freelance
sketch artist until he was tapped by the legendary
Edith Head to draw her designs for movies such
as *A New Kind of Love* with Paul Newman and
Joanne Woodward, and *Love with the Proper
Stranger,* starring Natalie Wood.

In 1962, Mackie moved to 20th Cen-
tury Fox to sketch for another legend, Jean
Louis. His initial assignment was to work on
the never completed Marilyn Monroe/Dean
Martin/Cyd Charisse movie, *Something's Got to Give,*
directed by George Cukor.

RIGHT: *This sketch in Mackie's portfolio opened many doors for
him as an aspiring designer. Even at twenty-one, his trademark
sense of glamour and elegance was readily apparent.*

BELOW: *Mackie's rendering of Edith Head's design for a stripper
in the 1963 Joanne Woodward movie,* A New Kind of Love.

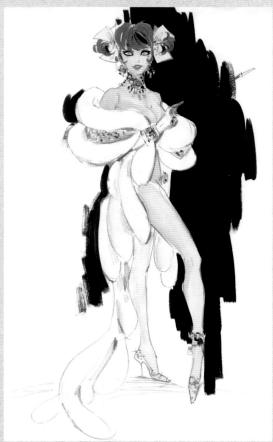

"*I learned a lot from Edith Head: how to work with producers, directors, and stars. That was her greatest attribute. For instance, if she had designed an entire sequence in pink and the star said 'Ugh, I hate pink!,' all the sketches would suddenly disappear, and Edith would say, 'PINK? Who said pink? I think we should do the whole thing in BLUE!' She was very smart, and a great businesswoman who worked her way up from the bottom to become head designer at Paramount.*"

LEFT AND ABOVE: *Two Mackie sketches of Edith Head's designs for the film* A New Kind of Love. *The one at left was for Eva Gabor, and above, Joanne Woodward.*

The legendary costume designer Jean Louis (last name Berthault) with Rita Hayworth, before it became fashionable to have three names in Hollywood.

"*Jean Louis was Mr. Glamour. He loved fashion because that's where he started, but when it came to designing anything for a housewife, he had no idea; he thought they all dressed like Donna Reed.*"

# Rhinestone *Goddess*

**IT WAS THE SPRING OF 1962, AND MARILYN MONROE WAS IN** a downward spiral. She had completed just a handful of scenes for what would be her final film, *Something's Got to Give,* and was constantly calling in sick with a laundry list of ailments. Much to the dismay of her costars, Dean Martin and Cyd Charisse, the George Cukor production had basically ground to a halt.

The wardrobe for the film was by Jean Louis (assisted with sketches by a twenty-three-year-old Robert Mackie), who had designed the famous "nude illusion" gowns for Marlene Dietrich's legendary cabaret acts. With the blessing of the film's studio, 20th

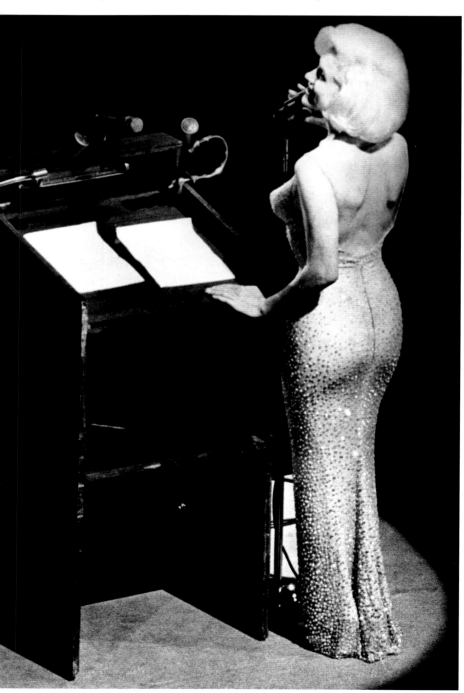

Century Fox (and an authorized day off), Monroe enlisted Jean Louis (and the mad sketching skills of Mackie) to help her create an unforgettable moment in the annals of pop culture, when politics, show business, and (nearly) naked sexuality would come together unapologetically under the guise of American patriotism.

On May 19, 1962, Monroe made one of her last public appearances, at the forty-fifth birthday party (and Democratic fund-raiser) for President John F. Kennedy. It was held at New York's Madison Square Garden ten days before his actual birthday, and the top ticket price was a hundred dollars. First Lady Jacqueline was decidedly not present for the antics, which included a comedy "bit" by Kennedy's actor brother-in-law Peter Lawford that, in retrospect, turned out to be the darkest of gallows humor. Playing on Monroe's notorious habit of holding up production (her reputation was on par with that of another troubled icon, Judy Garland), Lawford introduced her several times to no response. When she finally tippy-toed onto the stage as rehearsed, Lawford proceeded to announce her as "the late Marilyn Monroe," a prophecy just under three months premature.

Monroe ceremoniously doffed her white ermine coat, handed it to Lawford, and basked in the shock and adoring awe of the fifteen thousand people present. The other celebrities on the bill, including Jack Benny, Ella Fitzgerald, Bobby Darin, Peggy Lee, Henry Fonda, and Maria Callas, became footnotes the moment she revealed *the dress.* Some twenty-five hundred glittering rhinestones had been sewn onto a flesh-colored gown made of marquisette—and then Marilyn herself had been sewn into the garment, which fit her like a second skin every bit as miraculous as her first. The effect was sheer sex and harked back to the bad old days when the star had posed in the altogether for calendars and pinups—with a few strands of tinsel added for presidential decorum.

After flicking the microphone with her index finger to make sure it was "live," Monroe took one giant step out from behind the podium to offer the full effect, then proceeded to whisper-sing "Happy Birthday, Mr. President," followed by "Thanks for the Memory" with special lyrics. The whole performance lasted less than a minute, but history was made.

To review: The dress was designed by Jean Louis, but the original rendering was by Mackie. Almost sixty years later, Mackie recalled, "She really wanted to wake people up. She asked for something that would make everybody think she was nude, but her body appeared to be covered with diamonds when she took that fur coat off."

Diamonds. They're a girl's best friend, someone once sang.

LEFT: *Marilyn Monroe scores the biggest knockout at Madison Square Garden since Willie Troy hit the canvas in 1954.*

OPPOSITE, TOP LEFT: *The original Mackie sketch for Jean Louis's design, sold at auction and now in a private collection.*

OPPOSITE, RIGHT: *Mackie's 1990s reimagining of his original sketch.*

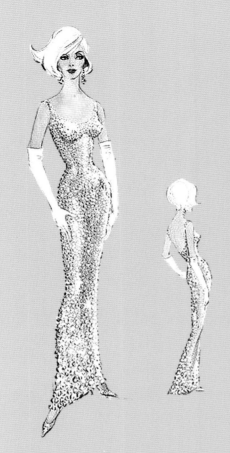

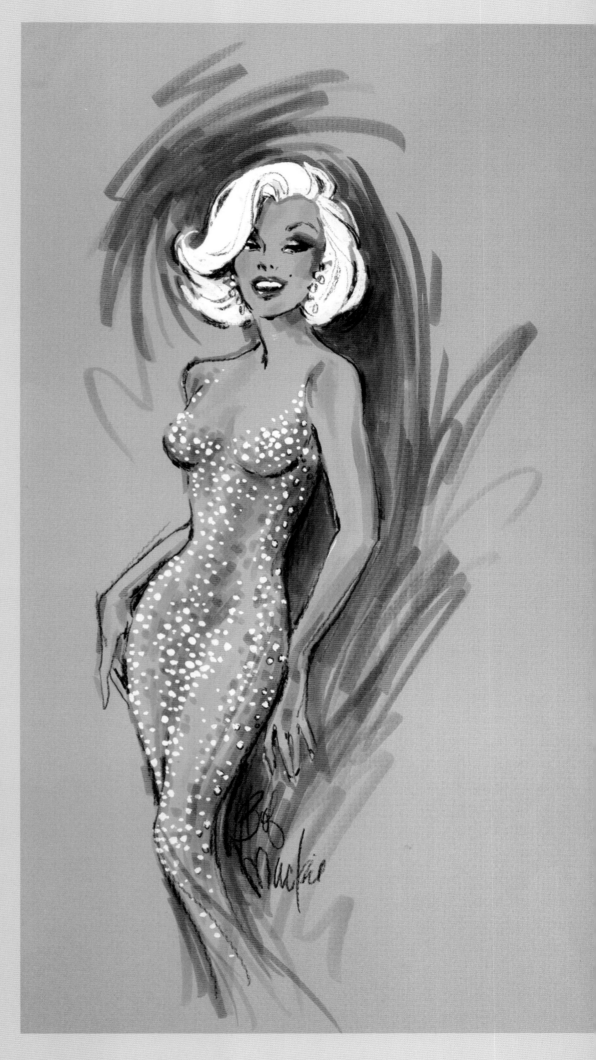

"She really wanted to wake people up. She asked for something that would make everybody think she was nude, but her body appeared to be covered with diamonds when she took that fur coat off."

# When *Judy* Met *Ray*

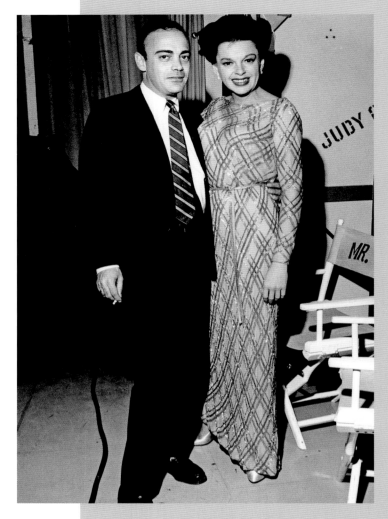

BY 1963, THE STUDIO SYSTEM, UNDER WHICH ACTORS, directors, and designers were tethered to a particular studio by an exclusive years-long contract, was in the throes of a slow death. Mackie, along with much of Hollywood, saw the freedom and possibilities of working in television, a medium that was expanding, along with its viewership, in every possible direction.

Ray Aghayan was absolutely right about *The Judy Garland Show* being a tough one. In fact, the only aspect of the production that wasn't riddled with angst was the creation of Garland's wardrobe. Maybe that's because the star had been raised at MGM, where everyone was told what to wear—not asked. Or maybe it's because she was financially strapped at the time and hoped to be able to cadge a few elegant pieces for her personal wardrobe. (When Aghayan found out that Garland had to travel to New York to do publicity and didn't have a coat, or even a dress to wear to lunch, he asked the set designer to create a street scene for one medley, then designed her a lovely dress with a matching fur-collared coat.)

Garland had recently lost a great deal of weight and looked better than she had in years. The minute she saw Aghayan's designs—or, more accurately, Mackie's sketches of them—she trusted him completely. In addition to the coat and dress, Aghayan created a series of stunning gowns, pantsuits, and casual wear that gave her boundless confidence—in her appearance, anyway. And, sure enough, every piece went home with her after they wrapped.

RIGHT, TOP: *Garland and Aghayan backstage at CBS Television City.*

RIGHT, BOTTOM: *Having salvaged much of her wardrobe from the brief run of her eponymous show, Judy wore the same Aghayan gown in 1964 for a night out on the town with fourth husband Mark Herron.*

OPPOSITE, TOP: *Judy Garland in her spectacular "poppy dress," designed by Ray Aghayan in what seems to have been a tip of the hat to* The Wizard of Oz. *The dress was reimagined in cooler colors for the 2019 biopic* Judy, *starring Renee Zellweger.*

OPPOSITE, BOTTOM: *Three more examples of Mackie's brilliant sketching skills, perfectly capturing the electric energy of Judy Garland.*

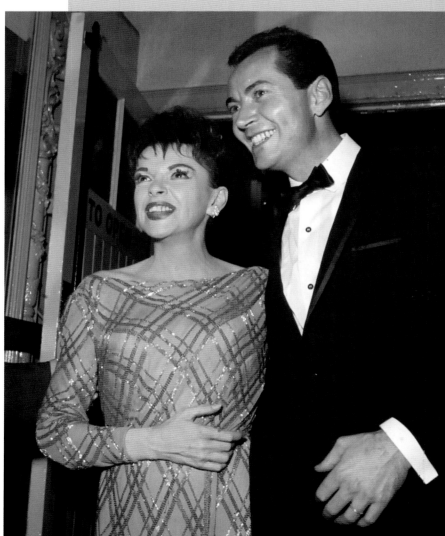

"*After I realized that Edith Head was never going to retire, I took my portfolio to NBC, which had a wonderful costume department run by Angie Jones. They looked at it and were complimentary. I was very flattered, of course, and that's where I met Ret Turner, a wonderful television designer, and Ray Aghayan. When Ray was offered* The Judy Garland Show *in 1963, he said, 'Would you like to be my assistant? I think this is going to be a tough one.' I said, '. . . Yeah, I think you're right!'*"

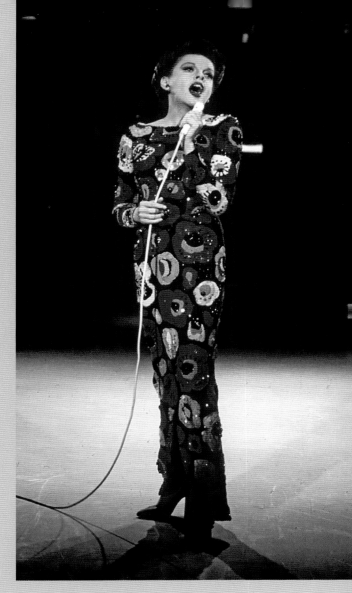

*"She had a very odd figure, so it would be impossible for her to go into a store and buy something," recalled Mackie. "She had very long legs for a woman of her height, was short-waisted, yet had a bust. I think Ray did a fantastic job with her. She never really looked the same before or after that."*

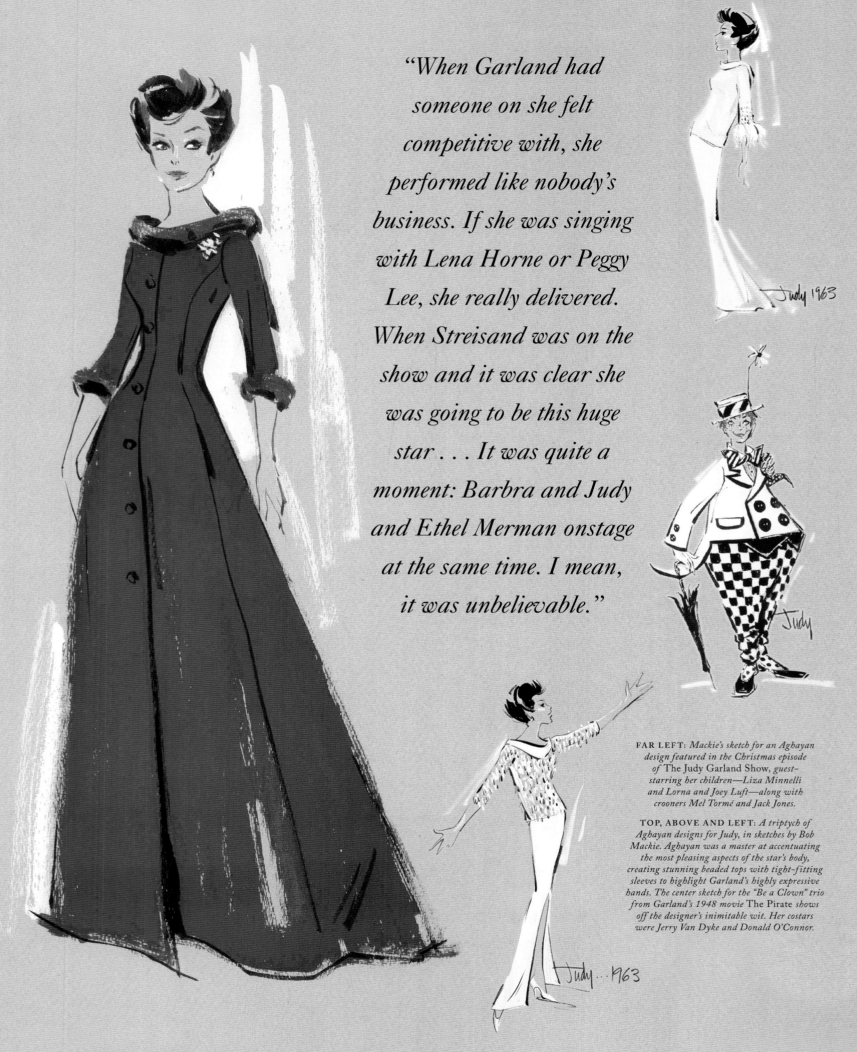

"When Garland had someone on she felt competitive with, she performed like nobody's business. If she was singing with Lena Horne or Peggy Lee, she really delivered. When Streisand was on the show and it was clear she was going to be this huge star . . . It was quite a moment: Barbra and Judy and Ethel Merman onstage at the same time. I mean, it was unbelievable."

*Judy 1963*

*Judy*

*Judy . . . 1963*

**FAR LEFT:** *Mackie's sketch for an Aghayan design featured in the Christmas episode of* The Judy Garland Show, *guest-starring her children—Liza Minnelli and Lorna and Joey Luft—along with crooners Mel Tormé and Jack Jones.*

**TOP, ABOVE AND LEFT:** *A triptych of Aghayan designs for Judy, in sketches by Bob Mackie. Aghayan was a master at accentuating the most pleasing aspects of the star's body, creating stunning beaded tops with tight-fitting sleeves to highlight Garland's highly expressive hands. The center sketch for the "Be a Clown" trio from Garland's 1948 movie* The Pirate *shows off the designer's inimitable wit. Her costars were Jerry Van Dyke and Donald O'Connor.*

# Mackie in *Judyland*

**ON HER BEST DAYS, THE FOUR-FEET-ELEVEN-INCH LEGEND** was a full-time job—which created a golden opportunity for Mackie. "Ray never knew when—or if—Judy would show up for her fittings, so I ended up dressing the chorus and the guest stars on my own," he remembered.

And what a roster of guest stars it was! In the course of his work on the Garland show, Mackie created gowns for the likes of Lena Horne, Peggy Lee, Ethel Merman, June Allyson, Martha Raye, and—perhaps even more significant—such rising stars as Liza Minnelli, Diahann Carroll, Chita Rivera, and a twenty-one-year-old from Brooklyn named Barbra . . . something. It wouldn't be the last time that he—or we—would hear from those gals.

The show was notoriously troubled, with a constantly rotating cohort of producers, directors, and staff. "I was counting up all the choreographers that came through," Mackie recalled. "We had Marc Breaux and Dee Dee Wood; Peter Gennaro from *The Perry Como Show;* Nick Castle; Danny Daniels; and Ernie Flatt [with whom Mackie would work for eleven seasons of *Burnett*]."

By all accounts, taping day was agony, with dozens of dancers sitting around in costume for hours, waiting for Garland to appear. When she finally did emerge from her trailer on the balcony of CBS Television City, she followed a custom-painted yellow-brick road leading to the studio.

Mackie's assessment of this formative experience? "Frankly, the whole thing was just a little weird."

---

ABOVE: *Mackie's designs for the dancers meshed beautifully with Aghayan's designs for Garland. Here, Judy and the Peter Gennaro Dancers perform the "Soul Bossa Nova" early in the show's run.*

RIGHT, TOP AND BOTTOM: *A Mackie rendering of an Aghayan design for Liza Minnelli's guest appearance on* The Judy Garland Show *comes to life on the soundstage. The pair would wear the outfits again for their smash appearance at the London Palladium in November 1964.*

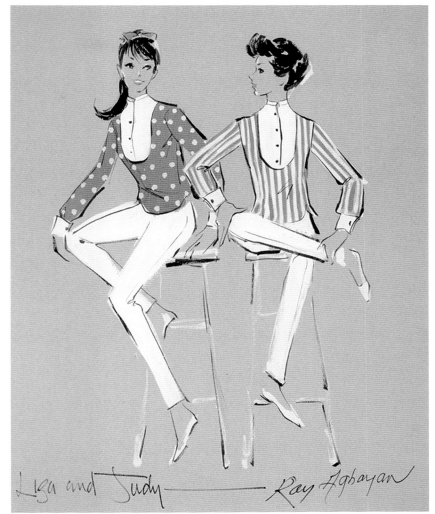

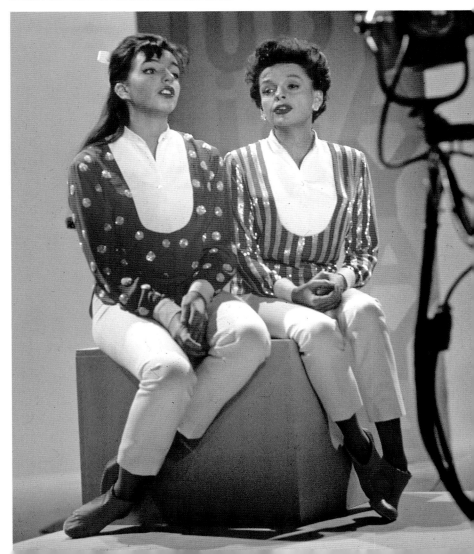

# ON HIS WAY

**ASK ANYONE WHO HAS EVER EXPERIENCED IT. GETTING** that first promotion, that new title, that office with a door—or, if you're an actor, that first mention in a *Playbill* or credits crawl—is an unparalleled shot of career adrenaline.

Bob Mackie's name first appeared in viewers' homes at the end of the sixth episode of *The Judy Garland Show* in 1963, when he was credited as assistant costume designer. Two years later, the words "Costumes Designed by Ray Aghayan and Bob Mackie" appeared over the closing music of the 1965 special *Danny Thomas' The Wonderful World of Burlesque*—and it was a career changer. The equal billing of the two designers probably came at the insistence of Aghayan, as it was pretty much unheard of for assistants to get screen credit in the 1960s.

Even as Mackie's career expanded in scope, he continued to do all of his own sketches as well as Aghayan's, unless the project was, in his words, "crazy big." The two became full-fledged partners, and Mackie attained irrevocable entrée into the fittings of the stars and the whole wide world of television, film, and theater. "We each had our distinct, sometimes differing opinions," recalled Mackie, "and, believe me, the younger partner had a *lot* to say!"

To quote Lin-Manuel Miranda (and we're told that this is obligatory for book sales), Mackie had graduated to "The Room Where It Happens."

---

LEFT, TOP TO BOTTOM: *Three Mackie renderings for Lucille Ball in the 1965* The Wonderful World of Burlesque.

RIGHT: *A Mackie sketch for Barbara Eden as the seductive Lalumne in the 1967 ABC musical adaptation of the Broadway musical* Kismet.

OPPOSITE, LEFT AND TOP RIGHT: *Lee Remick as an underwater goddess in a Ziegfeld Follies-inspired production number in the 1965 NBC Danny Thomas special,* The Wonderful World of Burlesque.

OPPOSITE, BOTTOM RIGHT: *Ricardo Montalban, Agnes Moorehead, Nanette Fabray, and Robert Coote as the White and Red Kings and Queens.*

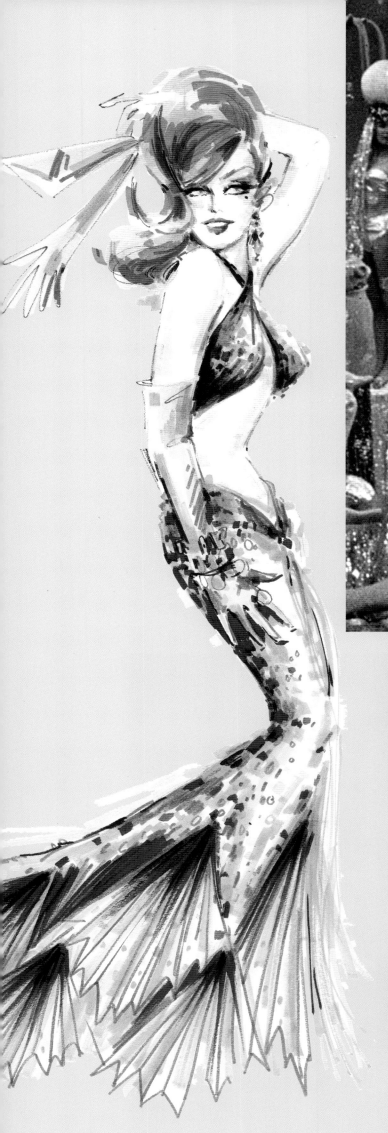

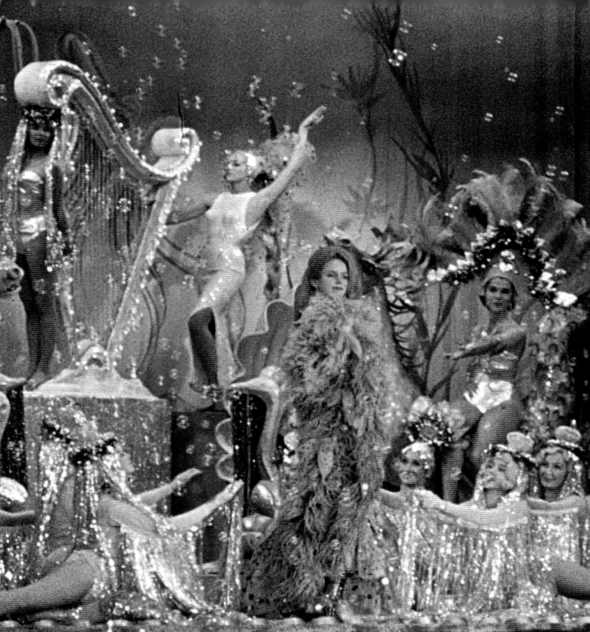

# Burlesque with a *Twist*

IN A SERIES OF THREE NBC SPECIALS BETWEEN 1964 AND 1966, Danny Thomas brought back a completely moribund art form for older viewers (and some young ones) who'd rather stay parked on their davenports than venture out to pay two bucks for a ticket and a couple of beers.

Presented in glorious living color, *The Wonderful World of Burlesque* starred some of the greatest farceurs in the business, including veterans of the Orpheum Circuit Jimmy Durante, Jack Benny, and Herbie Faye, plus slightly younger vaudeville/nightclub denizens Mickey Rooney, Jerry Lewis, Carl Reiner, and Dean Martin. But without the "secret sauce"—i.e., a bevy of long-legged, curvaceous gals with an acute sense of comic timing—any revival of burlesque would fall as flat as last night's seltzer down the pants. Enter Bob Mackie's creations for Lee Remick, Shirley Jones, Edie Adams, Carol Channing, Cyd Charisse, and the only comedienne who could've held her own in this wacky world—the most recognizable redhead of the twentieth century—Lucille Ball.

In these shows, the viewing audience was treated to such cutting-edge yuks as a restaurant sketch in which Jerry Lewis lost his false teeth in a water glass (are we having fun yet?). But the production numbers shone, led by Shirley Jones as a sexy soprano, Lee Remick descending from the heavens like Nicole Kidman in *Moulin Rouge*, and a fifty-five-year-old Lucy flying like a monarch butterfly on her way back to Beverly Hills from Capistrano. As Mackie remembered, "I was scared to death when I met [Lucy]. She was determined to out-fly Mary Martin in *Peter Pan*, with these huge butterfly wings to flap. She was a glorious-looking woman, five foot eight. When she started in Hollywood, she was one of the really tall girls in town. But after all that anxiety, I liked her a lot, and she did Carol [Burnett]'s show many times. She always looked great in anything you put on her. Even when it was funny, she just worked it."

RIGHT AND BELOW: *MGM musical legend Cyd Charisse from sketch to stage, in the 1967 fourth edition of Danny Thomas's series of burlesque specials.*

OPPOSITE TOP: *Remick and the ladies of the ensemble.*

OPPOSITE BOTTOM: *Mackie sketches for Shirley Jones and Lee Remick for two editions of Danny Thomas's* The Wonderful World of Burlesque.

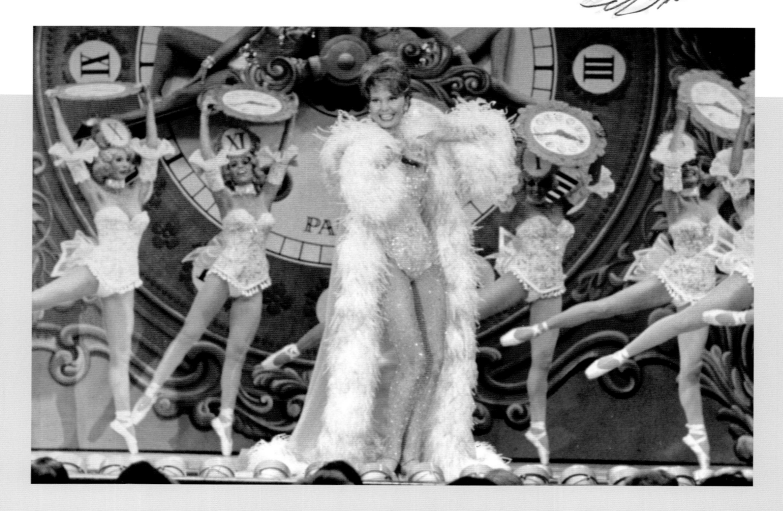

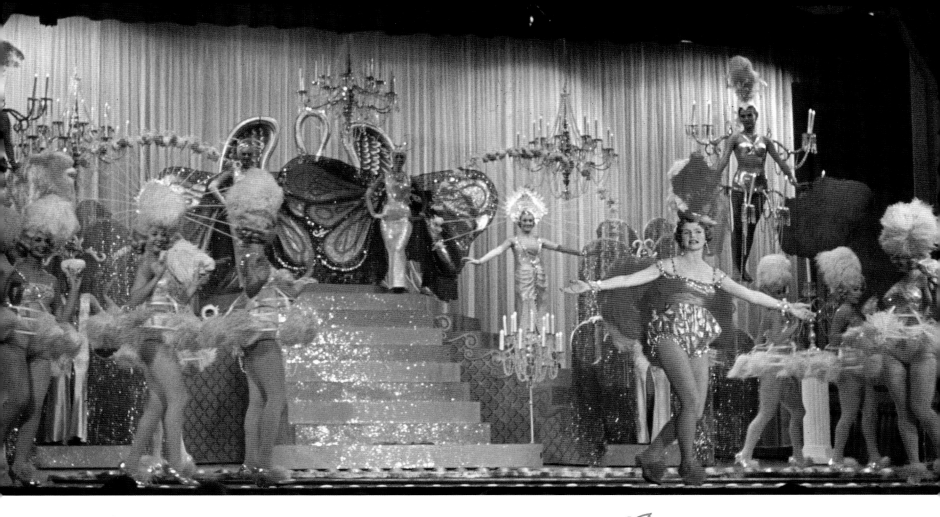

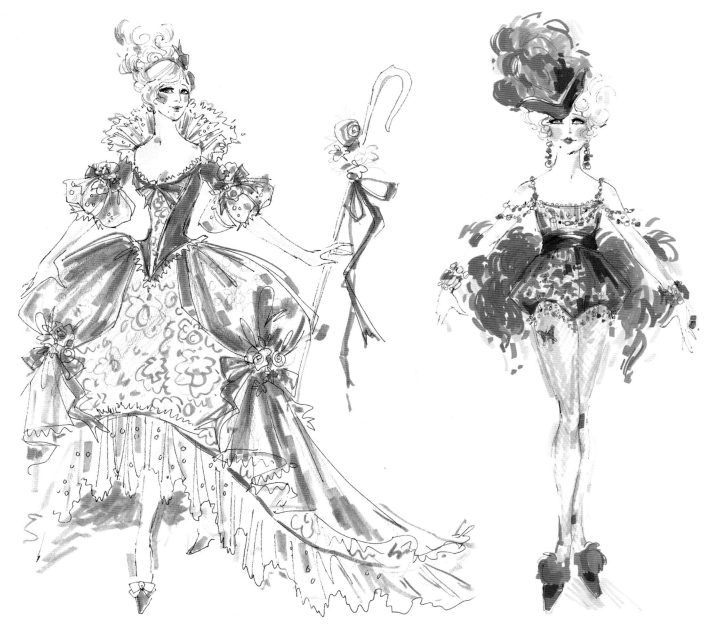

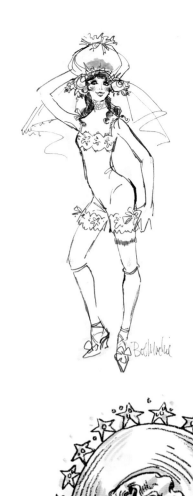

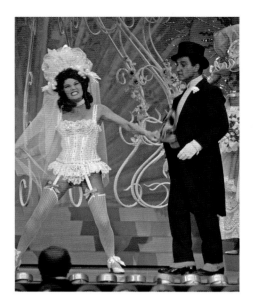

ABOVE, LEFT AND RIGHT: *The adorable, effusive Nanette Fabray would go on to wear many of his creations on* The Carol Burnett Show, *but she got her first taste of the Mackie magic in the 1967 edition of Thomas's specials.*

LEFT AND BELOW: *Lee Remick— the sketch and the reality. The real Remick is preparing to mount a crescent moon so she can descend from above singing, "Look for the Silver Lining."*

OPPOSITE: *Lucille Ball made it clear she was game for a flying harness, so Mackie designed a butterfly getup in which she swept onto the soundstage in classic burlesque style.*

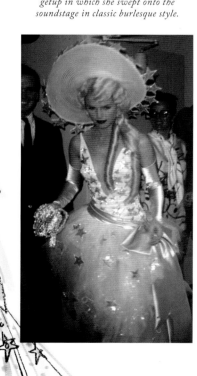

*"I was scared to death when I met Lucy. She was determined to out-fly Mary Martin in Peter Pan, with these huge butterfly wings to flap. She was a glorious-looking woman, five foot eight… She always looked great in anything you put on her. Even when it was funny, she just worked it."*

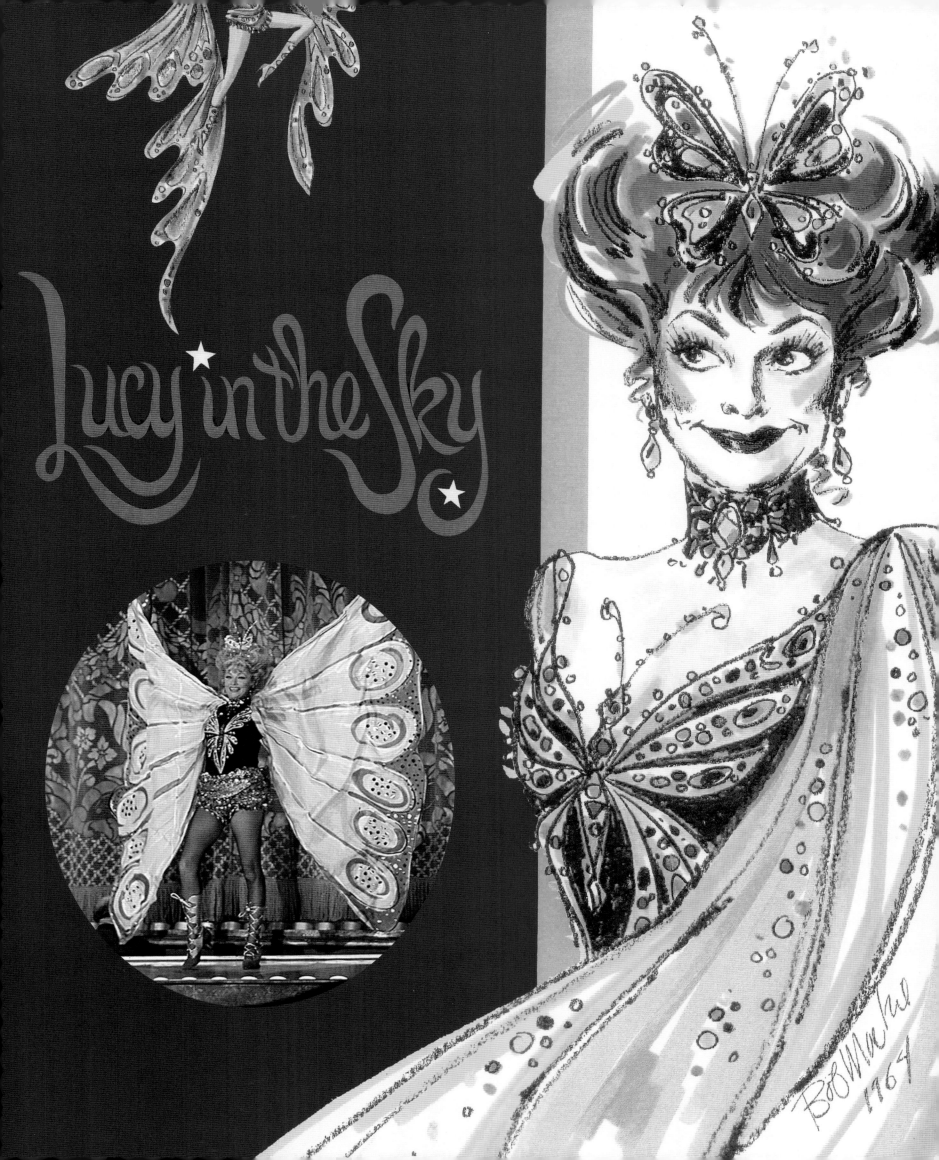

Lucy in the Sky

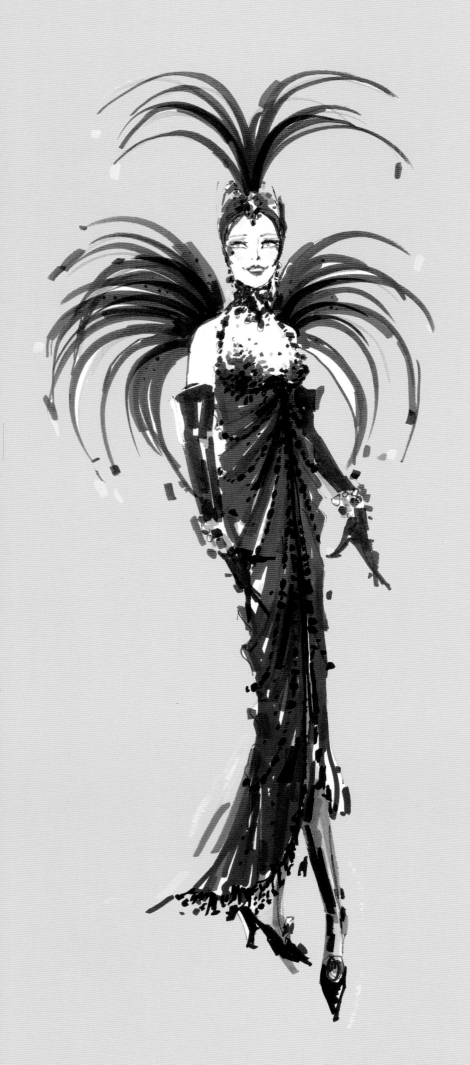

*Without the "secret sauce"—a bevy of long-legged, curvaceous gals with an acute sense of comic timing—any revival of burlesque would fall as flat as last night's seltzer down the pants.*

LEFT AND BELOW: *Lee Remick as Eva Tanguay, the "I Don't Care Girl."*

# Long Live the *Kings*

**MACKIE'S FIRST SOLO CREDIT AS A COSTUME DESIGNER** was for the 1965–66 ABC variety series *The King Family Show*—and it was something of an anomaly for him, considering his penchant for over-the-top glitz and glamour. As an act, the Kings—all proud members of the Church of Latter-day Saints—were a rather chaste affair compared to Judy and Marilyn. There was plenty of room for satin, chiffon, and silk, of course, but very little call for sequins, feathers, or glove-snug sheer illusion. "Yes, it was a culture shock, but it was all my own," commented the designer.

The central core of the group was four very blond sisters (Alyce, Luise, Marilyn, and Yvonne, if you are keeping score at home, with older sisters Donna and Maxine contributing special numbers), backed up by their husbands, in-laws, and assorted children. After years of hit records and a well-received appearance on *The Hollywood Palace* in 1964, the large-scale act had been tapped by ABC to front a mid-season replacement series premiering in January of the following year.

Despite initially good ratings and an unforgettable cover of the Beatles' "Yesterday" that has been viewed more than a hundred thousand times on YouTube, the show struggled against ratings heavyweights *The Jackie Gleason Show* and *I Dream of Jeannie*. That, plus a general shift in the cultural zeitgeist, caused ABC first to pare the show to a half hour and then cancel it just a year into its run—sending some thirty-nine family members off to form their own Mackie-clad unemployment line.

ABOVE: *The King Family in all their fertile, musical glory.*

LEFT AND RIGHT: *In 1968,* The Carol Burnett Show *did a hilarious spoof of the King Family. As the camera panned across eleven blondes, they introduced themselves as, "Bonnie, Betty, Barbara, Bunny, Bea, Barbie. . . ." Finally, the camera came to rest on Harvey Korman, dolled up hilariously in a blond wig and chiffon dress. After the slightest pause, he deadpanned, "Becky." Gales of laughter, but that was just the warmup; the camera continued on its way until it found blond-wigged Isabel Sanford, future star of* The Jeffersons. *"And I'm Beulah," she said in her no-nonsense contralto, "and I'll tell you something. I ain't the only blonde here with black roots."*

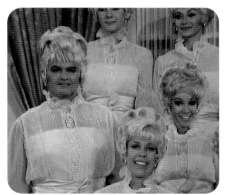

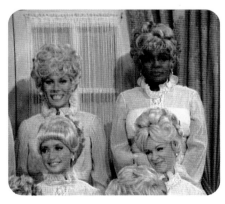

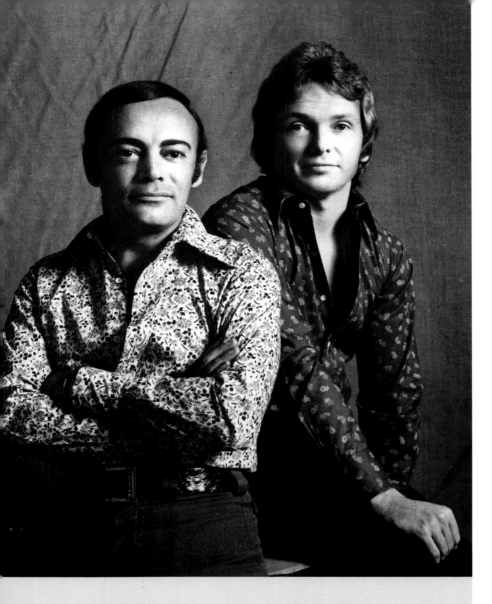

# Creative
# *Kismet*

**THE GROUNDBREAKING DESIGNER GORGEN RAY AGHAYAN,** mentor to Bob Mackie and his life partner for almost fifty years, was born in Iran to a wealthy family. His widowed mother was a royal dressmaker, and by the age of thirteen, Ray had created his first gown, for Fawzia Fuad, the first wife of the last shah of Iran.

As gifted as he was with a needle, Ray had stars in his eyes and yearned to leverage his good looks into a career in acting. He begged his mother, Yasmine, to send him to Los Angeles instead of Paris—the usual trajectory for affluent Iranian youths in the 1940s—and she assented. Ray studied acting and dance and appeared in the MGM film version of the Broadway musical *Kismet.* (His expertise in the rituals and protocol of his home country served him so well that he would go on to direct the play several times.)

When Ray realized that his true talent lay in dressing actors rather than dressing up as one, his career took off like a rocket. He dressed Doris Day, Betty Hutton, Dinah Shore, Leslie Caron, and Julie Andrews and was responsible for Juliet Prowse's glamorous metamorphosis into a Las Vegas superstar. If the world (or at least Hollywood) were a just place, his brilliant costumes for the 1967 movie *Doctor Dolittle* surely would have been nominated for an Academy Award.

"What Ray taught me about designing," said Mackie, "was that it was always about the stars and making them look good; about charging the audience up with their entrance even before they opened their mouths."

*"What Ray taught me about designing was that it was always about the stars and making them look good; about charging the audience up with their entrance even before they opened their mouths."*

LEFT: *Ray Aghayan and Bob Mackie in the early 1970s.*

BELOW: *Aghayan and Mackie at the Hollywood Arts Council's 30th Anniversary Gala in 2008.*

Amen. Perhaps of all of Ray's many triumphs, his greatest accomplishment in that department was his transformation of Judy Garland on her one-season CBS variety show in 1963–64. Besides the impact his work had on the star, it was during that assignment that Ray met and mentored a young Bob Mackie, and the two formed a personal and professional relationship that would last for five decades.

Ray and Bob quickly developed a rapport that very few collaborators ever achieve, fueling each other's creativity and forging a completely nonjudgmental, totally creative working environment where imagination, whimsy, and fresh ideas were celebrated and never discouraged.

As for Judy, the two men made sure she always looked willowy, elegant, and a foot taller than her actual four-eleven. Aghayan was masterful at calming the fragile superstar and shoring up her confidence with a series of pitch-perfect, theatrical, and yet easy-to-wear ensembles in which she made television history. Let's go to the videotape: If Judy hadn't felt great in what she was wearing, could she really have delivered those iconic performances?

The newly formed dream team would go on to design *Alice, Lady Sings the Blues, Funny Lady*, and clothes for Lola Falana, Carol Channing, and Barbra Streisand, among others. On his own, Aghayan also created the spectacular costumes for the opening and closing ceremonies of the 1984 Los Angeles Olympics. We give him perfect tens for those and all the rest.

TOP LEFT: *Mackie's rendering of Aghayan's design for Doris Day in the 1966 film* The Glass Bottom Boat.

TOP RIGHT: *Ray Aghayan and cast members on the set of the 1967 movie musical* Doctor Dolittle, *which featured some of his most inventive costumes. Note actors Rex Harrison (in the plaid vest) and Richard Attenborough at the upper right with their backs to the camera.*

ABOVE: *Juliet Prowse in a Russian-inspired Aghayan design for her Las Vegas act in the early 1960s.*

LEFT: *A trio of Mackie sketches of Aghayan's stylish designs for Angie Dickinson in the 1965 film* The Art of Love.

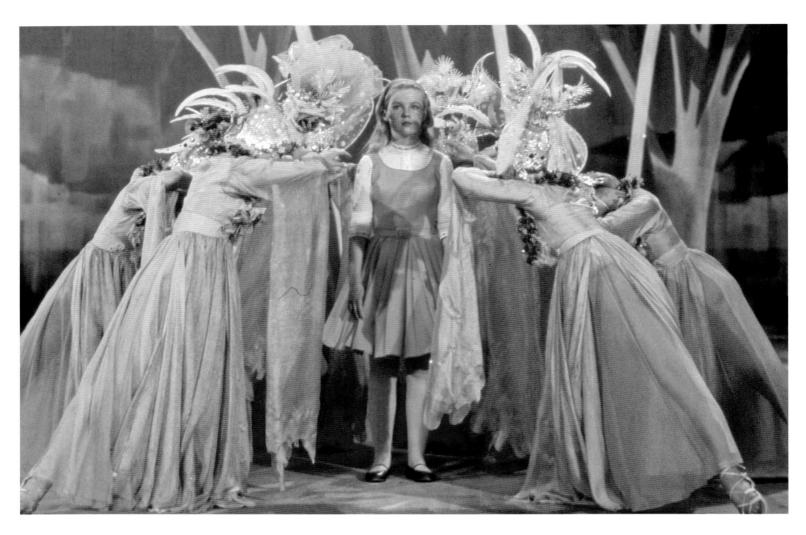

# *Curiouser* and *Curiouser*

**THE 1966 TELEVISION MUSICAL** *ALICE Through the Looking Glass*, designed by Bob and Ray and starring a panoply of show legends including Jimmy Durante, Agnes Moorehead, Jack Palance, Ricardo Montalban, Nanette Fabray, and the hottest new thing in counterculture humor—the Smothers Brothers—as Tweedledum and Tweedledee, was a turning point for the art of costume design for TV. Whereas Broadway and movie wardrobe designers had been lauded and feted for decades, there had never been an Emmy Award for costume design until Aghayan had a meeting with the Academy of Television Arts and Sciences and pressed them to create one.

While many television shows in the 1950s and early '60s were kitchen-sink sitcoms or dramas or courtroom nail-biters such as *Perry Mason*, when color television hit all three networks, the Pandora's box of imagination sprang open. When Aghayan's plea was met with skepticism by the nominating committee, who believed that costume designers simply purchased clothes at department stores and billed the networks for them, he responded (in his Iranian accent), "We are designing Lewis Carroll right now! YOU go to the May Company and grab a Red Queen costume for Miss Moorehead off the rack!"

Message received. The Academy created the first award for best "individual achievement in costume design," and guess who won it? Ray Aghayan and Bob Mackie, of course! Mackie remembered, "All the dancers were in these incredible felt costumes, and the flower garden all came to life; Jack Palance was the Jabberwocky, all mean and strange. It was wonderful and fun to do, because it was the first time I'd ever worked with fantasy on that kind of level. I was on my first trip to Europe when I heard we won an Emmy. I was on top of the world!"

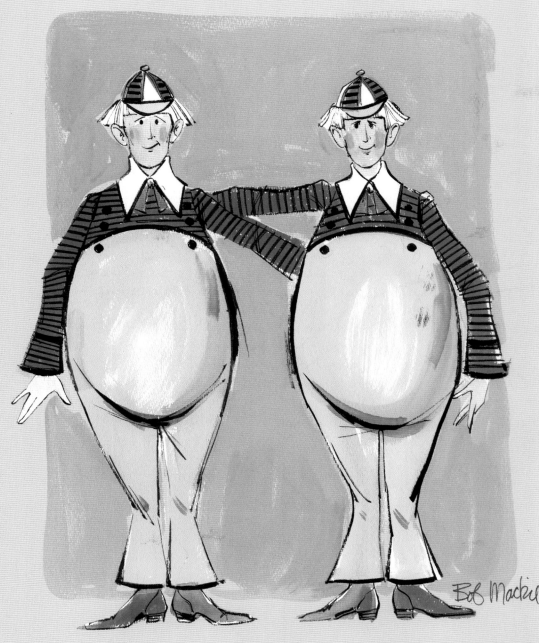

*"It was wonderful and fun to do, because it was the first time I'd ever worked with fantasy on that kind of level. I was on my first trip to Europe when I heard we won an Emmy. I was on top of the world!"*

OPPOSITE, TOP: *Judi Rolin as Alice, surrounded by a corps de ballet of dancing flowers.*

OPPOSITE, BOTTOM: *Movie bad guy Jack Palance as the evil Jabberwocky swapped his usual six-shooter for a vorpal sword. "Off with his head!"*

TOP LEFT: *Meet the Tweedles: Dee and Dum.*

LEFT: *Agnes Moorehead as the Red Queen, among a bevy of flamingoes in the 1966 NBC musical* Alice Through the Looking Glass. *The costumes earned Mackie and Aghayan their first Emmy Awards.*

BELOW: *Beloved comedian Jimmy Durante as major fall risk, Humpty Dumpty.*

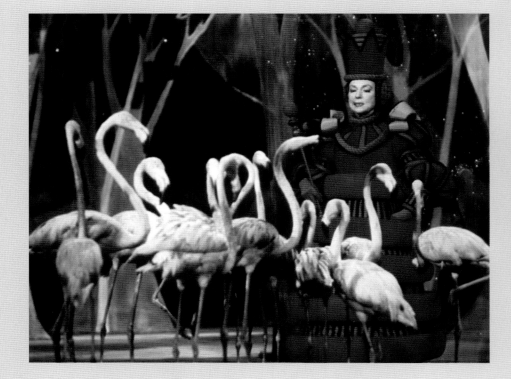

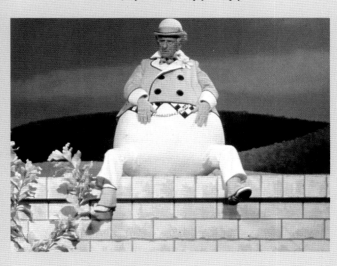

# Playing the *Palace*

**AFTER THE CANCELLATION OF *THE KING FAMILY SHOW*,** Mackie spent one season as designer for ABC's answer to Ed Sullivan, *The Hollywood Palace*. Over its first three seasons, the show had cemented its format as a weekly vaudeville—a true show-business olio featuring pop singers, stand-up comics, and circus performers (the aerial acts were filmed in the parking lot next door to the theater on Vine, right off of Hollywood Boulevard). Even the latest rock groups were part of the mix: The Rolling Stones made their U.S. debut on the show in 1964.

Rather than featuring one eponymous host, as on *Ed Sullivan*, the *Palace* offered a new headliner each week. Bing Crosby was the show's most frequent host, racking up more than thirty appearances, but many of the biggest stars in Hollywood took a turn as emcee, including Judy Garland, Frank Sinatra, Jimmy Durante, Fred Astaire, Sammy Davis Jr.—even Roy Rogers and Dale Evans. Of course, singers and comedians were the natural choice, as

they could be pressed into service throughout the show, performing solo or with other guests. But over the course of its seven seasons, the *Palace* offered up some gobsmacking choices. Bette Davis and Joan Crawford got their shot—mind you, not in the same week. Crawford's "performance" consisted of reading a poem called "A Prayer for Little Children." Yes, really.

Mackie's season was the show's second in glorious color. From 1966 to '67, the number of American households with color televisions doubled from five to ten million, and the inventive designer exploited that fact to the max. When working with the likes of Ann Miller, Juliet Prowse, Edie Adams, and Cyd Charisse, he could go to town, while Donald O'Connor, Van Johnson, and Crosby needed nothing more than the perfect tuxedo. Those weeks, Mackie focused his energy on over-the-top creations for the chorus.

"It was like vaudeville," said the designer, "like so many of the early variety shows, because so many of those people were still around. Vaudeville was dead, but these wonderful performers still knew how to dance and sing and tell jokes."

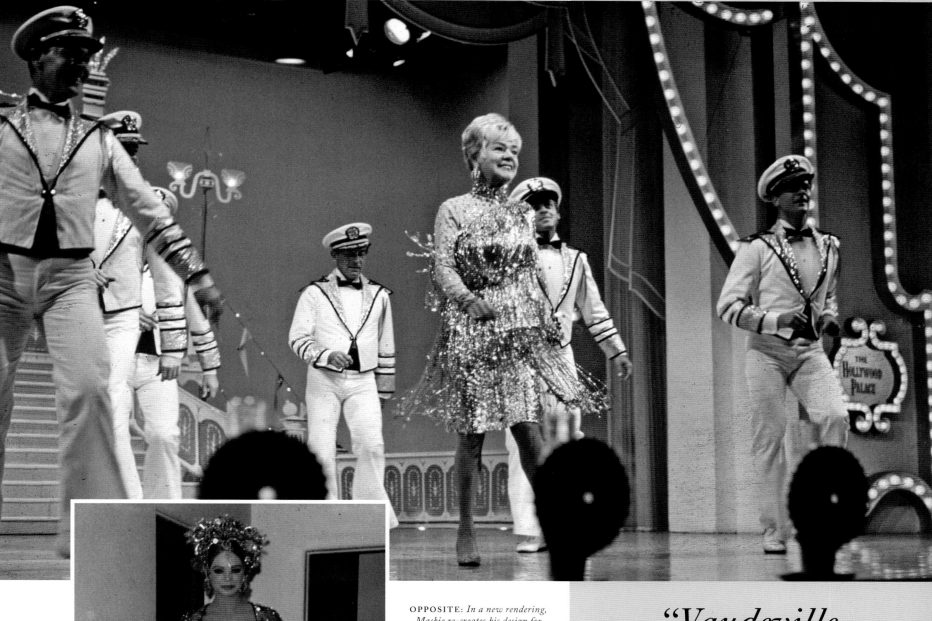

**OPPOSITE:** *In a new rendering, Mackie re-creates his design for the one-and-only Ann Miller as a Black Widow accompanied by two of her minions in the campy production number "Trapped in the Web of Love." Fifty-five years after the fact, the designer's sketching skills are as impeccable as his memory.*

**ABOVE:** *20th Century Fox musical superstar Alice Faye headlined* The Hollywood Palace *in 1967. For a production number set to the title song from* Mame, *she wore a gold-beaded Mackie original.*

**LEFT:** *One of Mackie's favorite muses, Juliet Prowse, about to perform one of her sinuous Jack Cole-inspired dance numbers on the* Palace.

*"Vaudeville was dead, but these wonderful performers still knew how to dance and sing and tell jokes."*

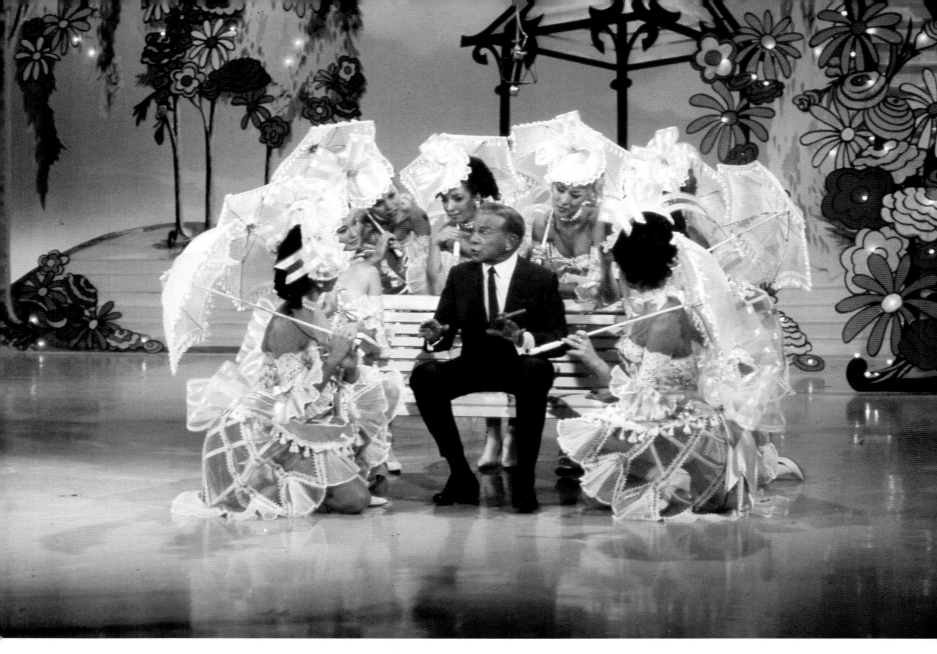

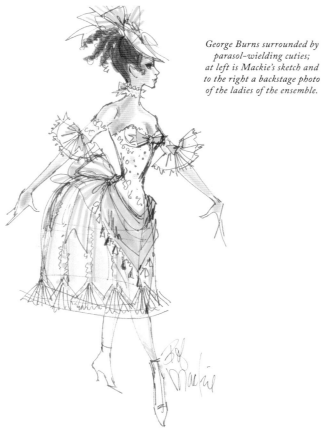

George Burns surrounded by
parasol-wielding cuties;
at left is Mackie's sketch and
to the right a backstage photo
of the ladies of the ensemble.

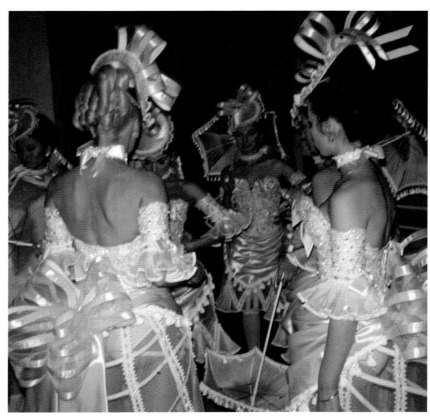

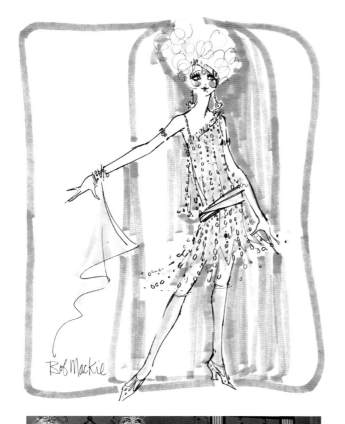

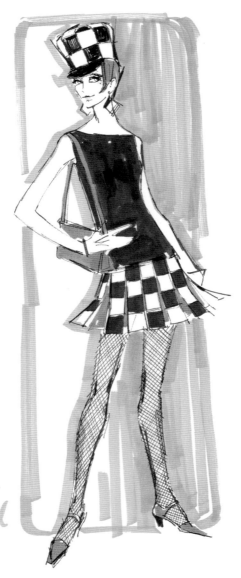

*Two Mackie renderings (at left, a flapper costume used in an opening number with host Bing Crosby; below, a "mod" chorine set to back up host Donald O'Connor in a tap specialty). Left center: Edie Adams in a Lady Godiva number. The ensemble's 1920s-style costumes would have fit right into the inventory of* The Carol Burnett Show.

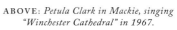

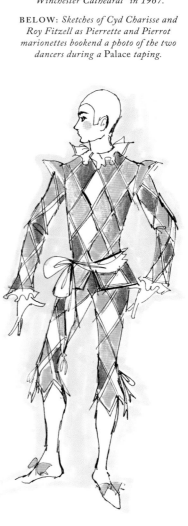

ABOVE: *Petula Clark in Mackie, singing "Winchester Cathedral" in 1967.*

BELOW: *Sketches of Cyd Charisse and Roy Fitzell as Pierrette and Pierrot marionettes bookend a photo of the two dancers during a* Palace *taping.*

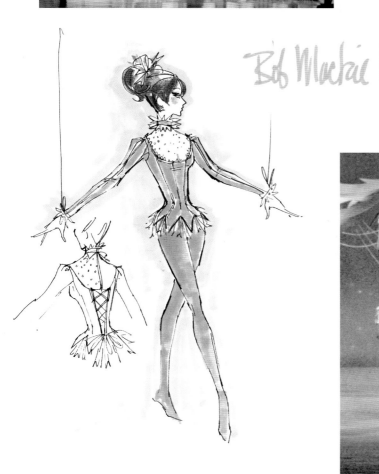

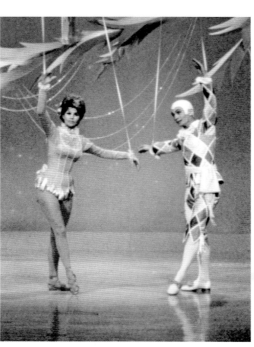

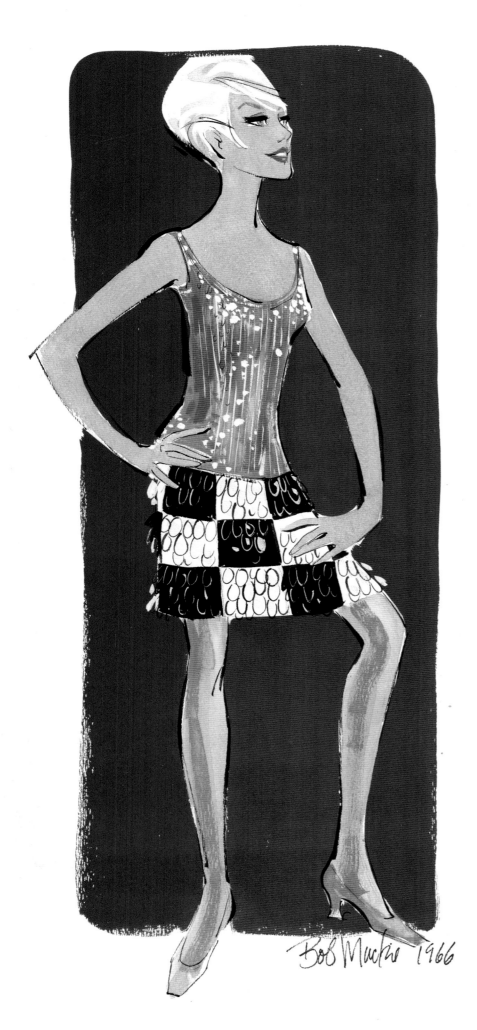

# *Mitzi* Girl

**IN 1966, THE GLAMOROUS, FUNNY, AND MULTITALENTED**
Mitzi Gaynor appeared on a Danny Thomas special called *My Home Town*, filmed on the MGM Studios lot with costumes designed by Ray Aghayan. Gaynor remembered, "Ray was Persian and funny and gorgeous, and we immediately clicked. A few months later, I was putting together a new show for Vegas. Ray couldn't do it, but he said he was sending over his friend who had done all the sketches for the Thomas special. I was in rehearsal, and this blond child popped his head into the room and said, 'Miss Gaynor? I'm Bob Mackie.' I said, 'Your voice hasn't changed yet!' And we've been 'married' ever since!"

Gaynor wanted to bring her nightclub act, which had been playing Las Vegas and the showroom circuit for years, into the 1960s—replacing her classic floor-length gowns and cocktail dresses with miniskirts, go-go boots, and the latest in "mod" fashion. Mackie followed her mandate to a Tee, and her revamped show at the Riviera Hotel in 1966 was a smash success, propelling Gaynor to a new level of popularity and fame.

The effort would prove a game changer for Mackie as well. As luck would have it, Carol Burnett and her husband, producer Joe Hamilton, caught Gaynor's act. Then on the hunt for someone to design for her upcoming CBS variety series, Burnett was wowed by Gaynor's imaginative, witty, and contemporary clothes. A meeting with Mackie was arranged, and—although Burnett thought the designer looked to be "about twelve years old"—she hired him on the spot. The rest, as they say, is history.

For her part, Gaynor was offered the chance to sing one of the nominated songs, "Georgy Girl," on the 1967 Oscar telecast. She accepted, though her initial reaction was "Georgy Girl? What's a Georgy Girl?"

The production number, costumed by Mackie and choreographed by Ernie Flatt (with whom he would work on Burnett's show the next eleven seasons), was one of those moments when art imitated life. For the first verse of the song, Mitzi wore horn-rimmed glasses, pigtails, a polka-dot Breton hat, and a shapeless smock dress, evoking the wholesome, corn-fed Mitzi people knew and loved from the movie *South Pacific*. But as she sang "The world will see . . . a new Georgy Girl!" off came the glasses, hat, and attached pigtails; away flew the forgettable *shmatta*; and there stood Mitzi in a Mackie stunner consisting of a hot-pink leotard festooned with blazing orange sequined fringe. Nellie Forbush had officially stepped into the 1960s, and she was frugging her fanny off for an audience of sixty-seven million viewers.

The energetic number, which received the longest ovation in Oscar history, paved the way for a series of Emmy-winning variety specials for Mitzi over the next decade, as well as a magical relationship between performer and designer that would endure to this day.

---

*Three sketches for Mitzi Gaynor's smash 1966 Las Vegas act. Mackie's designs transformed a musical movie star from the studio system of the 1950s into a hip, groovy, and suddenly sexy commodity.*

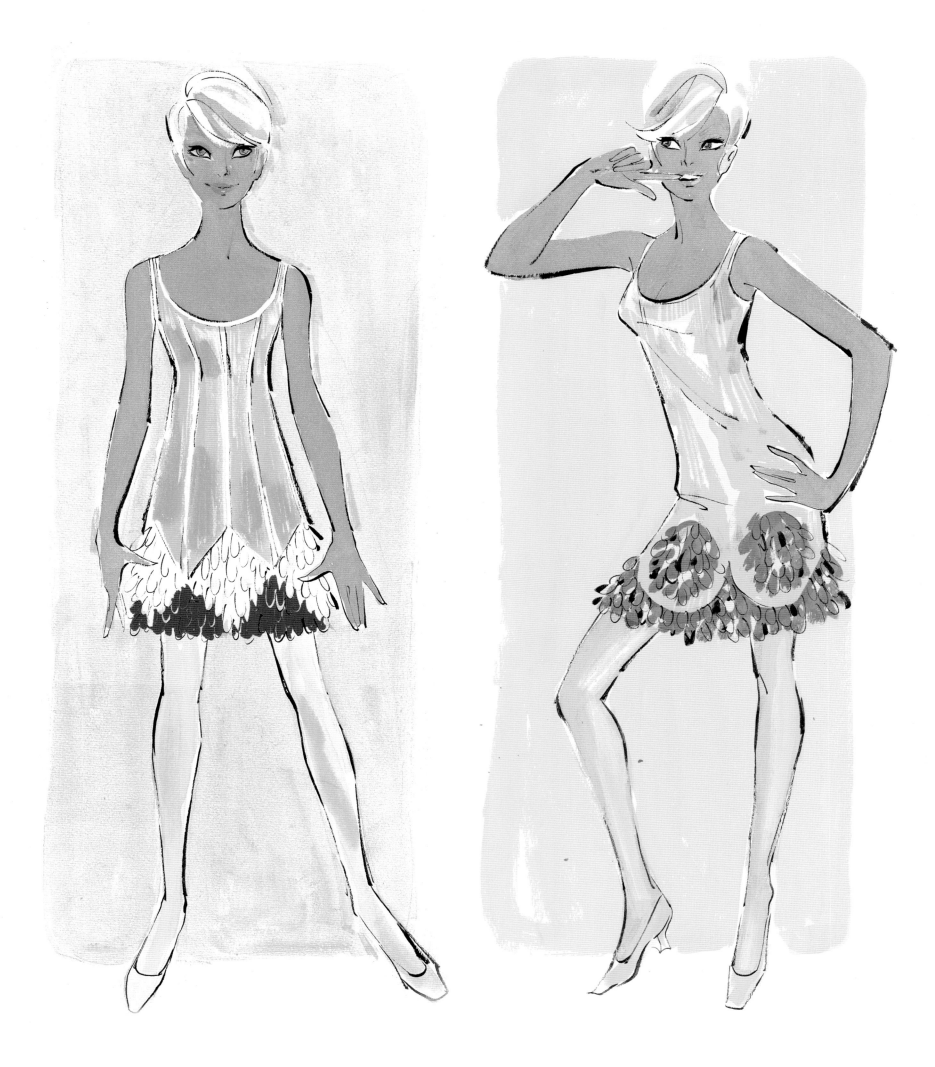

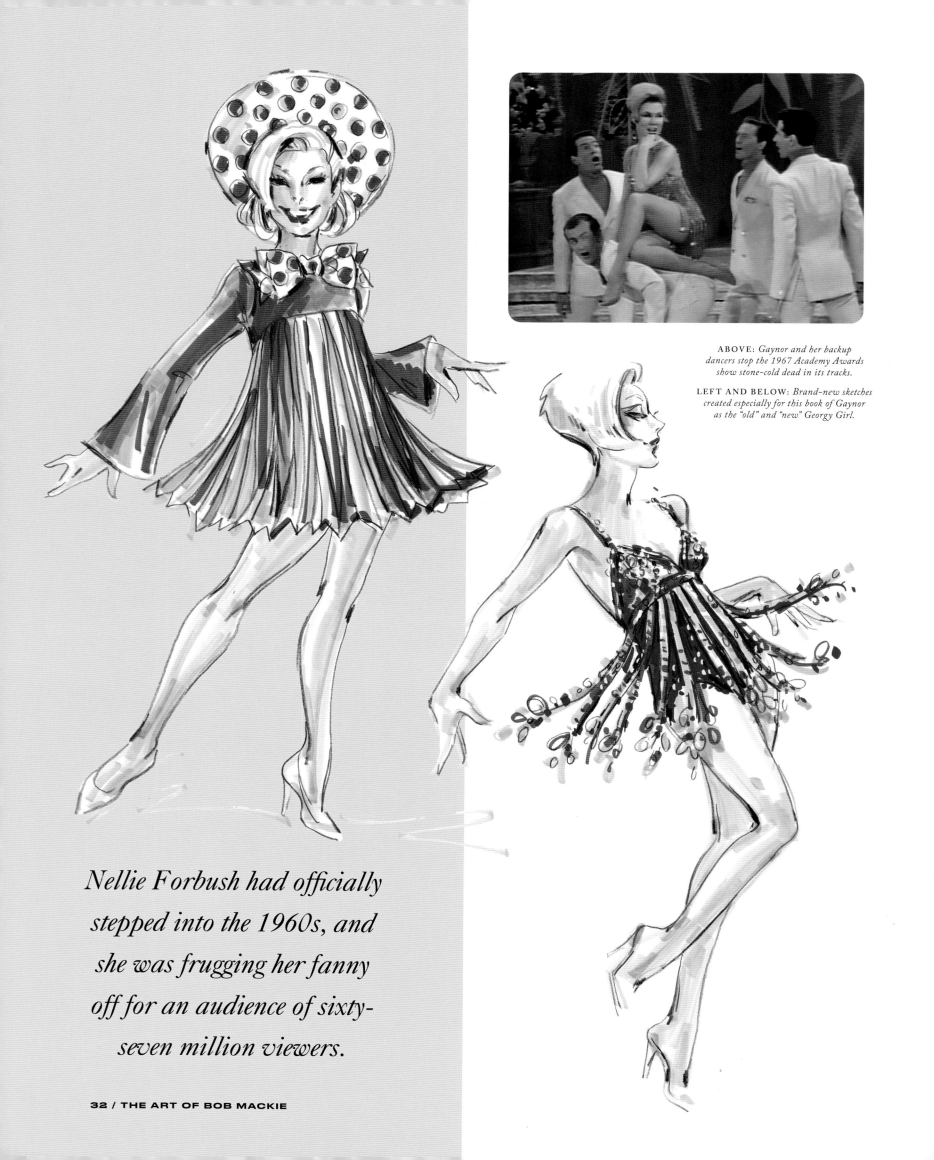

*Nellie Forbush had officially stepped into the 1960s, and she was frugging her fanny off for an audience of sixty-seven million viewers.*

# Broadway on the Box

**BY THE TIME BOB MACKIE'S DREAM OF DESIGNING A BROAD-**way musical finally came true, he'd been making a living in the business for six years. It was 1966, and he was tapped by producer Norman Rosemont to create the costumes for a series of ninety-minute TV adaptations of classic Broadway shows for ABC. The four titles chosen—each of which featured a handsome baritone lead—were *Brigadoon, Carousel, Kismet,* and *Kiss Me Kate.* (Bob would participate in just the first three; the last one would be filmed in New York City without him.) It was Rosemont's intention that Broadway and recording star Robert Goulet would star in all four.

Mackie recalled, "As it turned out, Bob [Goulet] didn't end up doing *Kismet,* though he hosted the telecast. They got José Ferrer, who couldn't really sing, so it made no sense. But I did get to work with Barbara Eden for the first time, which was terrific. She played Lalume and was gorgeous and so much fun to design for; and yes, we had to hide her navel yet again!"

The shows had top-notch casts. Besides Goulet, *Brigadoon* starred Sally Ann Howes and Peter Falk, and featured New York City Ballet legend Edward Villella as Harry Beaton. *Carousel* included recent *Bonanza* defector Pernell Roberts; and *Kismet* fielded Oscar winner George Chakiris and coloratura Anna Maria Alberghetti.

The big-budget productions were lavish. The set design for *Kismet* won a well-deserved Emmy, and we'd submit that Mackie's work rivaled any costume in an MGM musical or live Broadway show of its day.

The busy designer was coming off of his Emmy-winning work on *Alice Through the Looking Glass,* and these encapsulated versions of sumptuous Broadway shows would prove essential preparation for the weekly rigors of designing Carol Burnett's spectacular production numbers. Her show would premiere on CBS just a month before *Kismet* aired, as Johnny Carson used to say, "on another network."

RIGHT, TOP TO BOTTOM: *Robert Goulet as Billy Bigelow, Mary Grover as Julie Jordan, and Marlyn Mason as Carrie Pipperidge.*

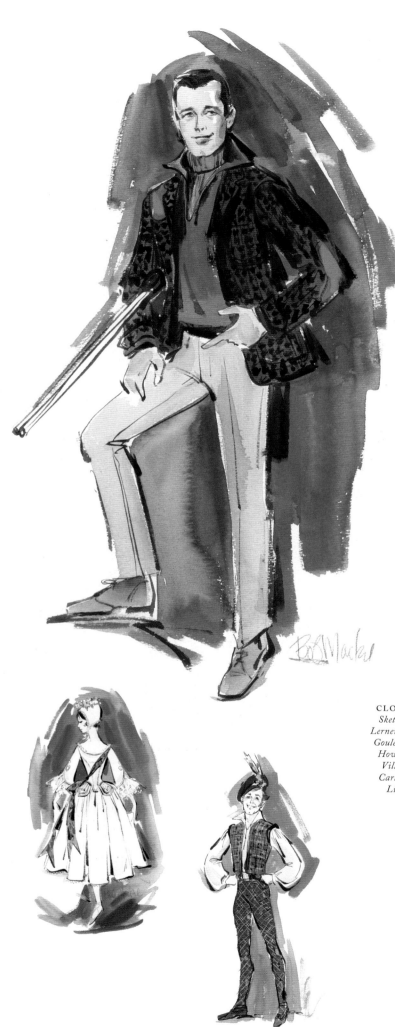

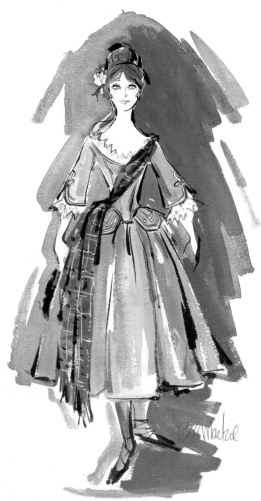

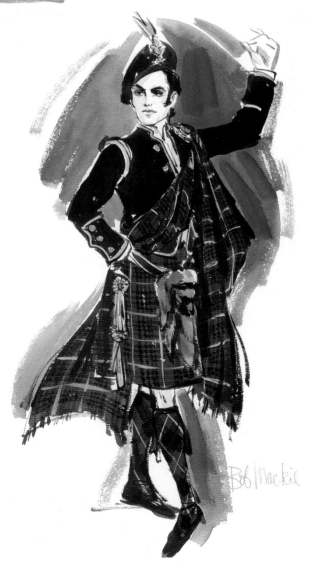

**CLOCKWISE FROM TOP LEFT:**
*Sketches for the 1967 TV version of Lerner and Loewe's* Brigadoon: *Robert Goulet as Tommy Albright, Sally Ann Howes as Fiona McLaren, Edward Villella as Harry Beaton, Thomas Carlisle as Charlie Dalrymple, and Linda Howe as Jean McLaren.*

*"I got to work with Barbara Eden for the first time, which was terrific. She played Lalume and was gorgeous and so much fun to design for; and yes, we had to hide her navel yet again!"*

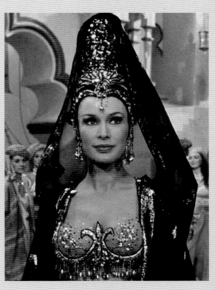

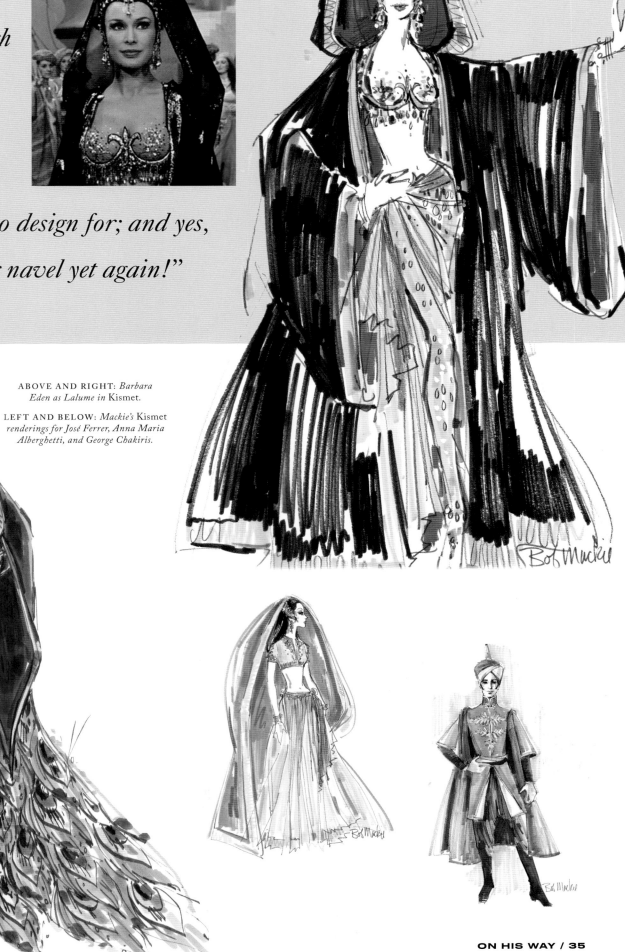

ABOVE AND RIGHT: *Barbara Eden as Lalume in* Kismet.

LEFT AND BELOW: *Mackie's Kismet renderings for José Ferrer, Anna Maria Alberghetti, and George Chakiris.*

# ADVENTURES IN TELEVISION

**WHEN CAROL BURNETT GOT THE CALL FROM CBS TO HEAD-**line her own variety hour, she was just the second woman in television history to do so—and the first comedienne to tackle sixty minutes of prime time in color. Carol had been a brilliant second banana and team player on *The Garry Moore Show*, and a bright light alongside Bob Newhart and Catarina Valente on the one-season flop *The Entertainers*. But this was a whole new ball game. Burnett's brand of antic comedy was tailor-made for full color—as was Bob Mackie's rainbow palette.

Carol would delight in spoofing the movie legends she'd idolized as an usherette at the Warner Bros. Theatre on Hollywood Boulevard—Lana Turner, Betty Grable, Rita Hayworth, even Gloria Swanson—all of whom would eventually guest-star on the *Burnett Show*. And with Mackie's invaluable help, these glittering stars, along with an enormous slate of original and unforgettable characters, came to life week after week, cementing both the star and the man who clothed her in the annals of television history.

Arguably (but who's arguing?), Carol couldn't have done it without the inspiration and support of her mentor, Lucille Ball. Well before she had her own name on a franchise, Carol appeared on *The Lucy Show* three times and later on *Here's Lucy*; and she was a special guest on the 1966 special *Carol + Lucy Plus Two*, costarring Zero Mostel. It stands to reason that when Miss Burnett called Miss Ball and asked, "Lucy, are you free next week?" the answer was "Sure, kid. When's the table read?" Just in case you thought the two flame-haired phenomena were rivals, let us reassure you: Theirs was one of the greatest non-tit-for-tat relationships ever.

With Carol's entrée into weekly variety—and a twenty-eight-year-old Mackie overseeing the shop—television entered a new chapter. So must we.

LEFT: *Mackie's bolero-inspired sketch for Broadway legend Gwen Verdon, for a 1968 Bob Hope TV special. The "Cool Hand Luke" dance, choreographed by Verdon's husband Bob Fosse, has become a beloved staple of every Fosse tribute.*

OPPOSITE: *Carol Burnett and Lucille Ball, comic cohorts and unflaggingly loyal friends until the day we lost Lucy, show off four of the best legs in the business in an extended musical sketch about two perfume salesgirls.*

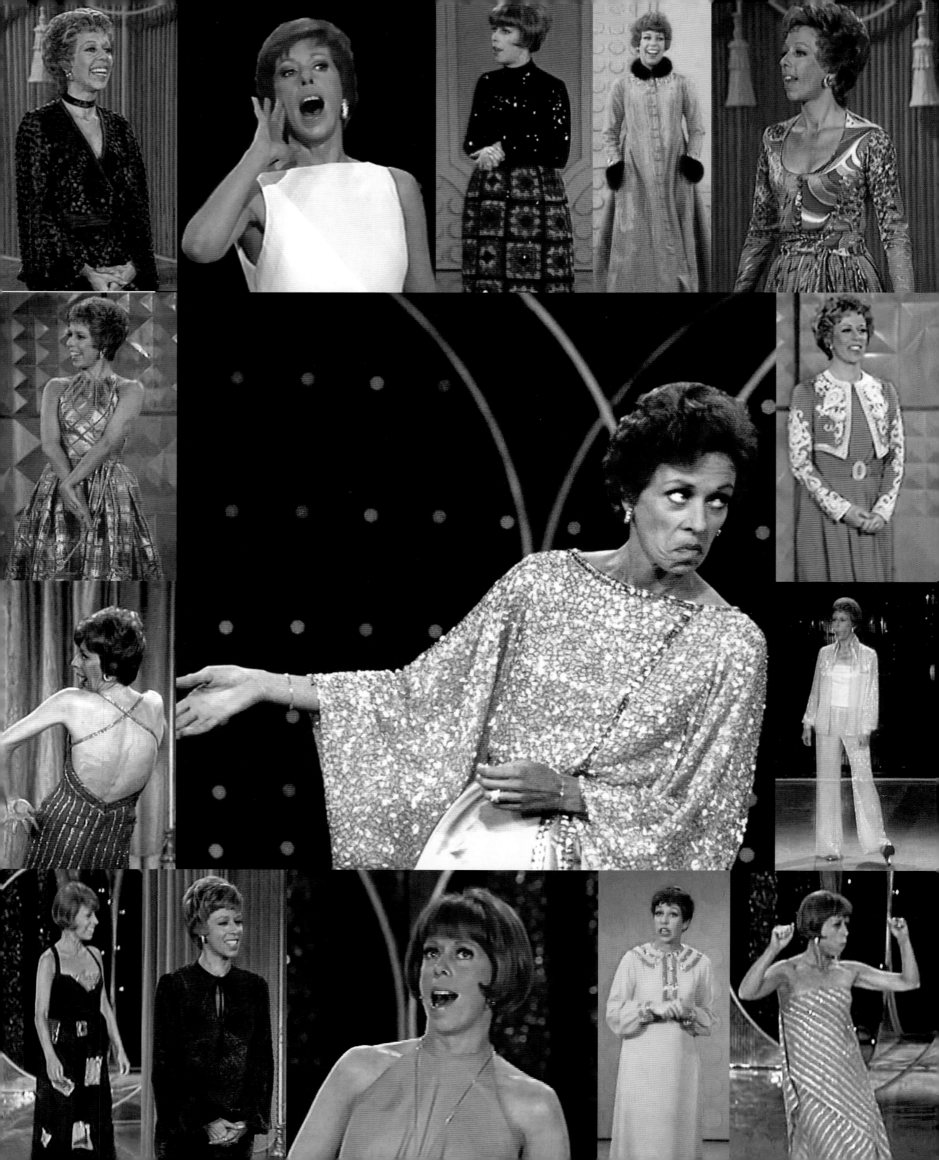

# "Bump up the *Lights*!"

**BEFORE** *THE CAROL BURNETT SHOW*, **NO OTHER VARIETY** offering had ever featured an unscripted question-and-answer segment with the studio audience. Let out a Tarzan yell for the most disarming, freewheeling, and fast-thinking host ever.

Mackie marveled: "Can you imagine it? Carol was actually afraid to talk to the audience when that show started. They had to trick her into it. At the first taping we did, she came out in her robe and just talked to the audience. (She wasn't dressed yet because we had a special costume for the big opening number. That's something we never did again.)" He went on to note that "Carol didn't mind talking to people twenty feet away; it was the idea of talking to that great unknown TV audience she didn't feel comfortable with. Joe [Hamilton, her husband and the show's producer] taped her give-and-talk without telling her and—of course—it was magic. She did it for eleven years, and she's STILL doing it at every opportunity. Carol can keep a crowd enthralled for ninety minutes just by conversing."

Of her groundbreaking show, Burnett recalled, "Most shows had a stand-up comic come out to warm up the audience before a taping, but I was terrified that whoever we hired would be funnier than our show, so I said no to that. Then our executive producer, Bob Banner, said, 'Carol, the audience needs to see you before you put on the wigs and the padding and black out your teeth.' 'What can I do?' I said. 'I can't tell jokes to save my life!' So Bob recommended, 'Just go out there and be you.' At first I was scared that no one would ask a question. After a few episodes, I was scared of what they would ask!"

In addition to the exhilaration of experiencing the "real Carol," the Q&A opening provided an opportunity to ogle the comedienne in a glamorous Mackie original before she donned her dizzying succession of nutty costumes. Each September, fans looked forward to the season premiere to see the new scenery (which, by season six, included stages that turned and split like the set of an MGM musical); Carol's chic new hairstyle; and Mackie's take on the latest fashion. Carol's dresses often featured pockets, which complemented her casual-chic, everywoman persona and the homey ambience of the sequence.

Cut to 1995. At an invited dress rehearsal of *Moon Over Buffalo*—Burnett's return to Broadway after a thirty-year absence—the show ground to a halt due to a glitch in the set's hydraulics. The restless audience sat squirming until Carol told the stage manager to lift the curtain (just waist-high so she could duck under, in keeping with her beloved folksy persona). Upon her emergence, she said the words that had so often kicked off her Q&A on TV: "Let's bump up the lights!" Roars of love greeted her, and she proceeded to answer audience questions until the scenic snafu was fixed.

Of her many gifts, perhaps Carol's greatest has always been the ability to know her audience, let them know her, and weave a heartfelt connection with them. Whether the question was "What kind of floor wax do you use?" or (for the five hundredth time) "Could you do your Tarzan yell?" she answered every query with warmth, patience, lung power—and a knockout dress.

**OPPOSITE:** *Carol Burnett in just a few of the 279 opening outfits that Bob Mackie designed for her over eleven seasons. Requests for her Tarzan yell were an almost weekly occurrence.*

**ABOVE AND LEFT:** *Two Q&A dresses, a sketch from 1968 and a photograph from 1971.*

**RIGHT:** *Carol Burnett can engage a studio audience like no one else. Her warmth, approachability, and quick wit during her beloved question-and-answer openers set the tone for the rest of the show.*

# Reaching for the *Stars*

**IT'S NO SECRET THAT CAROL BURNETT HAS ALWAYS WOR-**
shipped the movies—so much so that she was fired when, as a young
usherette, she refused to let a couple enter the theater during the last
five minutes of Alfred Hitchcock's *Strangers on a Train* for fear that
it would distract the other patrons and spoil the ending.

No worries about this glitch in her
résumé. She'd soon be off to UCLA, a
quick stop on Broadway, a sitcom turn
opposite Buddy Hackett, a series of
appearances on *The Ed Sullivan Show*, and
finally, Broadway stardom in *Once Upon
a Mattress*. After all that, at the ripe old
age of thirty-four, Carol found herself with
an hour of variety television to fill.

When it came to fielding guest stars, Bur-
nett aimed high. Within the first five
seasons, she'd snagged many of the
movie legends she had dreamed
about meeting back when she'd torn
tickets at the Warner Bros. The-
atre: Betty Grable, Bob Hope,
Rita Hayworth, Debbie Reynolds,
Bing Crosby, Ethel Merman, Don-
ald O'Connor, Lana Turner, Mickey
Rooney—the list goes on. She tapped comedy geni-
uses Imogene Coca, Nanette Fabray, Sid Caesar, and
Totie Fields, and welcomed such up-and-comers as
the Carpenters, Bobbie Gentry, Cass Elliot, George Car-
lin, Bernadette Peters, and Liza Minnelli, along with established
superstars Steve Lawrence and Eydie Gormé, Ella Fitzgerald, Mel
Tormé, Peggy Lee, Dionne Warwick, Perry Como, and Nancy Wil-
son. Week in and week out, the best of the best chatted, clowned,
and belted alongside Carol.

Of course, this was perfectly swell with her resident designer,
who got to create clothes for some of his own silver-screen idols.
Remember, little "Bobby" Mackie grew up starstruck in sunny
Southern California, too, with his own plans to conquer the world
of entertainment. The evidence is in: California dreamin' really can
pay off.

THIS PAGE: *In this whimsical 1968 sketch, pinup icon Betty Grable—one of Carol
Burnett's childhood idols—goes full-on country for the title song from* Hello, Dolly!

OPPOSITE: *Burnett's inner fan girl must have been swooning at the
opportunity to work with so many icons of the silver screen. Clockwise from
top left: Betty Grable and Martha Raye with Burnett in a 1968* Bonnie and
Clyde *production number; two Mackie renderings for screen siren Lana Turner's
1968 appearance; and Rita Hayworth and Burnett dressed as charwomen (one
of the only instances of someone other than Burnett donning the costume).*

*Within the first five seasons,
she'd snagged many of
the movie legends she had
dreamed about meeting back
when she'd torn tickets at the
Warner Bros. Theatre.*

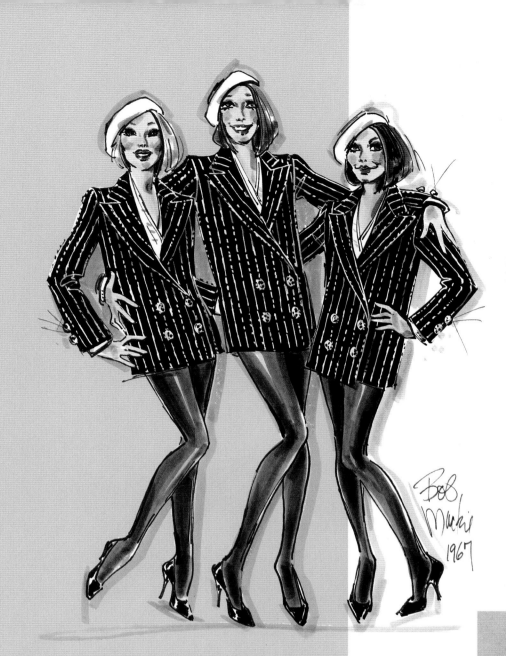

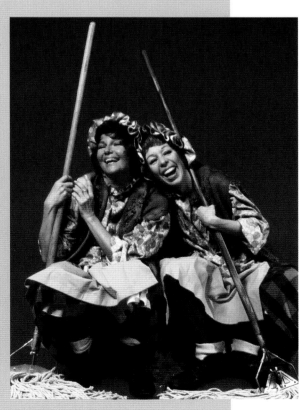

LEFT AND BELOW RIGHT: *Two of Broadway's greatest dancers, Chita Rivera (below right) and Gwen Verdon (left), made two appearances each on the* Burnett Show. *Here are sketches for Verdon's pink baby-doll outfit for an appearance in 1969 and Rivera's 1969 number "I Can Cook, Too."*

BELOW LEFT: *The brilliant Maggie Smith joined her chum Carol twice on the show. The sketch was for a 1975 appearance as an English floozy who disrupts the christening of a ship by Queen Elizabeth II.*

OPPOSITE PAGE, TOP RIGHT: *Carol Burnett and newly crowned movie star Lynn Redgrave, who was the guest at the first taping of* The Carol Burnett Show *(though it wasn't the first episode to air; that one featured Burnett's good luck charm, Jim Nabors).*

OPPOSITE PAGE, LEFT, CENTER, AND BOTTOM RIGHT: *A sequined jumpsuit and a flapper-style dress worn by Lesley Ann Warren in a 1967 turn on the show.*

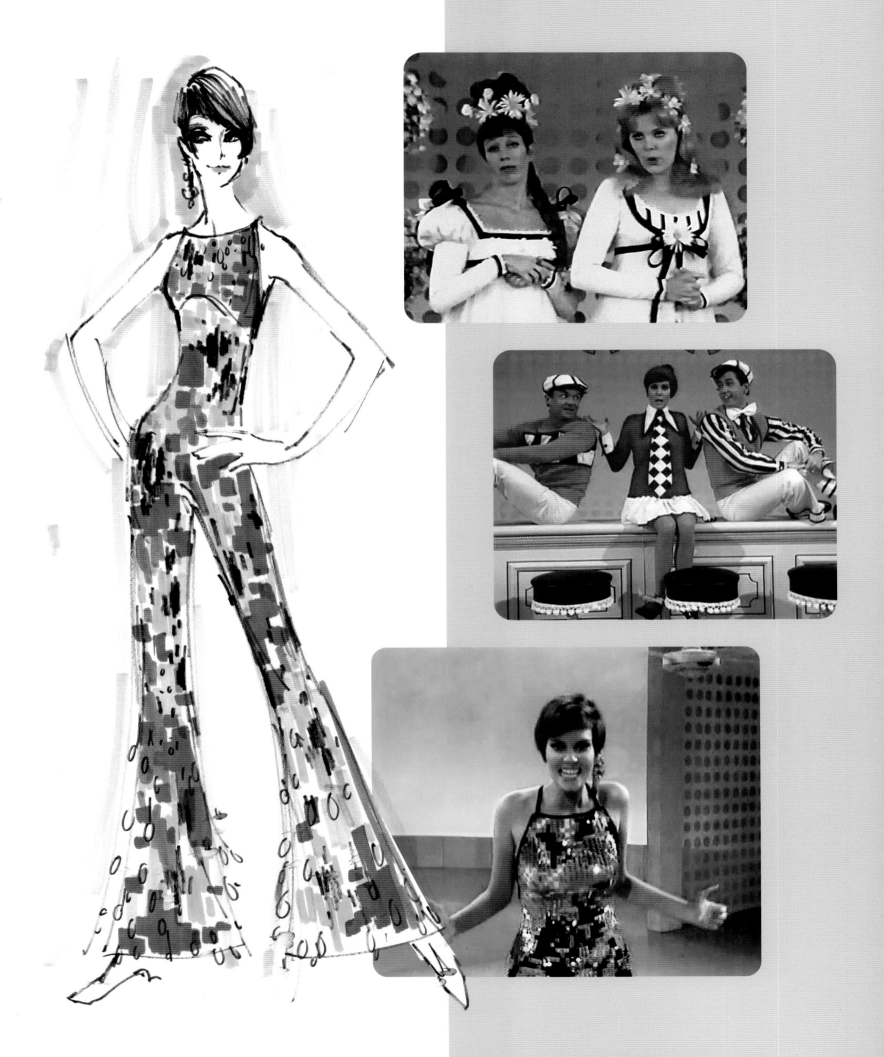

# What a *Character!*

**RECURRING CHARACTERS HAVE BEEN A STAPLE OF** television variety since its early days. Jackie Gleason's *Honeymooners* character Ralph Kramden began as a sketch on the DuMont network's *Cavalcade of Stars*; Red Skelton's lovable bum, Freddie the Freeloader, began in 1952 on Skelton's NBC show; and Lily Tomlin's legendary creations, Ernestine the Operator and little Edith Ann, won their first fans on *Rowan & Martin's Laugh-In*.

*The Carol Burnett Show* had its share of characters that lasted throughout the show's eleven seasons. Some of them, including "Carol and Sis" (featuring Vicki Lawrence, who was hired especially for these segments), appeared almost weekly in the early years, yet less frequently as the run continued. Those behind the scenes referred to "Carol and Sis"—based loosely on Burnett's experiences in New York, raising a younger sister with her husband—as the "orange-and-brown skits," based on the monochrome color scheme of the sets, costumes, and hair.

As the seasons progressed, audiences tended to respond more enthusiastically to Carol's more outrageous characters—thanks in part to Mackie's increasingly outrageous costumes. Some of the simpler, more family-oriented sketches, including Carol and Harvey Korman as "The Old Folks," faded away in favor of those featuring Mrs. Wiggins and Mr. Tudball, Eunice and her family, and a host of others you'll get to ogle later.

One of the sketches that remained surefire was the soap opera parody "As the Stomach Turns," created by the team of Gail Parent and Kenny Solms. Burnett brilliantly played the rare "straight woman," Marian Clayton, who was always in the middle of a crisis, drank a lot of coffee, and had deep thoughts to which we were privy. The ring of the doorbell inevitably heralded the entrance of some ridiculous character. Once, it was Cher in full Native American garb; another time, it was a satanically possessed Bernadette Peters kicking off a spoof of *The Exorcist*; many times, it was a towering Harvey Korman in drag and sporting a Yiddish accent as Mother Marcus, "Canoga Falls's freelance yenta." That one inspired one of Mackie's most delightfully over-the-top creations, featuring what can only be called a "hazardous bosom."

Besides Burnett's signature charwoman, which she had been doing since 1963 (although Mackie refined her look), three characters from the early years proved especially durable: the doddering Stella Toddler, who was two days younger than God and always had a date with physical disaster; the shrewish Zelda, whose whining, adenoidal voice inevitably drove her husband, George, to thoughts of homicide; and Nora Desmond, a spot-on takeoff of the diva from the classic film *Sunset Boulevard*. Nora was so pitch-perfect, in fact, that Gloria Swanson—the actress who had played Norma Desmond in the movie—contacted Burnett and asked if she could appear on the show.

The producers soon learned to allow for an extra couple of minutes of running time when these favorites appeared, as they would be filled with laughter and applause for one of Stella's slow-motion pratfalls or Nora's grand stairway entrances.

ABOVE: *Mackie's costume design for Zelda, also known as The Nudge. With bird seed for boobs and a fashionable sock/sandal combo, Zelda made life a living hell for her husband George, played by the brilliant Harvey Korman.*

LEFT: *Burnett had an absolute blast playing Queen Elizabeth II on many episodes of her show.*

OPPOSITE, TOP LEFT: *One of the most hilarious characters on early seasons of* Burnett *was the perpetually annoying Alice Portnoy, the Fireside Girl with the lateral lisp. In her relentless quest for donations, dear little Alice often resorted to blackmail.*

OPPOSITE, BOTTOM LEFT AND RIGHT: *The older-than-dirt Stella Toddler, in sketch form and in the flesh.*

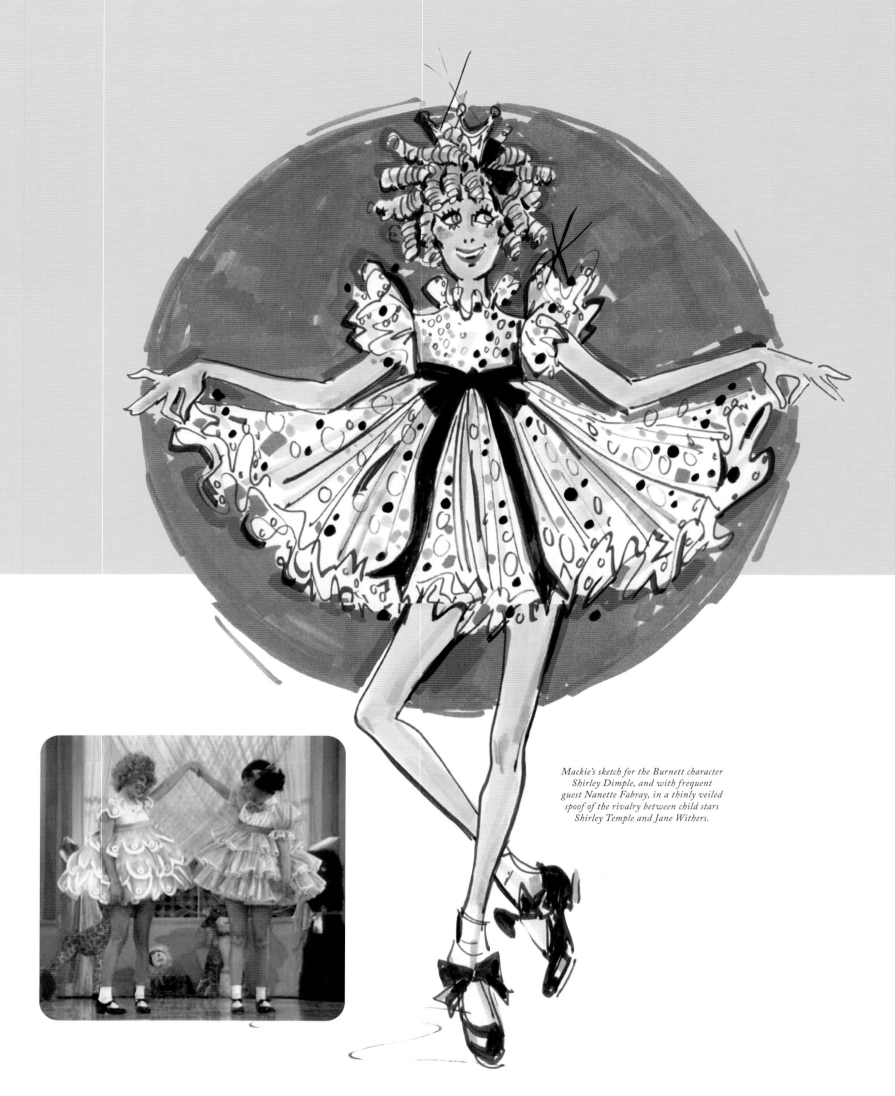

Mackie's sketch for the Burnett character Shirley Dimple, and with frequent guest Nanette Fabray, in a thinly veiled spoof of the rivalry between child stars Shirley Temple and Jane Withers.

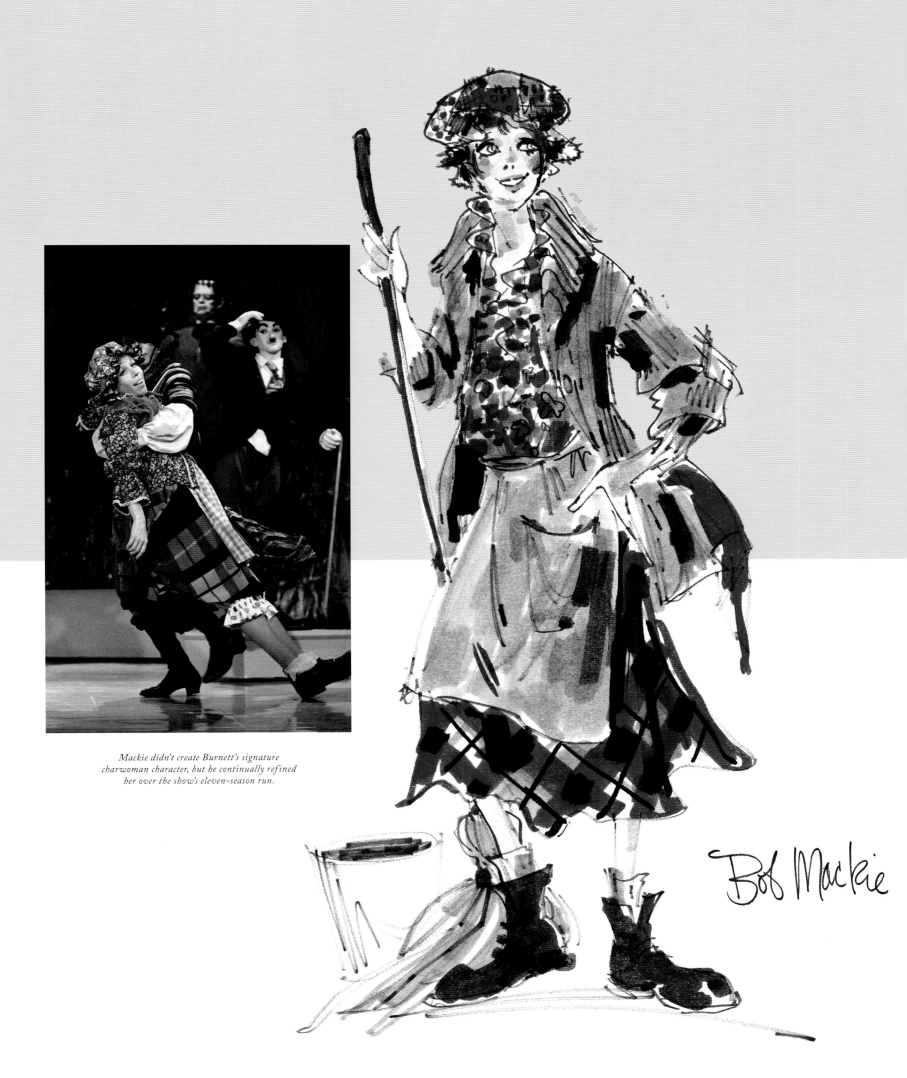

*Mackie didn't create Burnett's signature charwoman character, but he continually refined her over the show's eleven-season run.*

Bob Mackie

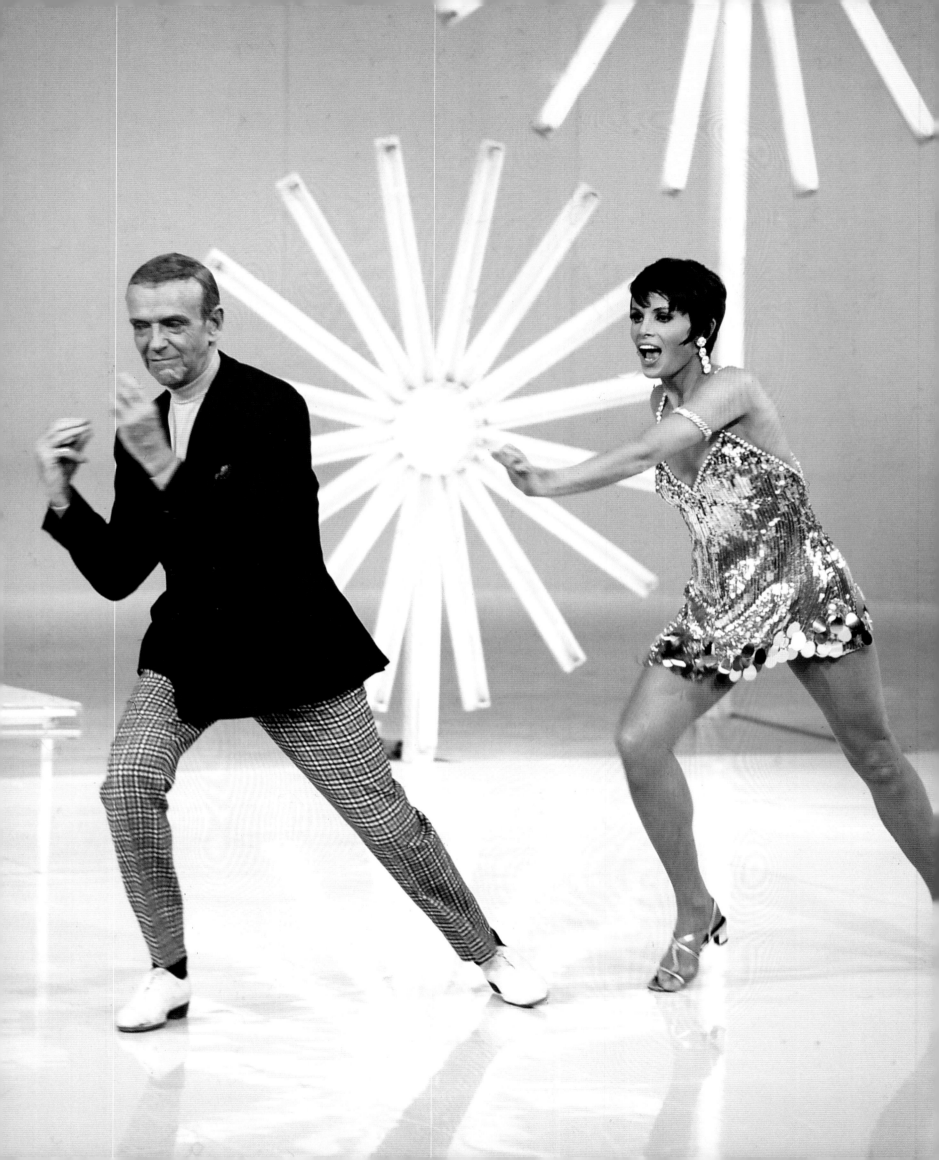

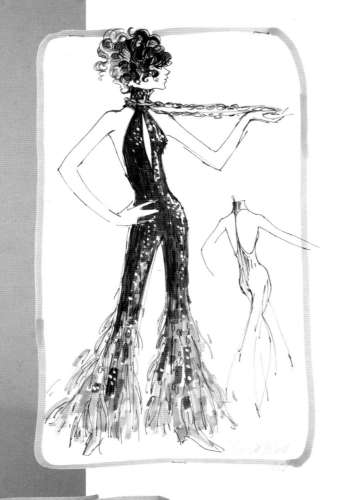

# Fred Forever *Young*

**FRED ASTAIRE WAS DEFINITELY A MAN WHO KEPT UP WITH** the times; remember, this was a dude who broke his wrist skateboarding at seventy-eight.

After a career that had already spanned sixty years, in 1968, Astaire appeared in his last TV variety special, costarring his final dance partner, the stunning Barrie Chase. Directed by Robert Scheerer and choreographed by Herbert Ross, *The Fred Astaire Show* was, in a word, groovy—as were the Mackie-designed costumes.

Instead of the usual twenty-five-piece orchestra, the show featured a variety of musical guests providing accompaniment. Simon and Garfunkel sang "Punky's Dilemma," an ode to a cornflake written (and rejected) for the film *The Graduate*, while Astaire and Chase danced dressed as flower children. Next came Sérgio Mendes and Brasil '66, followed by the Young-Holt Unlimited performing "Mellow Yellow" and the one-album-wonder band the Gordian Knot. At the eleventh hour, Astaire brought everyone back to earth by performing two songs from his upcoming film *Finian's Rainbow*. (Hey, his show, his chance to self-promote.)

Bob decked out the sixty-nine-year-old Astaire in mock turtlenecks, Cossack shirts, and Nehru jackets, while squeezing Chase into the shortest of minidresses and snuggest of sequined-and-feathered pantsuits—proving once again his ability to transform any woman into a knockout and any woman with a spectacular body into someone from another dimension. Considering the far-out vibe of this kooky special, another dimension was absolutely on point.

"We had *six weeks* of rehearsal . . . It was like doing a movie, really, so we had a lot of prep time, and there were lots of discussions about the sketches, so Barrie had the opportunity to change her mind. Which she did; there was a *lot* of mind changing. But I understood. She'd been dancing with a perfectionist for ten years, and she knew she looked great in clothes, so she had definite opinions. And I put Fred Astaire in bell-bottom pants! He was almost seventy and dressing like 'the kids.' He had such great style. He taught me a lot about men's clothes—what looks good, what doesn't, and what accentuates a dancer's 'line.' The whole experience is a great memory for me."

Mackie was probably just being humble, but whatever he learned from Astaire about men's clothes would serve him well as he went on to design costumes for Burnett's many guest stars and dancers, including Ben Vereen, Dick Van Dyke, and Ken Berry.

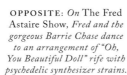

**OPPOSITE:** *On* The Fred Astaire Show, *Fred and the gorgeous Barrie Chase dance to an arrangement of "Oh, You Beautiful Doll" rife with psychedelic synthesizer strains.*

**ABOVE AND LEFT:** *Sketches for Barrie Chase and Fred Astaire that would make them right at home at the nearest discotheque.*

**BELOW:** *Chase and Mackie on the set, with a mutton-chopped Astaire in the background.*

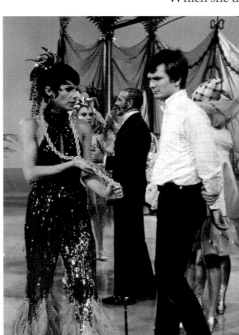

# Fun with *Dick* and *Mary*

**THE 1969 SPECIAL *DICK VAN DYKE AND THE OTHER WOMAN*** (the "other woman" being who else but Mary Tyler Moore?) marked a return to the small screen of America's sexiest TV couple of the decade, the triple-threat performers who had played Rob and Laura Petrie on CBS's smash-hit sitcom *The Dick Van Dyke Show* from 1961 to '66. Finally appearing in glorious color, Dick began the show by assuring viewers that there had never been anything unsavory about his relationship with Mary; she just happened to be his favorite woman besides his wife.

The special was a big gamble, for Van Dyke and particularly for the woman who was about to "turn the world on with her smile." Since their show had gone off the air three years earlier, Van Dyke had been unable to replicate his screen success in the beloved *Mary Poppins*, while Moore had weathered a crushing failure on Broadway in the musical *Breakfast at Tiffany's*, and a couple of poorly received films. She was about to begin filming the notorious *Change of Habit* with Elvis Presley, in which she was to play an inner-city nun and he a singing surgeon. What could possibly go wrong?

For the special, they both headed back to the comfy nest of CBS, where they put together an hour of song, dance, and sketch comedy written by *Van Dyke Show* stalwarts Sam Denoff and Bill Persky, who had recently created the hit show *That Girl* for Marlo Thomas. Mackie designed with his customary flash for Moore, whose wardrobe ranged from chic casual wear to glamorous evening gowns. She looked a lot like Laura Petrie, but now with the added benefit of the full spectrum of the rainbow.

His centerpiece series of looks was for an elaborate medley in which Moore chronicled the history of the women's movement (no less). Suffragette costumes gave way to sequined flapper dresses, Rosie the Riveter outfits, and finally, funkadelic jumpsuits, as Moore and the ladies of the ensemble belted out "If My Friends Could See Me Now." Since much of the rest of the show focused on husband-and-wife sketches—placing the duo in roles familiar to the audience—the women's lib extravaganza was particularly important for Moore, who was preparing to pitch a series in which she'd play a single career woman. Would CBS—and audiences—buy her in that role?

The special received excellent reviews and ratings, and Mary Tyler Moore would toss her hat into the air with joy each week for the next seven seasons. Mission accomplished.

---

TOP LEFT: *Mary Tyler Moore and Dick Van Dyke as Mackie-clad wedding-cake toppers.*

LEFT: Dick Van Dyke and the Other Woman *provided Mackie with the opportunity to dress Mary Tyler Moore as everything from a Roaring '20s vixen to a modern, liberated woman.*

# Leading
# *Lady*

**IN THE 1969 SUPREMES/TEMPTATIONS TV SPECIAL G.I.T. ON**
*Broadway*, Mackie won his second Emmy for the two Motown groups' love letter to the Great White Way.

Diana Ross's ten-minute "Leading Lady" medley, the spectacular centerpiece of the special (along with the Temptations' *Fiddler on the Roof* medley, which was jaw-dropping in a different way), was another step in the master plan of Ross's lover and Svengali, Berry Gordy, to push the other two Supremes into the background. Bookended by a specially composed ballad in the style of Judy Garland's "Born in a Trunk" from *A Star Is Born* (contributed by frequent Mackie collaborator Billy Barnes), Ross appeared as a succession of six of Broadway's most beloved characters, each wearing an eye-popping Mackie costume. Starting as a sassy Annie Oakley singing "Doin' What Comes Naturally," Ross then washed that man right out of her hair in an enormous wig for which Nellie Forbush would've been drummed out of the navy. She followed this as Eliza Doolittle, then Fanny Brice in her Baby Snooks persona belting out an impassioned "People." (As the special was produced by *Laugh-In* genius George Schlatter, one can't help but notice the hat tip to Lily Tomlin's Edith Ann character with the oversize armchair Ross was ensconced in.) Then it was back to Mermanland with a downright funky take on "Everything's Coming Up Roses," and a grand finale of "Mame," featuring a stunningly befeathered art deco Mackie masterpiece.

As the designer recalled years later, "With every costume I designed for her in that medley, Berry told me to try to create the impression that [Diana] originated each role on Broadway. I got the impression that he and she both wished she had. Afterwards, Berry came up to me and said, 'Bob, you did a real good job on the uniforms'—as if we'd been outfitting a very stylish school band!"

---

*Mackie's sketch for the sensational Supremes.*

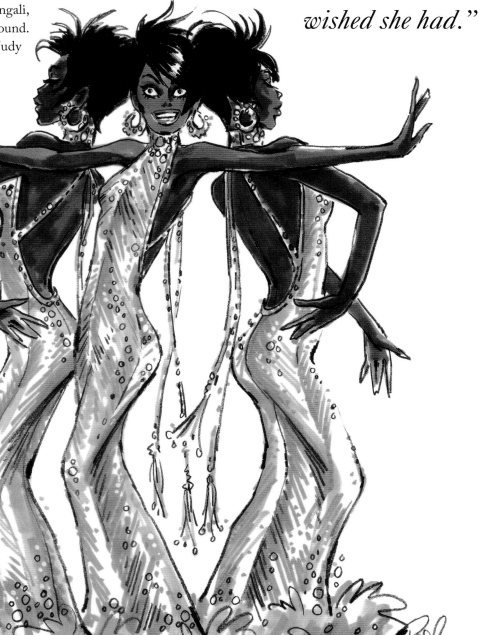

*"With every costume I designed for her in that medley, Berry told me to try to create the impression that Diana originated each role on Broadway. I got the impression that he and she both wished she had."*

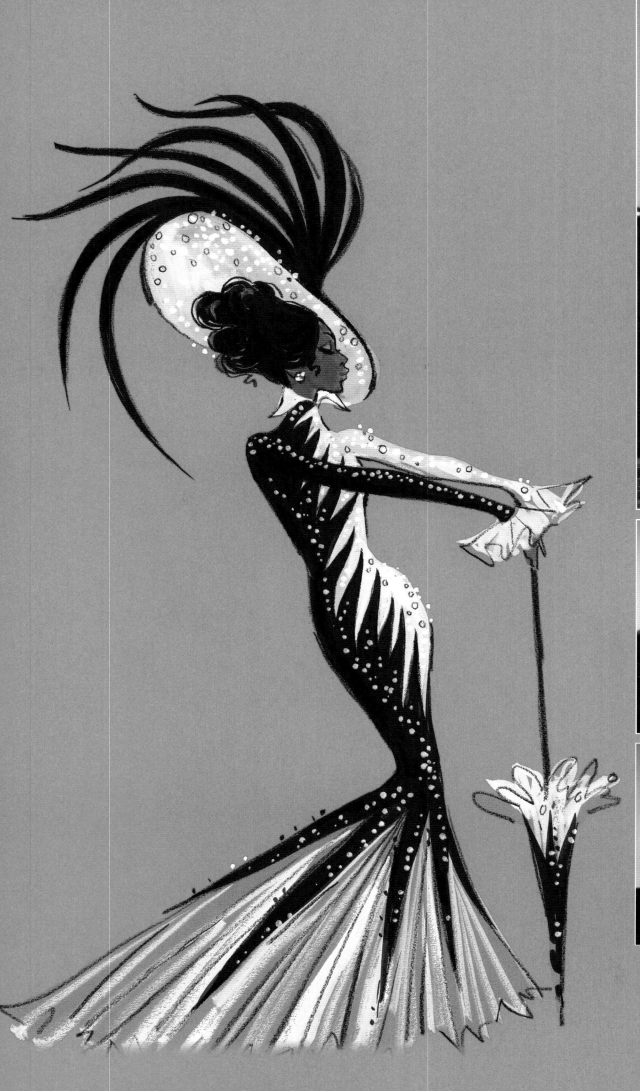

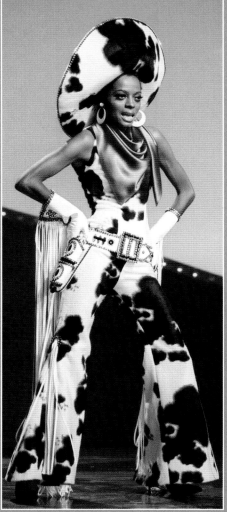

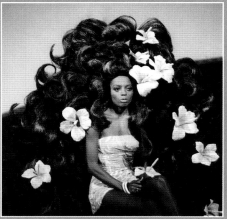

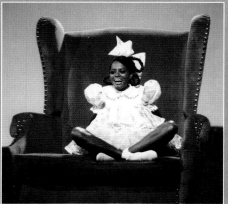

TOP TO BOTTOM: *Diana Ross as a straight-shooting Annie Oakley, a South Pacific goddess, and a pint-sized Fanny Brice.*

LEFT: *Mackie's take on Cecil Beaton for Ross's* My Fair *Lady number.*

OPPOSITE LEFT AND RIGHT: *A diaphanous cape overlay for Ross's Gypsy showstopper and her outfit for the title song from* Mame.

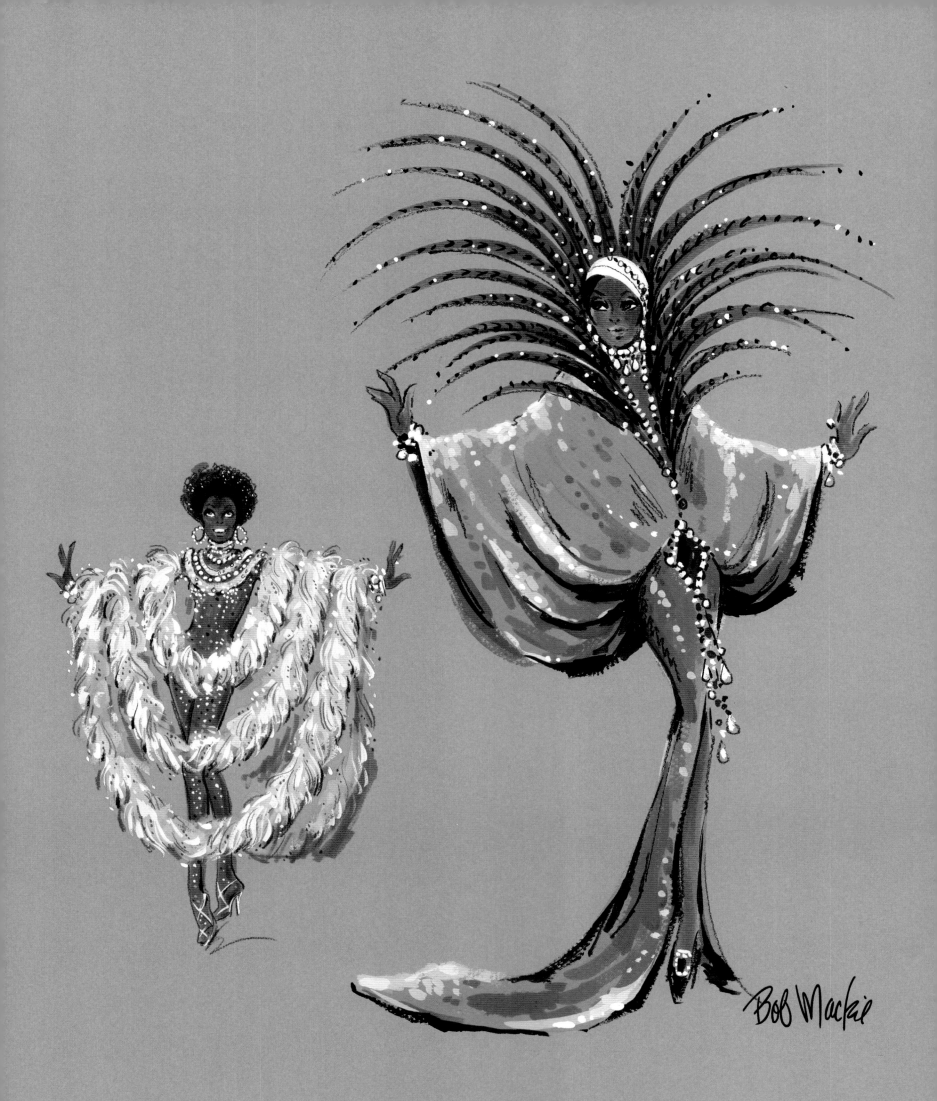

# Sins and *Blessings*

**YOU MIGHT CALL THESE TV SPECIALS, MADE TWO YEARS** apart, footnotes on the résumé of Bob Mackie, but they are more than worth the space they inhabit for the stars involved and the impact they had on a few careers, including Mackie's.

They were both directed by variety show veteran Clark Jones, who wooed Mackie away from his then home at CBS to contribute the fashion. The first, which aired in April 1969, was called *Carol Channing Proudly Presents the Seven Deadly Sins* and featured Carol Burnett and Danny Thomas. Channing's wardrobe was designed by Ray Aghayan, who had designed gorgeous beaded dresses and ball gowns for both Carol C. and Pearl Bailey in a musical special that had aired the previous month. (Yes, in those days, a star could conceivably headline *two* TV specials within a span of thirty days. Cue the Danny Thomas–style spit take.)

Channing, Burnett, and Thomas performed songs and sketches revolving around the seven big ones: gluttony, envy, lust, wrath, avarice, pride, and sloth—sort of like the Brad Pitt movie *Seven* but with a *lot* more sequins. Mackie designed all of Burnett's wardrobe, including a toga for a sketch about a Roman goddess. When she dropped her veils and turned to profile, she was nine months pregnant. Uhhhhh, just a wild guess, but . . . lust? To wrap it all up in a nice shiny package, the three ended the hour singing "Happiness" from *You're a Good Man, Charlie Brown.*

Turning, just as Burnett did, to the subject of motherhood, two Aprils later, *The First Nine Months Are the Hardest* aired on NBC.

It was another evening of song and comedy, this time revolving around three married couples dealing with the foibles of childbirth. Written by *That Girl* creators Bill Persky and Sam Denoff, and designed by Mackie, the hour starred Dick Van Dyke as narrator and utility player, plus three real-life married couples: *Mayberry R.F.D.* star Ken Berry and his wife, Jackie Joseph; *The Bold Ones* star James Farentino and his wife, Broadway and movie actress Michele Lee; and singer Sonny Bono and his wife, Cherilyn Sarkisian Bono (whoever she is). The flair that last couple showed for sketch comedy made network executives sit up and take note. Hey . . . these two are hip and funny! By the following August, Sonny and Cher were cracking wise on CBS.

"That was the second time I got to work with Cher, and it was a lot of fun. Those one-off shows were easy: quick and low-stress, especially with someone like Clark [Jones], who was a total pro. And, as Cher was the youngest of the three ladies, I got to design some pretty cool maternity dresses for her. Oh, and P.S., all three of those couples ended up divorced!"

**ABOVE:** *Carol Burnett turns to profile. Blackout. Comic pay dirt.*

**LEFT:** *Left to right: Michele Lee, Jackie Joseph, and Cher have eleventh-hour second thoughts as Dick Van Dyke oversees the proceedings in* The First Nine Months Are the Hardest.

**RIGHT:** *Carols Burnett and Channing in 1969, dressed respectively by Bob Mackie and Ray Aghayan.*

# Rocky *Raquel*

**PICTURE THIS: A TIME CAPSULE BURIED IN 1970 IS** unearthed in the year 2170. In it, among other treasures, is a three-quarter-inch videotape labeled *Raquel!* featuring a very odd example of . . . entertainment, is it? set among historically recognizable landmarks of the twentieth century: London Bridge, the Eiffel Tower, and other now decrepit relics. What exactly do our successors make of it all? Hard to say, since we have trouble parsing the meaning of it even now—though we have a suspicion that recreational drugs were involved. (Just kidding. Please don't sue us.)

In her first variety special, Raquel Welch—the glorious specimen of womanhood who has lived rent-free in the fantasies of men since she first donned a fur bikini—did an hour of song, all prerecorded and often presented as a voiceover while she strolled around in a series of glorious Bob Mackie gowns. Raquel's medley from *Hair* ("Aquarius" and "Let the Sunshine In"), sung in front of, climbing, and finally atop a Mayan temple, featured her and the chorus in a parade of Mackie stunners that are half op-art and half paean to the gods of kitsch. For sports fans, Raquel crooned the Bobbie Gentry/Helen Reddy hit "Peaceful" over footage of her gracefully skiing down the slopes of Sun Valley, Idaho.

But *was* it Raquel singing? While her dance abilities were apparent (and couldn't have been faked in any case), Welch's singing has never been her strongest résumé line. It's been reported—though not by Mackie—that in the process of editing the show, director David Winters identified a "problem" with the prerecordings and called in actress/singer Tina Cole of *My Three Sons* fame to dub nine of Raquel's twelve vocals. Make of this "technical glitch" what you will.

The special was said to have cost $350,000, an absolute fortune at the time, and was shot on location in London, Paris, Mexico, and multiple locations around the U.S. Filming began in the spring of 1969 but went on hiatus when it was just half completed so that Welch could go off and costar with Mae West in the infamous *Myra Breckenridge.* When production resumed, the powers that be decided it would be fun to highlight the Mae West connection by dressing their star as the aging bombshell. Bob Hope, with whom Raquel had performed on USO tours in Vietnam, teamed with her for the sequence, which had them duetting on the Beatles' "Rocky Raccoon" on a Western-style studio backlot.

Yeah, we don't get it, either. But we hope those future viewers appreciate the fashion show.

---

TOP RIGHT: *One of the more bizarre sequences in the TV special* Raquel! *involved Welch strolling the grounds of an English estate in a period Mackie gown to a voiceover of her reciting Tennyson's "The Lady of Shalott"—only to step inside and be serenaded by fellow sex symbol Tom Jones singing "I, Who Have Nothing." Now that's showbiz.*

RIGHT: *Raquel, Mayan style.*

FAR RIGHT: *A Polaroid of "Rocky" in a Mackie costume fitting, showing off her fringe benefits.*

# Pure *Goldie*

**ROWAN & MARTIN'S LAUGH-IN**, **THE CREATION OF THE** genius producer George Schlatter, turned out two bona fide superstars: Lily Tomlin and Goldie Hawn. The latter was a kooky former go-go dancer who became a show favorite as a bikini-clad, body-paint-wearing dingbat. Underneath what little she had on, though, beat the heart of a triple-threat performer with absolutely crackerjack comic timing.

After winning an Academy Award in 1970 for her first substantial film role in *Cactus Flower*, Hawn heeded Schlatter's call back to television to star in her own variety special. Her second film—*There's a Girl in My Soup*, with Peter Sellers—had just been released, and she was soon off to Germany to film *$* (aka *Dollar$*) with Warren Beatty. She was clearly on her way to movie stardom when she paused to bring *Pure Goldie* into people's living rooms.

For the special, which aired in February 1971 on NBC, Schlatter played it very safe in terms of content. Instead of slinging *Laugh-In*–style jokes of questionable taste, Hawn was presented as almost a virginal figure. Entering in a white Mackie stunner, Hawn sang the heart-tugging Kurt Weill/Ira Gershwin ballad "My Ship." Sketches with actor Bob Dishy and Hawn's *Laugh-In* pal Ruth Buzzi followed, along with a segment with Hawn's own father, violinist Edward Rutledge "Rut" Hawn.

The closest the show came to offering anything remotely naughty was a cameo by Johnny Carson, who introduced Goldie as "Loretta Birmingham" in a *Ziegfeld Follies*–style comic production number. The highlight of the special was as far away from double entendre as material could get: a duet with Kermit the Frog of "It's Not Easy Bein' Green." (The song had debuted on *Sesame Street* the previous year and would be recorded by everyone from Lena Horne to Van Morrison.)

The show wrapped up with a strongly sung "Have I Stayed Too Long at the Fair?" written by Billy Barnes, who had penned the musical material for a previous Schlatter/Hawn special that would never see the light of the airwaves: the notorious *Burlesque Is Alive and Living in Beautiful Downtown Burbank*.

---

TOP LEFT: *Goldie Hawn, dressed in a Mackie gown incorporating several sailor knots, sings "My Ship" on* Pure Goldie, *her first solo TV special.*

CENTER LEFT: *Hawn and* Laugh-In *pal Ruth Buzzi as flight attendants on the world's biggest airplane.*

BOTTOM LEFT: *Scandalous Mackie moment: Bob designed the costumes for a 1970 NBC special titled* Burlesque Is Alive and Living in Beautiful Downtown Burbank. *Starring Carl Reiner, Bobby Darin, and Goldie Hawn, the show pushed the envelope in terms of taste, and Goldie's wardrobe tested the temperature of network censors. Mackie's costumes for Hawn, while technically legal, created such clever illusions of nudity that they made the "suits" nervous—so nervous that the special, fully finished and previewed in an article about Hawn in* Life *magazine, was never aired.*

RIGHT: *Goldie Hawn wreaks comic havoc in a production number set to the Broadway showstopper "The First Girl in the Second Row."*

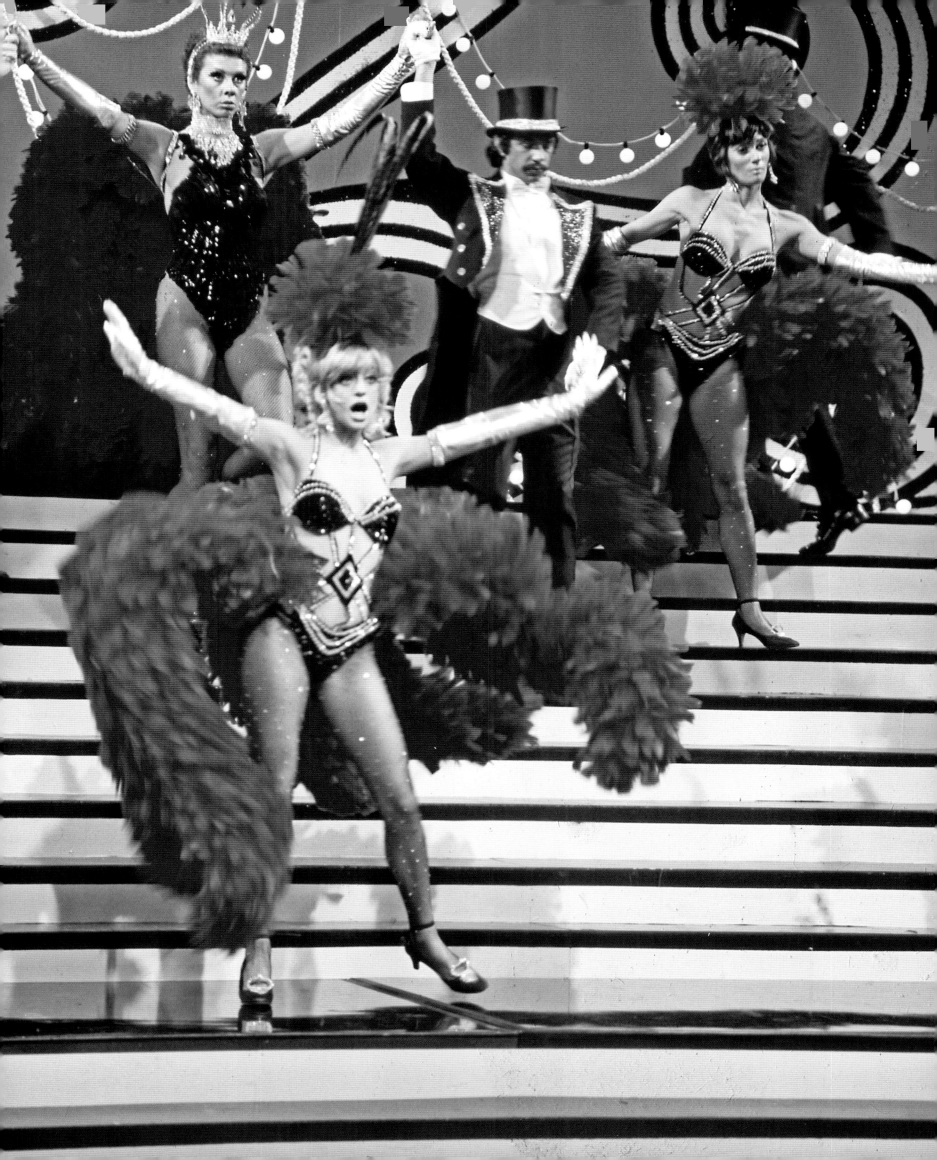

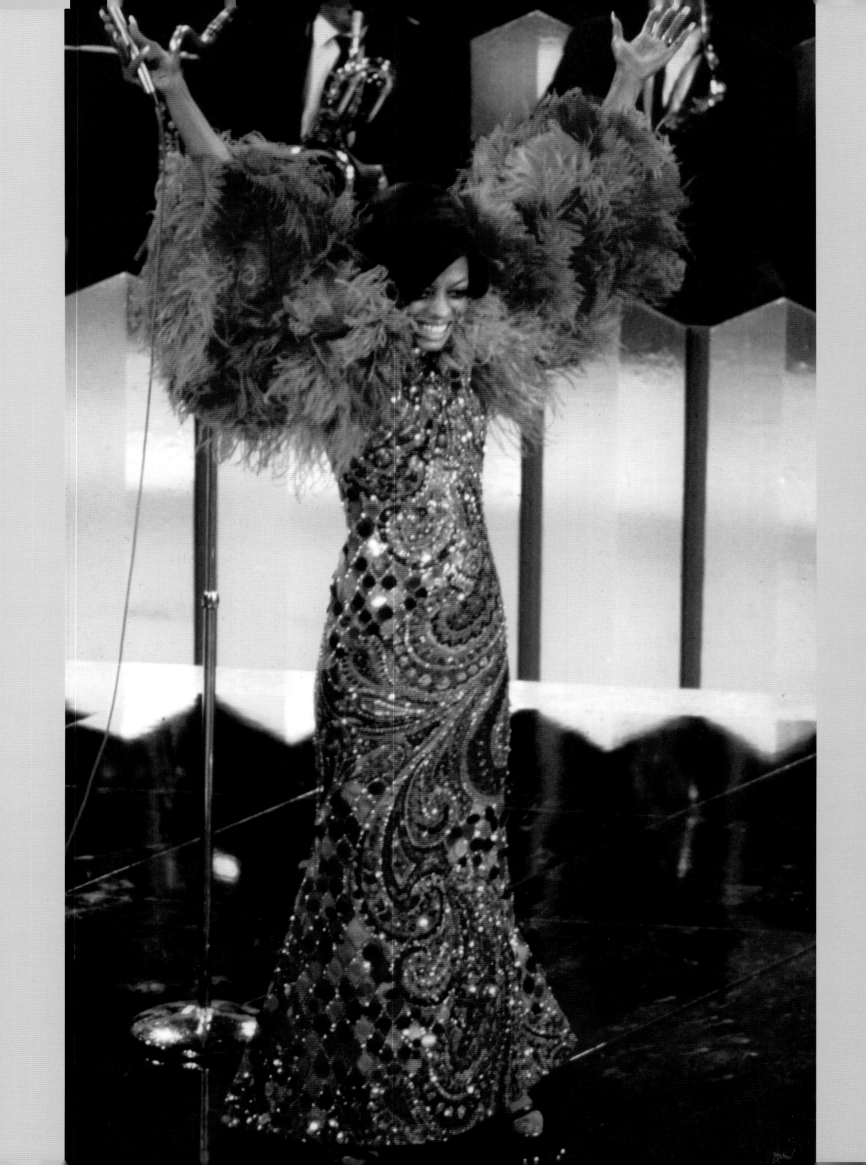

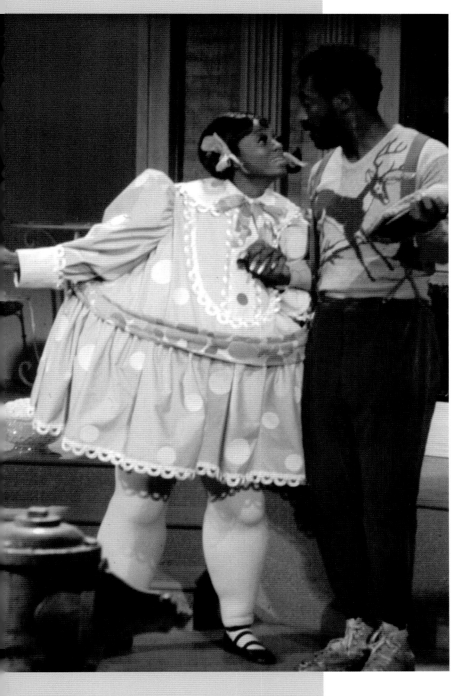

# Queen *Diana*

**WITH HER APRIL 1971 ABC-TV SPECIAL, THE CORONATION OF** Diana Ross as a solo act was complete. No Mary Wilson or Cindy Birdsong to pull focus, no haggling over a wide shot or a close-up; this was all Miss Ross for fifty-three minutes of nonstop adoration by the camera, the studio audience, and her guests. Also featuring Danny Thomas (with whom Ross had appeared on his sitcom *Make Room for Granddaddy*), Bill Cosby, and the Jackson Five, the special is notable for providing Michael Jackson with his solo television debut: a truly bizarre lamppost rendition of the Frank Sinatra standard "It Was a Very Good Year."

Mackie contributed a seemingly never-ending series of show-stopping costumes, including a pink and orange dazzler for Ross's opening number, "Don't Rain on My Parade" from *Funny Girl*. But Mackie's trademark wit was in full bloom as well. For a tribute to silent-movie comedians, he dressed Diana as Charlie Chaplin, W. C. Fields, and Harpo Marx. For the Cosby sequence, she wore a super-sized, cankle-highlighting fat suit to play the comedian's girlfriend, Alberta—a clear nod to the beloved character from his stand-up act, Fat Albert. All three stars—Ross, Jackson, and Cosby—were clearly at a crossroads. Within a year, the animated Saturday-morning hit *Fat Albert and the Cosby Kids* would premier on CBS, Michael Jackson would embark on one of the great solo careers of all time, and Ross would get an Oscar nod for *Lady Sings the Blues*.

OPPOSITE: *Diana Ross in quintessential Mackie, an explosion of feathers, beads, and sequins.*

LEFT: *A supersized Diana Ross as Fat Alberta in a sketch with guest star Bill Cosby.*

BELOW: *Stretching her comic wings, Ross paid homage to three legends of the silent movie era: Charlie Chaplin, W. C. Fields, and Harpo Marx.*

*This was all Miss Ross for fifty-three minutes of nonstop adoration by the camera, the studio audience, and her guests.*

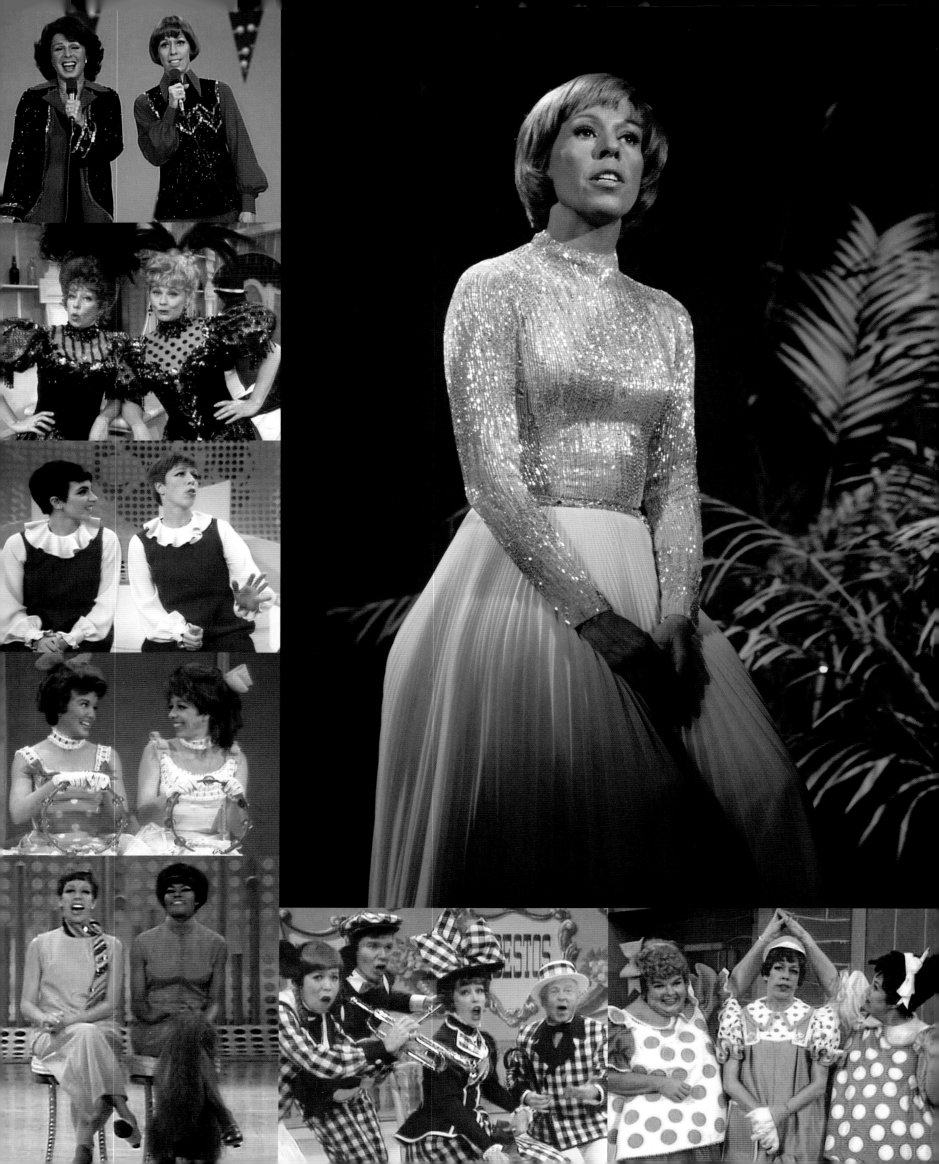

# *Carol* Makes Music

**AS *THE CAROL BURNETT SHOW* SETTLED IN AS A SOLID HIT,** other hour-long variety shows were nipping at its heels. Flip Wilson and Sonny and Cher were working hard to captivate younger, hipper viewers with their sly humor and more contemporary sounds; at the same time, the rise of public television meant there were new alternatives for "grown-ups" yearning for more highbrow entertainment.

That isn't to say Burnett wasn't highbrow. Her show had already featured opera stars Eileen Farrell and Marilyn Horne, ballet dancers Edward Villella and Violette Verdy, and jazz singers Ella Fitzgerald and Mel Tormé. But now it was time to cut loose a little. Enter the Jackson Five, Captain and Tennille, and the Pointer Sisters. At this point in variety television, even Broadway stars such as Ethel Merman and Gwen Verdon were considered "niche," and save for the occasional gonzo medley with Eydie Gormé or Sammy Davis Jr., the "American Songbook" flavor of the show's earlier years gave way to a more pop vibe. The exception was the show's glamorously costumed and elaborately designed finales that, due to music clearance issues, were rarely included in the half-hour syndicated version of the show called *Carol Burnett & Friends*.

It wouldn't be until the 2015 release of the DVD box set *The Lost Episodes* that audiences would once again get a glimpse of Mackie's brilliant costumes for the Farrell/Horne/Burnett opéra bouffe version of "The Three Little Pigs," not to mention his showstopping, Mae West–inspired designs for "Big Spender."

OPPOSITE: *Burnett's heartfelt solos became a nearly weekly staple of the show, and her Mackie gowns were as eagerly anticipated as her song choices. But Carol was no stage hog; throughout her eleven seasons, she shared the spotlight with singers from every facet of show business, including, top to bottom, Eydie Gormé, Lucille Ball, Liza Minnelli, Nanette Fabray, and Dionne Warwick.*

OPPOSITE, BOTTOM CENTER: *Carol surrounded by Vicki Lawrence, John Davidson, and Mickey Rooney.*

OPPOSITE, BOTTOM RIGHT: *Eileen Farrell, Burnett, and Marilyn Horne as an unlikely set of Three Little Pigs.*

TOP RIGHT: *A rendering for a Minnelli/Burnett performance of "Big Beautiful Ball" in 1967.*

RIGHT: *Two sketches for one of Burnett's favorite guest stars, Cass Elliot.*

BELOW: *Burnett and guest Melba Moore in one of the show's classic mini-musicals: "The Rip-Off," which told the tale of two tots who dared to steal jelly beans from a candy store.*

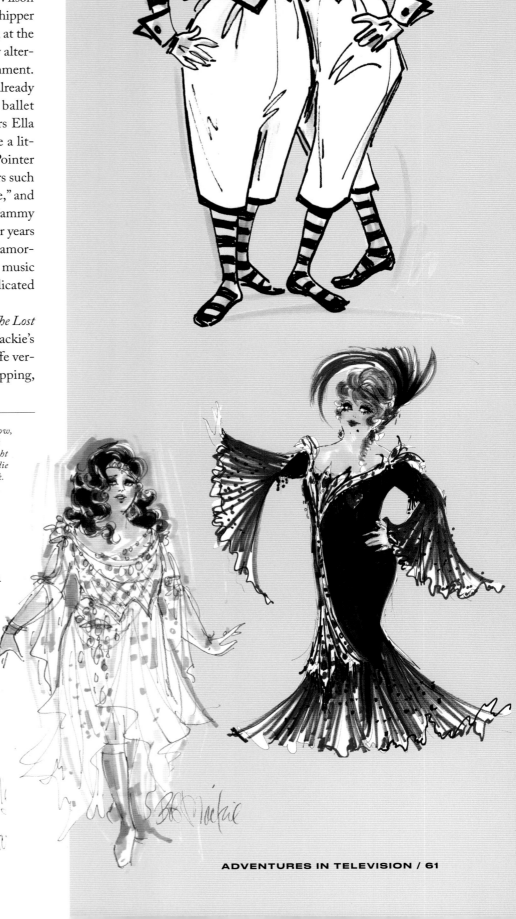

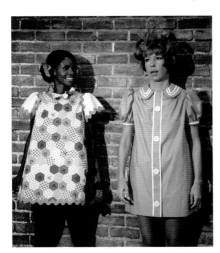

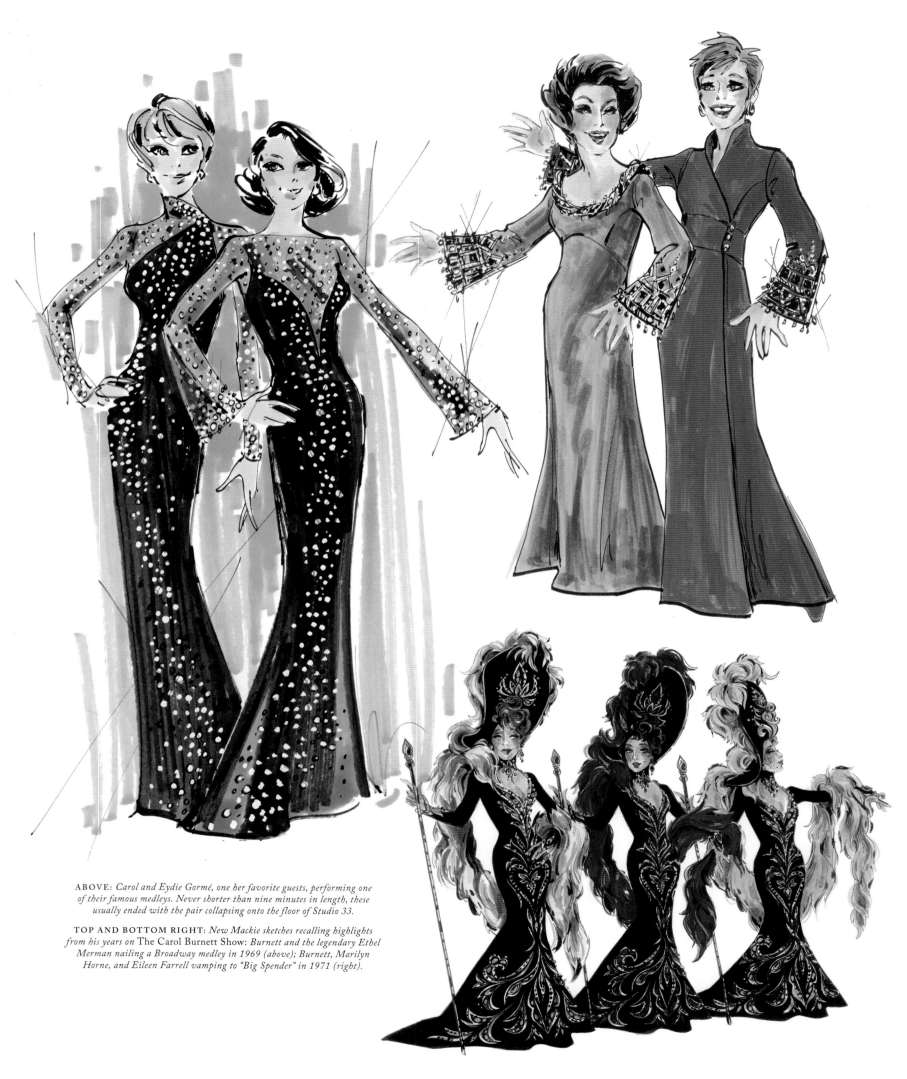

ABOVE: *Carol and Eydie Gormé, one her favorite guests, performing one of their famous medleys. Never shorter than nine minutes in length, these usually ended with the pair collapsing onto the floor of Studio 33.*

TOP AND BOTTOM RIGHT: *New Mackie sketches recalling highlights from his years on* The Carol Burnett Show: *Burnett and the legendary Ethel Merman nailing a Broadway medley in 1969 (above); Burnett, Marilyn Horne, and Eileen Farrell vamping to "Big Spender" in 1971 (right).*

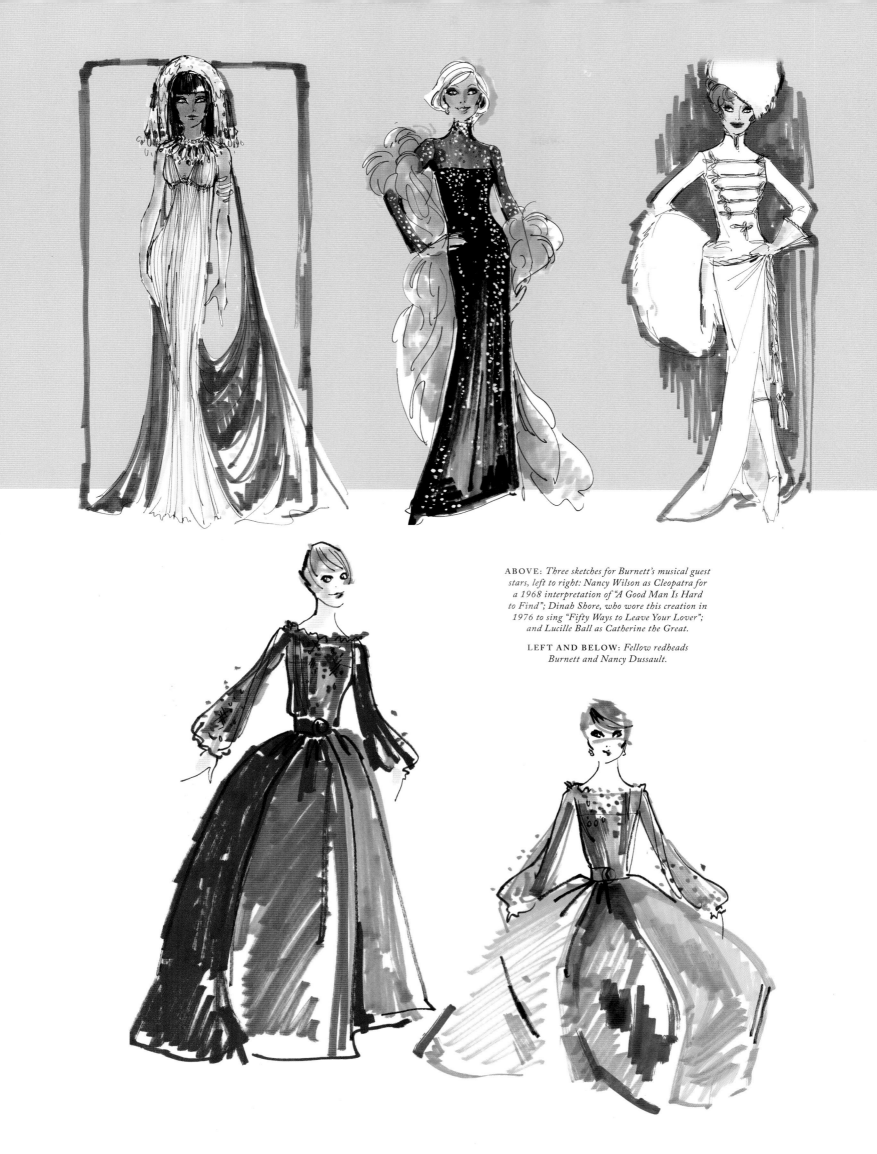

ABOVE: *Three sketches for Burnett's musical guest stars, left to right: Nancy Wilson as Cleopatra for a 1968 interpretation of "A Good Man Is Hard to Find"; Dinah Shore, who wore this creation in 1976 to sing "Fifty Ways to Leave Your Lover"; and Lucille Ball as Catherine the Great.*

LEFT AND BELOW: *Fellow redheads Burnett and Nancy Dussault.*

# *Mitzi* Makes Her *Move*

**AFTER MITZI GAYNOR'S SHOWSTOPPING PERFORMANCE OF** "Georgy Girl" on the 1967 Academy Awards, NBC approached her and her husband and manager, Jack Bean, about a new avenue for showing off her talent: television.

Up until then, Gaynor had appeared only sporadically on TV. Like most movie stars of her day, she was under contract to a studio, and studio heads did not feel kindly toward the brash, relatively new medium. (In the 1950s, Louis B. Mayer had famously told Debbie Reynolds, "I FORBID you to be seen on dat dumb box!") But movie musicals were on life support by the late 1960s unless your last name was Streisand or Andrews, and Gaynor hadn't appeared in a film since 1963.

Just months after Mitzi's memorable Oscar appearance, NBC tested out her ratings legs (although they had complete faith in her real ones) with *The Mitzi Gaynor Christmas Show*—an installment of its successful *Kraft Music Hall* variety series. With special guest star Ed McMahon as Santa Claus, the show got great reviews, and the peacock network spread its wings for the budding TV personality. The following year came *Mitzi!*, written by *Laugh-In* regular Ann Elder and *Hogan's Heroes* veteran Larry Hovis. It catapulted Gaynor into a new universe, and she became the most glamorous dancing variety star on television for the next decade.

Needless to say, Bob Mackie was responsible for the flash, providing one stunning gown after another for splashy dance numbers choreographed by the legendary Peter Gennaro, and witty costumes for movie spoofs of *His Girl Friday* and *Pillow Talk,* among others. The specials became the equivalent of one-hour MGM movie musicals you could watch at home.

The not so cleverly named *Mitzi's 2nd Special* began with Mitzi descending from the heavens on a platform, wearing a "prime time–appropriate" nude-illusion dress. It was shocking and fabulous and proved for all time that the team of Mitzi and Mackie was unbeatable. The only downside—if you could call it that—was that Bob would be pressed to design something similarly saucy for every regular client from that moment on, with the exceptions of Carol Burnett and Totie Fields.

Mitzi's back-to-backless triumphs at NBC paved the way for an unprecedented six-special deal with CBS that unspooled annually between 1973 and 1978. The first one, perhaps as a way to crow about her new deal, was titled *Mitzi . . . The First Time* and featured CBS stalwarts Mike Connors (Mannix SINGS!), Ken Berry, and her *There's No Business Like Show Business* father, Dan Dailey. As always, Mackie went to town, pushing the bounds of both glamour and illusion and ushering in an award-winning collaboration that would continue for the next five years.

ABOVE: *From sketch to screen, Mackie's showstopper for a spectacular "Everybody Loves My Baby" production number in Mitzi's first special.*

BELOW AND RIGHT: *Mitzi was usually backed by a whole chorus line of men, but here she engages in a rare trio dance, "Pretty For Me," featuring two of her most loyal cohorts and friends, Randy Doney and Alton Ruff.*

OPPOSITE: *Mitzi in a beaded, honey-colored Mackie, welcomes the audience of her first TV special in 1968. It would be the start of a decade of song, dance, comedy, and legs-legs-legs.*

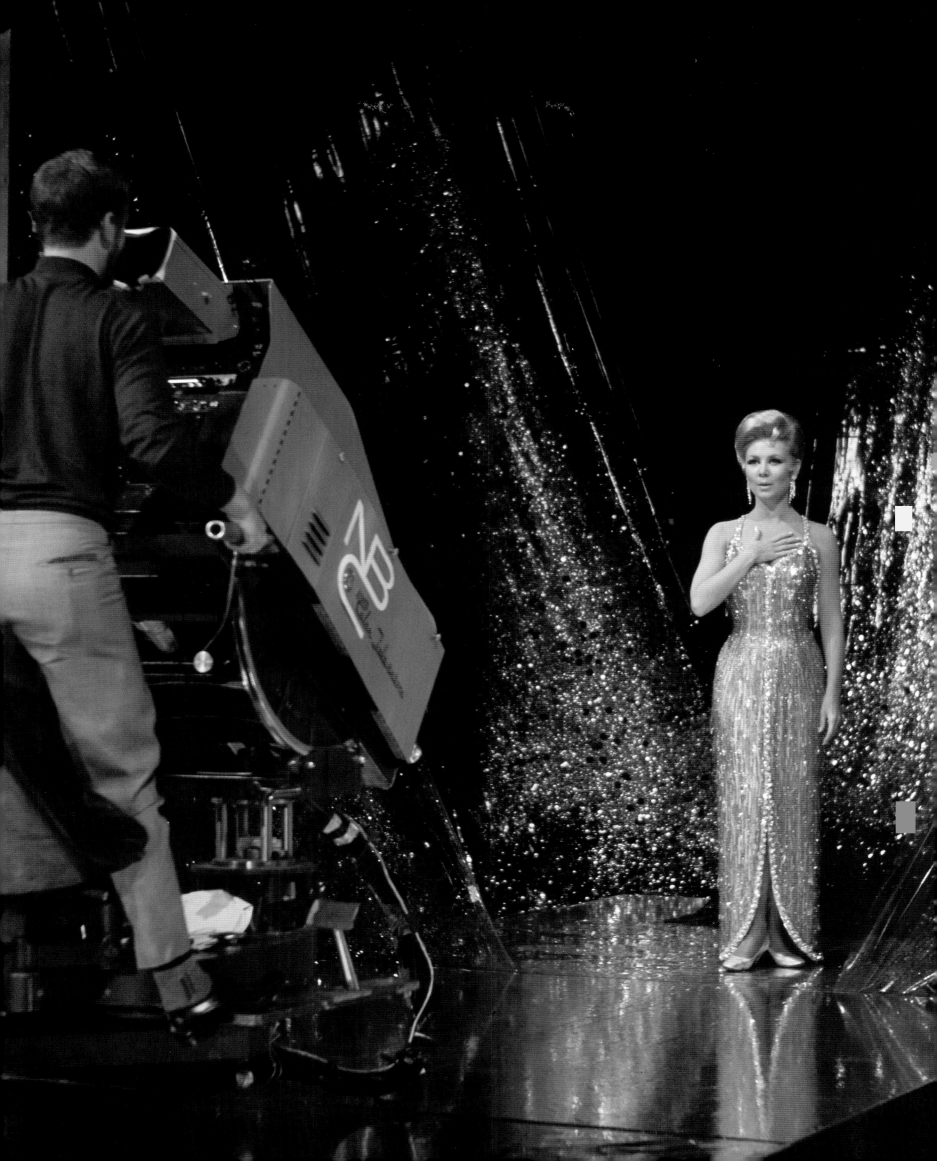

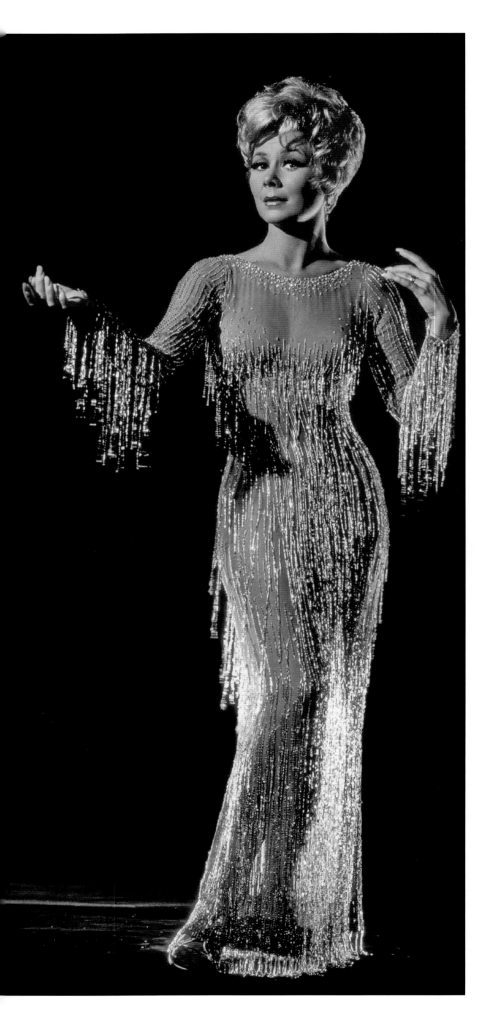

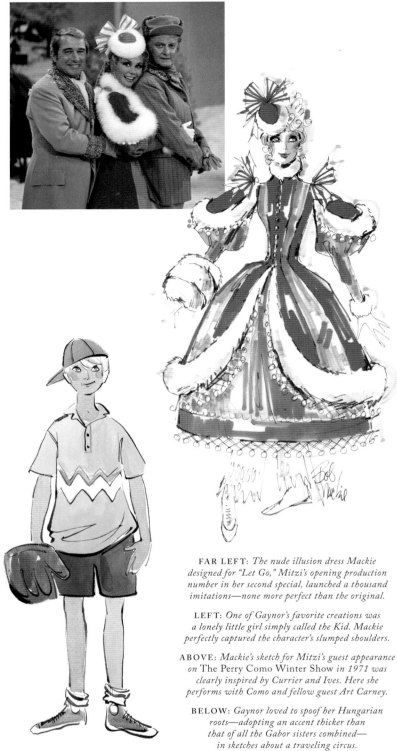

FAR LEFT: *The nude illusion dress Mackie designed for "Let Go," Mitzi's opening production number in her second special, launched a thousand imitations—none more perfect than the original.*

LEFT: *One of Gaynor's favorite creations was a lonely little girl simply called the Kid. Mackie perfectly captured the character's slumped shoulders.*

ABOVE: *Mackie's sketch for Mitzi's guest appearance on* The Perry Como Winter Show *in 1971 was clearly inspired by Currier and Ives. Here she performs with Como and fellow guest Art Carney.*

BELOW: *Gaynor loved to spoof her Hungarian roots—adopting an accent thicker than that of all the Gabor sisters combined— in sketches about a traveling circus.*

OPPOSITE: *Six Mackie looks for Mitzi Gaynor's early specials.*

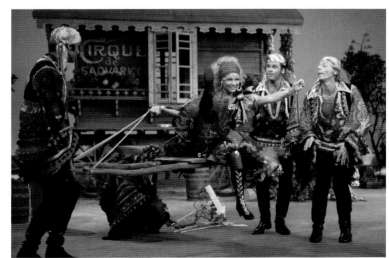

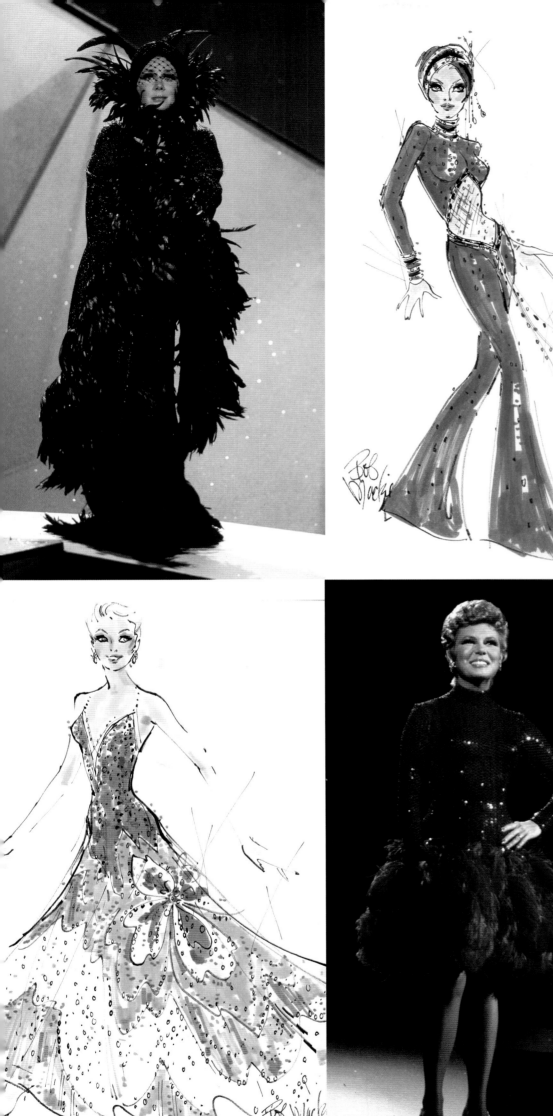
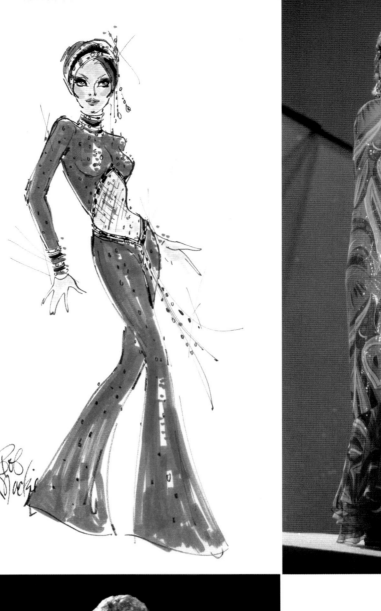
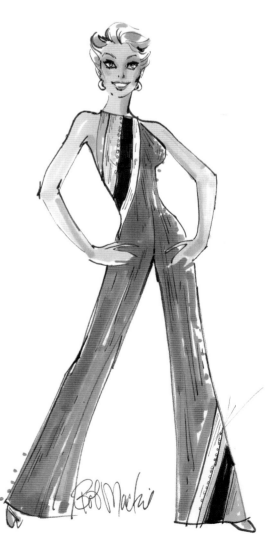
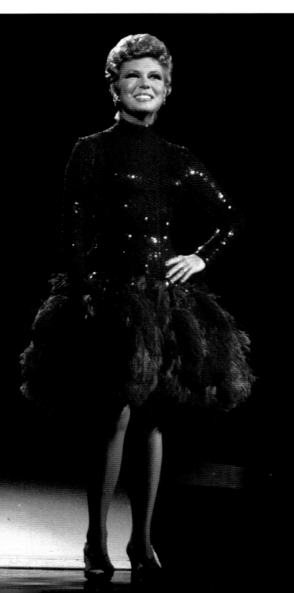

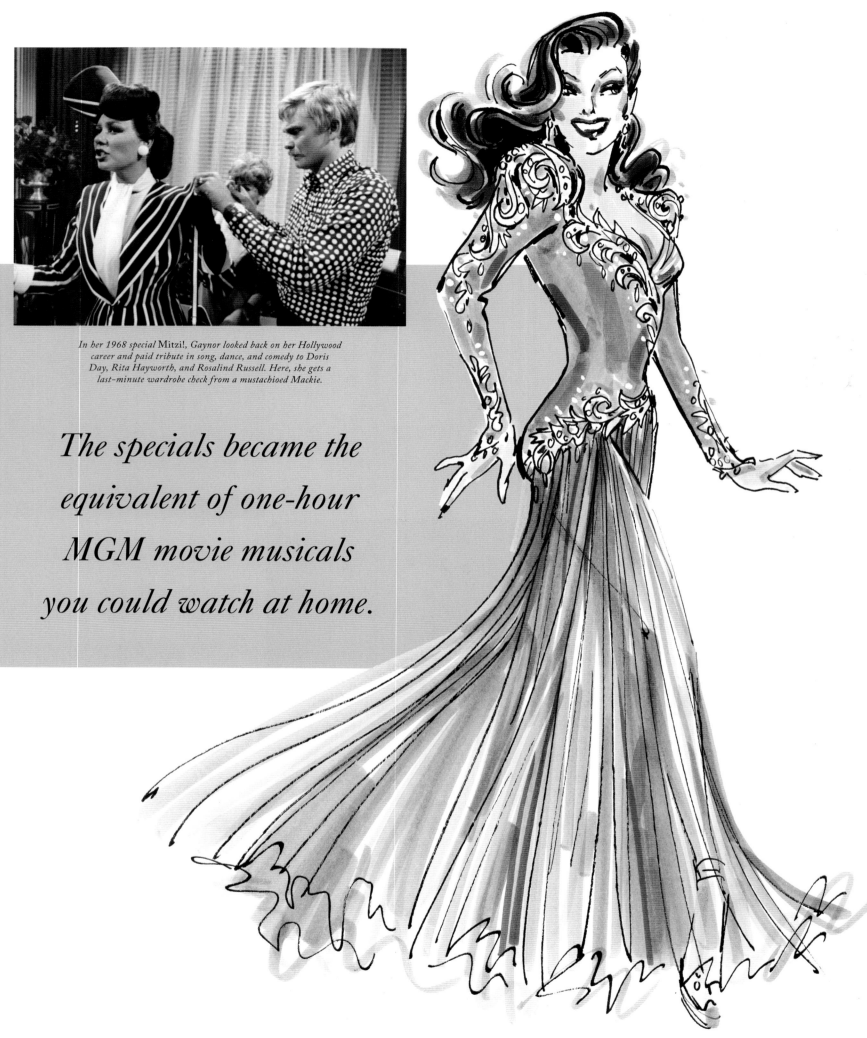

In her 1968 special Mitzi!, Gaynor looked back on her Hollywood career and paid tribute in song, dance, and comedy to Doris Day, Rita Hayworth, and Rosalind Russell. Here, she gets a last-minute wardrobe check from a mustachioed Mackie.

*The specials became the equivalent of one-hour MGM movie musicals you could watch at home.*

# Best *Chums*

**THE "TWO-HANDER," A SHOW FEATURING TWO STARS OF** equal magnitude, suits Carol Burnett's talents and generous sensibility to a Tee. Over many years, she proved herself at home sharing the spotlight with such titans as Beverly Sills and Dolly Parton—but her collaborations with Julie Andrews, her dear and mega-talented bestie, are in a class by themselves.

In 1961, following her Broadway triumphs in *My Fair Lady* and *Camelot* but before *Mary Poppins* made her a movie star, Andrews appeared twice with Burnett on CBS's *The Garry Moore Show*. Their city mouse/country mouse chemistry, surprisingly smooth vocal blending of Andrews's piccolo and Burnett's trumpet, and obvious affection for each other set Garry Moore's producer wheels turning. That producer—Joe Hamilton—would soon be Burnett's husband; his second best idea would be to team up the two ladies for a network special.

*Julie and Carol at Carnegie Hall*, which aired in June 1962, was written and directed by the genius Mike Nichols, on his way to becoming an Oscar- and Tony-winning director. It was a huge success, as was the subsequent record album. "[Andrews and Burnett] were so magical together. They looked great, were basically the same size, and the contrast between this very proper, grand lady and this slapstick clown . . . well, it just worked."

Nine years later, having racked up an Oscar (Andrews) and multiple Emmys (Burnett), the two reunited for *Julie and Carol at Lincoln Center*—now full-fledged stars in their respective realms. And why fix what isn't broken? The two best chums from opposite sides of the pond opted to follow the template of their earlier show to the letter: opening duet, comedy sketch, solo turn for one, comedy sketch, solo turn for the other, gonzo joint medley, and heartwarming finale.

This time, perhaps partly because they were finally being broadcast in color, Burnett tapped her pal Bob Mackie to provide the wardrobe—from stunning evening gowns for the opening number to hilarious, over-the-top takeoffs of modern dance costumes, to sequined sweater vests and knickers for the medley. To be honest, the sequel lacked some of the excitement of the Carnegie Hall triumph. Without Nichols on board, the writing felt less fresh; and what had seemed utterly unforced in 1962 had become a bit calculated. Even the antic ten-minute medley of contemporary songs seemed to offer less variety and pizzazz than the earlier one, which had been a history of musical comedy from "Ah, Sweet Mystery of Life" to highlights from *West Side Story*. On top of all that (literally), the night before they were to tape the show, Burnett performed a last-minute peroxide touch-up on her own hair that left her looking a bit like Harpo Marx. In spite of it all—and abetted, as always, by Mackie's witty contributions—the unlikely but palpable chemistry and charisma were fully evident, and a pretty good time was had by all.

"Julie is practically perfect, with that poise and that beautiful British complexion. And, of course, she can talk like a truck driver if she wants to!"

*Mackie's argyle-and-knickers look for a 1960s period medley in the 1971 special* Julie and Carol at Lincoln Center.

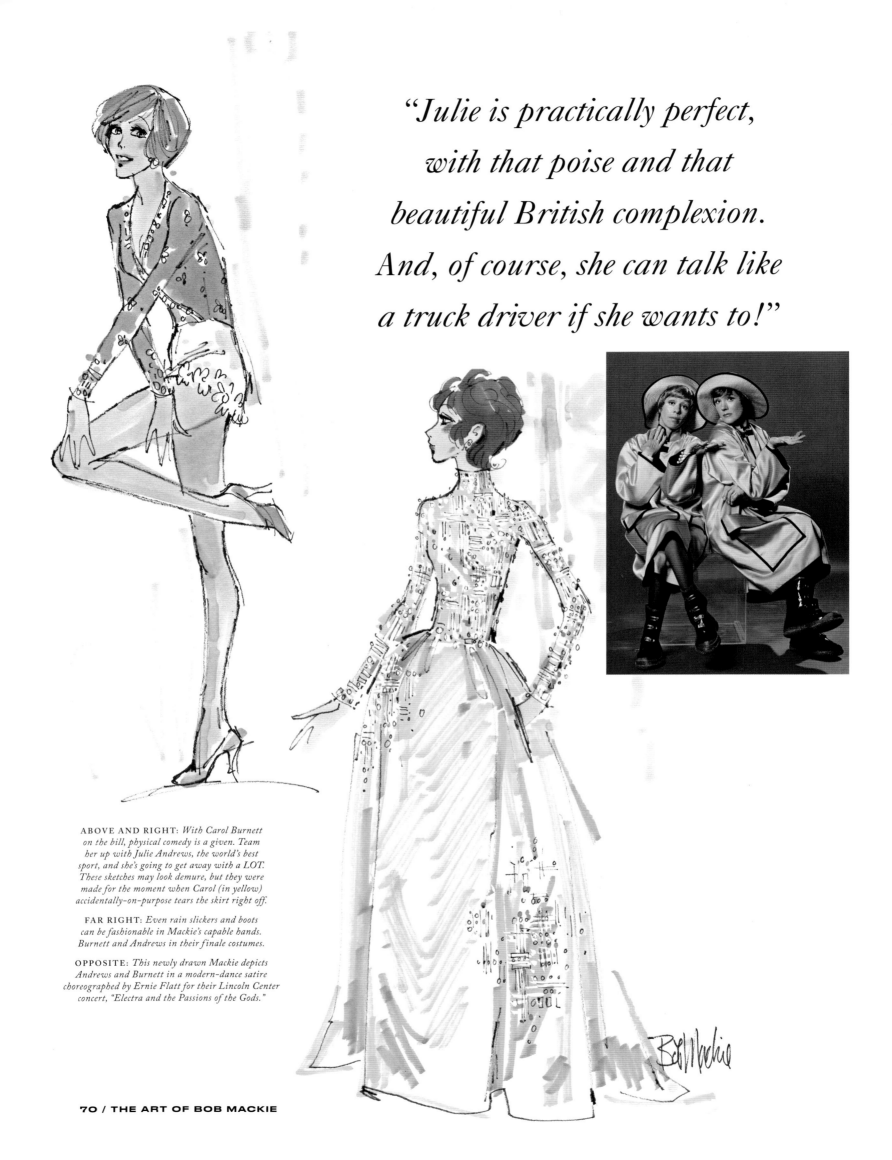

*"Julie is practically perfect, with that poise and that beautiful British complexion. And, of course, she can talk like a truck driver if she wants to!"*

**ABOVE AND RIGHT:** *With Carol Burnett on the bill, physical comedy is a given. Team her up with Julie Andrews, the world's best sport, and she's going to get away with a LOT. These sketches may look demure, but they were made for the moment when Carol (in yellow) accidentally-on-purpose tears the skirt right off.*

**FAR RIGHT:** *Even rain slickers and boots can be fashionable in Mackie's capable hands. Burnett and Andrews in their finale costumes.*

**OPPOSITE:** *This newly drawn Mackie depicts Andrews and Burnett in a modern-dance satire choreographed by Ernie Flatt for their Lincoln Center concert, "Electra and the Passions of the Gods."*

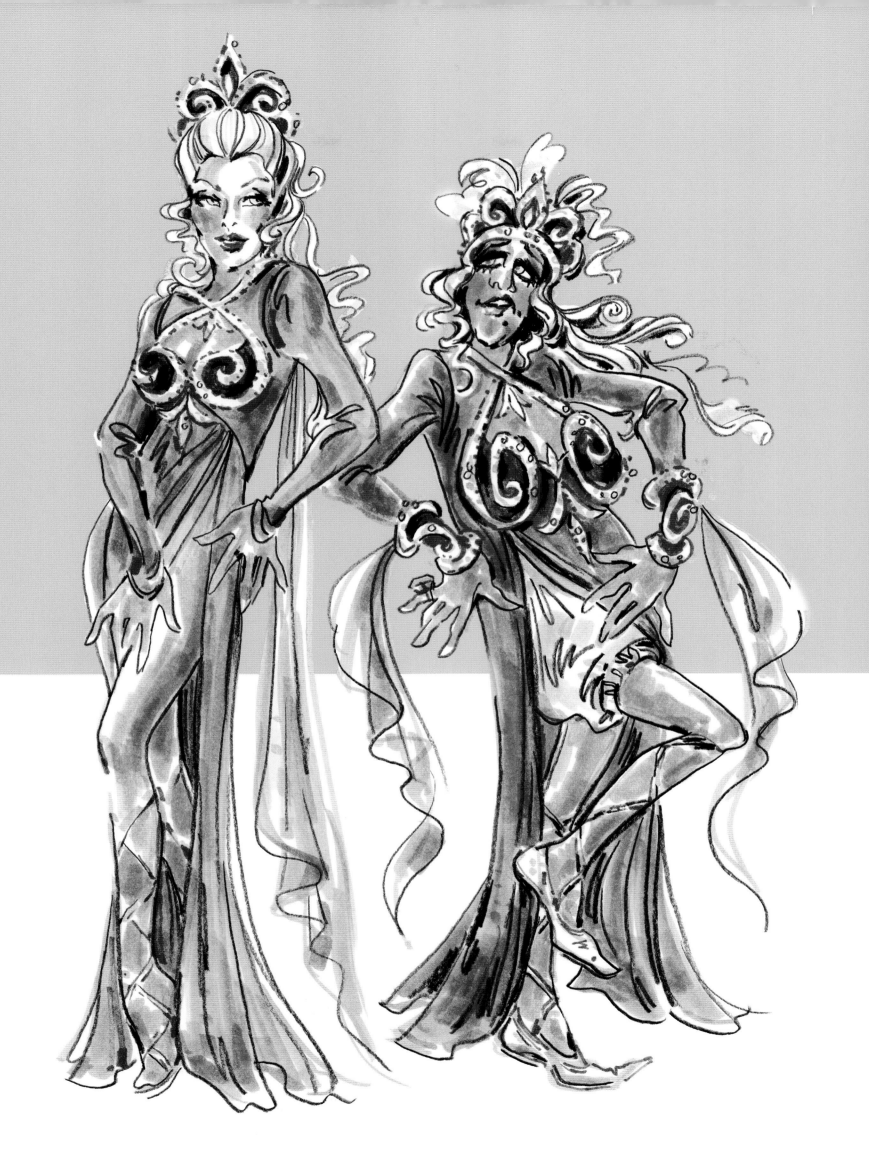

# She's Got *Bob*, Babe

**"I MET CHER WHEN SHE WAS ON THE FIRST SEASON OF THE** Burnett show. I remember spotting her in the hallway at CBS, looking at a beaded dress I had done for Carol. When she saw me, she said, 'Gee, I hope someday I can ask you to make something like this for me!' 'When you're ready, I'm ready!' I said. Four years later—in 1971—she and Sonny were offered a summer replacement series, and she asked me to do it. I thought it would be *impossible* to work on that and Burnett at the same time, so I said no. But there is never any saying no to Cher if she decides to talk you into something!"

There you have it: The queen of the bare midriff trumped the king of sequins, and Mackie signed on—but only to design the costumes for the leading lady. For Sonny, the guest stars, and the ensemble, he recommended his talented friend and colleague Ret Turner.

"The *only* way I was able to work on both shows was that they were in the same building," Mackie recalled. "There was Studio 33, which was where Carol taped, *then* the men's room, then Studio 31, where Sonny and Cher taped. So I ran back and forth, forth and back. For six years."

*Cher revolutionized the look of TV variety forever, thanks to the magic touch of Bob Mackie. Forget the wholesomeness of Dinah Shore or the classy/comic mashup of Carol Burnett. Cher was chic in a whole new way. Of course, there were scads of witty, spot-on creations for the comic bits, but when Cher was being Cher, she and Bob took glamour to a whole new level—and there was a lot of skin up there.*

The show, which followed a similar format to that of the wacky redhead down the hall, was an immediate smash. The only significant difference between the shows was that, instead of a Q&A with the audience, *Sonny & Cher* began with scripted banter between the married cohosts. Guess who always managed to zing a few zingers over her petite spouse's head? (The supposedly vast difference in their respective heights, in truth only an inch but comically exaggerated by Cher's lofty footwear, rarely went unremarked upon.)

After that, it was typical 1970s variety fare, with solos, duets, and comedy sketches featuring a parade of guest stars, a final production number, and a wrap-up with the title duo "making up" by sweetly singing their signature song, "I Got You, Babe."

Like Burnett, Sonny and Cher developed recurring routines, some trotted out on a weekly basis. These included "Sonny's Pizzeria," featuring a harassed Bono as the owner of a restaurant with inedible cuisine; and "The Fortune Teller," with Cher inside a carnival fortune-telling machine granting wishes for her guests while offering nothing but put-downs for Sonny. Poor Sonny—but the audience ate it up, thanks to the deft writing by Chris Bearde, straight from *Rowan & Martin's Laugh-In*; Allan Blye of *The Smothers Brothers Comedy Hour*; and a young upstart named Steve Martin, whose career got a big boost when he became a semi-regular on the show.

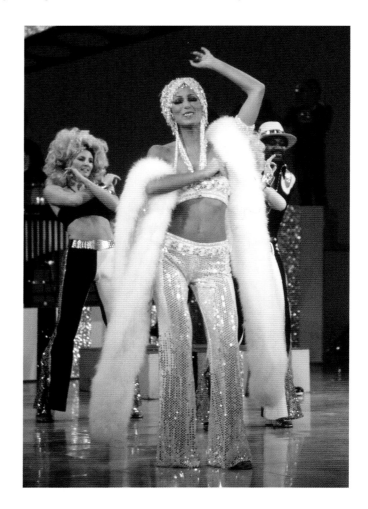

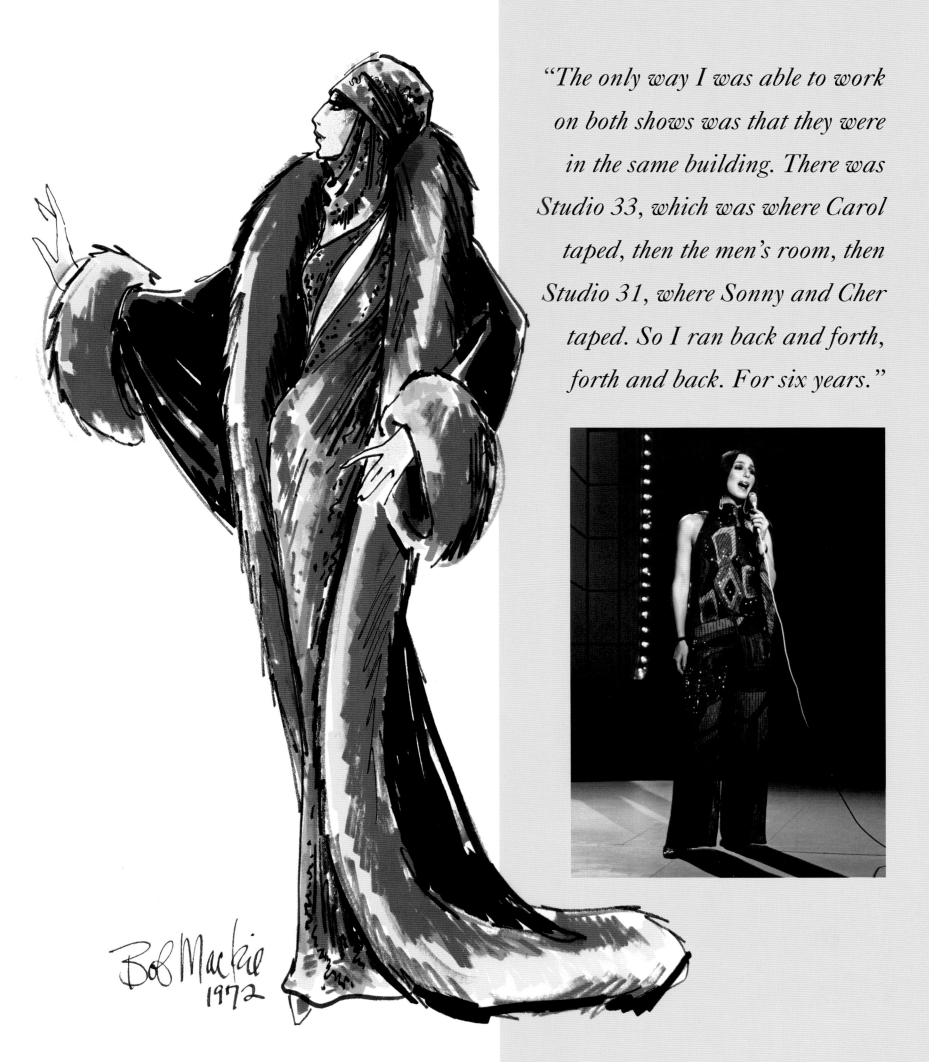

*"The only way I was able to work on both shows was that they were in the same building. There was Studio 33, which was where Carol taped, then the men's room, then Studio 31, where Sonny and Cher taped. So I ran back and forth, forth and back. For six years."*

Bob Mackie
1972

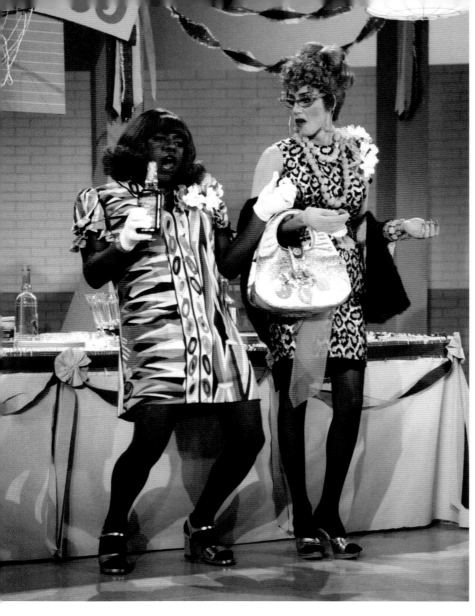

# Dirty *Laundry*

**LAVERNE LASHINSKI, THE TACKY, BRASSY, GUM-CHEWING** harpy who made her debut on *The Sonny & Cher Comedy Hour* in 1973, was the only character Cher carried over to her own variety show. Most often appearing in sketches set in a Laundromat, Laverne cracked wise with her friend Olivia—played by the wonderful Teri Garr (costumed by Ret Turner in a pink minidress with plastic rollers in her hair). The two game gals complained about their husbands, told corny jokes ("You know, they say that some marriages are made in heaven. Harry and I got the only one made in Japan"), and folded clothes.

Cher relished the chance to showcase her estimable comic gifts by playing a vibrant recurring character in the vein of Carol Burnett's Stella Toddler and Mrs. Wiggins. Dressed in a padded leopard-print jumpsuit, cat's-eye glasses, a moth-eaten cardigan, and a warped "Lucy" wig, Cher cast about with the designers for finishing touches. Everything clicked into place when a guy from the props department gave Cher a piece of bubble gum to chew and Mackie made sure one bra strap hung down past her shoulder.

Ultimately, Laverne ventured out of the Laundromat and into other sketches, memorably barging into Liberace's house for a personally guided tour and attending her high school reunion, where she ran into Flip Wilson's classic Geraldine Jones persona.

Laverne: "Don't you remember me? I was your constant high school companion!"

Geraldine: "You're not the football team!"

Cher loved playing Laverne so much that she incorporated the character into her concert tours in the 1980s, singing Rod Stewart's "Do Ya Think I'm Sexy?" As Mackie said of the character, "Laverne was a great foil for all of Cher's glamorous moments. She wore every tasteless thing I could come up with. And now fashion has caught up with Laverne. Those hooker shoes, the leopard print, and straw bags with flowers on them are back out on the market again . . . If you wait long enough, you come back into style!"

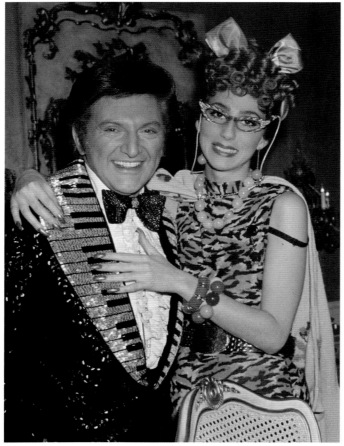

TOP LEFT: *Laverne Lashinski and Geraldine Jones (Flip Wilson) walk down memory lane.*

LEFT: *Laverne crashes the Beverly Hills house of her idol Liberace, who knew a thing or two about sartorial excess himself.*

OPPOSITE, TOP LEFT: *Laverne in her pad, decorated in the style of Hugh Hefner's talk show digs on* Playboy After Dark.

OPPOSITE, BOTTOM LEFT: *Semi-regular sketch player Teri Garr and Laverne meet "Broadway Joe" Namath at a Laundromat.*

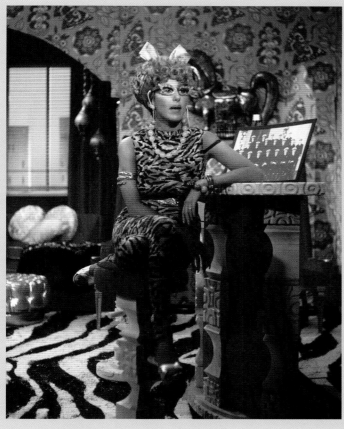

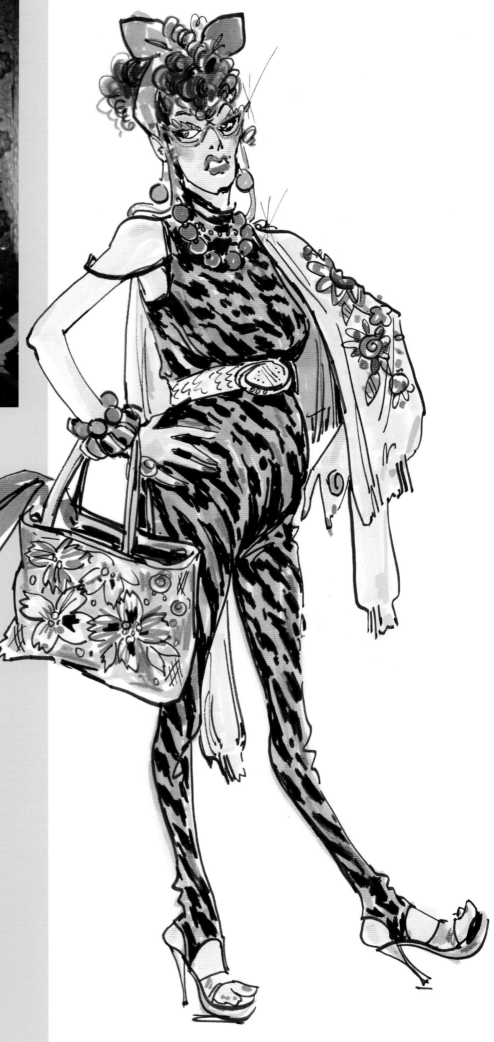

*Everything clicked into place when a guy from the props department gave Cher a piece of bubble gum to chew and Mackie made sure one bra strap hung down past her shoulder.*

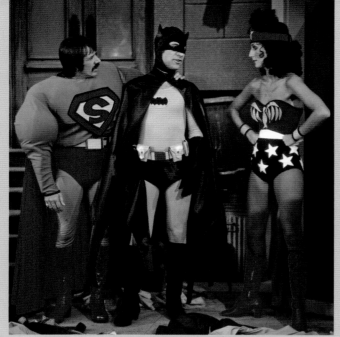

# See You in the *Funny Papers*

**IN ADDITION TO ITS WEEKLY SOLOS, DUETS, AND PRODUC-**tion numbers, *The Sonny & Cher Comedy Hour* featured many short sketches, some lasting just thirty seconds but all requiring pitch-perfect costumes. Cher's clothes were in Mackie's capable hands, but his friend and longtime colleague Ret Turner was responsible for what Sonny and the rest of the cast wore, as Bob dashed between that show and Carol Burnett's, for which he designed EVERYTHING. Still—Cher required some twenty costumes a week, including four or five gowns from scratch. (She didn't mind recycling her Laverne drag, but she was savvy enough to know that her audience wanted to see her in new threads every week, the flashier the better.)

In the breakneck comic style of *Laugh-In* and *The Carol Burnett Show*, the blackout sketches on *Sonny & Cher* were designed to hit the audience fast and get out of Dodge before anybody realized how painfully corny most of them were. Perhaps fearing that some older viewers still saw the couple as long-haired, fur-vest-clad hippies, they often mined comic strips for gold, showing the people at home familiar characters with a twist. Sonny as a five-five Superman and Cher as a five-ten Lois Lane, for example, elicited an immediate guffaw, as did Cher as Bugs Bunny towering over Sonny as Elmer Fudd. Once, during the recurring "Vamp" sequence, Cher appeared atop the piano as always, but instead of reclining, she knelt in an insanely tall Orphan Annie wig while Sonny tickled the eighty-eights in a Daddy Warbucks bald cap that made him look shorter than ever. Oh, and someone *really* tiny stood by in a Sandy costume. Let's hope it wasn't little Chastity.

---

THIS PAGE AND OPPOSITE: *Sonny and Cher loved to take on comic-strip personae, including: Popeye and Olive Oyl, above; Superman (with Don Adams as Batman), top left; Elmer Fudd and Bugs Bunny, center left; Li'l Abner (with Cher as Daisy Mae, flanked by regular Teri Garr as Moonbeam McSwine and "Tennessee" Ernie Ford as Abner), bottom left; and Little Orphan Annie (opposite).*

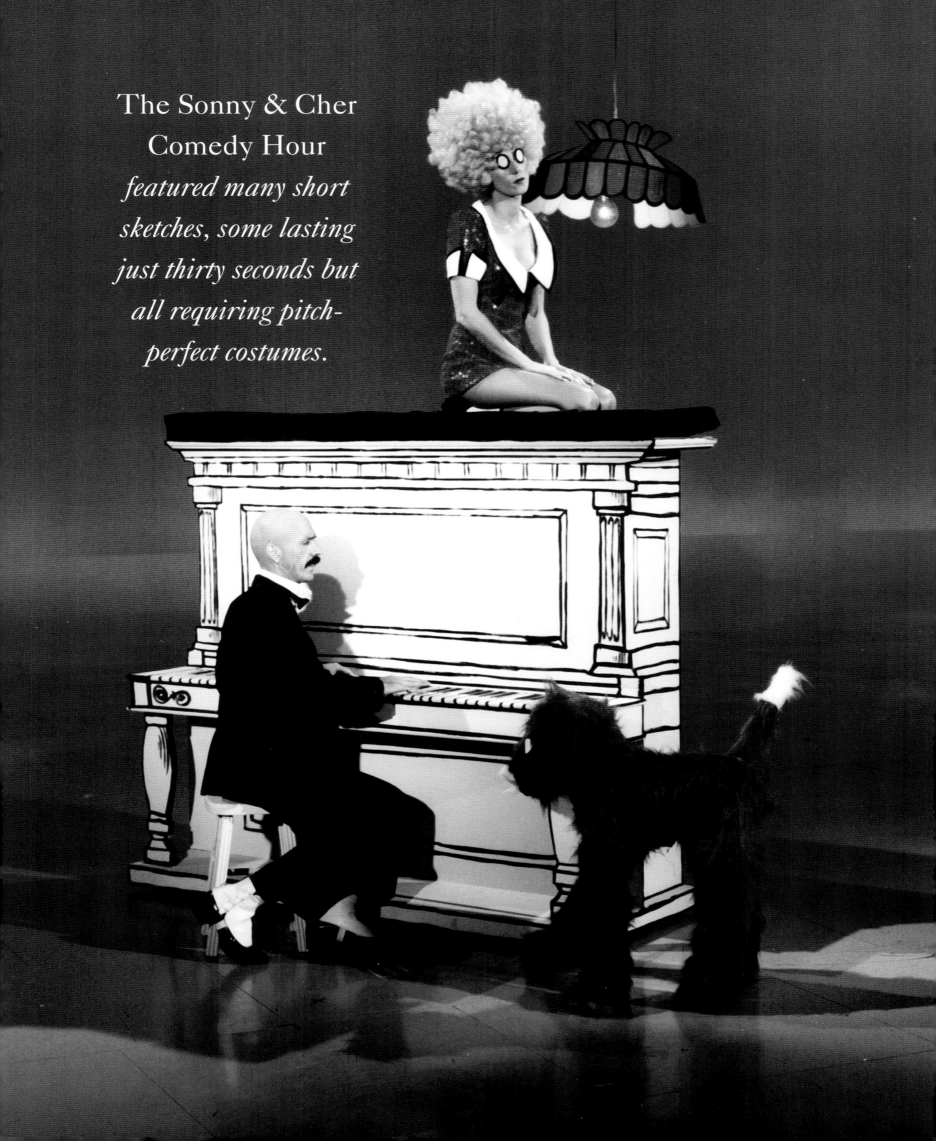

The Sonny & Cher Comedy Hour *featured many short sketches, some lasting just thirty seconds but all requiring pitch-perfect costumes.*

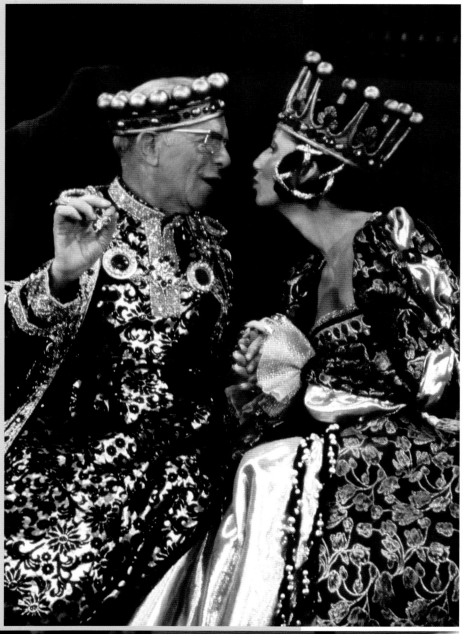

# Be Our *Guest*

LEFT: *George Burns as a stogey-smoking King Ferdinand and Cher as Queen Isabella in a 1972 sketch.*

BOTTOM LEFT: *Sonny and Cher with guest star Sandy Duncan in the 1972 song-and-dance number "The Gypsy Doodle."*

BELOW: *Jean Stapleton and Cher did a wicked spoof of the "mutual admiration society" tone of* Julie and Carol at Lincoln Center, *with Cher as an adoring Burnett and Jean as a cooing Andrews. Mackie provided re-creations of his designs for the special two years earlier, but with a switch. Whereas Burnett had been in yellow and Andrews in pink, for the sketch on Sonny & Cher, the actresses swapped colors.*

OPPOSITE, TOP LEFT: *Sonny and Cher with Jimmy Durante on the August 1971 premier episode of what began as a summer replacement series,* The Sonny & Cher Comedy Hour.

OPPOSITE, TOP RIGHT: *Jerry Lewis, Cher, and Sonny in a* Three Musketeers *spoof in 1972.*

OPPOSITE, BOTTOM LEFT: *Jimmy Durante and Cher as George and Martha Washington in a "Vamp" segment blackout, with Sonny as a lightning-struck Benjamin Franklin.*

OPPOSITE, BOTTOM RIGHT: *Guest star Truman Capote as Lord Horatio Nelson and the Bonos as Napoleon and Josephine in a 1973 sketch. Some children of the 1970s learned much about world history (not to mention costume history) from the designs of Bob Mackie and Ret Turner.*

# *Ret* Rides In

**FIRST, THE NAME. WHEN COSTUME DESIGNER WALTER** Turner was a teenager, he and his fellow students in Marianna, Florida, decided to call one another by backward versions of their names. Walter became Retlaw, and that was abbreviated to Ret.

With high hopes that his talent for acting would be embraced by Hollywood, Turner made his way to Los Angeles in 1950. After working for a theater company and quickly realizing his destiny was backstage and not on it, he found himself in the wardrobe department at NBC, eventually becoming manager. By 1958, he was designing for variety shows helmed by Tennessee Ernie Ford, Andy Williams, and Jerry Lewis. He was one of the first people Bob Mackie met when he landed at the NBC costume department in 1962, and Mackie, Ray Aghayan, and Ret became great friends and mutual admirers. During the height of the TV variety show in the 1970s, Turner suggested to Mackie and Aghayan that they open a rental company to deal with the thousands of costumes they were producing, and EC2 Costume Rentals was born. (The EC stood for Elizabeth Courtney, whom you'll read about shortly.)

The quintessential example of the mutual respect between Mackie and Turner came in 1972, when Mackie was offered *The Sonny & Cher Comedy Hour*. He was already working nonstop on Carol Burnett's show and knew he couldn't possibly handle the workload. He agreed to design Cher's wardrobe only and recommended Turner for the rest. Bingo—the results were spot-on and led to more recommendations and collaborations between the two gifted artists: on Mitzi Gaynor's specials and on the sitcom *Mama's Family*, a half-hour version of the popular sketches from the Burnett show. Ret also created all of the clothing but Burnett's on the 1991 sketch comedy show *Carol & Company*, every wacky stitch for *The Donny and Marie Show*, and ensembles for Eydie Gormé, Debbie Reynolds, Debbie Allen, and other talented ladies. For his efforts, Ret racked up twenty-three Emmy nominations and five wins.

When it came to his own wardrobe, Ret's look never varied: He could always be seen in a black suit with a red tassel around his neck. As indefatigably devoted to glamour as his friend Bob, Ret never stopped designing. When he died at eighty-seven, he was the oldest working member of the Costume Designers Guild and a proud inductee into its Hall of Fame.

---

TOP LEFT: *Friends and collaborators Ret Turner and Bob Mackie in 1991.*

LEFT: *Three of Ret Turner's clever designs for a* Wizard of Oz *fantasy sequence on* The Donny and Marie Show, *featuring Lucille Ball as the Tin Man, Marie Osmond as Dorothy, and Ray Bolger reprising his original movie Scarecrow.*

# Dressmaking *Magic*

**ONE OF HOLLYWOOD'S RENOWNED DRESSMAKERS FOR** over forty years, Elizabeth Courtney had a workroom where Hollywood's finest designers, including Ray Aghayan, Ret Turner, Jean Louis—and Bob Mackie—did their fittings. It was Courtney who assured that the iconic gowns of Marilyn Monroe, Elizabeth Taylor, Kim Novak, Cher, and Marlene Dietrich, among many others, fit like the proverbial glove.

As Dietrich recalled in her autobiography, *My Life*, "It's true [twue?] that Jean Louis and I, along with Elizabeth Courtney, a woman with very talented fingers, would have endless discussions over where a diamond, a minuscule mirror, or a glass pearl should be placed. Then Elizabeth would mark the spot with a tiny red thread."

Surprisingly, because CBS Television City was originally built in the style of a radio studio, there was no on-site costume department. Costumes for such shows as *The Judy Garland Show*, *The Carol Burnett Show*, and *The Sonny & Cher Comedy Hour* were executed in Courtney's studio on Melrose in Studio City.

Perhaps Lily Tomlin best summed up the magic of a visit to her studio: "Going to Elizabeth Courtney's is like going to Disneyland. Anything you want, anything you want *to be*, it's all there for you."

---

BELOW LEFT: *Couturier extraordinaire Elizabeth Courtney.*

BELOW RIGHT: *Courtney joins Mackie in a 1973 fitting for Cher.*

*"Going to Elizabeth Courtney's is like going to Disneyland. Anything you want, anything you want* to be, *it's all there for you."*
—Lily Tomlin

# MASTERING MOVIES

"I GREW UP WANTING TO BE A DESIGNER IN FILMS, LIKE ALL those musicals put out by MGM. But wouldn't you know it? The studios pretty much stopped making them the minute I got into the business. That's why I got into television. In the 1960s, all of the spectacle, the fancy sets and costumes, the star performances were on TV variety shows. I am *so glad* I got to experience that before it went out of style!"

Bob Mackie made that declaration in 2000, but of course, he was being too modest. He didn't just experience all that glamour, he played a large part in defining it. He made his mark in films as well, designing spectacular gowns for Sharon Stone in *Casino* and Jennifer Lopez in *Maid in Manhattan*, among other creations. But the man himself will tell you that he didn't always relish life on a movie set. Some of his not-fondest memories involve endless hours on the sets of *Funny Lady* and *Pennies from Heaven*.

Mackie's movie career began earlier: His first film credit was for the 1967 Debbie Reynolds/Dick Van Dyke film *Divorce American Style*, though even then he had his complaints about the medium. Although he created indisputably stylish clothes for Reynolds, Jean Simmons, and Lee Grant, he found himself feeling less than fulfilled working on ready-to-wear looks, and Debbie shared his lack of satisfaction. (No love lost, though. The two would reunite a few years later in Vegas and revel in their mutual love of sequins and bugle beads.)

Mackie happily moved over to television and busied himself there for the next five years, until Diana Ross came calling on him and Ray Aghayan to redesign the costumes for her Billie Holiday biopic *Lady Sings the Blues*.

While television provided his more enduring home, Mackie did fulfill the fantasies of his youth to some degree by designing three fascinatingly diverse movie musicals (four, if you count *Staying Alive*), plus many specialty gowns for ladies who demanded an ensemble or two that would stop a movie cold.

LEFT: *Bob Mackie and director Herbert Ross discuss the finer points of Christopher Walken's undergarments on the set of* Pennies from Heaven.

RIGHT: *Mackie's sketch for Debbie Reynolds in* Divorce, American Style *(1967)—on which he received his first movie credit.*

OPPOSITE: *Barbra Streisand in a knockout Mackie/Aghayan design for the "Great Day" production number in* Funny Lady.

# *Diana's* Holiday

**BOB MACKIE RECEIVED HIS FIRST ACADEMY** Award nomination for costumes he had to create in two weeks.

The movie *Lady Sings the Blues*, a loose biography of the ups and many downs of the jazz singer Billie Holiday, was about to begin filming, and its star, Diana Ross, was not pleased. Paramount Pictures, the studio producing the movie, had given the film and its producer, Ross's Svengali Berry Gordy, the equivalent of "shave and a haircut, two bits" for a costume budget.

Miss Ross's only real acting experience prior to 1972 was when she, Mary Wilson, and Cindy Birdsong played a trio of singing nuns on an episode of *Tarzan*, and she wanted gowns befitting her dramatic film debut. Over the course of two hours, Lady Day would be depicted onstage and off, high as a kite and sober, in and out of prison. When she wasn't wearing a straitjacket, Ross wanted to look her best.

As Mackie remembered it, "I was doing *Sonny & Cher* and Carol's show at the same time, and literally had two weeks before filming began, so Ray [Aghayan] came in and did it with me, because there was no way I could be there all the time. And Diana absolutely adored Ray, so he was a great calming influence."

Ross would need more and more of that calming as time went on. The film shoot veered off schedule and over budget as the team was in constant rewrite mode. At one point, Paramount saw a rough cut of what had been shot so far and pulled the plug, leaving Motown Records to pick up the tab and Berry Gordy to pick up the director's reins—albeit briefly.

The process was like assembling an airplane as it taxied down the runway, and sadly, it shows. Midway through the movie, the characters suddenly launched into what sounds like improvised contemporary slang— including an alarming number of lines that started with "Man . . ." But Ross consistently rose above it all, sounding, acting, and *looking* every bit the true movie star she'd always known she could be. Her period-perfect day wear and stunning evening gowns didn't hurt.

The movie was a huge hit, and costars Billy Dee Williams and Richard Pryor were rightfully recognized for their electric performances. In spite of the chaotic production and the many liberties taken with Holiday's life story, Academy Award nominations were doled out for the music, art direction, costumes, and the star herself, who had wowed critics and audiences alike with her confident, harrowing portrayal of Holiday. Sadly, Mackie (along with Aghayan and Norma Koch) lost to Anthony Powell for his work on *Travels with My Aunt*. It wasn't to be Ross's year, either; she pasted on a smile for the cameras as Liza Minnelli accepted the honor for a little film called *Cabaret*.

Nonetheless, Ross had conquered Hollywood at the age of twenty-eight and entered the pantheon of movie stardom. She'd make just two more theatrical releases, neither nearly as well received, but . . . God bless the child who's got her own.

---

THIS PAGE AND OPPOSITE: *Ray Aghayan and Bob Mackie's creations for* Lady Sings the Blues *included performance gowns, lingerie, period-perfect daywear—even a straitjacket.*

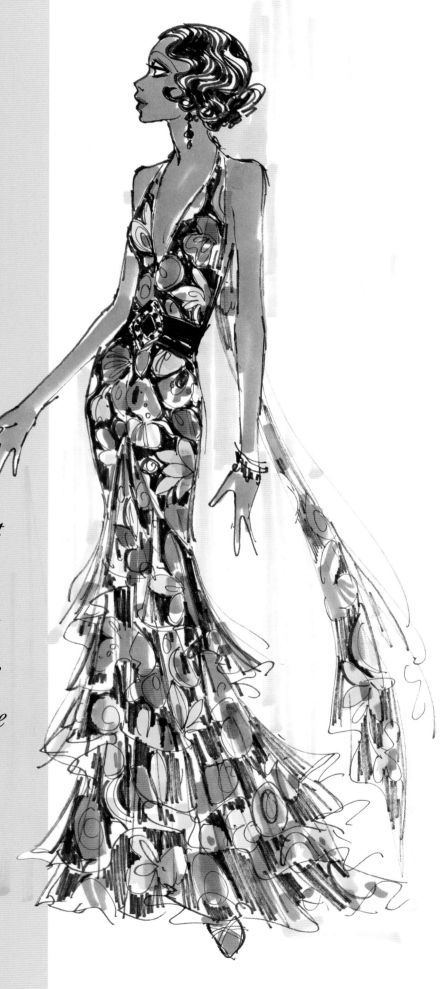

"*I was doing* Sonny & Cher *and Carol's show at the same time, and literally had two weeks before filming began, so Ray Aghayan came in and did it with me, because there was no way I could be there all the time. And Diana absolutely adored Ray, so he was a great calming influence.*"

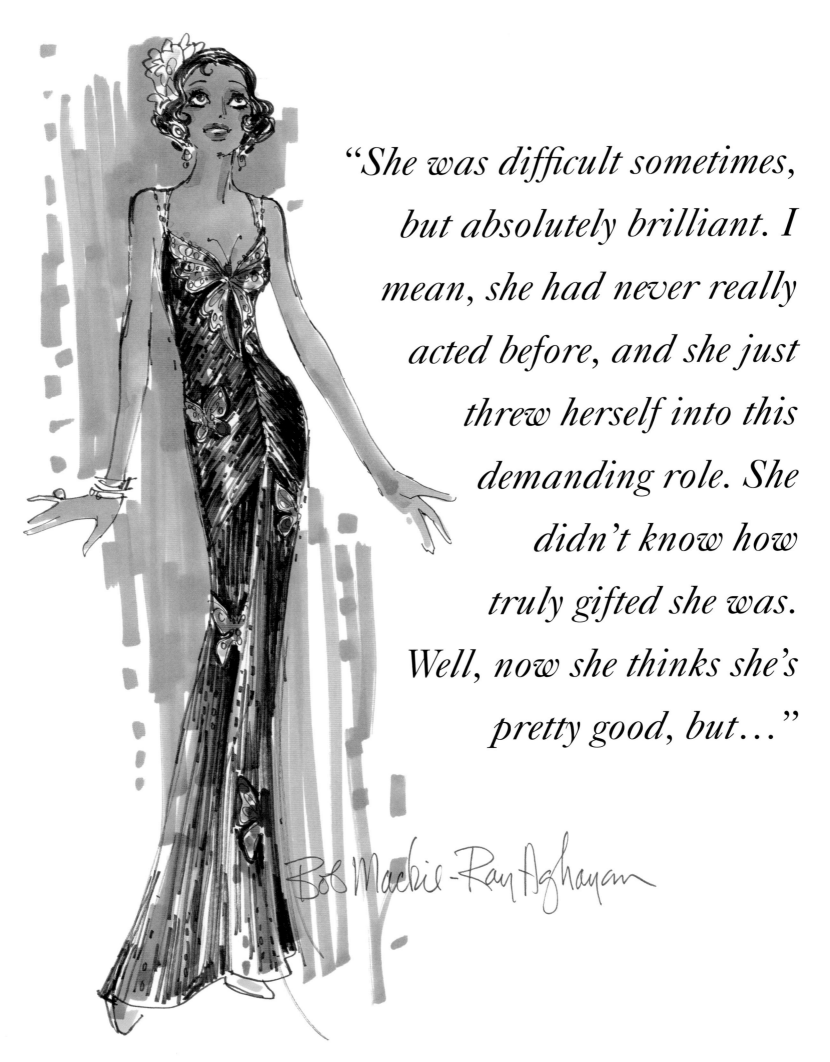

"*She was difficult sometimes, but absolutely brilliant. I mean, she had never really acted before, and she just threw herself into this demanding role. She didn't know how truly gifted she was. Well, now she thinks she's pretty good, but…*"

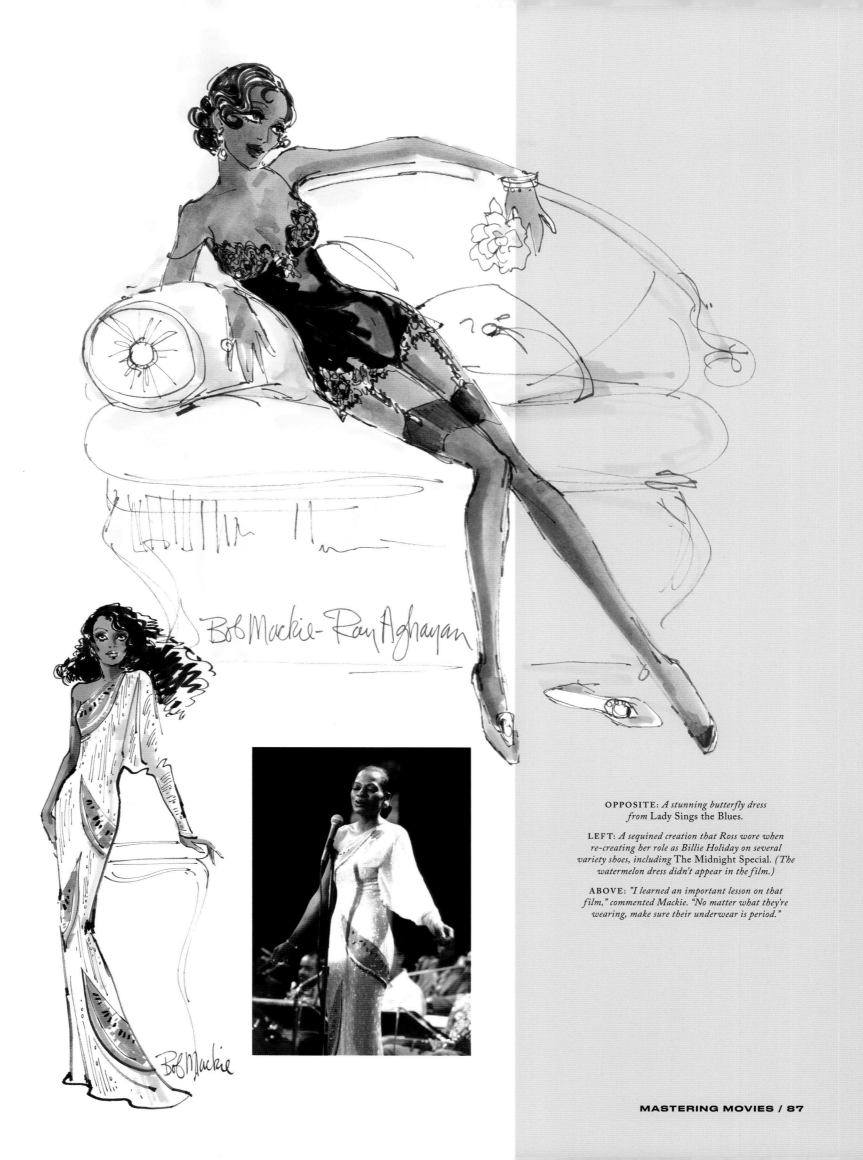

*Bob Mackie-Ray Aghayan*

OPPOSITE: *A stunning butterfly dress from* Lady Sings the Blues.

LEFT: *A sequined creation that Ross wore when re-creating her role as Billie Holiday on several variety shoes, including* The Midnight Special. *(The watermelon dress didn't appear in the film.)*

ABOVE: *"I learned an important lesson on that film,"* commented Mackie. *"No matter what they're wearing, make sure their underwear is period."*

# Color Her *Barbra*

**FUNNY LADY WILL FOREVER BE KNOWN TO FILM BUFFS AS** the movie Barbra Streisand sued NOT to make, but don't let that scare you off. The final product—a 1975 sequel to the 1969 Academy Award–winning Fanny Brice biomusical *Funny Girl*—bears little evidence of the litigation and drama that preceded it.

Here's how it went down. After *Funny Girl*, Streisand signed a multi-picture deal with producer Ray Stark (not coincidentally, the husband of Brice's daughter Frances). All went well for a while, and they scored hits with *The Owl and the Pussycat* and *The Way We Were*, but then the star wanted out. Lawyers were hired and papers flew until Streisand read the *Funny Lady* screenplay by Jay Presson Allen, who'd also penned *Funny Girl*, and saw something she could work with.

That's not to say the process of making the picture was a total picnic. Costar Ben Vereen, like *Funny Girl* costar Anne Francis before him, saw much of his performance relegated to the editing room floor. Yet as Mackie, who co-designed the costumes with Ray Aghayan, said, "I watched it recently, and after all the late nights, the back-and-forth, and the headaches for Ray and me, it's actually a very enjoyable film."

We agree.

Although it didn't provide La Streisand with another gold statuette, we're sure she felt it was an honor to be nominated alongside her collaborators Mackie and Aghayan for costumes and John Kander and Fred Ebb for their song "How Lucky Can You Get?" (Not quite lucky enough, apparently.)

The main hitch with *Funny Lady* can be discerned from its title. While *Funny Girl* depicts a young Fanny Brice scrapping her way into show business, stopping the Ziegfeld Follies, and kissing Omar Sharif, the sequel revolves around the adult Fanny, no longer as gawky and winsome offstage as she was on and a bit long in the tooth for her old Baby Snooks routine. What's more, there's no Kay Medford (who had received a richly deserved Oscar nomination as Fanny's unflappable mother in the original), and precious little Omar shows up in just two brief scenes.

Designing for a diva didn't faze Mackie and Aghayan, who'd both worked with more than a few. And they brought something truly fresh to the film, while Irene Sharaff's designs for the original had been glorified re-creations of her Broadway designs. Ray and Bob swathed Barbra in blood-red fur, satin sheaths, and bugle beads, accentuating her beautiful curves. (Mrs. Strakosh may have called the young Fanny's "incidentals . . . no bigger than two lentils," but by *Funny Lady*, she was sporting what Mackie himself called a "spectacular bosom.")

How lucky can you get?

---

*Barbra Streisand, back in her starmaking role of Fanny Brice, sings "Am I Blue" in a design by Ray Aghayan and Bob Mackie for the 1975 movie musical* Funny Lady.

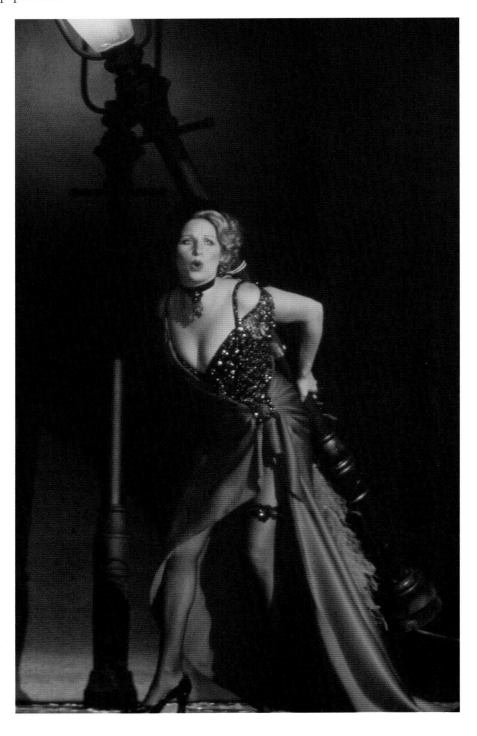

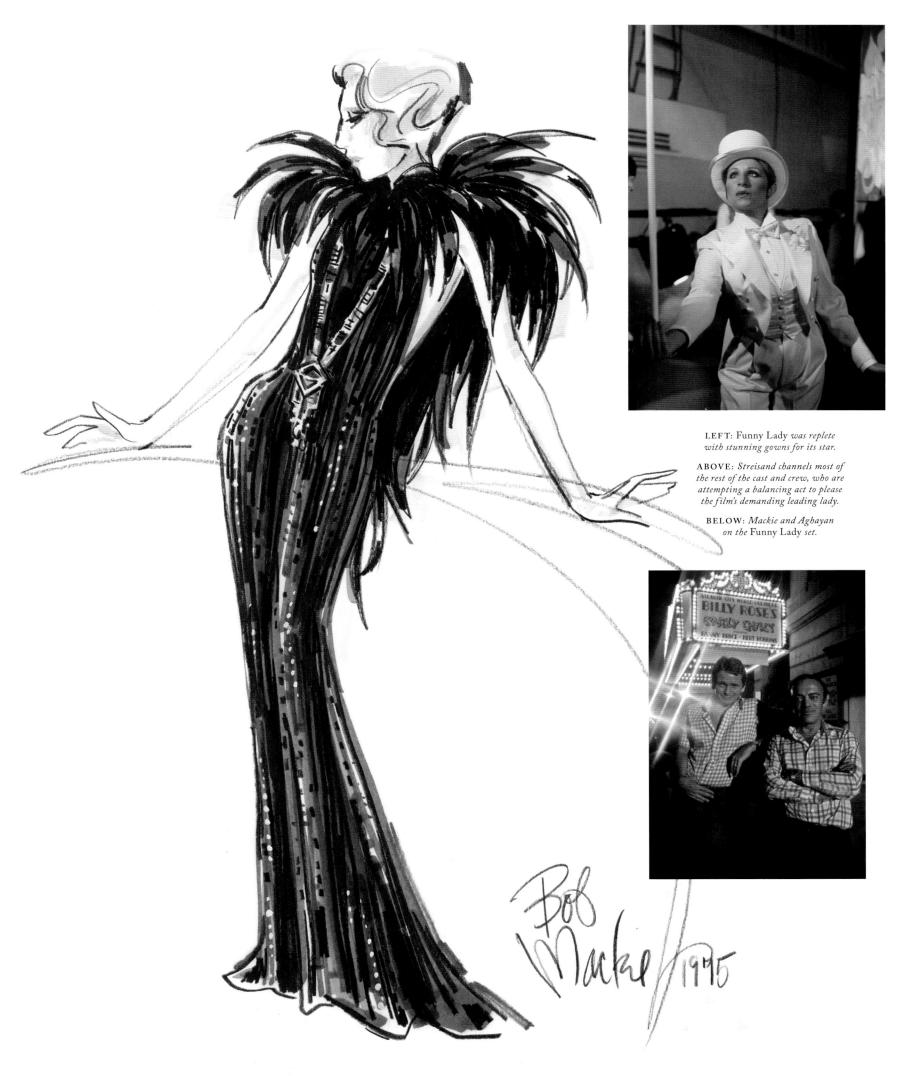

**LEFT:** *Funny Lady was replete with stunning gowns for its star.*

**ABOVE:** *Streisand channels most of the rest of the cast and crew, who are attempting a balancing act to please the film's demanding leading lady.*

**BELOW:** *Mackie and Aghayan on the* Funny Lady *set.*

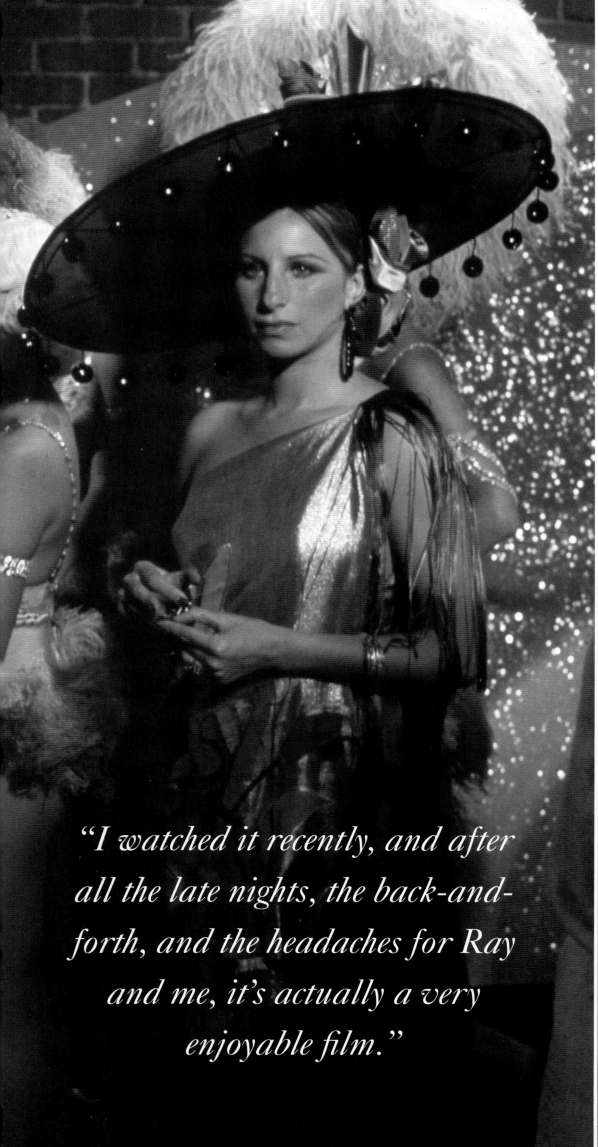

"*I watched it recently, and after all the late nights, the back-and-forth, and the headaches for Ray and me, it's actually a very enjoyable film.*"

ABOVE AND BELOW: *Although she was not always an angel on the set, Barbra Streisand made a hilarious Little Eva in the song "So Long, My Honey Lamb."*

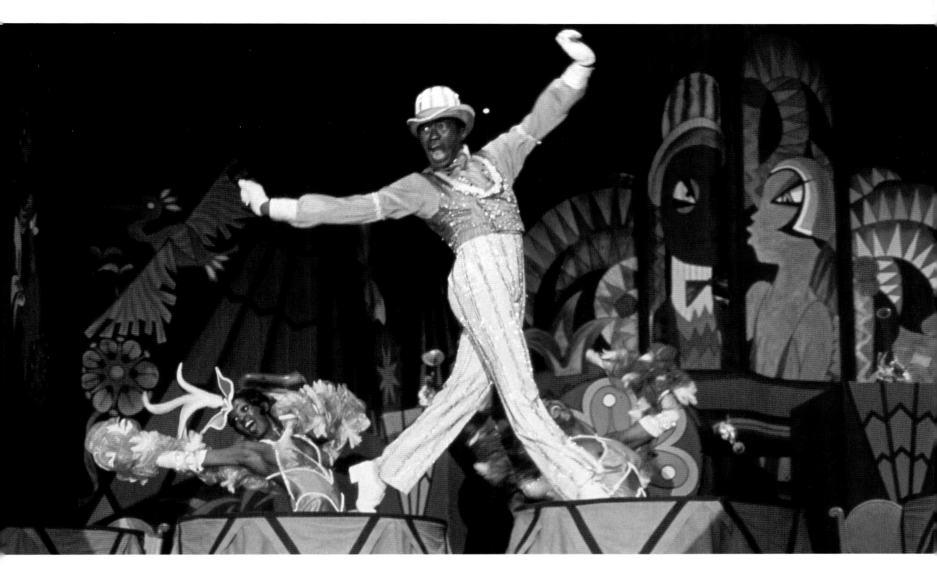

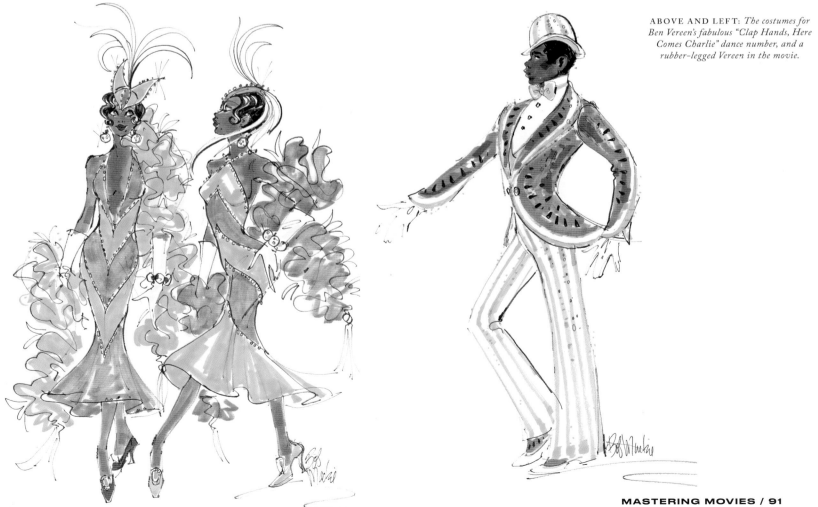

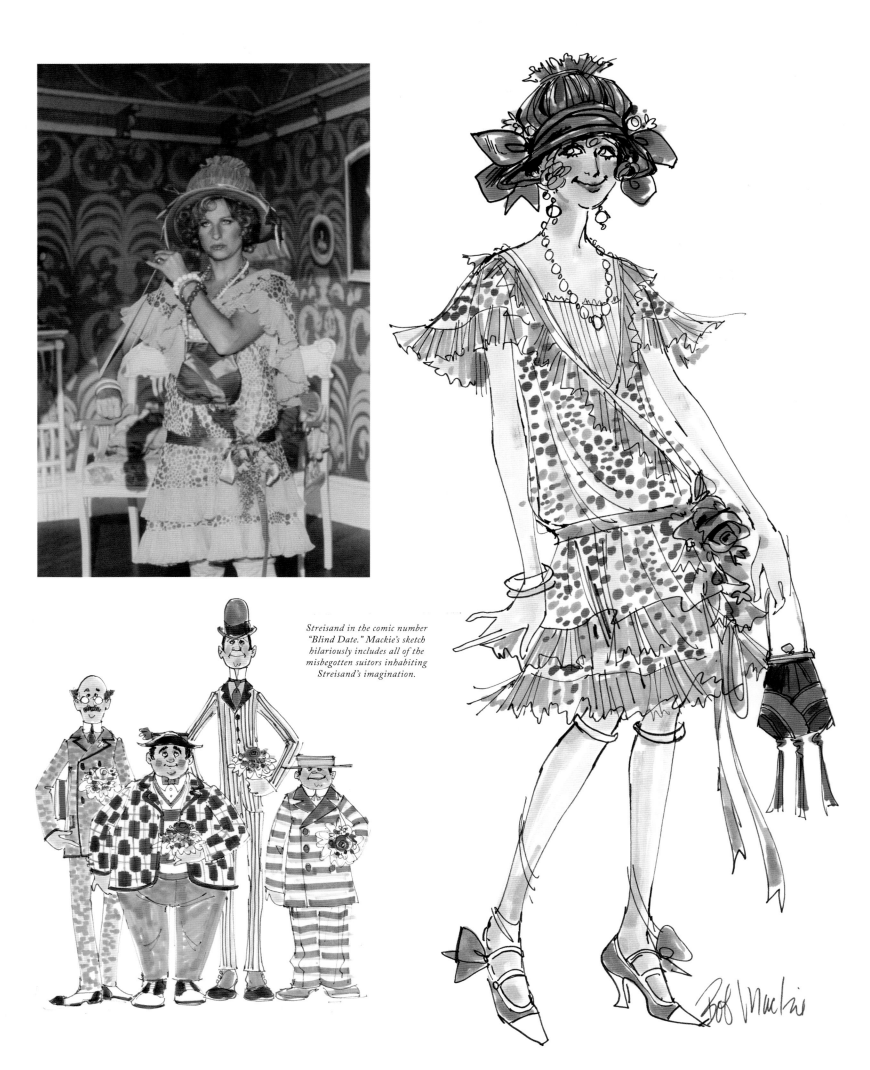

Streisand in the comic number "Blind Date." Mackie's sketch hilariously includes all of the misbegotten suitors inhabiting Streisand's imagination.

# Two-Sided *Coin*

**THE 1981 MOVIE *PENNIES FROM HEAVEN* WAS BOB MACKIE'S** last Oscar nomination to date. Directed by Herbert Ross (with whom Mackie had worked on *The Fred Astaire Show* and the movie *Funny Lady*) and starring Steve Martin and one of Mackie's favorite muses, Bernadette Peters, it featured a movie-stealing tap dance/striptease by an oilier-than-usual Christopher Walken.

As the two downtrodden lead characters wend their way through their financial and personal heartaches, they find solace in the fantasy world of the movie musicals of RKO and Warner Bros., seen originally in black and white but delivered here in spectacular Technicolor. For his part, Mackie created both sides of the penny: one tarnished, soiled, and devalued due to the heartache of the Great Depression; the other gleaming, sunny-side up, and straight from the mint.

The movie was marketed as MGM's return to their golden age of 1940s and '50s musicals, but the subject matter (based on the 1978 Dennis Potter BBC series starring Bob Hoskins) was a far cry from *Meet Me in St. Louis* or *Singin' in the Rain.* In *Pennies,* sweet little Bernadette has an affair with a married sheet-music salesman played by Steve Martin, gets knocked up, gets fired from her job as a schoolteacher, has an abortion, and ends up a prostitute in the employ of Christopher Walken. Martin ends up at the gallows, set up by his vengeful wife. Hardly the stuff of an Astaire-Rogers movie (indeed, Fred Astaire openly and vocally hated the film), but the work of Mackie and visual consultant Ken Adam made for a visually stunning and cohesive mise-en-scène, its drab, realistic sequences exploding into rich, colorful fantasy.

Mackie was a constant presence on the set, always refining his designs and making sure they were absolutely true to period. As he remembered it, "It was kind of like doing two films: a realistic Depression-era drama and a Busby Berkeley musical all in one. I had to design 1930s-era underwear because you couldn't buy it. Camisoles and garters, boxer shorts with yokes and tiny buttons."

That kind of attention to detail, along with the strength of the performances (Martin blamed his reputation as the "wild and crazy guy," in part, for the film's failure), helped turn the box-office flop into an enduring cult favorite. As they say in vaudeville, "It's all in the timing."

*Mackie's burnished vision of the 1930s for* Pennies from Heaven *gleamed like Fort Knox, but don't scratch too hard; you might discover fool's gold.*

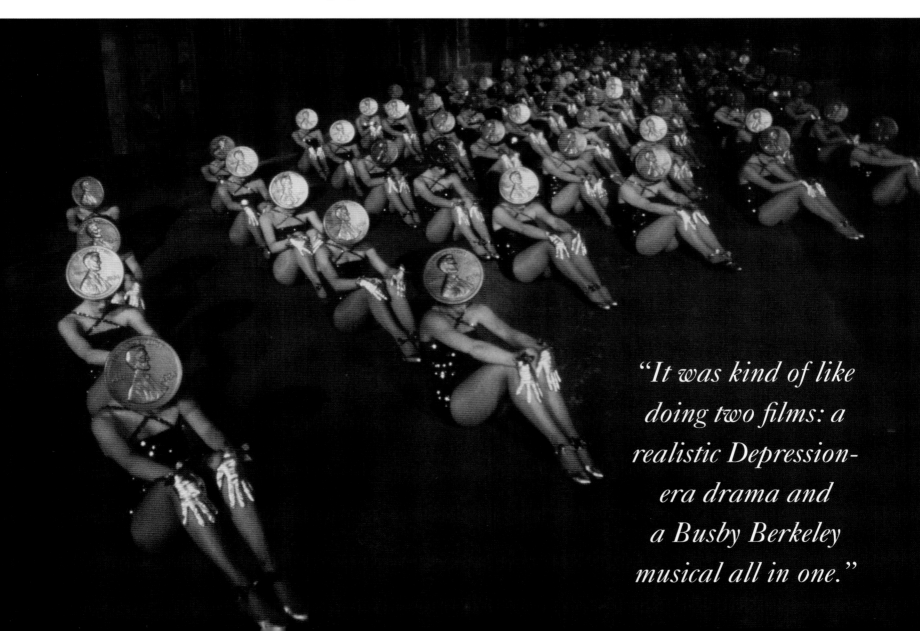

*"It was kind of like doing two films: a realistic Depression-era drama and a Busby Berkeley musical all in one."*

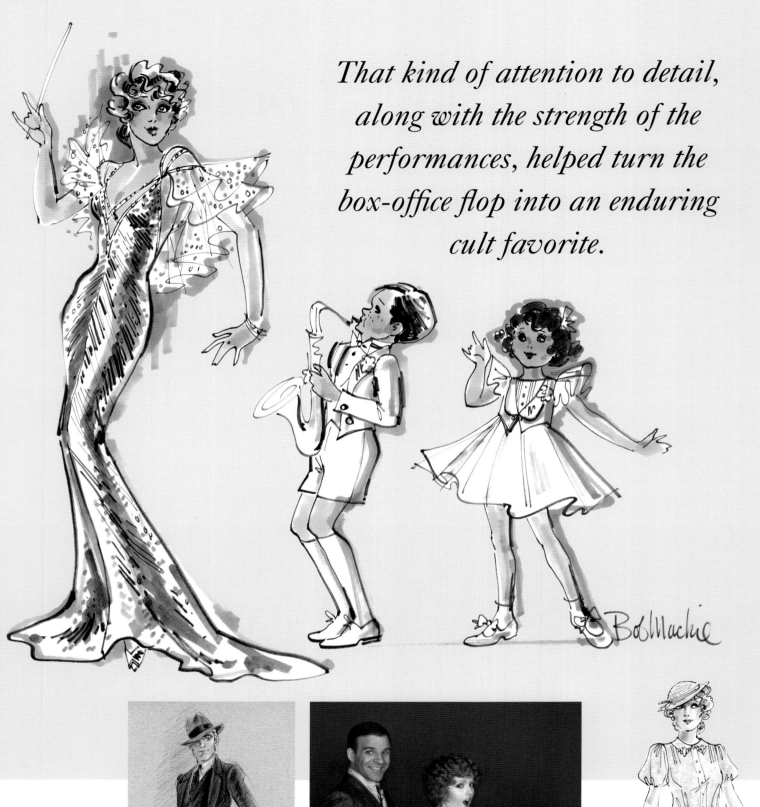

*That kind of attention to detail, along with the strength of the performances, helped turn the box-office flop into an enduring cult favorite.*

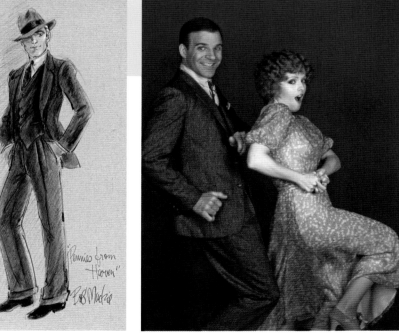

ABOVE: *Bernadette Peters and two of her tap-dancing, instrument-playing students in the sublime "Love Is Good for Anything That Ails You."*

RIGHT: *Designs for the first meeting of Bernadette Peters and Steve Martin in a music store.*

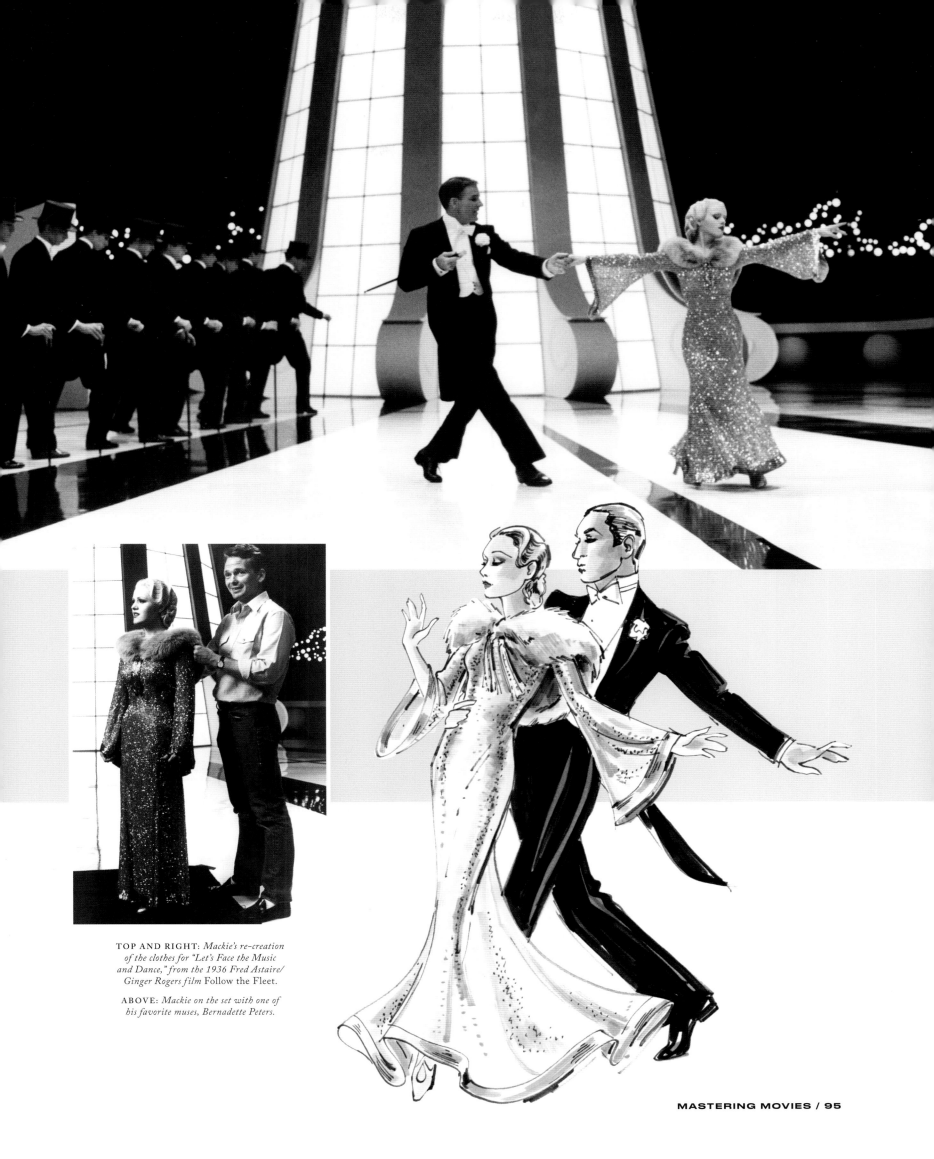

TOP AND RIGHT: *Mackie's re-creation of the clothes for "Let's Face the Music and Dance," from the 1936 Fred Astaire/ Ginger Rogers film* Follow the Fleet.

ABOVE: *Mackie on the set with one of his favorite muses, Bernadette Peters.*

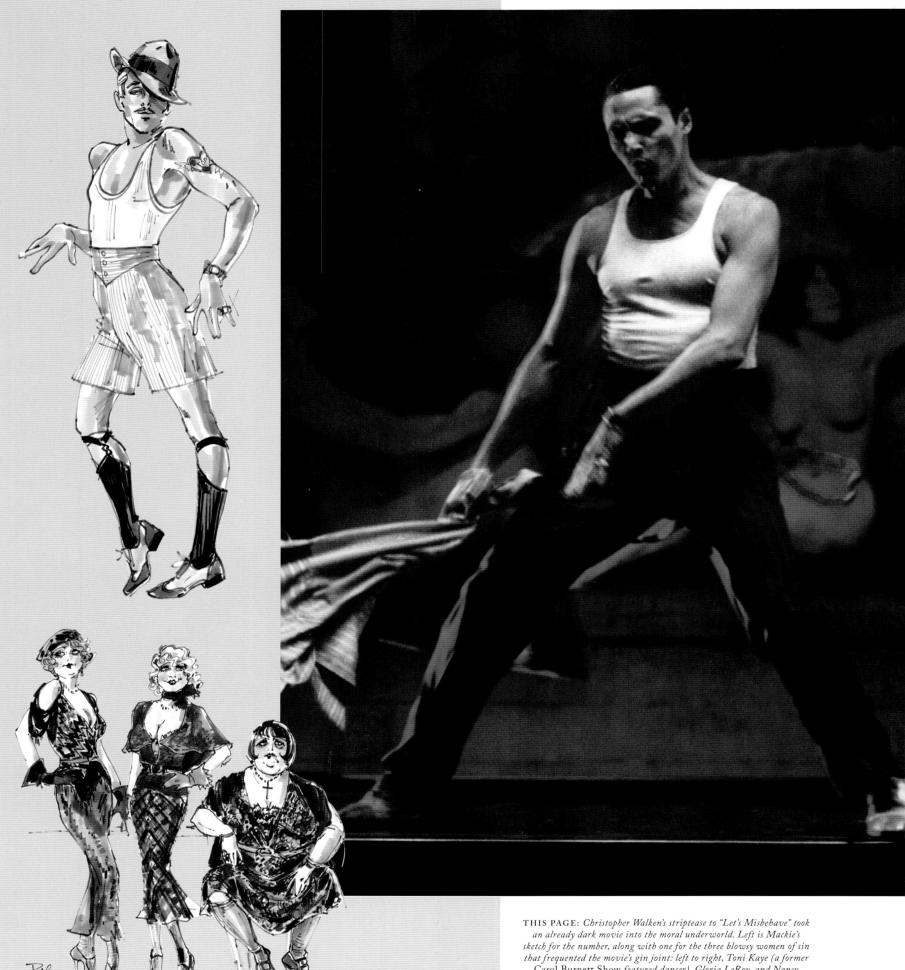

Bob Mackie

THIS PAGE: *Christopher Walken's striptease to "Let's Misbehave" took an already dark movie into the moral underworld. Left is Mackie's sketch for the number, along with one for the three blowsy women of sin that frequented the movie's gin joint: left to right, Toni Kaye (a former* Carol Burnett Show *featured dancer), Gloria LeRoy, and Nancy Parsons (best known as Coach Balbricker in the 1981 movie* Porky's).

OPPOSITE: *Upper left, a look for Bernadette Peters; right, a look for one of the chorus girls.*

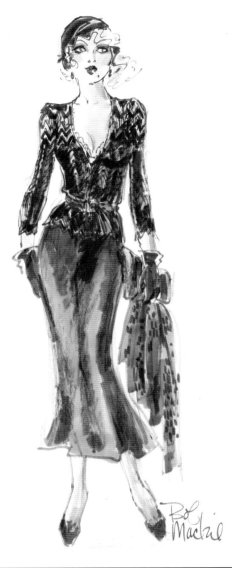

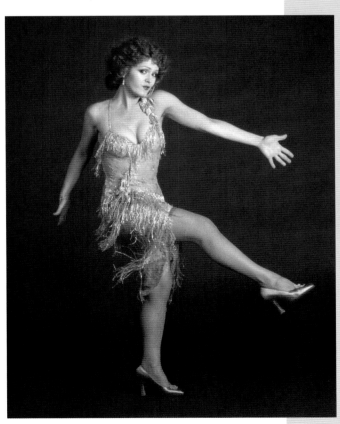

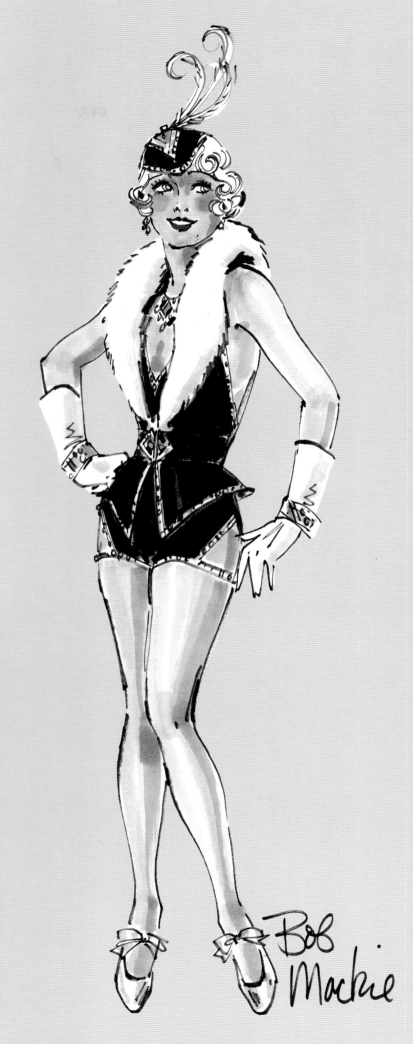

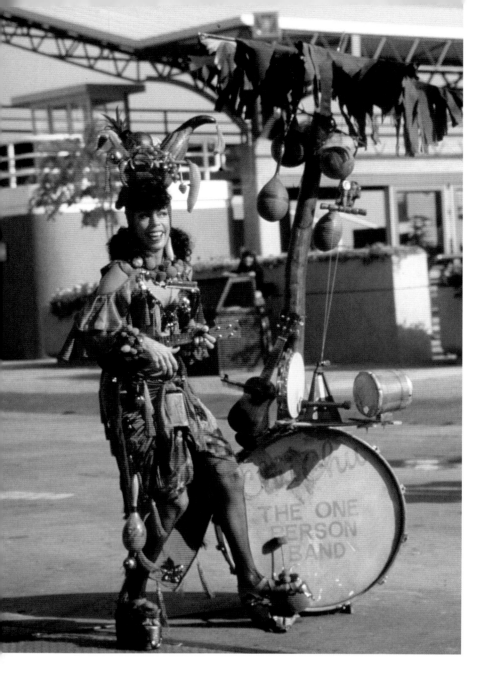

# *Flash* in the Pan

**A LEGENDARY MISFIRE, THE 1981 ALAN ARKIN/CAROL BUR-**nett vehicle *Chu Chu and the Philly Flash* was a major disappointment for Burnett fans, after she'd notched such terrific film performances in *Pete 'n' Tillie*, Robert Altman's *A Wedding*, and *The Four Seasons*, opposite her buddy Alan Alda.

Director David Lowell Rich—best known for high-flying disaster movies such as *The Horror at 37,000 Feet* and *SST: Death Flight*—failed to bring this one in for a landing. Written by Arkin's then-wife, Barbara Dana, *Chu Chu* tells the tale of a homeless, alcoholic former baseball star (Arkin) who gets into a turf war with a Carmen Miranda–style street performer (Burnett) on the San Francisco waterfront. When the pair find a briefcase full of secret government documents, they go on the lam for an exhausting ninety-two minutes.

The movie became a punch line for Burnett's comic foil, Burt Reynolds (who had made his own share of flops) for years. In her review in *The New York Times*, critic Janet Maslin reported, "Miss Burnett's wardrobe, by Bob Mackie, is the funniest thing in the movie."

LEFT: *Mackie happily drew upon his childhood fascination with the over-the-top movie musicals of 20th Century Fox in designing costumes for the one-woman Carmen Miranda knockoff played by his great pal Carol Burnett.*

BELOW: *The film may have been a misfire, but the costumes were a witty, flamboyant delight.*

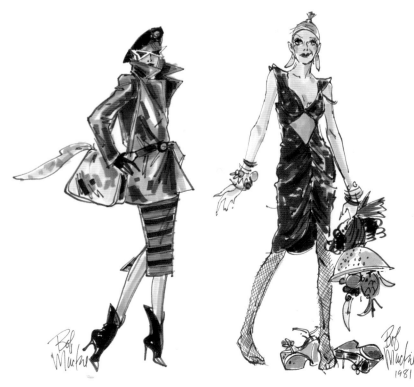
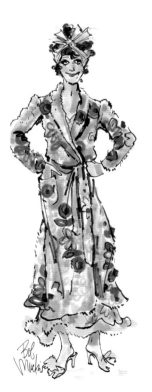
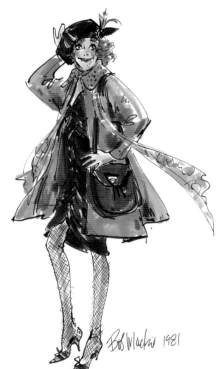

# *Alive* and Kicking

BY 1982, AFTER PULLING OFF THE HERCULEAN TASK OF designing the vast wardrobe for *Pennies from Heaven*, Bob Mackie looked around and realized that television variety—his bread and butter for twenty years—had all but evaporated. Two of his most loyal muses had veered into films (Carol Burnett shining in *The Four Seasons* and *Annie,* and Cher proving herself an accomplished dramatic actress in *Come Back to the Five & Dime, Jimmy Dean, Jimmy Dean*). Even variety specials had gone the way of the dodo. Americans were tuning their dials to prime-time soaps and ensemble dramas such as *Hill Street Blues*, leaving Bob to wonder exactly what his next act would be.

Enter Sylvester Stallone and John Travolta. Paramount Pictures had been desperately trying to convince Travolta to do a sequel to the 1977 smash *Saturday Night Fever*, but he'd turned down the project numerous times. It wasn't until the studio brought Stallone on board as director and screenwriter that Travolta signed on—resulting in a dance film with a plot so preposterous it wouldn't meet its match for nearly twenty years, when Elizabeth Berkley would ascend from pole dancer to Vegas star in *Showgirls*.

Mackie was called upon to design costumes for the big finale of the dance-musical-within-the-movie, *Satan's Alley*—during which Travolta would literally fling his leading lady into the wings on opening night and perform an extended dance solo, in the process showing off his well-oiled, newly chiseled physique (courtesy of training by his new mentor, "Sly").

Well, it was a gig . . . and it was going to call for Spandex, lots of it. Mackie had worked with the stretchy stuff before, of course, creating rock-chick looks for Cher and biker outfits for Ann-Margret and Cheryl Ladd, not to mention naughtily distressed, form-fitting ensembles for Tina Turner and Raquel Welch.

The costumes he came up with for the film were appropriately sexy and theatrical and, in retrospect, probably the only aspect of the production that made sense. There's an old adage we just made up that says Broadway is hard; movies about Broadway are just about impossible.

We hesitated to ask Bob to think back on it, but when we did, he pulled no punches: "*Agh* . . . it was just an awful movie. All I did were the performance clothes for this ridiculous production number—all leg warmers and headbands with a little S and M thrown in. I guess it looked fine. Actually, it was all pretty horrible."

---

TOP RIGHT: *Channeling Raquel Welch in* One Million Years B.C.*, John Travolta leaps over bad reviews and dodges an arsenal of pyrotechnics as Tony Manero, a man with a dream. And raggedy leg-warmers.*

RIGHT: *A slicked up Travolta with costar Finola Hughes in the finale of* Satan's Alley, *the musical-within-a-turkey in* Stayin' Alive.

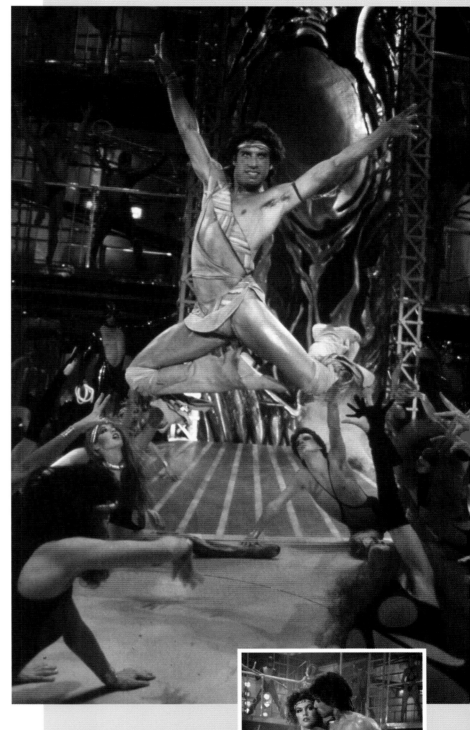

"*I guess it looked fine. Actually, it was all pretty horrible.*"

# Dress for *Success*

**THROUGHOUT THE 1940S, '50S, AND '60S, IT WASN'T** uncommon to spot a credit for the design of clothes for just one particular performer in a film. Both of Mackie's earliest mentor/employers, Edith Head and Jean Louis, were famous for it. The next time you watch *Myra Breckenridge* (God help you), note "Miss Mae West's costumes by Edith Head" in the crawl. And at the conclusion of *Imitation of Life*, watch for "Gowns for Lana Turner by Jean Louis." Credit where it's due—and a marvelous bit of self-promotion, at which both Miss Head and M. Berthault excelled.

And while Bob Mackie was responsible for every costume in *Pennies from Heaven*, even he has been known to contribute specialty gowns for the leading ladies of the silver screen. Of course, the films weren't always winners. "Miss Osmond's performance gowns" for the Donny and Marie flop *Goin' Coconuts* come to mind, as does Pia Zadora's wardrobe for the 1982 film *Butterfly*, which somehow won the actress both a Golden Globe for new star of the year and *two* Razzie Awards, for worst actor and worst new star. How's that for a mixed review? But whether the material was good or bad, Mackie made sure his stars transcended it. In the case of Sharon Stone in *Casino*—designed by Rita Ryack and John Dunn with gowns rented from Mackie—his pieces helped land her on magazine covers all over the world.

FAR LEFT, TOP: *Ann-Margret wore five different bodacious Mackies in the 1979 western spoof* The Villain—*identical but for their various shades of gingham.*

FAR LEFT, BOTTOM: *Sally Field reprised her turn as a runaway bride in* Smokey and the Bandit II, *but with a much elevated wardrobe thanks to Bob Mackie.*

LEFT: *Although the 1989 movie adaptation of the comic strip Brenda Starr would not net box office gold, Brooke Shields's costumes hit the jackpot.*

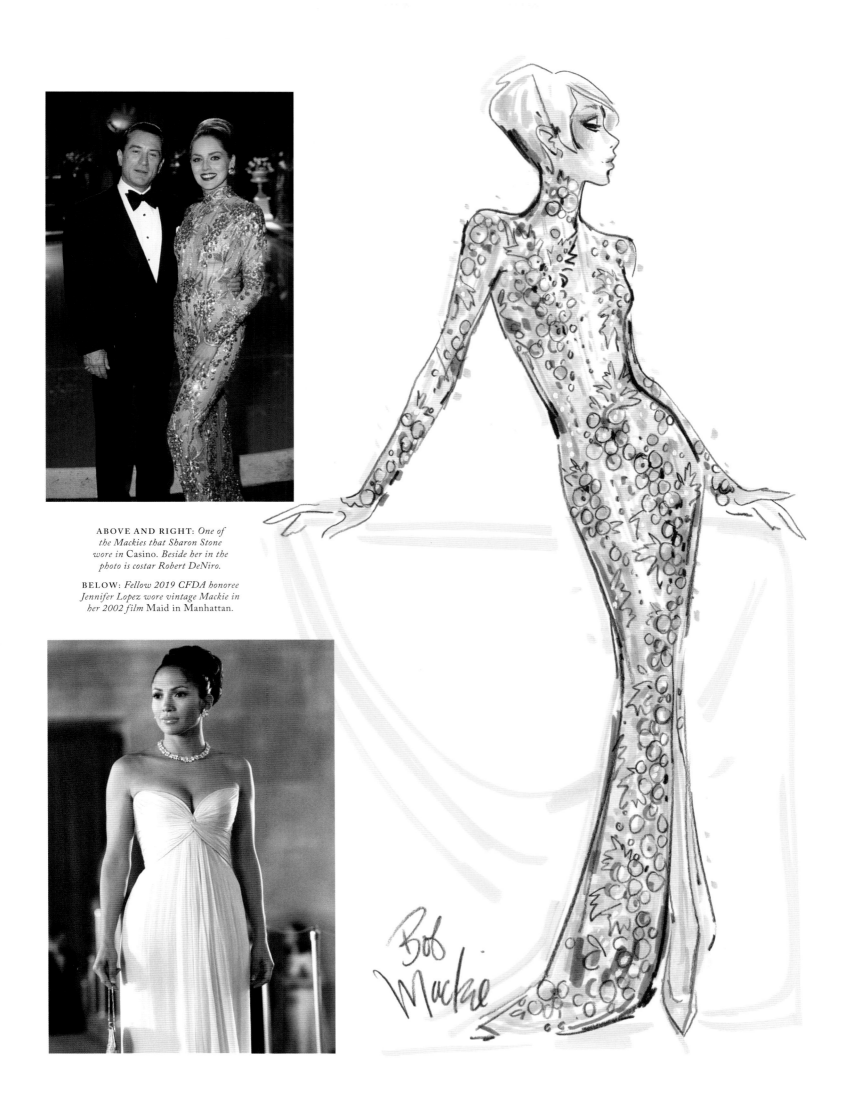

**ABOVE AND RIGHT:** *One of the Mackies that Sharon Stone wore in* Casino. *Beside her in the photo is costar Robert DeNiro.*

**BELOW:** *Fellow 2019 CFDA honoree Jennifer Lopez wore vintage Mackie in her 2002 film* Maid in Manhattan.

# Over Here, *Miss Cher!*

**IT'S CALLED "STEP AND REPEAT" OR, IF YOU'RE A NOMINEE,** "The Walk of Dreams"—but it is most commonly referred to as the Red Carpet (though it isn't always red and often not an actual carpet). Whatever you call it, when you are standing on it smiling like an idiot, hands on your hips to push your décolletage upward and forward, trying to look natural while throngs of "paps" scream

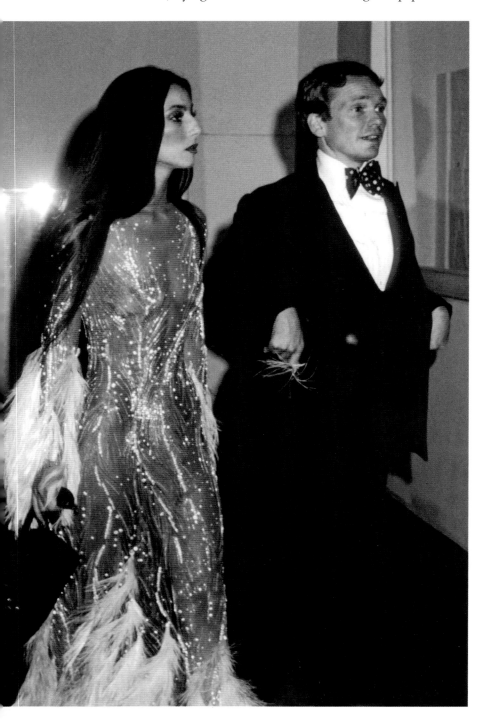

out your name, you want to look fabulous. If you're smart, you'll give Bob Mackie a jingle—which is what celebrities have been doing for over fifty years, hoping to end up in the pages of *People*, *Us*, or (fingers crossed) *Vanity Fair*.

Indisputably, it was the Mackie magic that landed Cher a coveted cover twice. In 1974, the designer and his muse sauntered into the Met Gala arm in arm, Bob in a proper tuxedo and a polka-dot tie and Cher in beads, feathers, and nude illusion. There was no fear of a "nip slip"; how could there be, when everything was in plain sight? Traffic stopped, several Upper East matrons suffered the vapors, and Diana Vreeland—then the consultant for the gala—went orgasmic over the ensuing publicity. (No doubt she regretted having told Cher she had a "pointy head" six years earlier.) Forget the fashion and gossip rags—the showstopper made the cover of *Time* in a photo by the legendary Richard Avedon.

Mackie remembered, "It created a lot of hubbub. In those days, *Time* reserved its covers for world leaders or someone who invented something important, like a vaccine. The newsstands sold out of it immediately, and some cities even banned it—funny, considering how some stars can barely keep their clothes on today."

Smash cut to 1986. After Cher was egregiously snubbed for her tremendous performance in the movie *Mask*, she was asked to present the award for best supporting actor. She approached Mackie and said, "I want to wear something really outrageous—like what I used to wear on the show." "Are you sure?" Mackie replied. "Aren't you afraid you'll pull focus from whoever wins the award?" No response but a smile.

Mackie went to work on one of his most iconic looks, and Cher and Don Ameche (who'd won for *Cocoon*) made headlines around the world. When asked about playing second fiddle to the most outrageous Oscar getup until Björk killed a swan, the seventy-seven-year-old Ameche said, "Are you kidding? I was on the front page of every newspaper the next day, and I sure wouldn't have been if it weren't for Cher!"

---

LEFT: *Cher enters the 1974 Met Gala on the arm of the creator of the now-legendary gown that landed her on the cover of* Time.

OPPOSITE: *Cher and Don Ameche enjoy their red-carpet moment as the press goes wild for one of the most memorable gowns in Oscar history.*

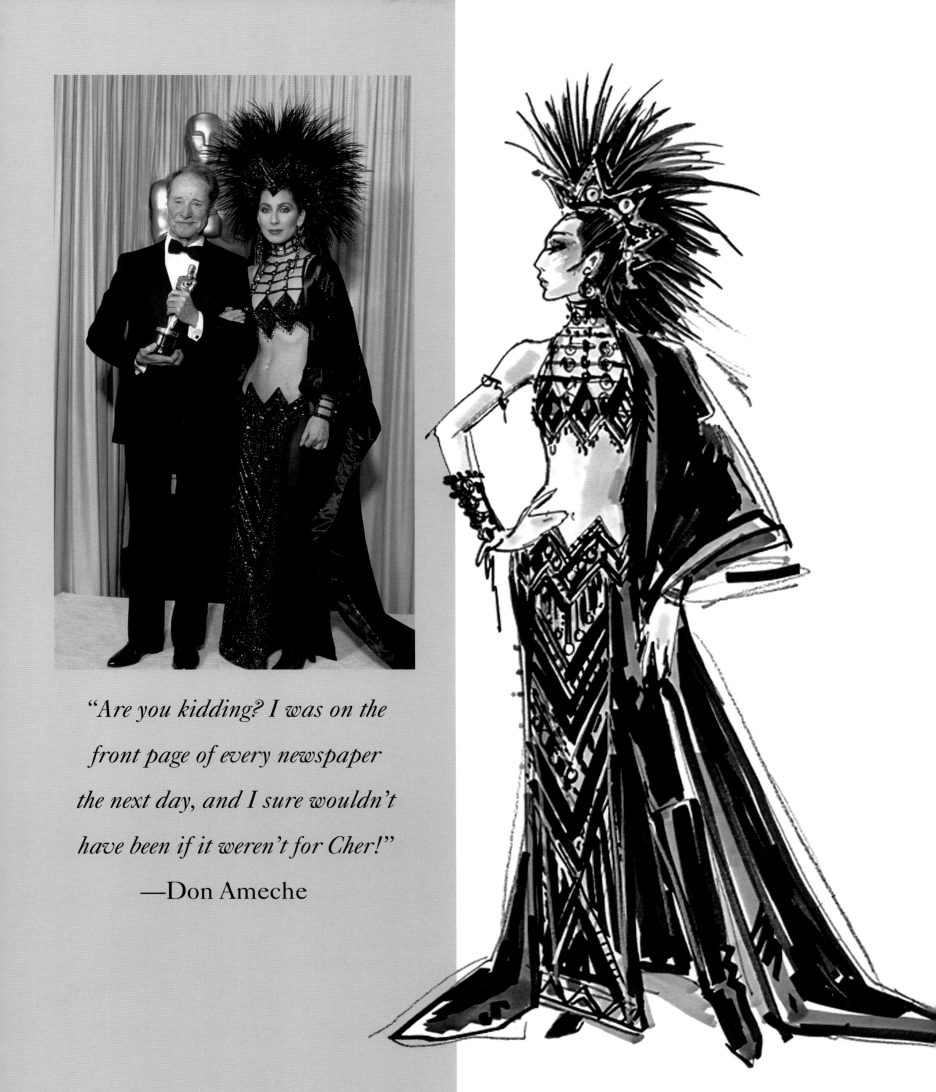

"*Are you kidding? I was on the front page of every newspaper the next day, and I sure wouldn't have been if it weren't for Cher!*"
—Don Ameche

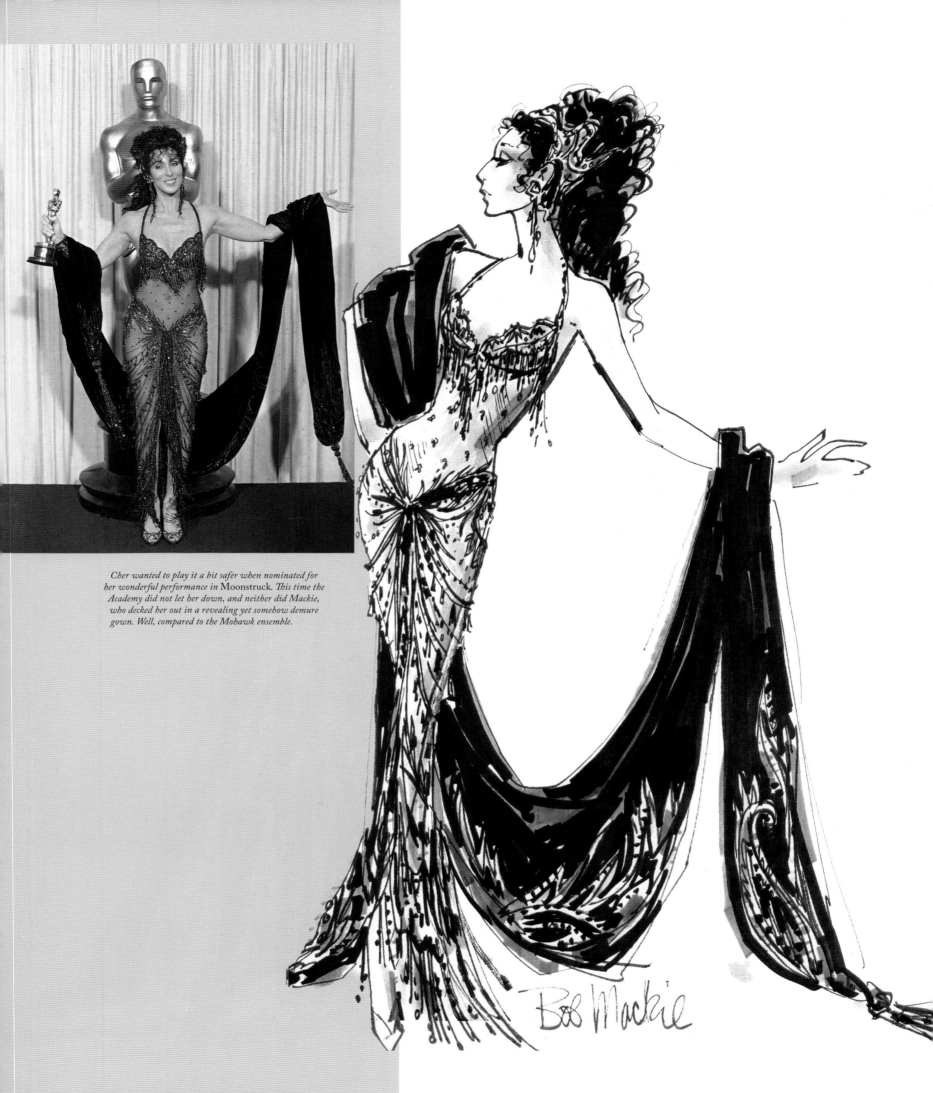

*Cher wanted to play it a bit safer when nominated for her wonderful performance in* Moonstruck. *This time the Academy did not let her down, and neither did Mackie, who decked her out in a revealing yet somehow demure gown. Well, compared to the Mohawk ensemble.*

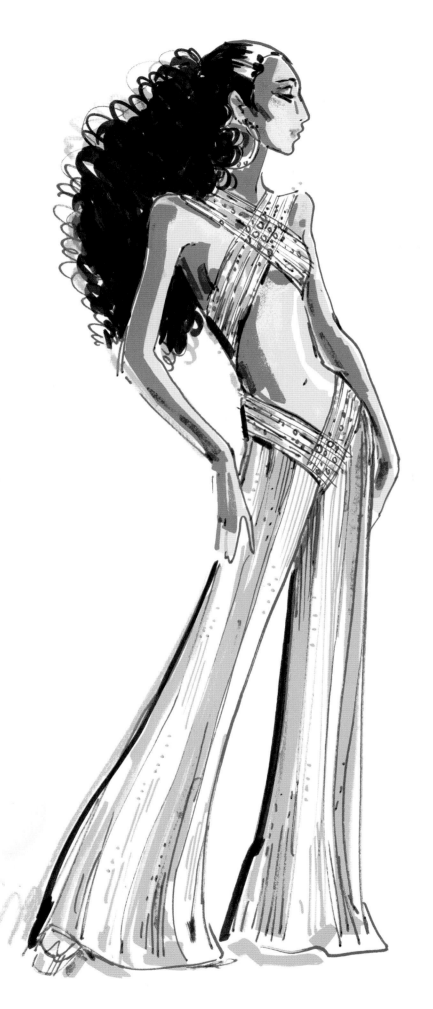

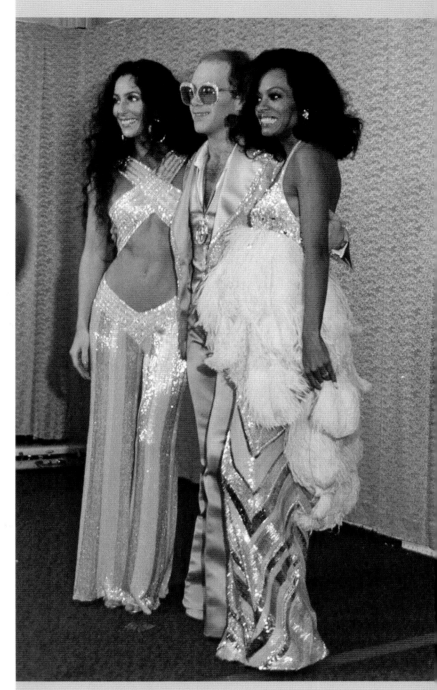

A knockout silver halter for Cher came to life at the 1975 Grammy Awards, where she hung out with two other pop legends, Elton John and Diana Ross, also dressed in Mackie. Miss Ross was visibly pregnant at the time, thus the ostrich feather–trimmed gown and the hint of "ab envy" for her fellow superstar.

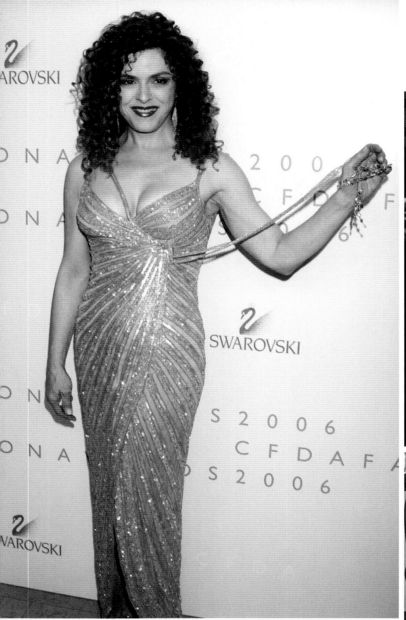

# Walking the *Walk*

**SOME STARS AREN'T LOOKING TO START A FASHION** revolution. They just want to look and feel elegant, glamorous, and "put together" from head to toe, and they, too, know they can count on Mackie. The designer has created red-carpet looks for A-listers from A to Z, for movie premieres, awards shows, and any event that calls for a grand entrance.

CLOCKWISE FROM ABOVE: *Bernadette Peters at the 2006 CFDA Awards; Diana Ross in a Mackie tuxedo, as a nominee at the 1973 Academy Awards for her role in* Lady Sings the Blues; *MGM legend Ann Miller in a dazzling Mackie jacket, arriving at the 2001 premiere of her final film,* Mulholland Drive; *everyone's favorite Jeannie, Barbara Eden, on the red carpet; Goldie Hawn with partner Kurt Russell at the 1989 Oscars.*

OPPOSITE, CLOCKWISE FROM LEFT: *Mackie and Diahann Carroll at the 2002 Academy of Television Arts and Sciences Hall of Fame ceremony, where Carroll paid tribute to her newly inducted friend; Jada Pinkett Smith in vintage Mackie at the 2007 Screen Actors Guild Awards; Broadway legend Carol Channing, a Mackie fan for five decades; dueling prime-time soap divas Linda Gray and Joan Collins, escorted by the designer of the hour. (Collins wears the gown Mackie designed for her 1989 TV Guide cover).*

*Mackie accompanying Ross on the red carpet.*

*They just want to look and feel elegant, glamorous, and "put together" from head to toe, and they know they can count on Mackie.*

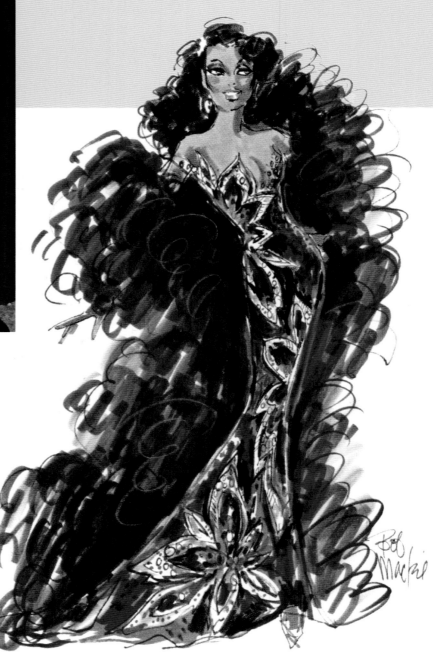

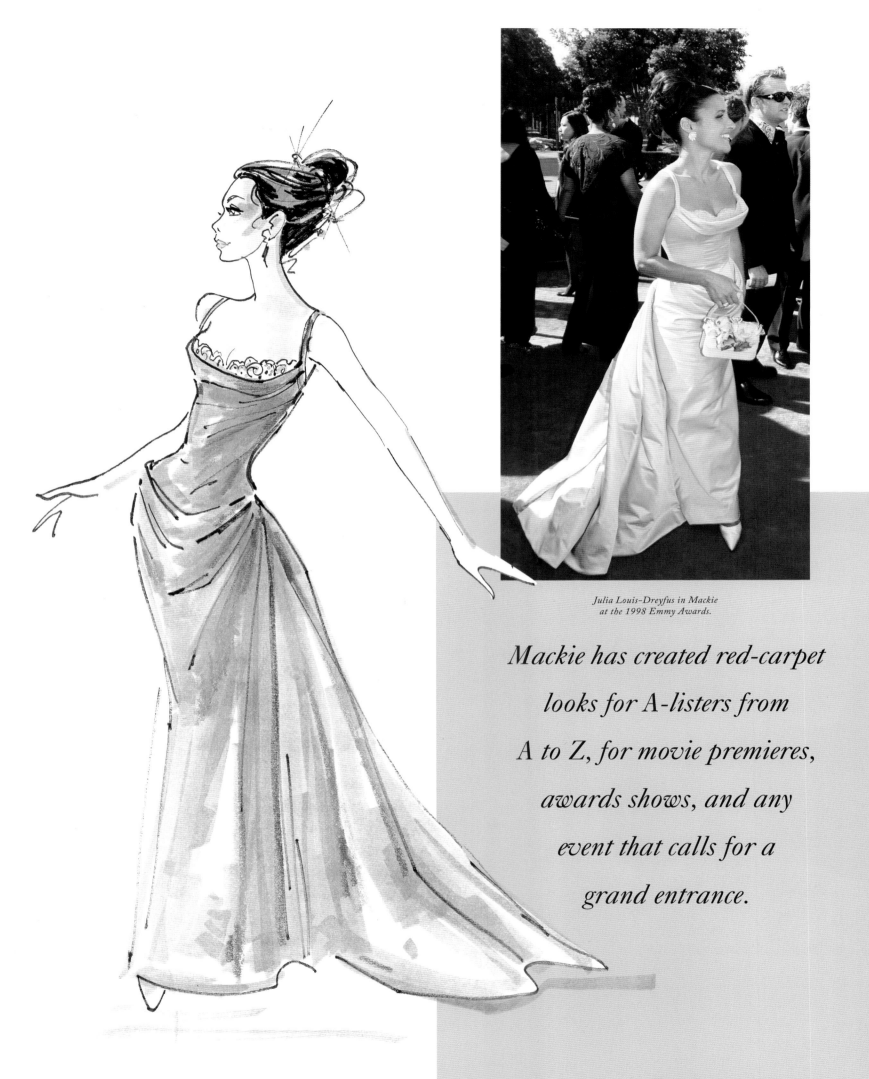

*Julia Louis–Dreyfus in Mackie
at the 1998 Emmy Awards.*

*Mackie has created red-carpet
looks for A-listers from
A to Z, for movie premieres,
awards shows, and any
event that calls for a
grand entrance.*

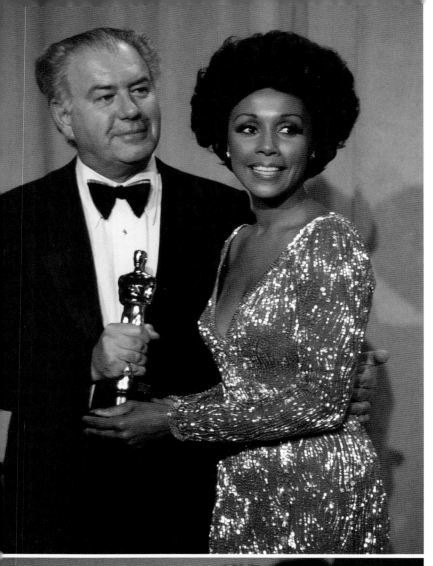

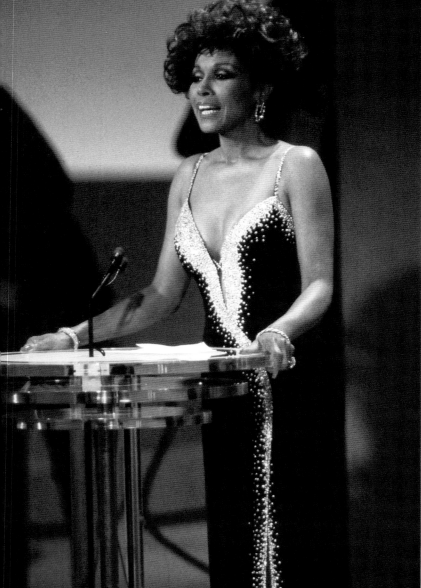

# And the *Winner* Is...

**IN 1973, MACKIE CREATED A GOWN FOR ANGELA LANS-**bury's opening production number ("Make a Little Magic," by Billy Barnes) that surpassed any gown the star had worn in *Mame* on Broadway. In 1976, he created a gorgeous "nude" dress for Angie Dickinson, who presented the best-song statuette to Keith Carradine for "I'm Easy" from the movie *Nashville*. The same year, he designed Bernadette Peters's gown for her memorable performance of "How Lucky Can You Get?" from *Funny Lady*. (Mackie and Ray Aghayan were also nominated for their costumes for the sequel to *Funny Girl*, but sadly, both their designs and the song lost.) In 1981, Mackie dressed Debbie Allen and Gregory Hines in "Cotton Club meets outer space" silver for a medley of the songs of Harry Warren.

In 1991, Madonna came calling, asking Mackie to dress her for her performance of Stephen Sondheim's nominated song from *Dick Tracy*, "Sooner or Later." Her intention was to stop traffic just as Cher had five years earlier, and what better for the purpose than wall-to-wall sequins in dazzling white? Recently split from *Tracy* costar and director Warren Beatty, Madonna was escorted to the ceremony by none other than Michael Jackson. Mission accomplished: Headlines were made again.

The next time Mackie stopped the Oscars was in 1999, when his partner, Ray Aghayan, asked him to design host Whoopi Goldberg's opening look. During a year when *Shakespeare in Love* and *Elizabeth* were best picture nominees, he crafted a devilishly detailed Elizabeth I look that stopped the show. As Mackie explained, "It had to go over her gown, and she was wearing whiteface, the wig, the whole works. It was constructed as a huge cage, so she could just step into it and zip up, because the change out of it was very, very fast. Bruce Vilanch came up with the idea, and Whoopi was terrific to work with."

It's no exaggeration to say that Bob Mackie, often in tandem with Ray Aghayan, changed the trajectory of fashion in film and on the red carpet. What worlds could possibly be left to conquer? Hmm . . . how about that sparkly man-made mecca just four hours northeast of Hollywood? You know the place . . . where fortunes are won and lost with the spin of a wheel, all secrets are safe, and nobody would be caught dead without bling and lots of it. Paging Dr. Bling.

LEFT, TOP AND BOTTOM: *Diahann Carroll and winner Nelson Riddle (for his adapted score for* The Great Gatsby*) at the 1975 Academy Awards; Carroll presenting in Mackie at the 1985 Emmy Awards.*

OPPOSITE, LEFT AND TOP RIGHT: *Mackie's Marlene Dietrich-inspired Angie Dickinson gown, which she wore as a presenter at the 1976 Academy Awards, and Dickinson with husband Burt Bacharach backstage.*

OPPOSITE, BOTTOM RIGHT: *Gregory Hines and Debbie Allen in a salute to movie composer Harry Warren at the 1982 Academy Awards.*

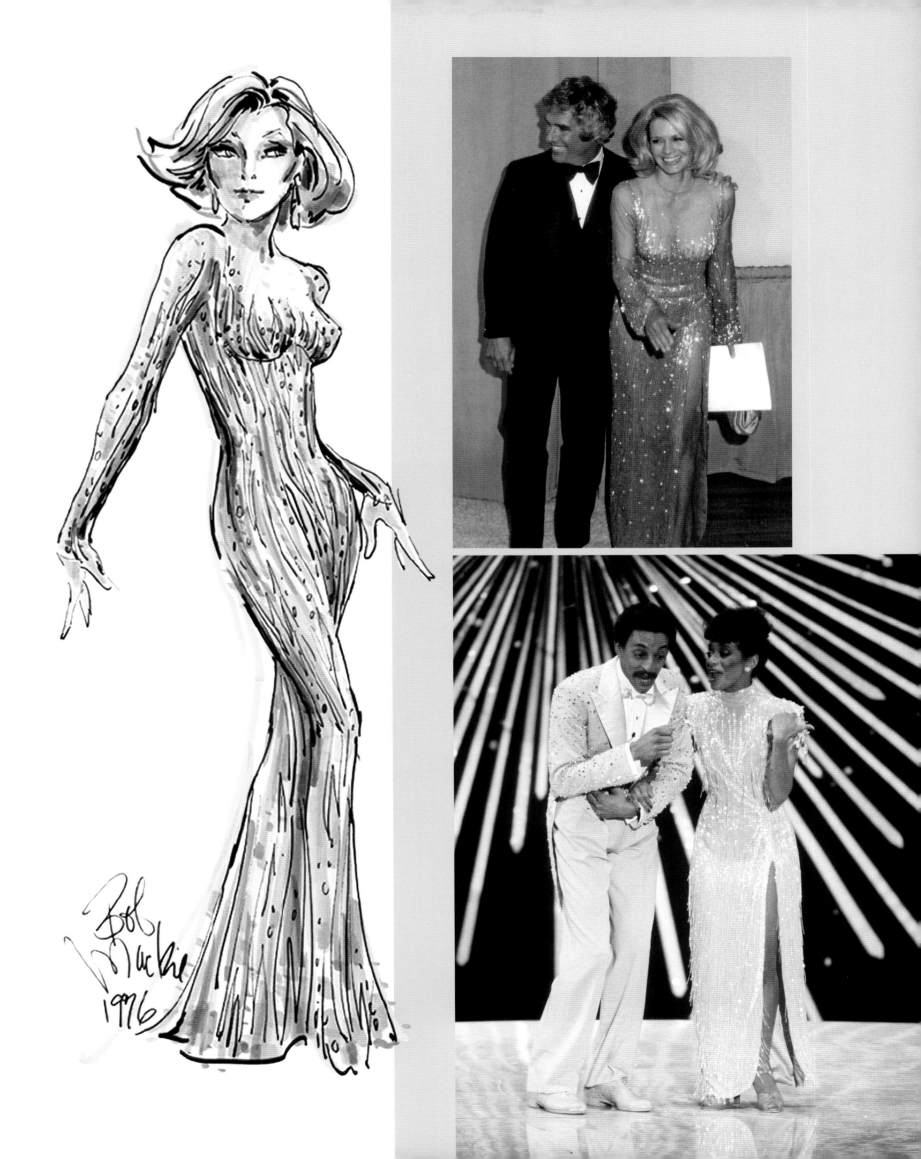

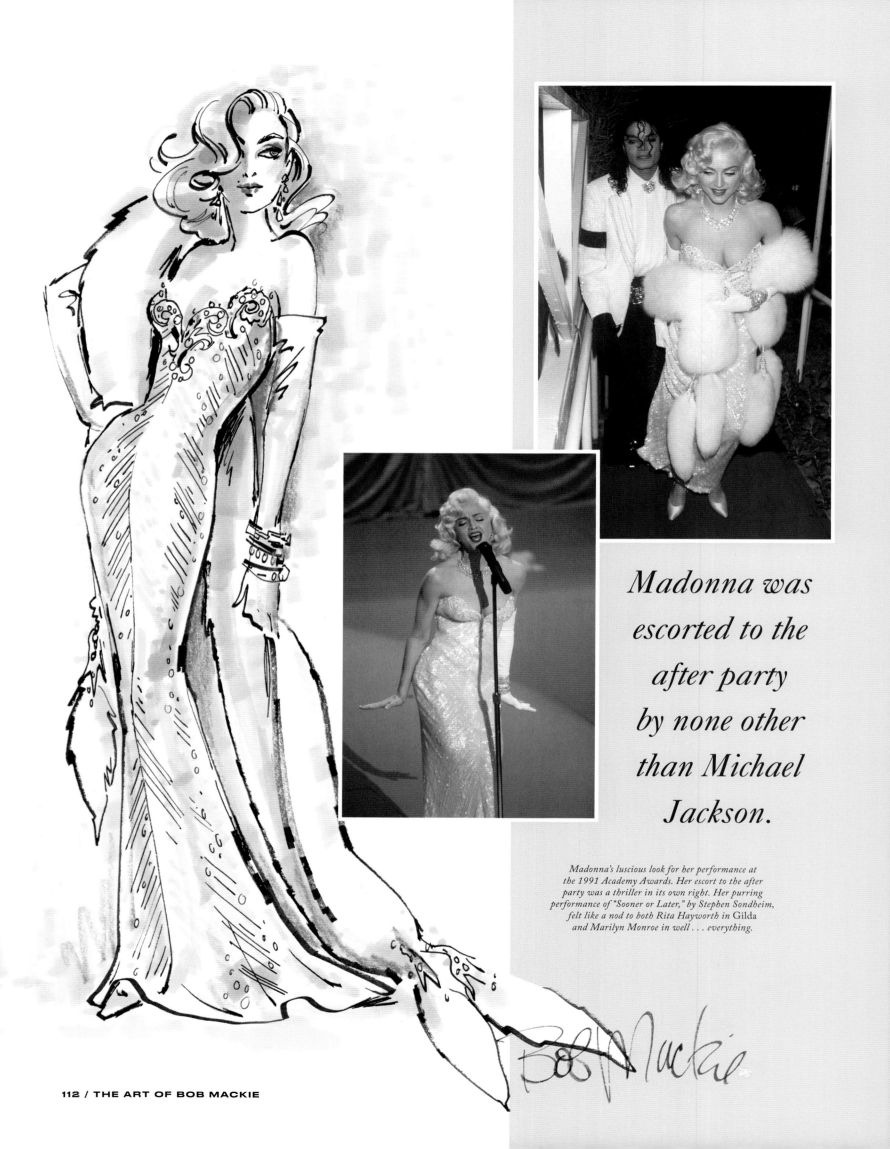

*Madonna was escorted to the after party by none other than Michael Jackson.*

Madonna's luscious look for her performance at the 1991 Academy Awards. Her escort to the after party was a thriller in its own right. Her purring performance of "Sooner or Later," by Stephen Sondheim, felt like a nod to both Rita Hayworth in Gilda and Marilyn Monroe in well . . . everything.

Bob Mackie

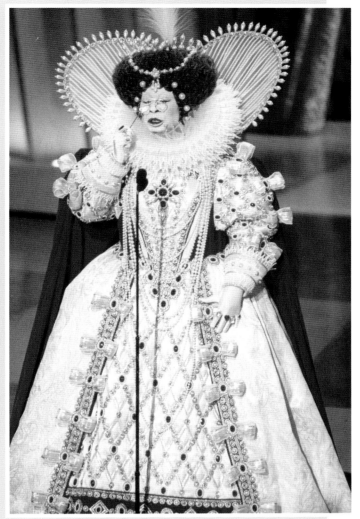

*"It had to go over her gown, and she was wearing whiteface, the wig, the whole works. It was constructed as a huge cage, so she could just step into it and zip up, because the change out of it was very, very fast."*

*Mackie's sketch for Whoopi Goldberg as Queen Elizabeth I, and the result at the 1999 Academy Awards.*

# VIVA LAS VEGAS!

**SIN CITY. LOST WAGES, NEVADA. THE CITY OF SECOND**
Chances. In the past few decades, the glittering playground of high rollers, high-class call girls, and high-octane floor shows has given way to kid-friendly chain restaurants, elaborate circus performances, theme hotels, and water parks. That's not to say there's no class left: Step right this way to enter the Bellagio Gallery of Fine Art, where you can take in some genu-wine Degas, Monet, Picasso, and Renoir between roulette and blackjack.

The Las Vegas that Bob Mackie encountered in 1967, when he went out there to design the looks for Mitzi Gaynor's record-breaking engagement at the Riviera, was a different animal. It was still very much the playground of the Rat Pack and other five-star headliners, for one thing. And it was "21 and over," period, full stop.

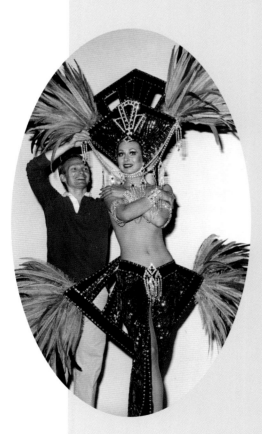

The glitz and flair Mackie brought to Mitzi's shows were so in tune with the town's vibe that he attracted the attention of performers of all kinds—not just dancers like Gaynor but singers, comics, you name it. Goldie Hawn, Joan Rivers, Vikki Carr, Totie Fields, Lola Falana, Cyd Charisse—the designer's phone must have been ringing off the hook. And it was in Vegas that Mackie whipped up some of his most delicious confections for his legendary clients Cher, Ann-Margret, Debbie Reynolds, and Juliet Prowse.

The marquee names on his roster were beyond impressive, but Mackie's most opulent productions—and the ones he is proudest of to this day—were *Hallelujah Hollywood!*, and *Jubilee!*, designed by Pete Menefee. The latter was his (and perhaps anyone's) longest-running continuous production—thirty-four years in the "big room" at Bally's. It boasted a cast of sixty showgirls and boys and a re-creation of the sinking of the *Titanic*.

While disaster reenactment was not Bob's passion, he was more than comfortable with dozens of six-feet-tall Glamazons descending an endless staircase. Nothing like *Jubilee!*, with its eye-popping profusion of feather headdresses, G-strings, and bugle beads, had been seen since *The Ziegfeld Follies*. Nor have we seen anything like it since.

As any costume designer will tell you, it's not the yardage, it's the placement of the sequins.

---

*Mackie adjusts the headdress of legendary* Jubilee! *showgirl Janet Ford Spelman. Opposite: Six feet and one inch of glorious pulchritude.*

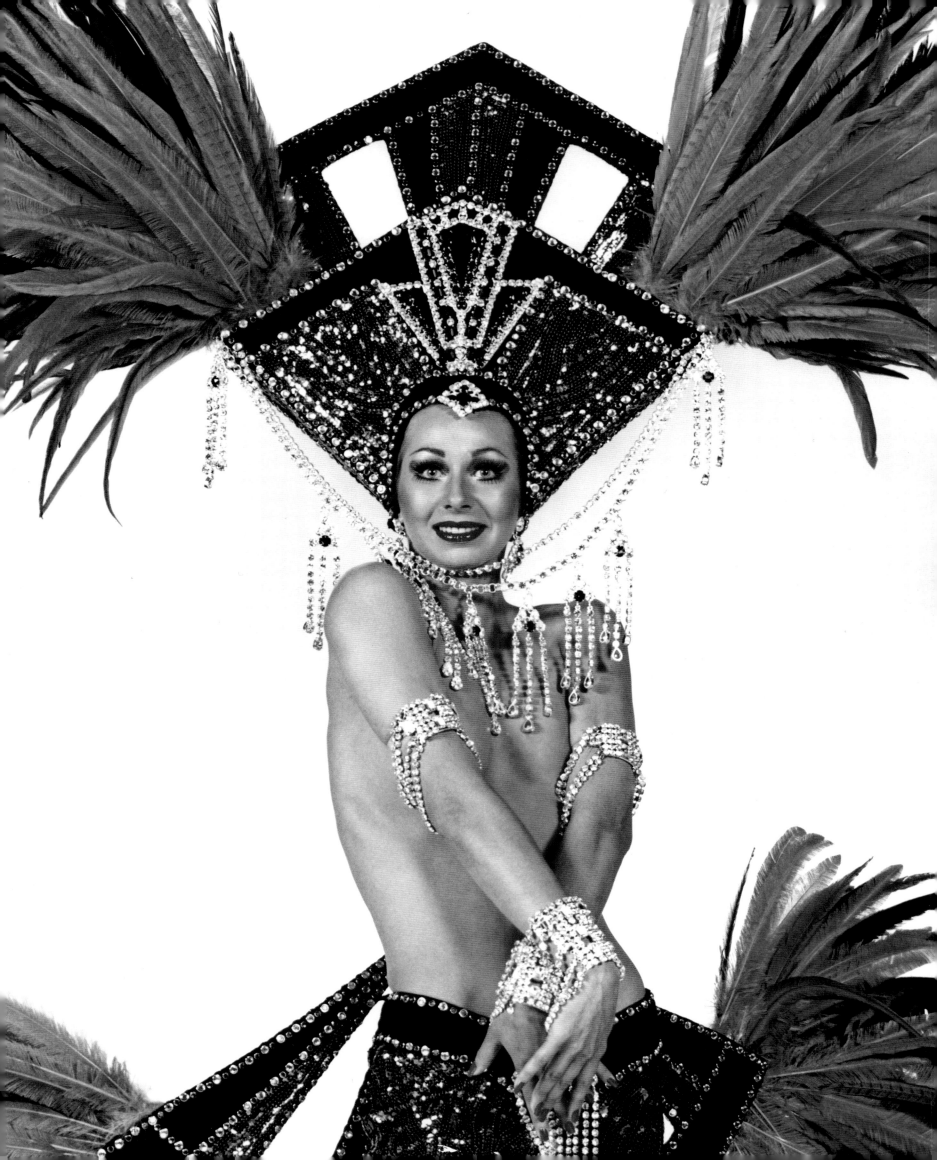

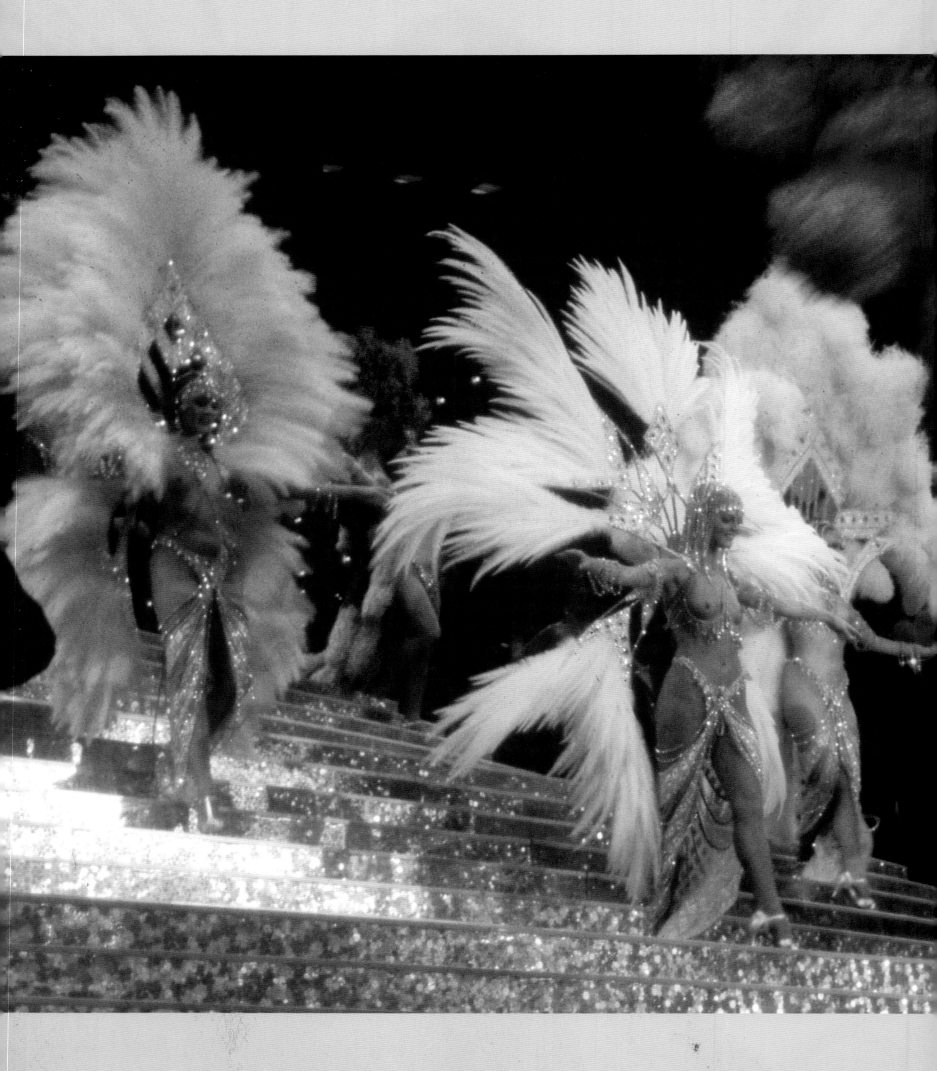

# Grander Than *Grand*

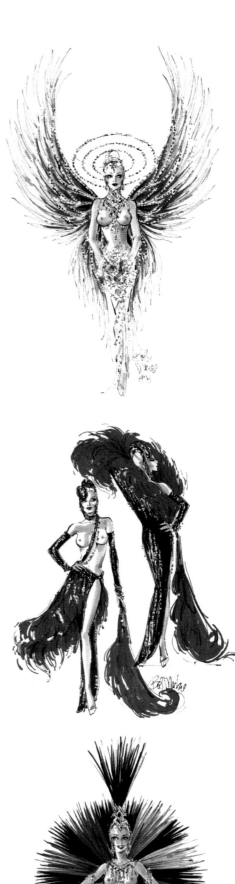

**THE MUSICAL REVUE** *HALLELUJAH HOLLYWOOD!*, **A BRAIN-**child of producer Donn Arden, opened the MGM Grand hotel in Las Vegas in 1974. Vowing to create nothing less than the most spectacular show on the Strip, Arden had hired the unrivaled Sultans of Spangle—Ray Aghayan and Bob Mackie—to design more than seven hundred costumes for a hundred singers, dancers, and the tallest, most statuesque showgirls this side of Greek mythology. Oh, and two lion-and-tiger-taming magicians named Siegfried and Roy.

The results did not disappoint. Did we mention that the show was mounted in the Ziegfeld Room—the largest stage in the world at the time—and that the finale was a tribute to Ziegfeld himself? This paean to the "glorifier of the American Girl" utilized a three-and-a-half-story Grand Stairway that would have impressed the impresario himself, upon which the impossibly statuesque ladies descended using what is known in showgirl biz as the "Ziegfeld Walk." Topless. (Kids, feel free to visit the tigers in the lobby after the show.)

It was glitzy, gaudy, and *de trop* in the best possible way.

The show was a huge hit from the start and ran continuously until taking a break for retooling in 1980. A newly conceived show called *Jubilee!* was nearly ready to go when tragedy struck. A fire broke out in one of the MGM's restaurants, engulfed the entire building within six minutes, and killed eighty-five people.

Many of the sets and costumes were destroyed or damaged by smoke, and the budget ballooned to $10 million—but the show must go on. *Jubilee!* opened in July 1981, in all its glory. This time, Aghayan wasn't involved, and Mackie designed only the costumes

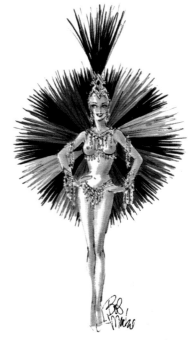

LEFT: *Showgirls descend the Grand Stairway in* Hallelujah Hollywood!, *which would be reborn as* Jubilee! *and make Bob Mackie the king of Las Vegas glamour for thirty-eight years.*

ABOVE AND RIGHT: *Proposed looks for the thirty-five-minute* Jubilee! *finale.*

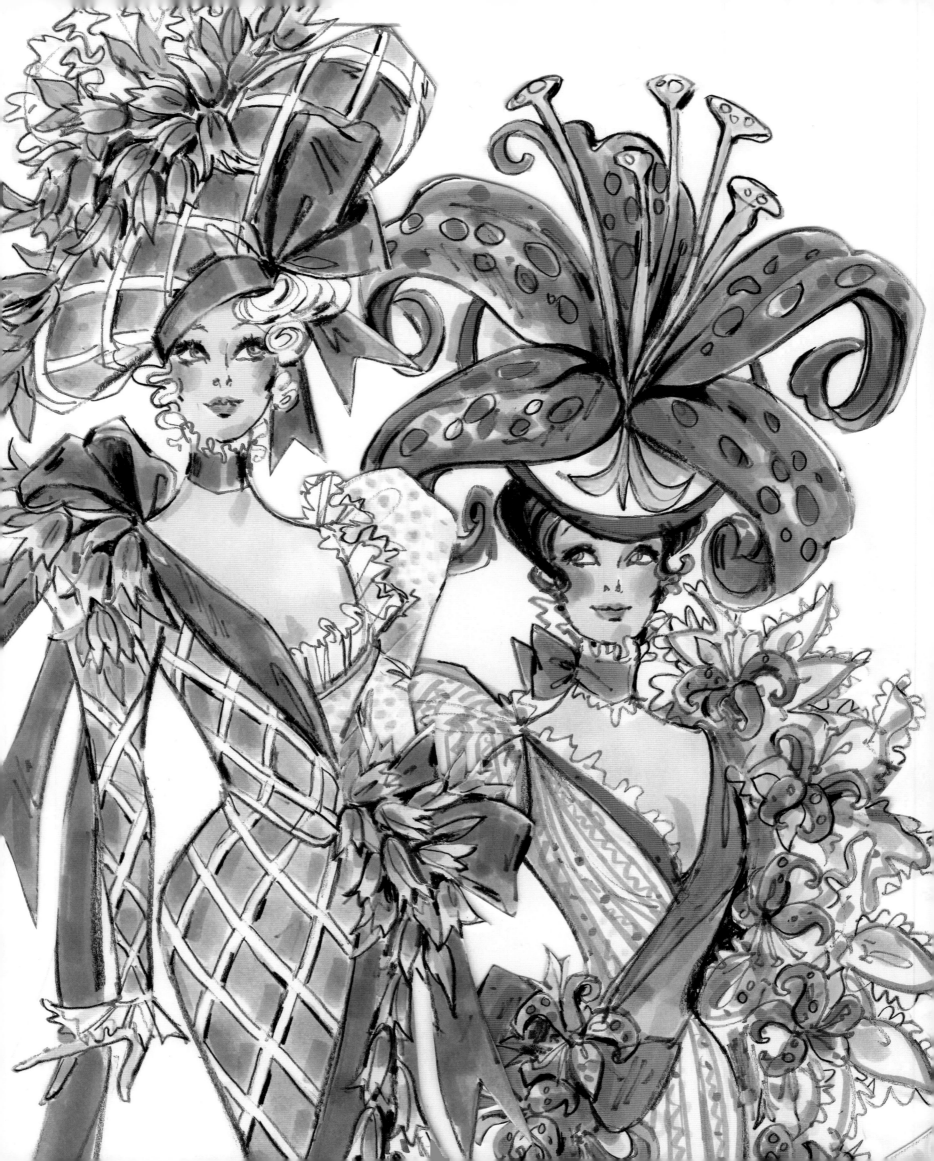

for the show's finale—though "only" is something of a misnomer. The new Ziegfeld tribute ran thirty-five minutes and required multiple costume changes for each dancer. (As the dressing rooms were inconveniently located two flights below the stage, many of the hardworking ladies had to trek some seventeen hundred stairs per show. Don't ask who was counting.)

*Jubilee!* proved as hardy a perennial as its predecessor, lasting through the sale of the MGM Grand to Bally's in 1986 and running until the hotel closed altogether in 2016. By that point, it had enjoyed the longest run of any show in Las Vegas history—an amazing thirty years.

Gliding across a 190-foot-wide stage wearing feathers, sequins, pasties, a G-string, and a thirty-five-pound headdress. What . . . and leave show business?

---

*The Floradora Girls from* Hallelujah, Hollywood!

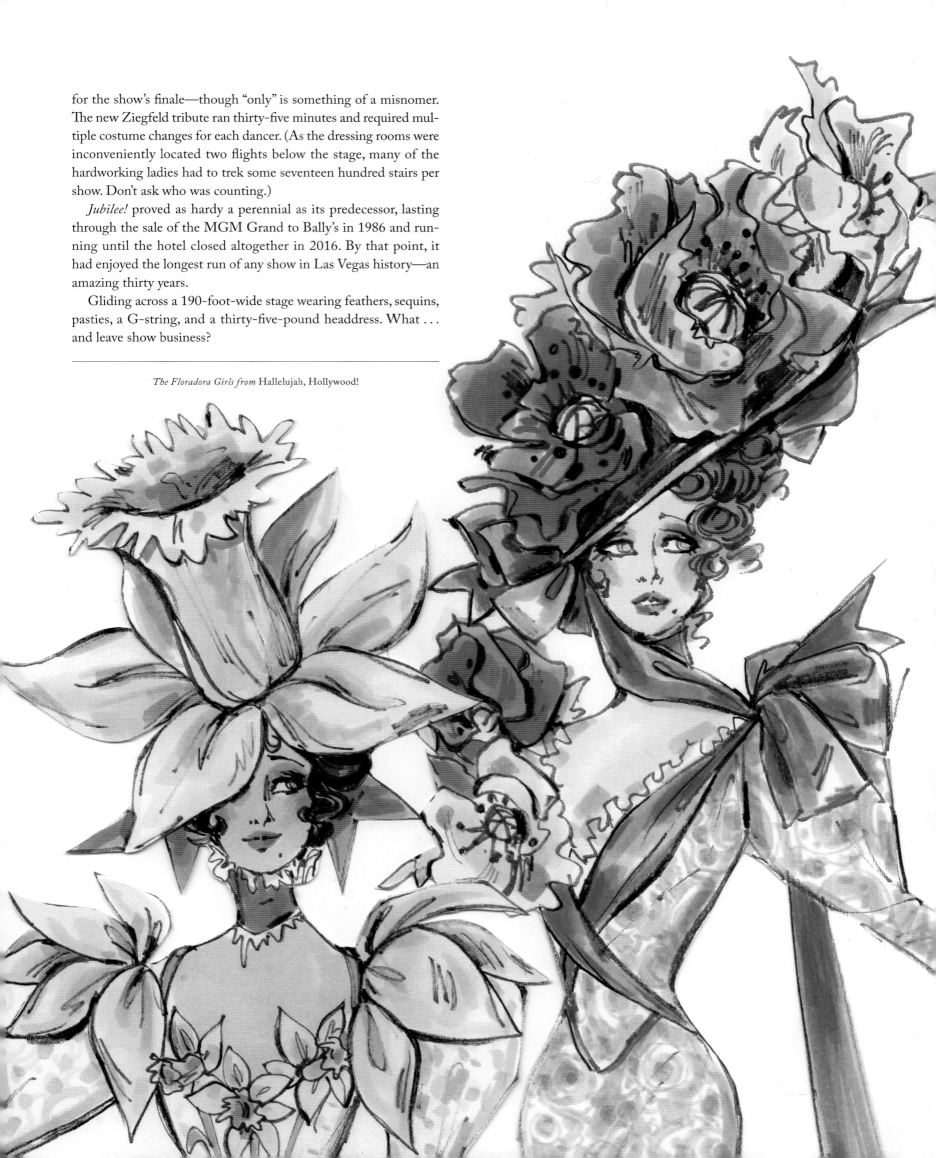

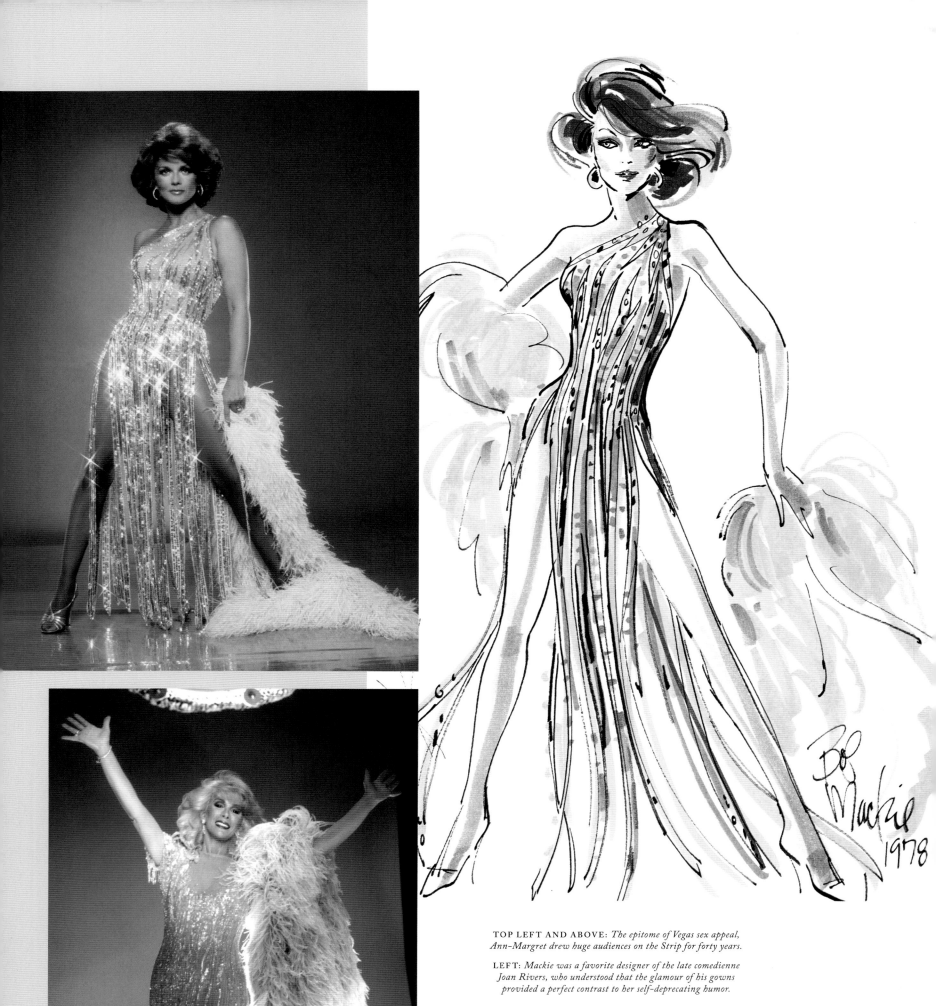

Bob Mackie
1978

TOP LEFT AND ABOVE: *The epitome of Vegas sex appeal, Ann-Margret drew huge audiences on the Strip for forty years.*

LEFT: *Mackie was a favorite designer of the late comedienne Joan Rivers, who understood that the glamour of his gowns provided a perfect contrast to her self-deprecating humor.*

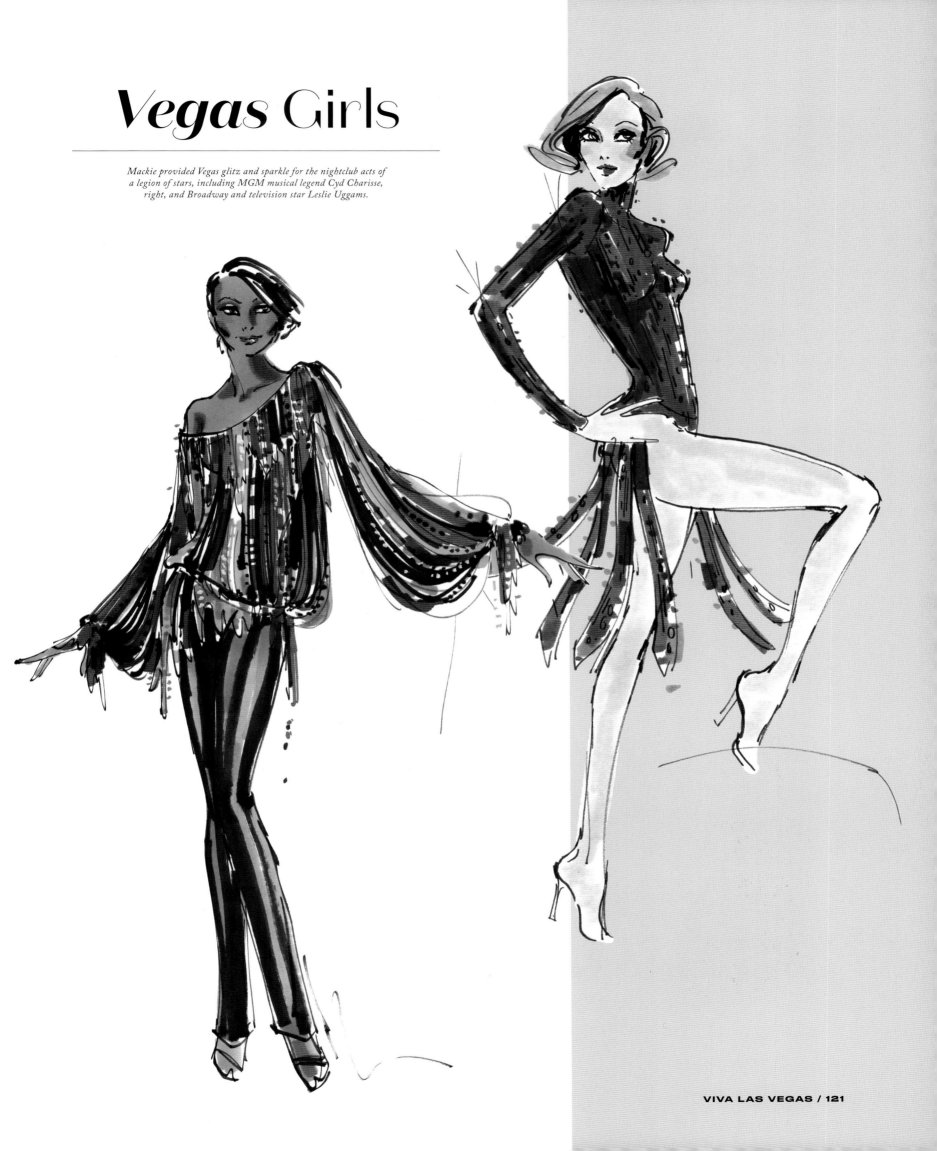

# Vegas Girls

*Mackie provided Vegas glitz and sparkle for the nightclub acts of a legion of stars, including MGM musical legend Cyd Charisse, right, and Broadway and television star Leslie Uggams.*

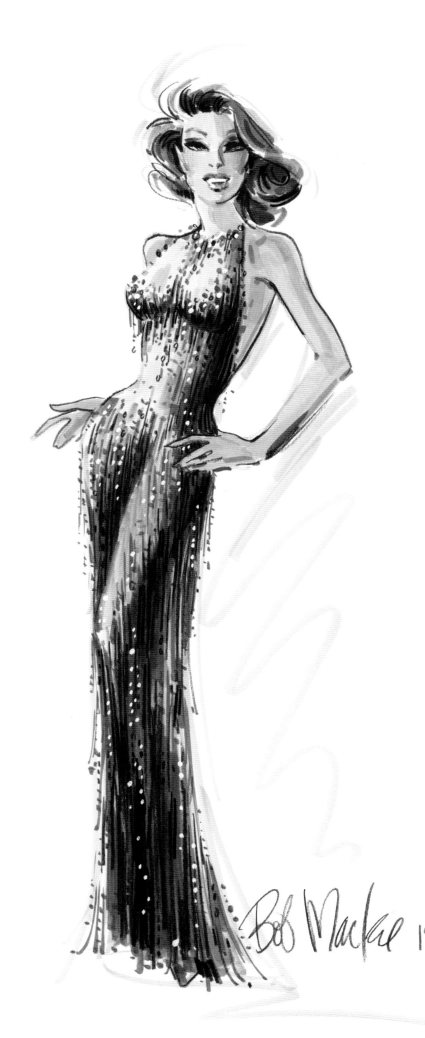

Bob Mackie 1974

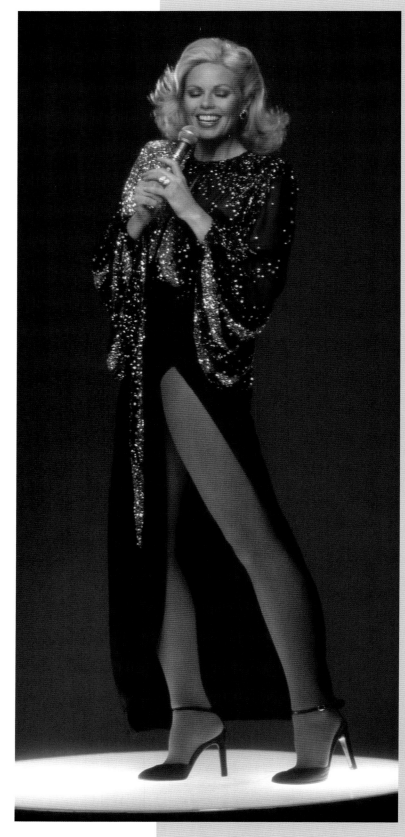

*A sketch for sex symbol Raquel Welch, and pop singer Toni Tennille in the flesh. Mackie helped the latter glam up her image for her solo career.*

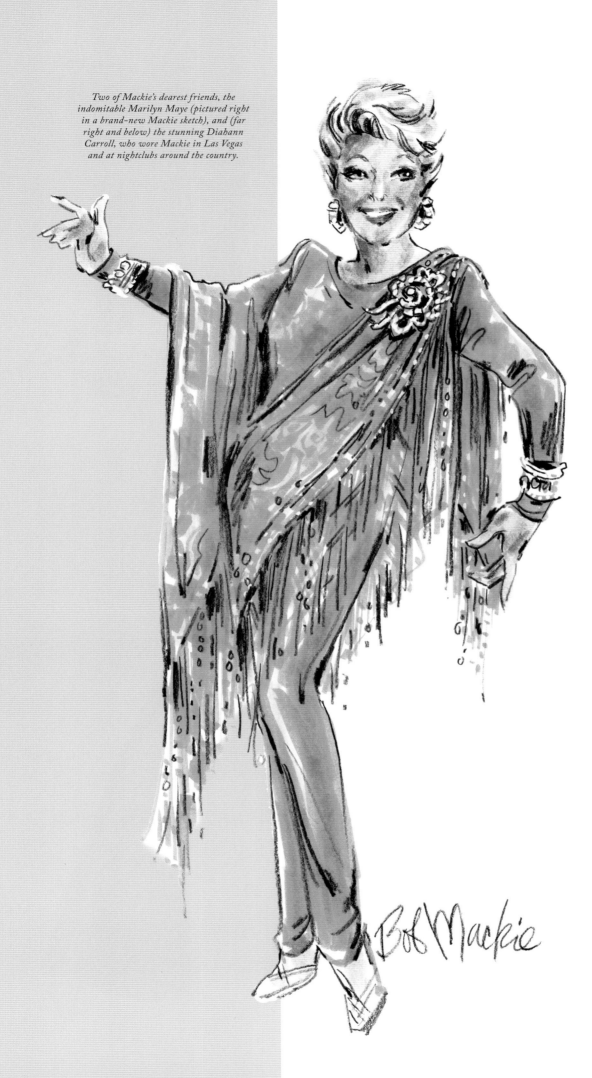

*Two of Mackie's dearest friends, the indomitable Marilyn Maye (pictured right in a brand-new Mackie sketch), and (far right and below) the stunning Diahann Carroll, who wore Mackie in Las Vegas and at nightclubs around the country.*

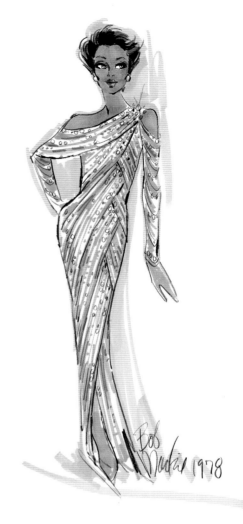

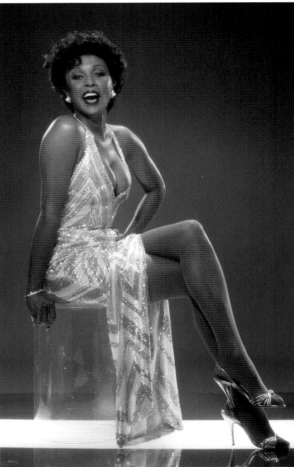

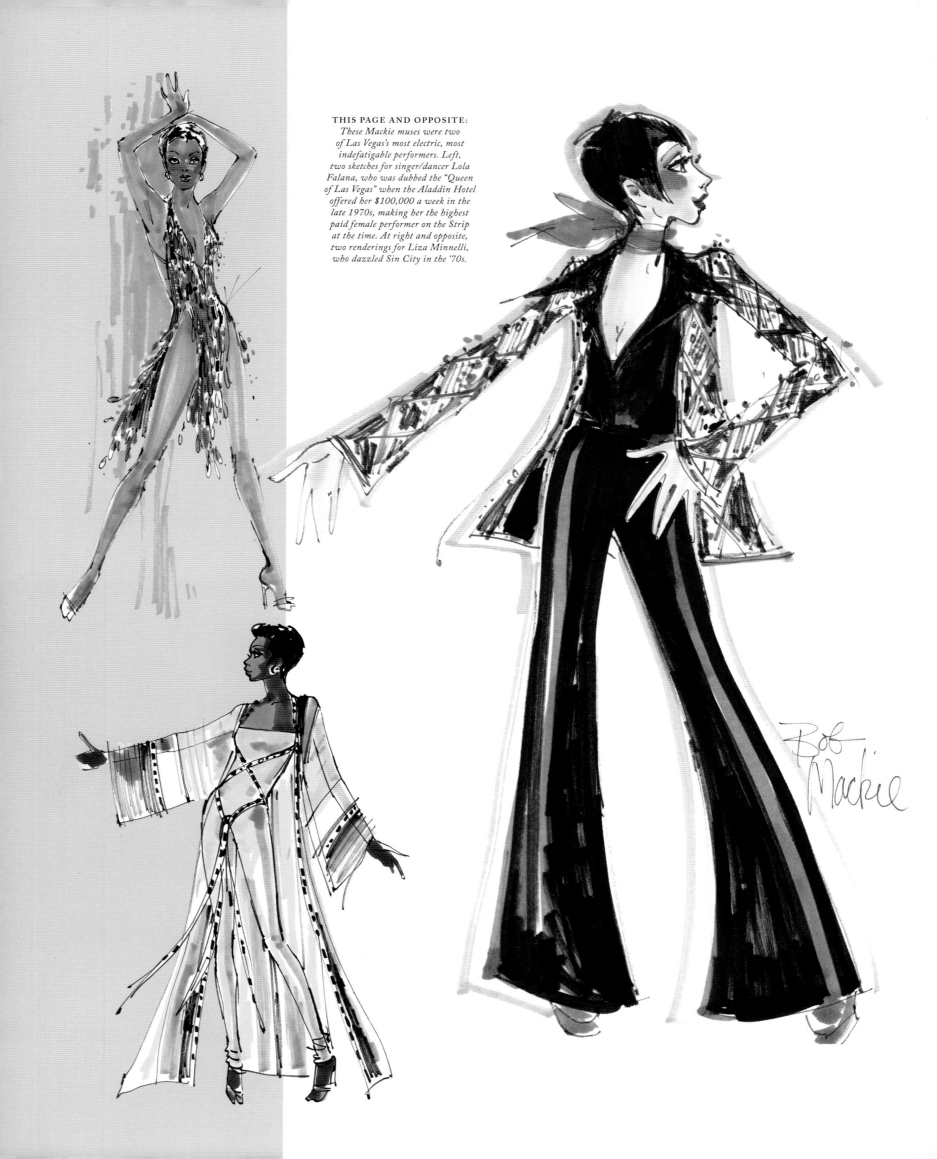

**THIS PAGE AND OPPOSITE:**
*These Mackie muses were two of Las Vegas's most electric, most indefatigable performers. Left, two sketches for singer/dancer Lola Falana, who was dubbed the "Queen of Las Vegas" when the Aladdin Hotel offered her $100,000 a week in the late 1970s, making her the highest paid female performer on the Strip at the time. At right and opposite, two renderings for Liza Minnelli, who dazzled Sin City in the '70s.*

Bob Mackie

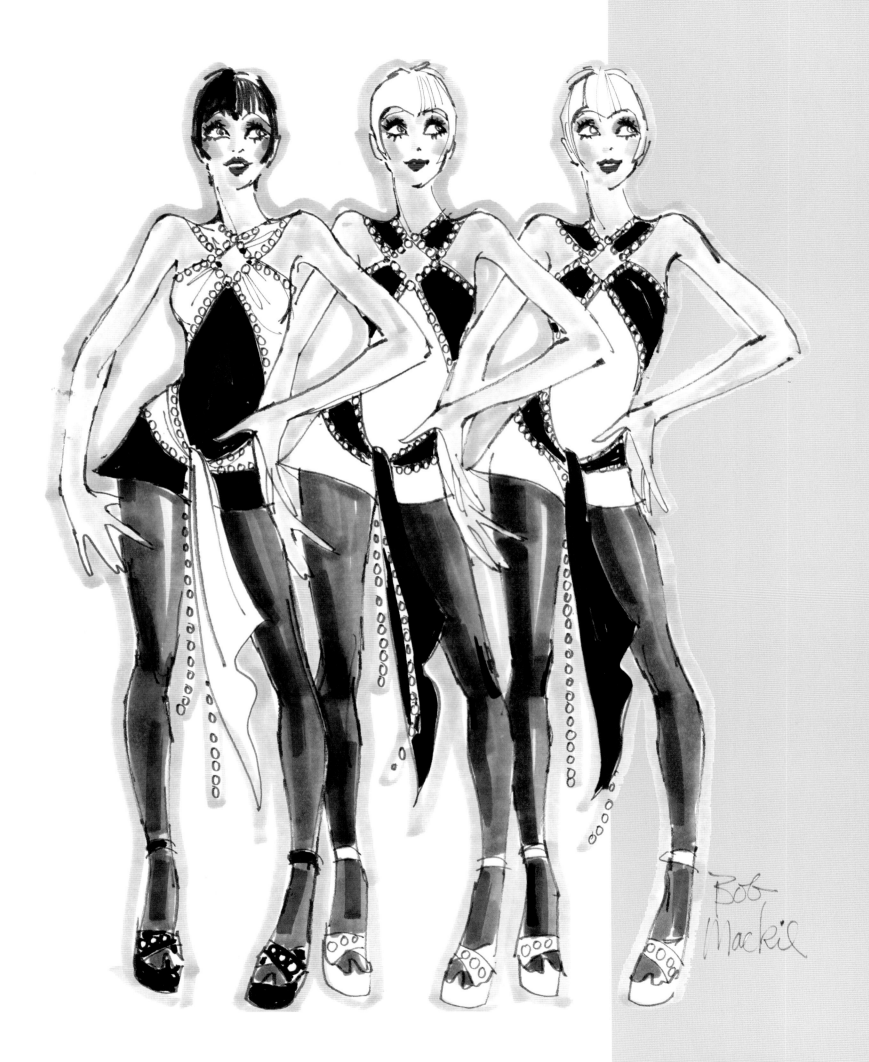

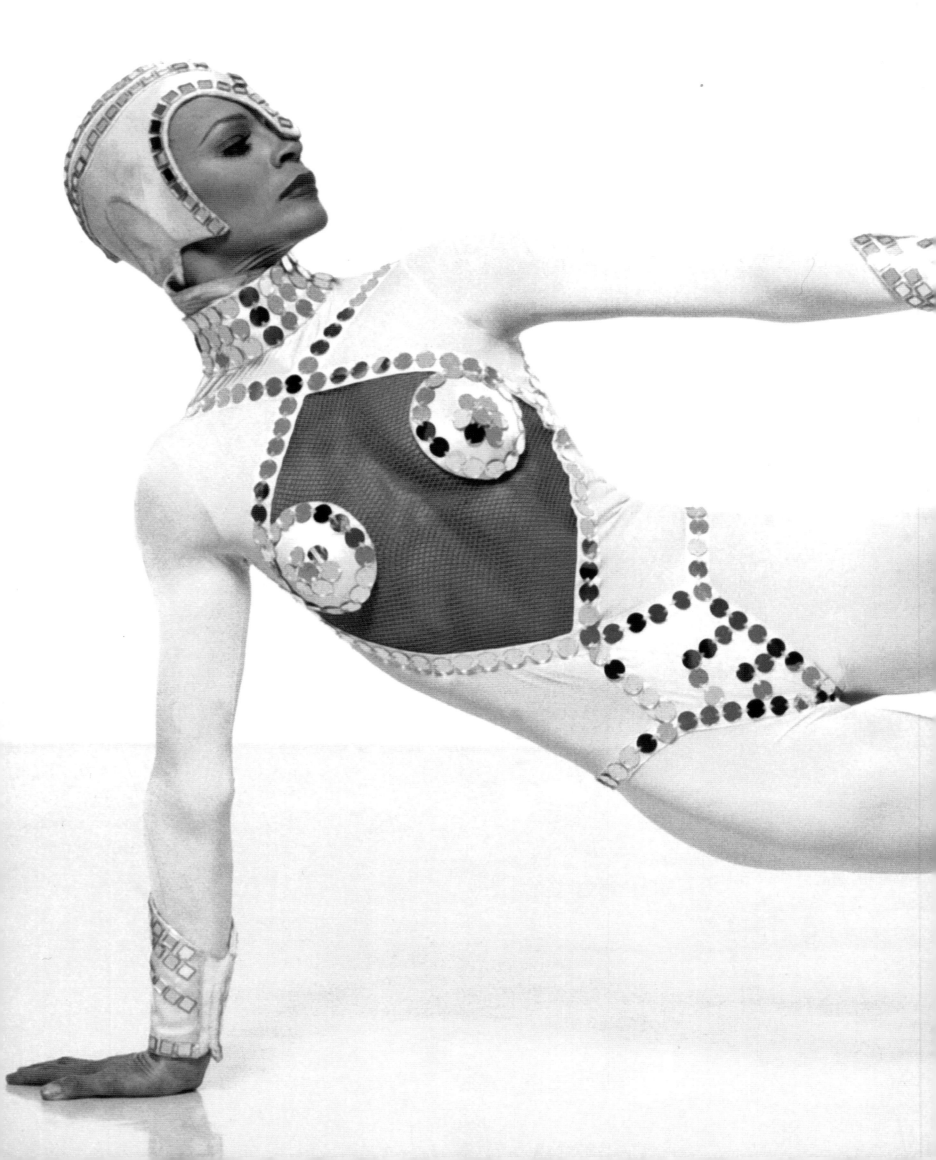

# *Bob* and *Juliet*

JULIET PROWSE—THE SOUTH AFRICAN TRIPLE THREAT WHO conquered the West End in the original London production of *Kismet* and went on to become a fixture in American film and theater—was much more than a client to Bob Mackie; she became one of his dearest friends.

After achieving stardom in the 1960 movie version of *Can-Can*, supporting Shirley MacLaine, Frank Sinatra, and Maurice Chevalier, Prowse was in a dead heat with Leslie Caron for gamine of the year. But, while Caron couldn't even sing in the shower, Juliet could belt it out with the best of them. Advantage Prowse. Looking to spread her wings, she enlisted Mackie and Aghayan to design looks for a Las Vegas act. In the Russian Cossack suit they came up with for one dance number, she not only stopped the show; she probably could have stopped World War I. The simple beaded top over a black leotard they created for another number was so flattering and comfortable that it became Prowse's go-to outfit for appearances on numerous variety shows, from *Ed Sullivan* to *Dean Martin*. (White bugle beads over jet-black tights may seem antithetical to the dawning age of color TV, but there was nothing understated about Juliet's flame-red hair, lithe form, and antelope legs.)

Bob went on to create a *Kismet*-inspired costume for *The Hollywood Palace* in 1966, and in the process, he and Ray forged a close friendship with Juliet that would last a lifetime. "We got on famously," he noted. "Nobody could wear clothes like her . . . those legs . . . that heart. She just exuded this warmth that drew you in . . . And she was a fantastic cook! She was born in Bombay and never met a spice she didn't like."

Bob and Juliet would go on to collaborate on many more Vegas shows, as well as an appearance on the television anthology *The Love Boat* (for which he designed not one but two stunning outfits) and two productions of the musical *Mame*—one in Las Vegas in 1969, the other in Lake Tahoe in 1995. While managing to appear ageless in the latter and garnering respectful reviews, Prowse was by that time undergoing treatment for pancreatic cancer.

While the under-initiated may remember her as the redheaded looker who had affairs with Sinatra and Elvis, Juliet Prowse was ever so much more. The fact that she left us before the age of sixty is a genuine loss for lovers of sublime musical performance, and a deeper one for her loved ones—Mackie prominent among them. Juliet had this to say of her dear friend: "Bob always makes a woman feel feminine. And his work is impeccably fashionable yet functional. I can stand in a Mackie, kick my leg up over my head, bring it back down, and the bodice never moves. That's talent."

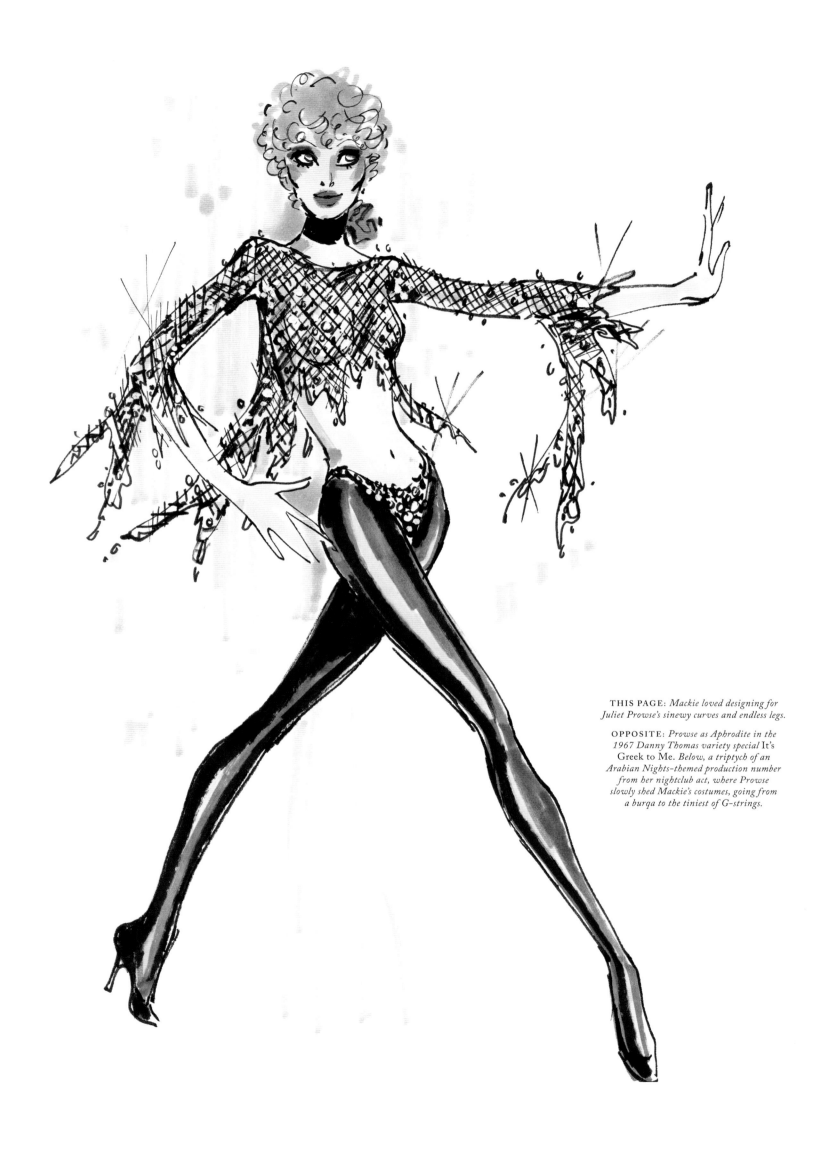

THIS PAGE: *Mackie loved designing for Juliet Prowse's sinewy curves and endless legs.*

OPPOSITE: *Prowse as Aphrodite in the 1967 Danny Thomas variety special* It's Greek to Me. *Below, a triptych of an Arabian Nights–themed production number from her nightclub act, where Prowse slowly shed Mackie's costumes, going from a burqa to the tiniest of G-strings.*

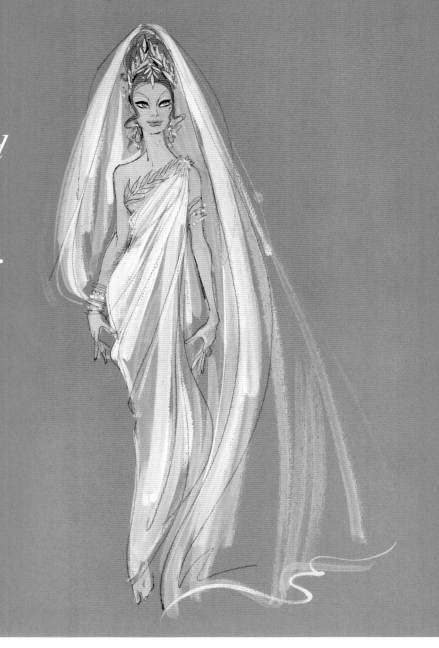

> *"Bob always makes a woman feel feminine. And his work is impeccably fashionable yet functional. I can stand in a Mackie, kick my leg up over my head, bring it back down, and the bodice never moves. That's talent."*
> —Juliet Prowse

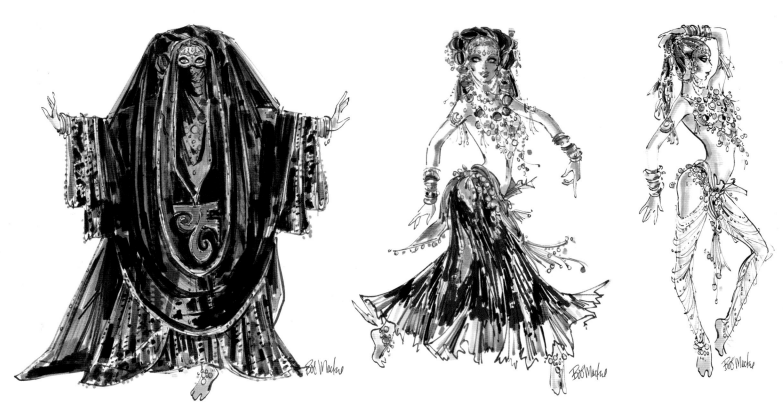

# Debbie Does *Vegas*

**MARY FRANCES REYNOLDS OF EL PASO, TEXAS, MOVED** with her parents to Burbank, California, when she was seven, grew up in a poor but loving household, wore dungarees, and dreamed of becoming a physical education teacher. All of that changed when she impulsively entered the Miss Burbank Contest in 1948, hoping to snag the prize of a blouse, a silk scarf, and a free lunch. She walked away with all those and something even better: a screen test at Warner Bros. the very next day. Two years later, and with a new first name, Debbie Reynolds had been signed by MGM and was on her way to being a full-fledged movie star.

There's no question that Reynolds conquered Hollywood, but her most regular source of employment over the decades was in her adopted hometown of Las Vegas, where she headlined on and off the Strip from 1962 to 2013. In the 1990s, she opened a hotel there, complete with a museum of Hollywood memorabilia that included dozens of her own costumes as well as tuxedos from all five members of the Rat Pack. She had, after all, been a gal pal and costar to Frank and his amigos for years, along with Shirley MacLaine and Angie Dickinson.

Reynolds did three-month stands at the Riviera for ten years and wowed 'em in the Crystal Room at the Desert Inn for eighteen. The work was exhausting but rewarding, as Reynolds fed off the energy of a live audience. She tapped Bob Mackie—whose first movie design credit

was for her 1965 film *Divorce American Style*—to costume many of her shows, and the two became fast friends.

Mackie was also on board when Reynolds took her act to Broadway's Minskoff Theater in 1976, the site of her Tony-nominated triumph in the musical revival of *Irene* three years earlier.

At one point, Reynolds, who had no problem logging an unheard-of two shows a night, seven days a week, held the record for the most consecutive performances in Vegas—more, even, than her great and indefatigable friends Wayne Newton and Liberace.

When recalling her fifty-year love affair with Sin City, Reynolds noted, "I have nothing but happy memories of the days when you could get on the plane to Vegas without being shot at. Liberace and I would walk right up the ramp with a bottle of champagne, just having a wonderful time. Those really were the days."

LEFT: *Mackie often dressed Reynolds in blue, the perfect color for a performer whose rendition of "Alice Blue Gown" lit up the Broadway revival of* Irene.

BELOW LEFT: *A backdrop reminded the people in the cheap seats that they weren't seeing Connie Stevens.*

BELOW RIGHT: *Debbie Reynolds in Mackie on a 1978 NBC variety special.*

OPPOSITE: *Movie legend Debbie Reynolds tapped her way off Mackie's sketch pad and into Las Vegas history.*

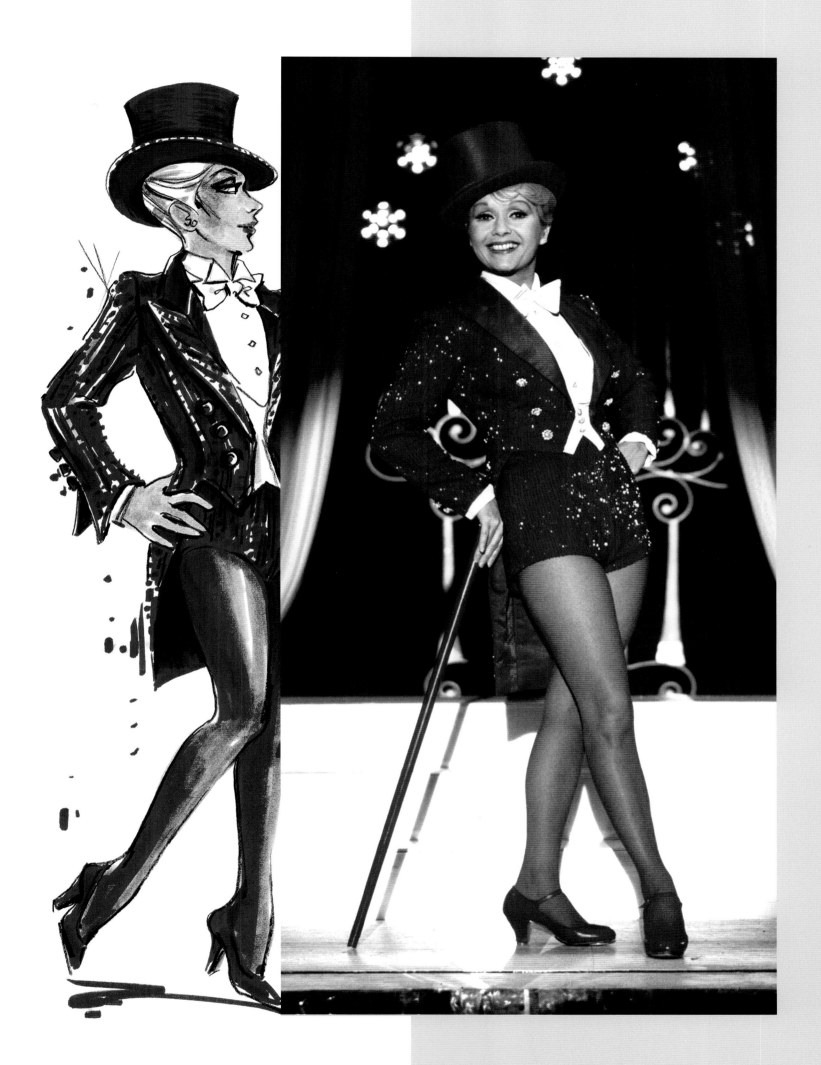

# TELEVISION GOLD

**BEFORE CAROL BURNETT BROKE THE GLASS CEILING IN** 1967, the only women who'd starred in their own weekly variety series were Dinah Shore, Judy Garland, and Rosemary Clooney— and Dinah was given only fifteen minutes per show for the first seven years she was on the air! That would change in the 1970s, when suddenly, every female star from Pearl Bailey to Julie Andrews was hosting a show. This was good news for the Mackie machine, which took command of the genre so relentlessly that it was hard to believe there wasn't a Mackie clone hidden away in his guesthouse.

A by-product of designing for two weekly variety shows was that his client list grew. From Cher's solo variety hour alone, he began to work with Tina Turner, Elton John, and Bette Midler. He also designed for TV action stars Cheryl Ladd and Lynda Carter, who'd leveraged their musical chops into multi-special deals with the networks.

Mackie was accomplishing all this while still outfitting his long-time clients Carol Burnett, Cher, and Mitzi Gaynor—not only for their specials but for talk show appearances, Las Vegas acts, and the red carpet.

As the era of the variety special continued unabated, Mackie designed for Ann-Margret, Toni Tennille, and Marie Osmond, while continuing to dress Diana Ross and Goldie Hawn. Of course, it wasn't all Emmy fodder: There was the infamous *Star Wars Holiday Special* in 1978. May the sequins be with you.

*Carol Burnett and Cher perform the "Vaudeville" sequence within the nine-minute "Lonely at the Top" medley on Cher's 1975 variety show.*

# More Carol *Classics*

**FOR THE FIRST SIX SEASONS OF *THE CAROL BURNETT SHOW,*** musical comedy outstripped straight sketch comedy each week—but that would change, thanks to several factors.

The first was the introduction of the "Family" sketches, with Burnett playing the comic/tragic Eunice Harper Higgins; Vicki Lawrence as Mama Thelma Harper and Harvey Korman as Eunice's loser husband, Ed. Created by writers Dick Clair and Jenna McMahon, based on Mike Nichols/Elaine May routines they had come up with in the early 1960s, the team moved the "family" farther south, which allowed Burnett to draw inspiration from her own Texas-born mother.

Chasing but never quite grabbing her dreams of class, happiness, and stardom, Eunice always wore a version of the same ragtag green-and-yellow-flowered dress that Mackie had found in a thrift store and altered. Some thirty sketches from across the show's final four seasons reveal the creativity of the designer's constant repurposing of that commonplace garment (attention: Smithsonian and/or Metropolitan Museum costume collection).

While most people seemed to find the sketches hilarious, some felt the portrayal of the embittered middle-aged woman, her sardonic mama, and her idiot slacker of a husband cut a bit too close to the bone. Cary Grant, for one—an avowed fan of Burnett's, and the feeling was mutual—once told her that whenever a Family sketch came on, he had to mute the television, as the scenes were just a little too painful.

The second thing that changed the *Burnett Show*'s comic trajectory was the warped comic genius of Tim Conway. Many people remember Conway as a regular since the beginning of the show's run (probably because the syndicated half-hour *Carol Burnett and Friends* featured only material from the show's final six seasons), but that wasn't the case; he was a regular for just the final three seasons, though he appeared often as a guest before that—including in the beloved "Dentist Sketch" in Season 3. That one yielded everybody's favorite cast crack-up, as Harvey Korman dissolved into uncontrollable hysterics at Conway's benign brilliance. Once Conway joined the resident cast, the comedy came fast and furious, and music became the punctuation.

Besides Mackie's costumes for Eunice and company and Chiquita—Carol's wicked takeoff on "Cuchi-Cuchi Girl" Charo—he was the architect behind one of the most memorable duos on 1970s television, the impossibly inept secretary Mrs. Wiggins and her increasingly frustrated boss, Mr. Tudball. In nineteen

sketches over three seasons, Wanda Wiggins sported a blond Farrah Fawcett wig and the tightest black skirt into which a girl could squeeze her assets. During her first costume fitting, Burnett was skeptical. "I can't walk in this thing!" she insisted. "Stick out your behind," Mackie instructed. Slowly, endlessly, the star maneuvered her way across the stage in her high-heeled pumps, and "Mrs. Huh-Wiggins" came to life on the spot. Add "director" to Mackie's résumé.

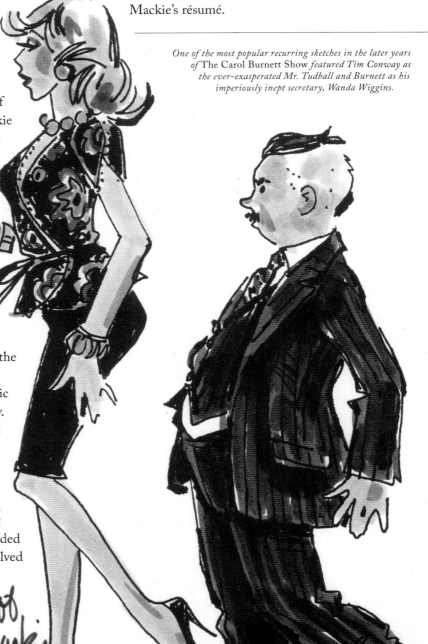

*One of the most popular recurring sketches in the later years of* The Carol Burnett Show *featured Tim Conway as the ever-exasperated Mr. Tudball and Burnett as his imperiously inept secretary, Wanda Wiggins.*

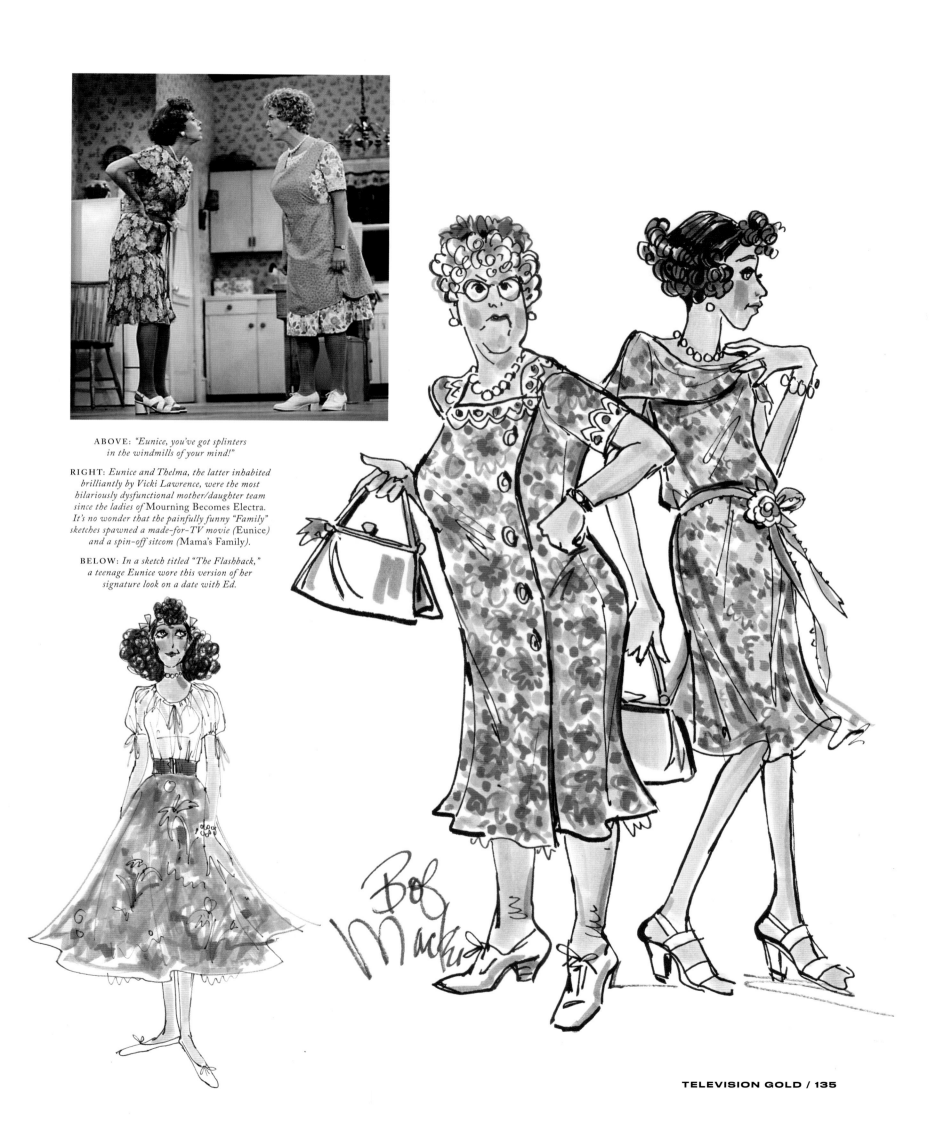

ABOVE: *"Eunice, you've got splinters in the windmills of your mind!"*

RIGHT: *Eunice and Thelma, the latter inhabited brilliantly by Vicki Lawrence, were the most hilariously dysfunctional mother/daughter team since the ladies of* Mourning Becomes Electra. *It's no wonder that the painfully funny "Family" sketches spawned a made-for-TV movie (*Eunice*) and a spin-off sitcom (*Mama's Family*).*

BELOW: *In a sketch titled "The Flashback," a teenage Eunice wore this version of her signature look on a date with Ed.*

# Ready for Her *Close-Up*

**AS PREVIOUSLY NOTED, BOTH CAROL BURNETT AND BOB** Mackie grew up loving the movies, which, after all, were the main export of their native Southern California. Burnett and her grandmother would head one block south from their tiny apartment to Hollywood Boulevard to watch movie after movie—and steal a few rolls of toilet paper on the way out of the theater. Mackie's favorites were the MGM musicals, with their over-the-top production numbers and spectacular costumes and sets.

When *The Carol Burnett Show* went on the air and the two teamed up, this shared love and knowledge of film classics would bring to life some of the most beloved and hilarious sketches of the show's eleven-season run. In addition to Nora Desmond, the parody of Gloria Swanson in *Sunset Boulevard* that became so popular she was made a recurring character, a number of Burnett characters skewered film icons—and the more iconic, the sharper the skewer. Joan Crawford was a favorite target: *Mildred Pierce* became *Mildred Fierce* and *Torch Song* became *Torchy Song*. All Mackie had to do was make the shoulders wider, the heels higher, and the lapels larger, and Burnett was off and running. Instead of *Random Harvest*, we saw *Rancid Harvest*; *Rebecca* became *Rebekky*; and *The Petrified Forest* was *The Putrified Forest*. (Whenever a stand-in Humphrey Bogart was called for, singer Steve Lawrence filled the bill perfectly, revealing a true flair for sketch comedy.)

---

**BELOW LEFT AND OPPOSITE:** *Burnett's wacky take on the classic film noir* Sunset Boulevard *is right up there with* "Went with the Wind" *in the hearts of fans. In the sketch, her Nora Desmond is attended to by Harvey Korman's ever-faithful Max.*

**BELOW:** *Burnett's movie spoofs were comic gold, thanks in no small part to Mackie's work. Top row, clockwise from left: Burnett as "Golda" in a riff on Rita Hayworth's* Gilda; *Burnett with mermaid Nanette Fabray as her son's fiancée in "Guess What's Coming for Dinner?" (Her clothes in this one were a spot-on reference to Edith Head's designs for Katharine Hepburn in the original film.); Burnett as Joan Crawford in one of several "Mildred Fierce" sketches enjoyed by viewers over the years. Bottom row, left to right: Burnett as Doris Day in "Pillow Squawk", Carol, singer/actress Gloria Loring, and Vicki Lawrence in* Valley of the Dolls, *and in another turn as "Mildred Fierce" redux.*

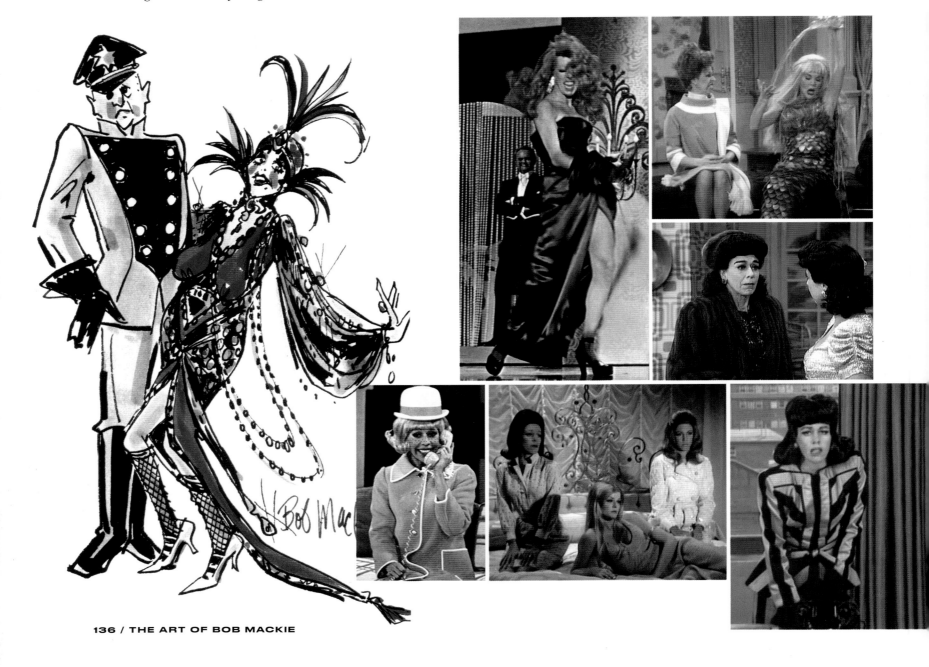

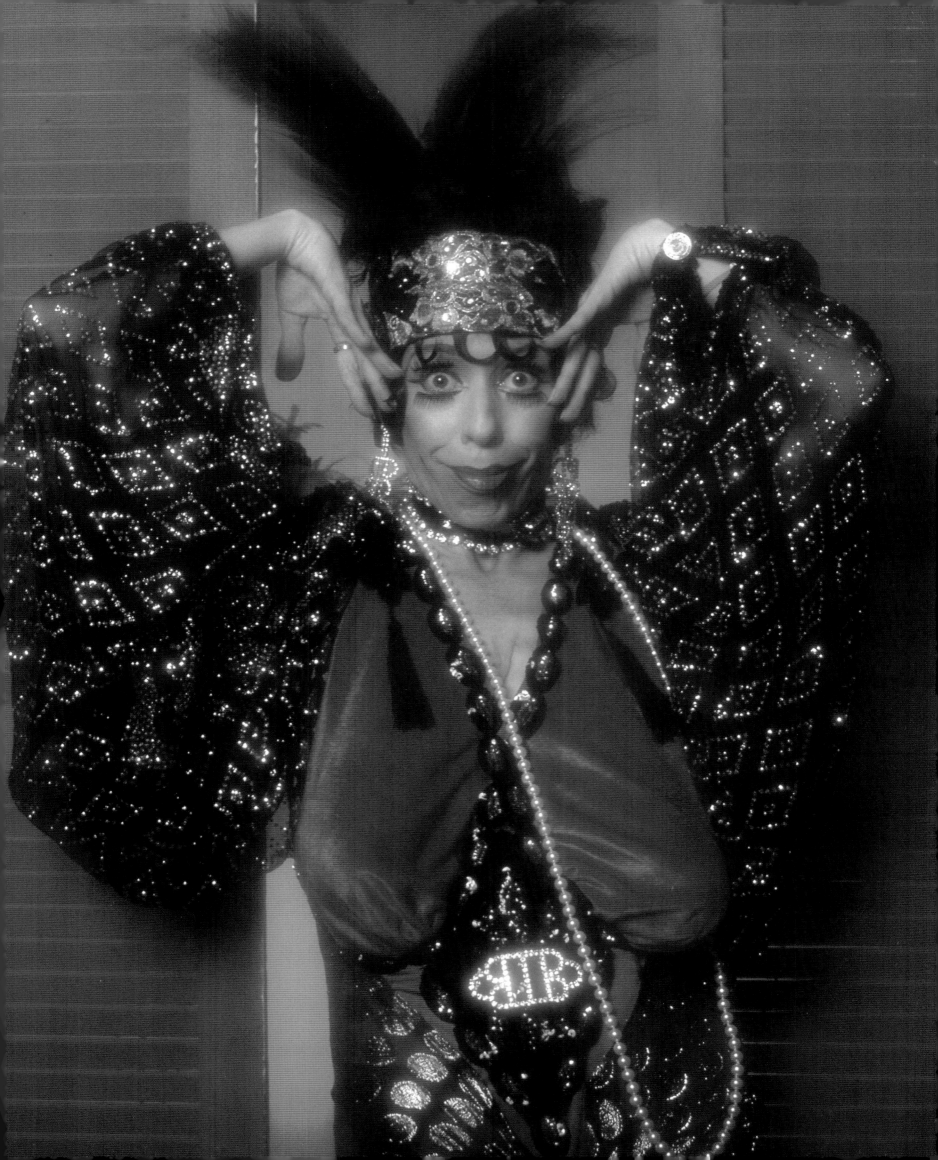

And then came The Dress—a comic confection from the mischievous mind of Mackie so memorable and significant to popular culture that it is on display at the Smithsonian Institution. "That dress will be carved on my tombstone," quipped Mackie.

In the fall of 1976—Harvey Korman's last season on the show—Carol's friend Dinah Shore was to be a guest star, and young writers Rick Hawkins and Liz Sage came up with the idea of spoofing *Gone with the Wind*. The result is an incredibly sharp piece of comic writing called "Went with the Wind," distilling the three-and-a-half-hour movie into twenty uproarious minutes with Burnett as "Starlet" O'Hara, Korman as "Rat" Butler, Shore as "Melody" Hamilton, and Vicki Lawrence as "Sissy" the maid. (Thankfully, Lawrence's takeoff of Butterfly McQueen did not include any sort of makeup that would make the sketch unairable today.)

The apex of the parody comes with Starlet's entrance down the grand staircase in a dress fashioned from the family portieres—curtain rod and tassels included. "Thank you . . . I saw it in the window and I just couldn't resist it," she drawls, to the longest laugh in TV variety history. (To this day, plenty of shows "sweeten" their laugh tracks in post-production, even those taped in front of a live audience. When The Dress appeared, the audience's reaction went on so long it had to be edited down.)

Mackie remembered reading the script: "It said, 'Starlet comes down the stairs with the curtains hanging on her,' and I thought, 'That's not funny enough. I don't want to make a joke out of the fact that she threw it together quickly—the movie already did that.' And then I thought, 'Hmm . . . curtain rod . . .'"

"Bob called me into wardrobe," Burnett recalled, "and said, 'I have an idea.' And he wheeled out a mannequin, and I fell on the floor and said, 'That is the most brilliant sight gag I have ever seen.'"

Mackie knew the curtain rod was very heavy, "So I went up these steep escape stairs backstage and helped Carol's dresser Annette put it on her. It all had to be done in real time, while Harvey and Vicki played a little scene down below. When she went out, the audience went crazy. It still makes people laugh to this day. This silly thing that popped into my head has somehow became iconic. I mean, FIT did an exhibit of my whole career, and what did they put in the window? That dress!"

## "That dress will be carved on my tombstone."

TOP RIGHT: *A sketch for Dinah Shore, who deployed her southern charm as "Melody" Hamilton in the iconic "Went with the Wind."*

RIGHT AND OPPOSITE: *"Starlet" O'Hara makes her entrance and confronts Harvey Korman's "Rat" Butler, who struggled to find his Clark Gable impression until he donned the Mackie costume and everything fell into place.*

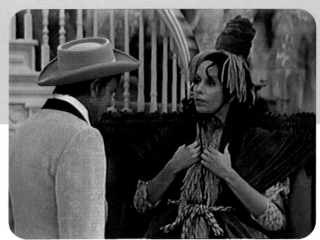

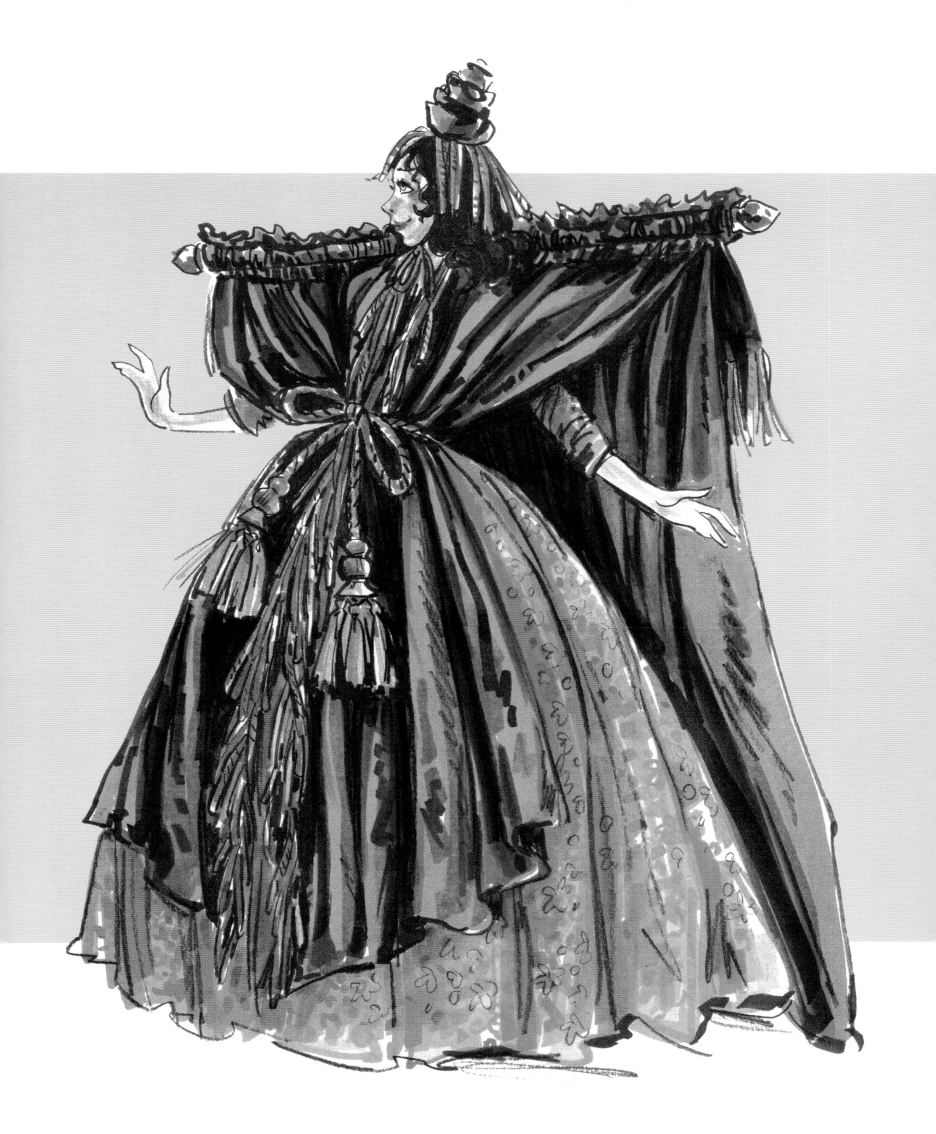

# Unconventional Challenge

**BEFORE *PROJECT RUNWAY*, BEFORE *MAKING THE CUT*,** before Tim Gunn had even met Heidi Klum (perhaps because she was just two years old at the time), there was *McCall's* magazine and the "*McCall's* Challenge."

In what was definitely a "make it work" moment, Bob Mackie was presented with a task that predated the crafty reality shows by four decades: Create high-fashion dresses out of handkerchiefs, scarves, dish towels, and beach towels. "Oh, and by the way, Bob, did we mention that your models will be four of your favorite muses and some of today's most famous fashion plates? You'll be dressing Bernadette Peters, Ann-Margret, Carol Burnett, and Cher." (One can only assume that Diana Ross was too busy filming *Mahogany* to play.)

Photographed by the legendary Douglas Kirkland, the resulting editorial spread was the 2020 equivalent of getting Rihanna, Angelina Jolie, Jennifer Aniston, and Lady Gaga to pose in garments made of paper towels, bath mats, Ziploc bags, and Dixie cups.

It was 1975, and Bob readily rose to the challenge as a lark, a goof, a stunt. Today, such things come with million-dollar prizes and launch unknown designers into the stratosphere—a fact that genuinely bewilders the designer.

Whatever you think of the result, we agree with Bob: "Clothing should be made of cloth." Amen.

LEFT TO RIGHT: *Mackie's muses, Bernadette Peters, Ann-Margret, Cher, and Carol Burnett, in an array of unconventional materials.*

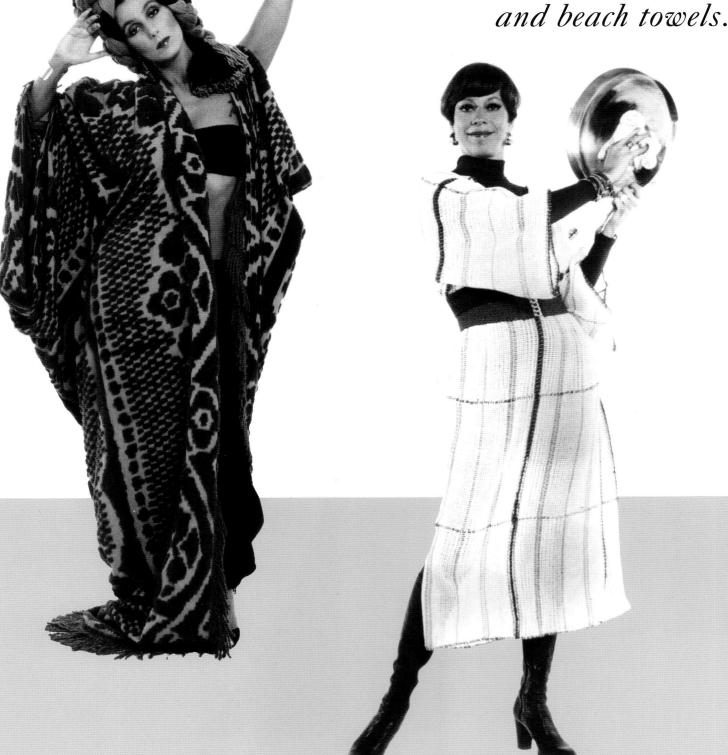

*Mackie was presented with a task that predated the crafty reality shows by four decades: Create high-fashion dresses out of handkerchiefs, scarves, dish towels, and beach towels.*

# Breaking Ground in Style

**THE BEAUTIFUL, MULTITALENTED DIAHANN CARROLL WAS** not only a longtime client of Bob Mackie's but a friend until her death in October 2019.

"We first met when I appeared on *The Judy Garland Show* in 1963," Carroll recalled, "and I began working with Ray [Aghayan] and Bob almost immediately. Bob is a master of making a gown work onstage. It has to breathe with the body, and the line of the gown has to be there all the time, no matter how you move."

Mackie designed for Carroll for red-carpet events and nightclub engagements, as well as her short-lived 1976 variety series, *The Diahann Carroll Show.* Hers was a career of firsts: the first black woman to win a Tony Award for best actress, for the Richard Rodgers musical *No Strings*; the first black woman to star in a television series (the groundbreaking 1968 sitcom *Julia*) not playing a domestic worker; and, as she proudly called herself, "prime-time soap's first black bitch," as the glamorous Dominique Devereaux in the hit potboiler *Dynasty*. Bringing a whole new audience to that show (along with high school classmate Billy Dee Williams), Carroll threw herself into her epic catfights with Joan Collins. (These classic battles were purely for the cameras, as the two were great friends off-screen.)

Although Nolan Miller designed the shoulder-padded wardrobe for *Dynasty*, Mackie was Carroll's designer of choice for many of the most important occasions of her life. He and Ray Aghayan collaborated on the sequined gown and floor-length fur cape she wore to the 1975 Academy Awards, when she was nominated for best actress for her performance in *Claudine;* Mackie designed her wedding ensemble for her fourth marriage, to singer Vic Damone and in return, Carroll inducted her friend and favorite designer into the Television Hall of Fame in 2002—in a Mackie, of course.

In her introductory remarks on that occasion, she noted, "Bob has honed his sense of glamour and theatricality into an art form. No one does what Mackie does the way Mackie does it. The body is transformed under his guidance."

---

OPPOSITE: *Designs for Diahann Carroll, one of Mackie's most elegant clients and a dear friend.*

FAR LEFT: *Carroll in sequins and lace at the Emmy Awards.*

LEFT: *The élan of his sketches for her communicate Mackie's affinity for Carroll. This beautifully unfussy garment— the silhouette, the attitude of the outstretched arms, the cut of the bodice—exudes "Carroll by Mackie."*

BELOW: *A 1975 publicity shot for Carroll's eponymous variety show.*

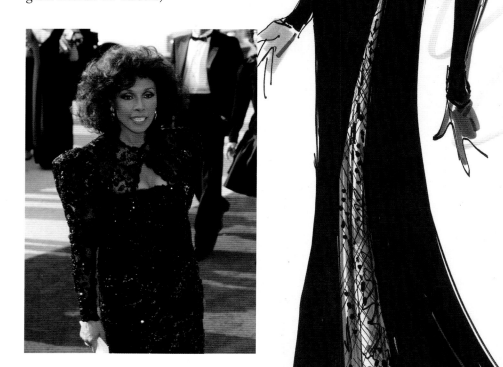

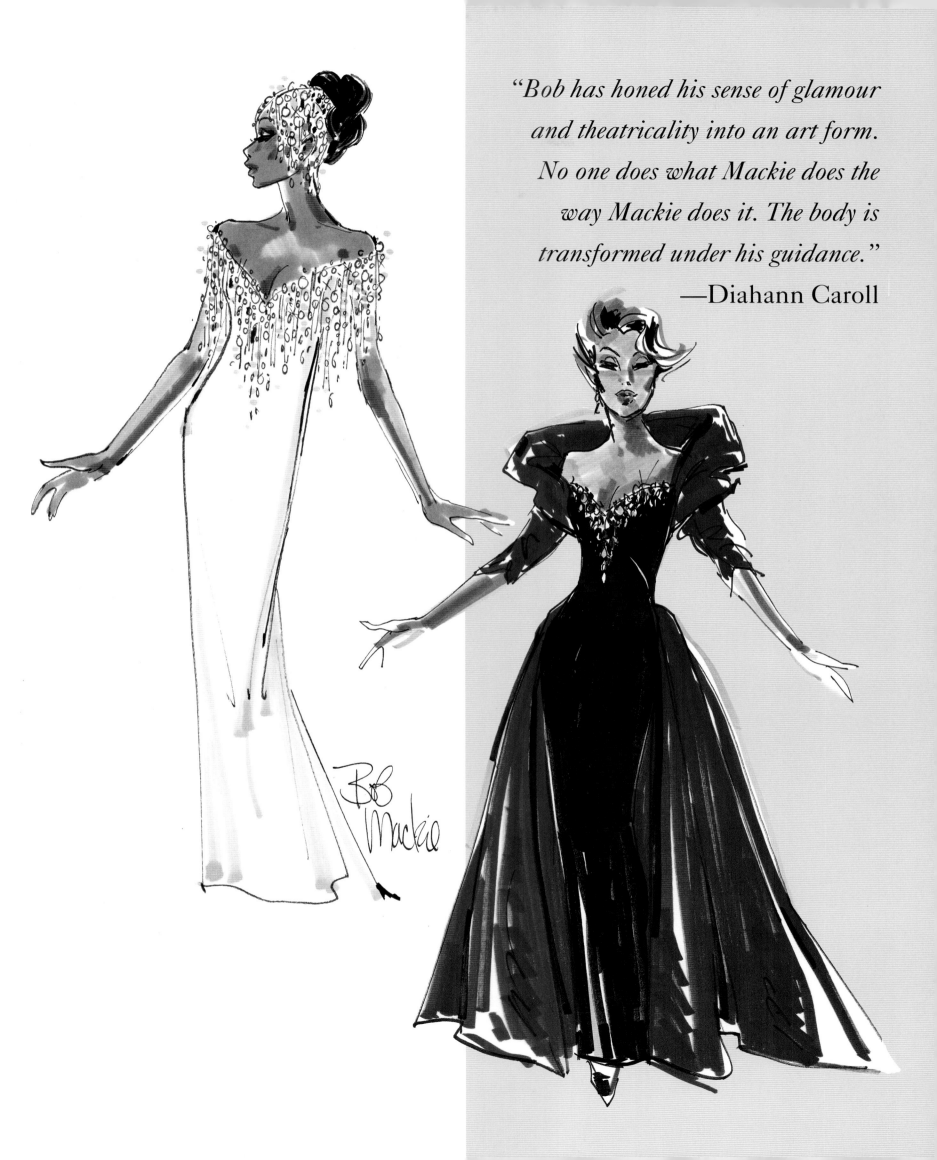

*"Bob has honed his sense of glamour and theatricality into an art form. No one does what Mackie does the way Mackie does it. The body is transformed under his guidance."*
—Diahann Caroll

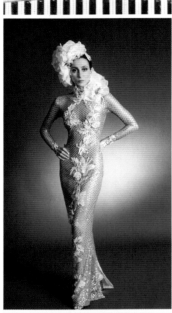

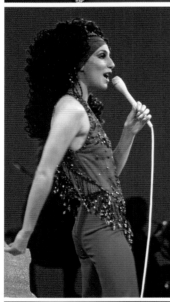

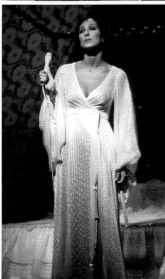

# Cher Goes *Solo*

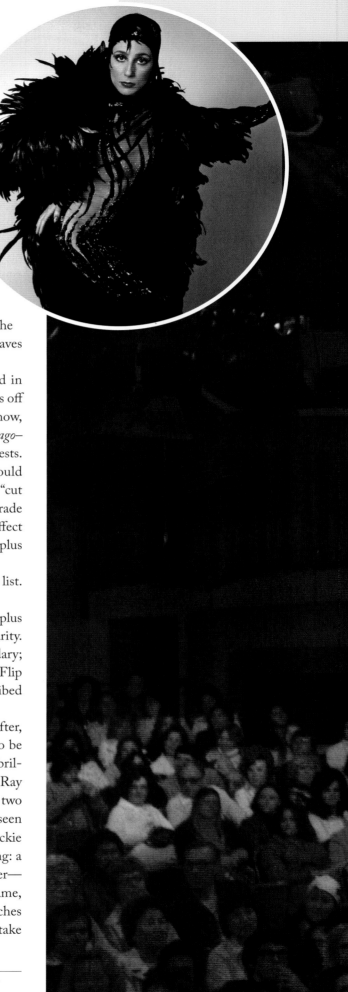

**AFTER THE VERY PUBLIC MUDSLINGING** divorce of Cher and Sonny Bono in 1974, the two set off to conquer television separately, as solo acts. Knowing exactly where its bread was buttered, CBS sent Sonny packing to ABC, and *Cher* premiered as a midseason replacement in February 1975. It would last for just twenty-six episodes (the length of one full season at the time), but it endures in beloved reruns to this day. By contrast, *The Sonny Comedy Revue*, with Teri Garr filling in on the distaff side, ran for just thirteen weeks and departed the airwaves before *Cher* even premiered.

Cher and her mind-boggling array of guest stars engaged in duets for the ages, all decked out in a Mackie wardrobe that was off the charts. The star made a grand entrance at the top of each show, and her opening outfit—concealed by a cape, a cloak, a *Dr. Zhivago*–esque fur number—was as eagerly anticipated as that night's guests. She'd begin a ballad, the band would kick in, the tempo would double, and she'd drop her outerwear to reveal a stupendous "cut up to here and down to there" Mackie original, which she'd parade down the runway to screams from the studio audience. The effect was part Gypsy Rose Lee, part Mitzi Gaynor, and all "Cher plus Mackie equals perfection."

The premier episode of *Cher* had a quite disappointing guest list. NOT.

In fact, she'd summoned a promising lad named Elton John, plus Bette Midler and Flip Wilson, both at the peak of their popularity. Bette and Cher's lingerie-clad "Trashy Ladies" medley is legendary; and "Laverne and Geraldine's High School Reunion," featuring Flip as his beloved and brassy drag counterpart, can only be described as comic gold.

The problem with the show began to emerge shortly thereafter, as it slipped into the weekly grind. The guest list continued to be stellar—including Carol Burnett, Jerry Lewis, Nancy Walker (brilliant as the mother of Cher's Laverne character), David Bowie, Ray Charles, Linda Ronstadt, Kris Kristofferson, Rita Coolidge, and two appearances by Tina Turner. You haven't LIVED until you've seen the Beatles medley featuring Cher, Tina, and Kate Smith in Mackie designs that are pure magic. And yet . . . something was lacking: a target for Cher's zingers. To see her jamming with Tina Turner—also recently liberated from the bonds of matrimony—on "Shame, Shame, Shame" was a thrilling rock moment; but corny sketches with the likes of Ted Knight and Wayne Rogers fell flat. We'd take Cher over Sonny any day, but as her foil, he was irreplaceable.

*The many moods of Cher.*

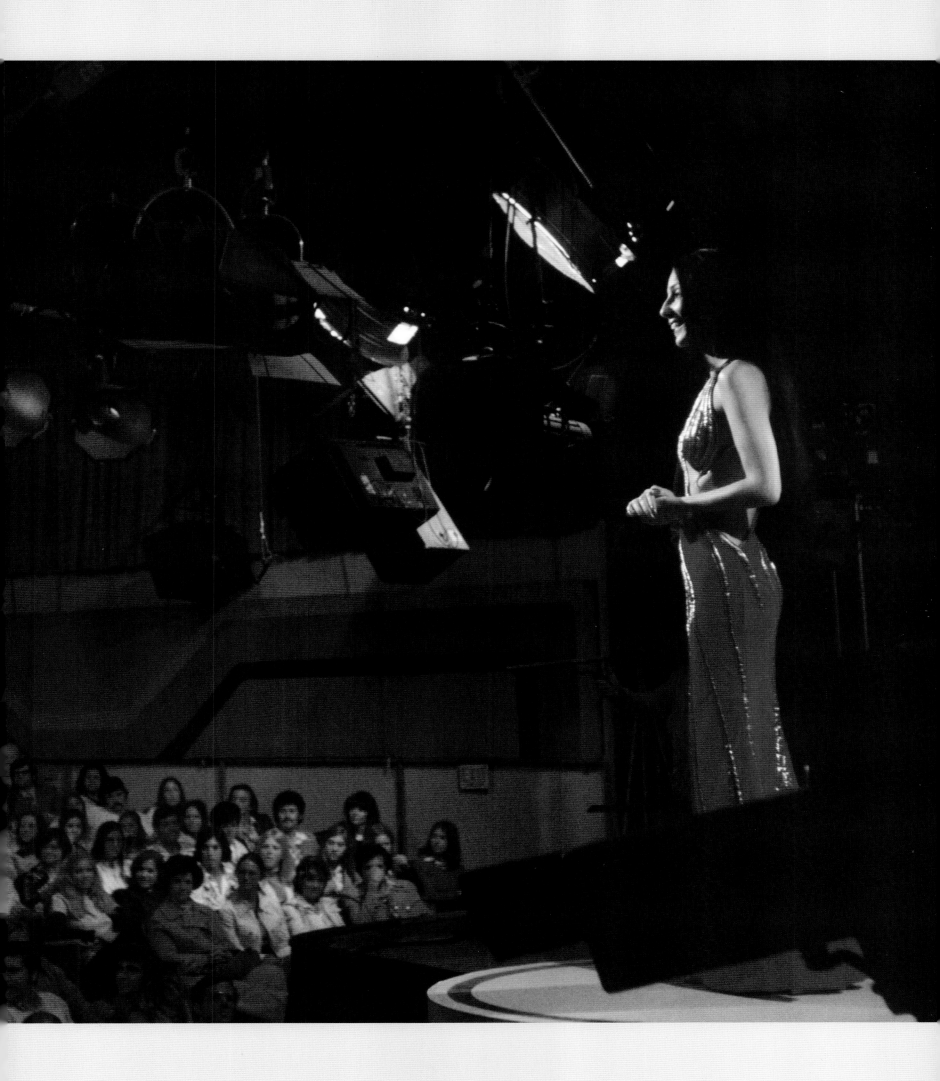

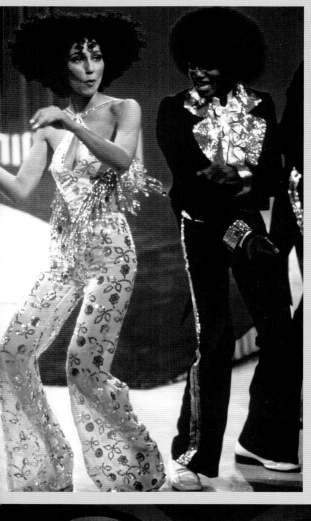

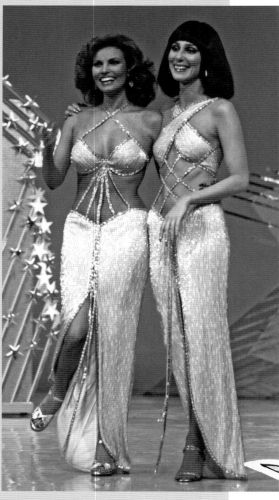

# Cher's *Show-stoppers*

FAR LEFT AND LEFT: *Cher in a hairdo throwdown with Michael Jackson and an ab throwdown with Raquel Welch. The two women sang the Peggy Lee standard "I'm a Woman"— as if they had to remind us.*

BELOW: *In Cher's Mother Goose spoof, "Mabel's Fables," Bette Midler played a newly hatched gosling.*

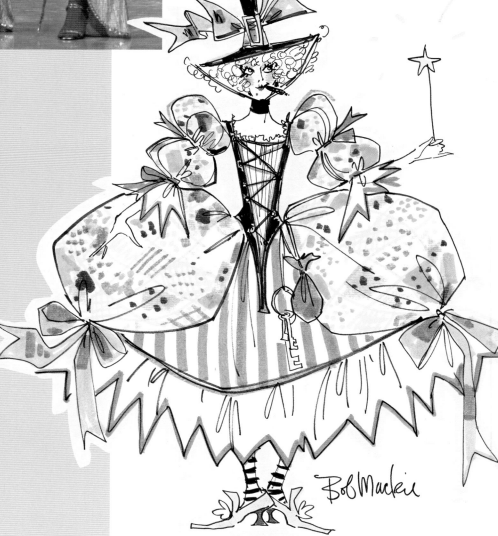

Bob Mackie

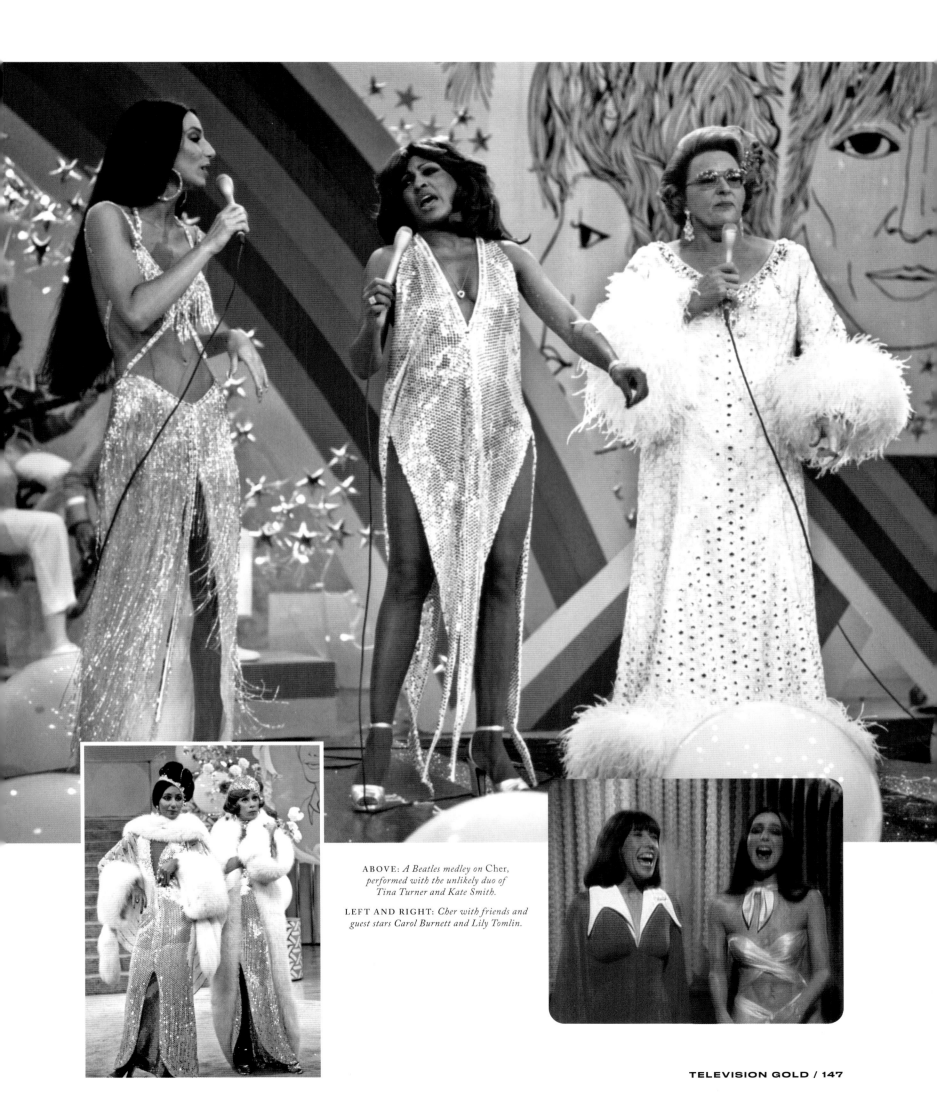

ABOVE: *A Beatles medley on* Cher, *performed with the unlikely duo of Tina Turner and Kate Smith.*

LEFT AND RIGHT: *Cher with friends and guest stars Carol Burnett and Lily Tomlin.*

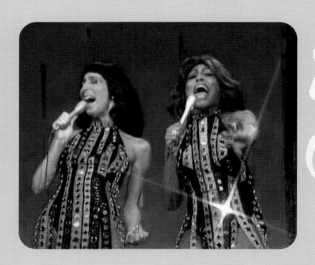

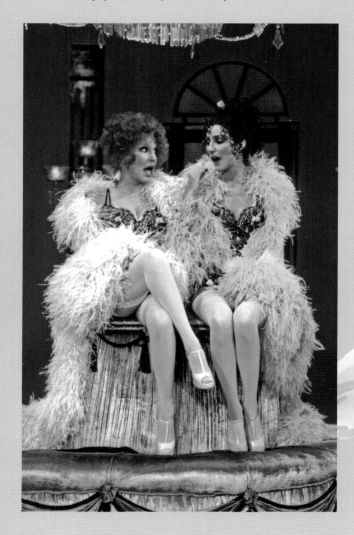

ABOVE: *Cher and Tina Turner singing "Shame, Shame, Shame" remains an unparalleled moment of pop diva nirvana.*

BELOW AND RIGHT: *Cher and Bette Midler perform a "Trashy Ladies" medley.*

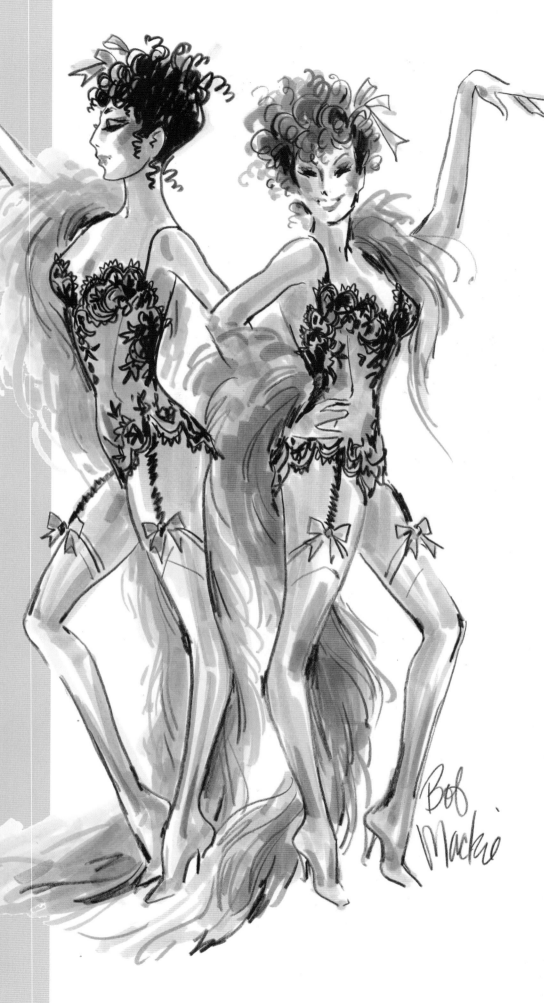

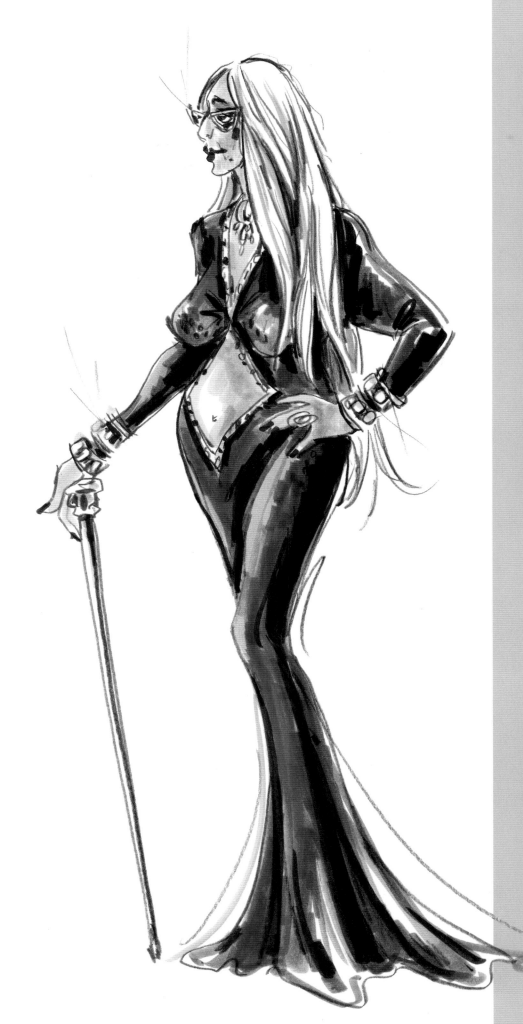

*Elton John (top), Bette Midler, and Flip Wilson join Cher
in a retirement home sketch on the premier episode.*

*Mackie summoned
a vision of a retired
Cher—as if that
could ever happen.*

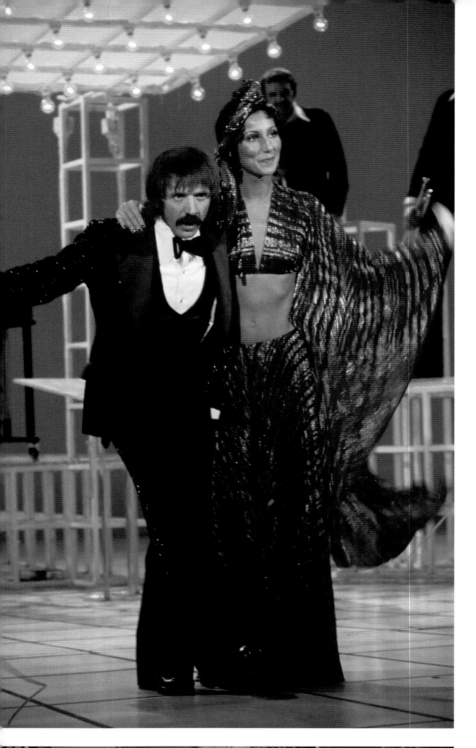

# Back and *Bickering*

**SONNY'S 1974 SOLO VARIETY SHOW: CANCELED. CHER'S** the following year: ditto. The brass at CBS could only conclude that the two together were much more than the sum of their respective parts—that it was their chemistry that had attracted viewers.

"Sonny's show had flopped, and Cher had proved she could succeed as a solo act, so there was a lot of tension," Mackie remembered. "Sonny was always ambitious, but with the second show, it just became magnified. It wasn't so pleasant, and I think everyone was relieved when they finally decided to pack it up." Never mind the fact that they were now divorced, and Cher was pregnant with new husband Gregg Allman's child. To the delight of the network, they agreed to get the act back together and let the ol' sparks fly.

The result, now called *The Sonny & Cher Show*, premiered in early 1976, and nobody wanted to fix what wasn't broken. The show was taped in the old studio, and the writers revived a lot of the old shtick. Perhaps the most substantial reference from their past endeavor was Bob Mackie and Ret Turner coming back to design the clothes, which were as whimsical and wonderful as ever. Some things never change.

In spite of all that, the show struck a decidedly different tone. (Did you notice the elimination of the word "comedy" from the show's title? Yeah, that.) When Johnny Carson cracked wise about his various ex-wives, they weren't standing next to him onstage. Cher had always lobbed insults at Sonny, but now her comments seemed more cruel than comical, and so did his responses. At one point, Cher offered her ex a rare compliment, and he responded, "That's not what you said in the courtroom." Ouch. And their rendition of "Don't Go Breakin' My Heart"? Awkward.

They could still commandeer high-profile guests, including Bob Hope, Tom Jones, Muhammad Ali, Carol Burnett, and rising star Farrah Fawcett-Majors; the costumes were just as elaborate; but the magic was gone.

Just a year later, in January 1977, the network moved the show to Friday nights—a death slot for a variety show—and the writing was on the wall of Studio 41 at Television City. The format was dying, anyway, what with Burnett hanging up her charwoman mop next door. Hats off, though, to one of the funniest, most unlikely couples in TV variety history, who could finally go their separate professional ways for good. Can't blame a network for trying.

---

ABOVE LEFT: *Married or divorced, the height difference between Sonny and Cher was always good for a laugh.*

LEFT: *Cher and Debbie Reynolds join the Russian circus in a 1977 production number.*

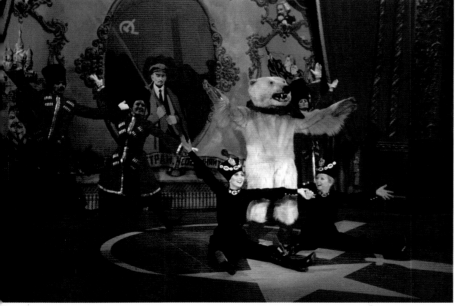

*"It wasn't so pleasant, and I think everyone was relieved when they finally decided to pack it up."*

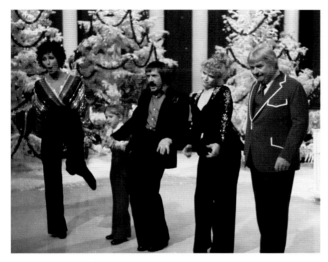

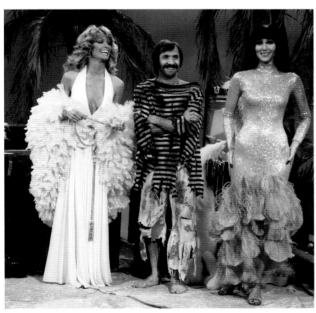

TOP: *Christmas with Sonny and his former wife? Thank god Bernadette Peters, Captain Kangaroo (aka Bob Keeshan), and little Chastity were around to cut the tension.*

ABOVE: *Farrah Fawcett-Majors joins the dynamic duo on a 1976 episode of* The Sonny & Cher Show.

RIGHT: *Mackie's stylish outfits for Cher's return to television were tailor-made for one-upping her ex.*

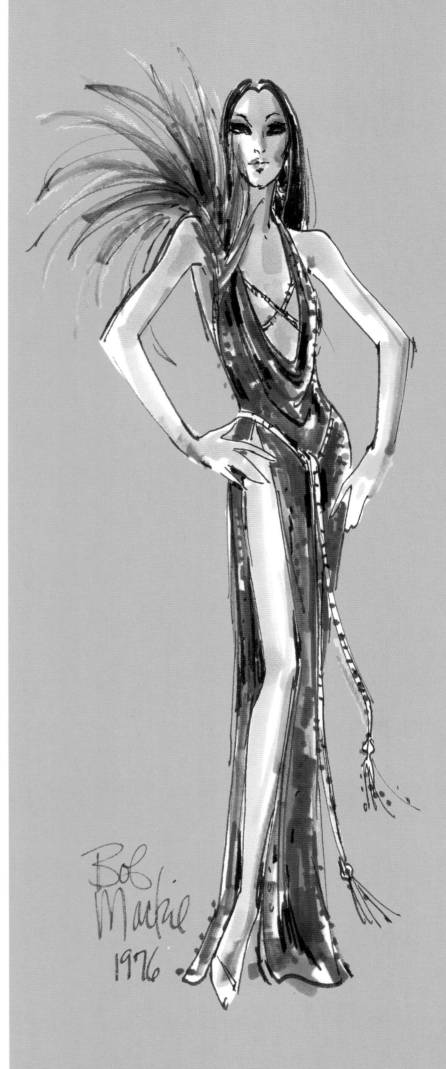

# Viva **Ann-Margret**

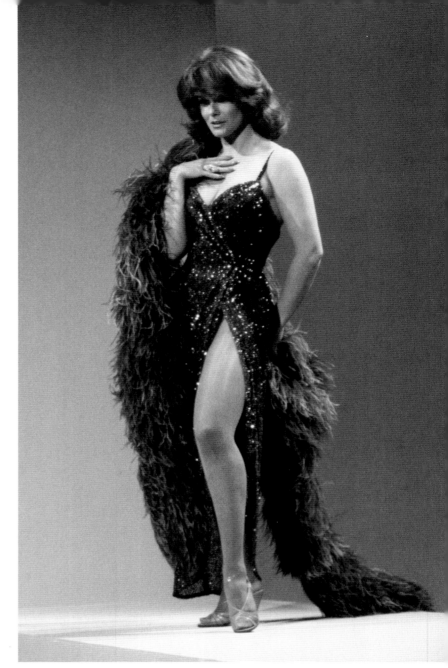

**THE *THIRD* MOST FAMOUS ACTOR TO ATTEND NORTHWEST-**
ern University (after Charlton Heston and Warren Beatty) was an
innocent lass transplanted from Sweden who joined a vocal group,
got discovered by George Burns (who asked her to perform a soft
shoe in his Vegas act), and was whisked off to Hollywood before
she had a chance to register for sophomore English.

Ann-Margret Olsson burst on the scene as a flame-haired
triple-threat bombshell who would go on to conquer every cor-
ner of show business in spite of some setbacks along the way: a
near-fatal fall onstage in Lake Tahoe in 1972; a husband who was
ill for thirty years; a battle with alcoholism; and the challenge of
constantly reinventing herself as Hollywood morphed before her
eyes. It's tempting to compare Ann-Margret to Madonna, although,
by all reports, she has always been much less cranky.

Her roles have run the gamut from jitterbugger to biker chick,
simple Swedish immigrant to glamorous movie goddess. Segue-
ing from a wholesome, starry-eyed teenager in *Bye Bye Birdie* to
a very bad girl in *Kitten with a Whip* and Elvis Presley's perfect
match in *Viva Las Vegas*, she has always been as versatile as she is
beautiful. Consider the two very different roles for which she was
Oscar-nominated: Bobbie in *Carnal Knowledge* and the title char-
acter's mom in *Tommy*.

Perhaps her acuity for what (and whom) she needs at any given
moment in her career explains her relationship with Bob Mackie.
Whereas Carol Burnett, Cher, and Mitzi Gaynor wholeheartedly
anointed Mackie their forever designer, Ann-Margret called on
Bob only when her specific vision—for a TV special or Las Vegas
show—suited his talents. Which was often enough.

When Ann-Margret needed sequins and feathers, she called
Bob. When she needed a leather biker suit, she called Bob. Turn-
of-the-century petticoats? Bob. Western gunslinging garb? Bob.
Rockette-style outfit? Bob. She was clear about her requirements
and understood Mackie's wheelhouse.

Perhaps she didn't summon the Mackie magic as often as some
of his regular ladies (truthfully, she often wore jeans and cowl-neck
sweaters in her specials), but no one has ever filled out a sequined
leather, fringed jacket, and cowboy boots like Ann-Margret Olsson.
(If you're looking for her beauty secret, eat your Swedish meatballs.
She swears by them.)

Believe it or not, the 2001 revival tour of *The Best Little Whore-
house in Texas* marked Ann-Margret's debut in a musical comedy.
Less surprising: The clothes were wall-to-wall Mackie.

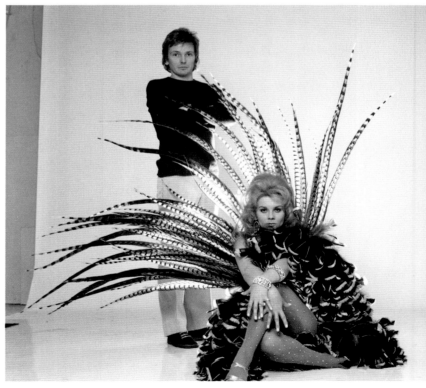

TOP RIGHT: *Ann-Margret's natural gifts were
augmented beautifully by Mackie's designs.*

RIGHT: *Mackie and Ann-Margret in 1976.*

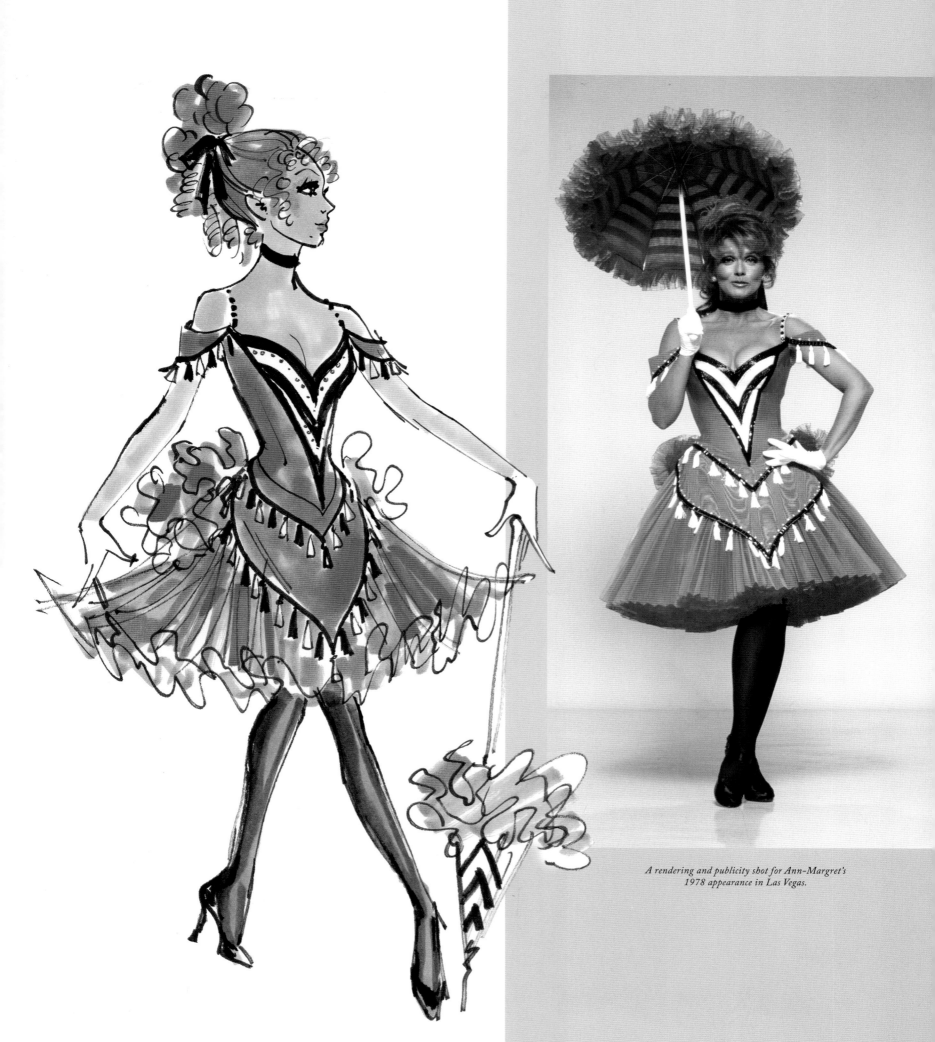

*A rendering and publicity shot for Ann-Margret's 1978 appearance in Las Vegas.*

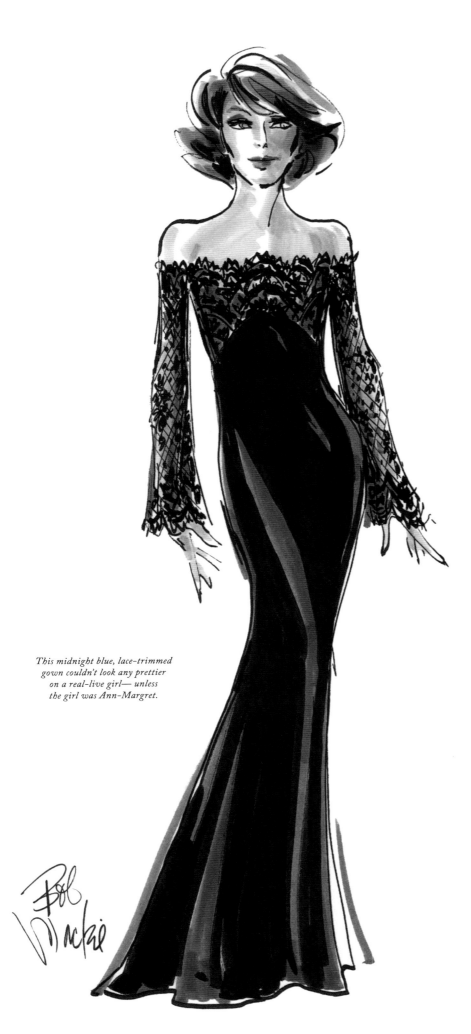

*This midnight blue, lace-trimmed gown couldn't look any prettier on a real-live girl— unless the girl was Ann-Margret.*

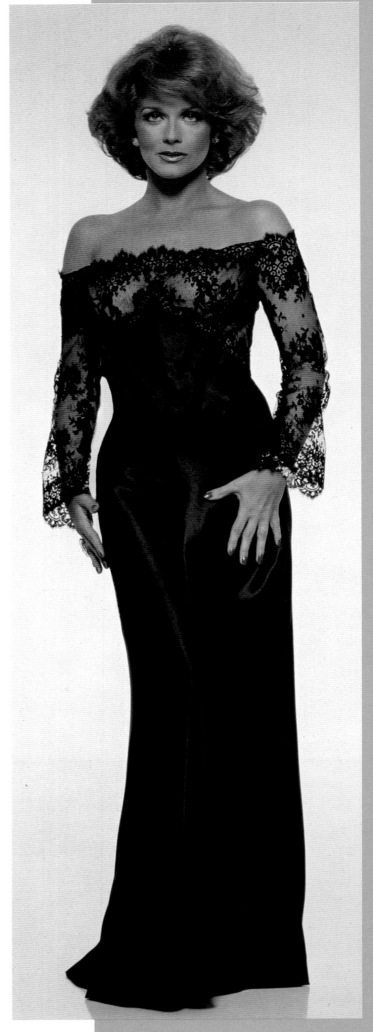

*When Ann-Margret needed sequins and feathers, she called Bob. When she needed a leather biker suit, she called Bob. Turn-of-the-century petticoats? Bob. Western gunslinging garb? Bob. Rockette-style outfit? Bob.*

TOP LEFT: *A sketch from the 1977 special* Rhinestone Cowgirl.

TOP RIGHT: *Ann-Margret may have been four inches too short to qualify as a real Rockette, but hey, it was her show, and she had the inches where they counted.*

LEFT AND RIGHT: *Mackie won a well-deserved Emmy for his work on Ann-Margret's 1980 special* Hollywood Movie Girls.

# Getting a *Head* in Show Business

**THE 1978 NBC-TV SPECIAL *ROCKETTE: A HOLIDAY TRIBUTE*** *to Radio City Music Hall* starred Ann-Margret and included guest appearances by an odd grab bag of guests including Gregory Peck, Beverly Sills, Ben Vereen, and Greer Garson, along with the world's most famous thirty-six-woman precision chorus line. The show was half variety special and half call to arms, as both the theater and the troupe had fallen on hard times in the wake of New York City's financial crisis. All in all, it was an enjoyable 120 minutes, if not a ratings blockbuster, providing a showcase for the flaming redheaded sex kitten from Sweden's finest assets.

Smash cut to 1989, when Bob Mackie noticed a *TV Guide* cover featuring Oprah Winfrey's now oddly oversize head atop a gown he had designed for that special—for Ann-Margret—eleven years earlier. To add insult to indignity, instead of a leather settee, Oprah was sitting atop a pile of cold, hard cash. Mackie made a few calls, and holy hell broke loose. It turned out that a freelance illustrator named Chris Notarile had used a publicity shot from the Rockette special because it was the pose he was looking for. Never mind the fact that he hadn't gotten permission or offered credit to the designer, or that it might not have been in the best taste to put an African American woman's head on a white woman's body.

In his defense, Notarile (or, as pronounced in the original Italian, "not-a-REALLY") offered, "If Flipper had been in the proper position, I would have used that picture."

*The full Ann-Margret, left, and some good parts plus Oprah, right.*

*"If Flipper had been in the proper position, I would have used that picture."*

—Chris Notarile

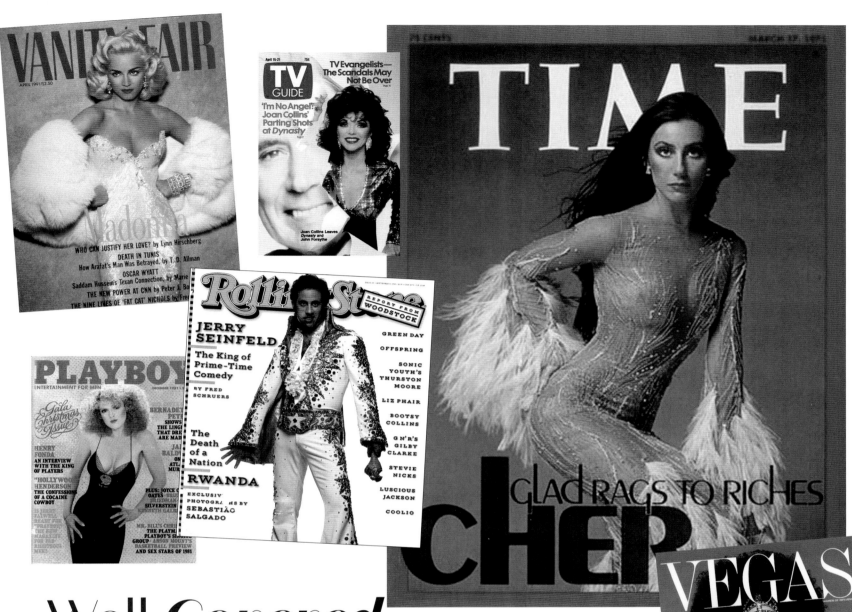

# Well *Covered*

**ELLEN DEGENERES ONCE SAID, "I CLEANED OUT MY CLOSET** so well I ended up on the cover of *Time* magazine!"

It was a punch line, of course, but it's also the truth. One of the most accurate gauges of "Who's hot and who's not" can be found by perusing the covers at the local newsstand. As Madonna sang in "Vogue" (the song, not the magazine): "Marlon Brando, Jimmy Dean / On the cover of a magazine," and she should know. Among her most famous appearances on a cover (and she's made a lot of them) was *Vanity Fair* in 1991, wearing a version of the dress Bob Mackie had designed for her for that year's Academy Awards.

Magazine covers are guaranteed profile boosters, and celebrities have been calling on Mr. Mackie to create looks for cover shoots since the 1960s. In addition to Cher's *Time* cover and the Ann-Margret/Oprah head-swap debacle, Mackie's designs have appeared on every glossy periodical you can think of besides *Sports Illustrated* and *Popular Mechanics*, worn by everyone from Joan Collins to Jerry Seinfeld. Come to think of it, why hasn't someone asked him to design a little number for *SI*'s annual swimsuit issue?

# A Lass Named *Ladd*

**CHERYL JEAN STOPPELMOOR, A WIDE-EYED NINETEEN-** year-old bundle of talent from Huron, South Dakota, arrived in Hollywood in 1970 determined to make a name for herself in the music business. After getting hired as one of the singing voices on the Hanna-Barbera animated series *Josie and the Pussycats*, she married producer David Ladd, took his name, and bided her time doing a few TV guest shots . . . until she was catapulted to stardom as Farrah Fawcett's replacement on *Charlie's Angels*.

In addition to being able to run in heels while pulling a pistol from her shoulder bag, Ladd was an excellent and genuinely charming pop singer. (Her 1978 single "Think It Over" made it to Number 34 on the *Billboard* charts.) She decided to leverage her celebrity to get back to what she loved, in a series of three TV variety specials.

As usual with such shows, there was an effort to appeal to a broad demographic. Ladd's first outing, *The Cheryl Ladd Special* in 1979, featured Waylon Jennings and Ben Vereen. Ladd sang country-western, then dove into a sequined fantasy designed around the disco hit "Tropical Nights." The most memorable Mackie crea-

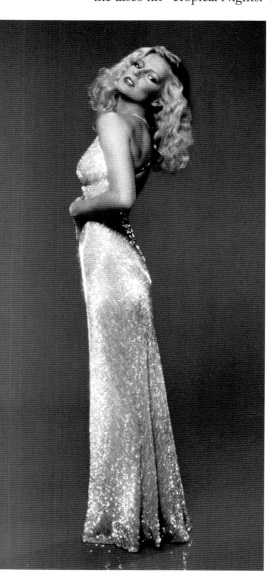

tions in the show were unveiled in a duet with Ladd and Vereen, the former clad in a spangled sarong and the latter in skintight matching pants and a shirtless vest that made his getup in the movie *All That Jazz* look positively chaste.

Most notable in Ladd's somewhat forgettable second special, *Souvenirs,* were Mackie's designs for the production numbers. Guest-starring this time were fellow ABC stars Joyce DeWitt and Jeff Conaway, along with the Charlie Daniels Band.

Her final special, *Cheryl Ladd: Scenes from a Special,* aired in 1982 and had the toniest guest list of all: rock star Rick Springfield and Carol Burnett, who related naturally to Ladd's combination of small-town folksiness and Hollywood gumption. Ladd had guest-starred on Burnett's show in 1978, and the two had clearly hit it off. Burnett donned her iconic charwoman costume, and Ladd followed suit for a duet of

Dolly Parton's "Nine to Five." The two also performed a medley of women's empowerment songs dressed as a couple of "ladies who lunch"—all looks courtesy of Mackie.

For each homespun special, Mackie created at least three eye-popping gowns that transformed Cheryl Jean Stoppelmoor into Grace Kelly. Only Oscar himself can wear all gold as well as Cheryl Ladd in Bob Mackie.

---

LEFT AND BELOW: *The angelic Cheryl Ladd, alternately sporty and drop-dead elegant in Mackie.*

OPPOSITE: *A look for Ladd's rendition of "Heatwave" for her first special in 1979.*

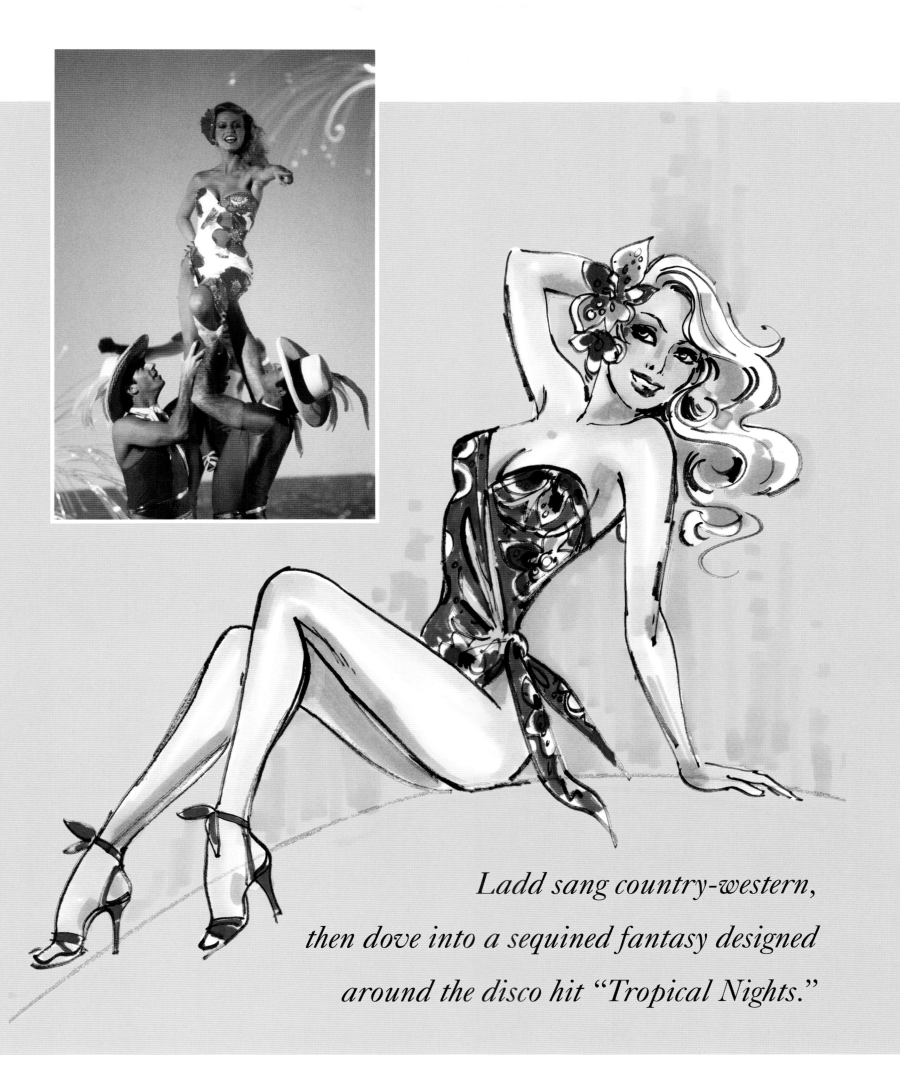

*Ladd sang country-western, then dove into a sequined fantasy designed around the disco hit "Tropical Nights."*

*For each homespun special, Mackie created at least three eye-popping gowns that transformed Cheryl Jean Stoppelmoor into Grace Kelly.*

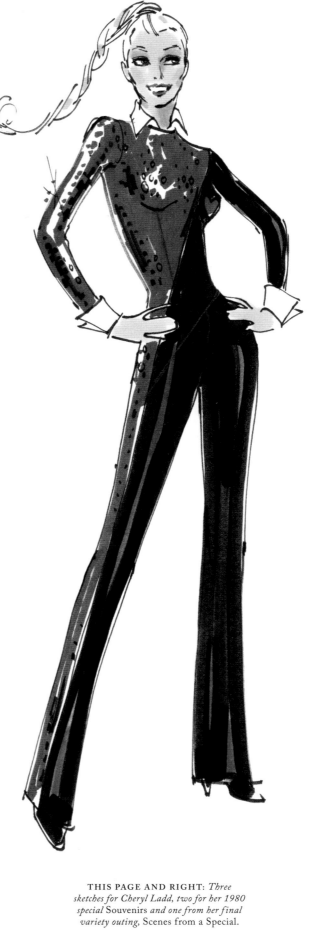

THIS PAGE AND RIGHT: *Three sketches for Cheryl Ladd, two for her 1980 special* Souvenirs *and one from her final variety outing,* Scenes from a Special.

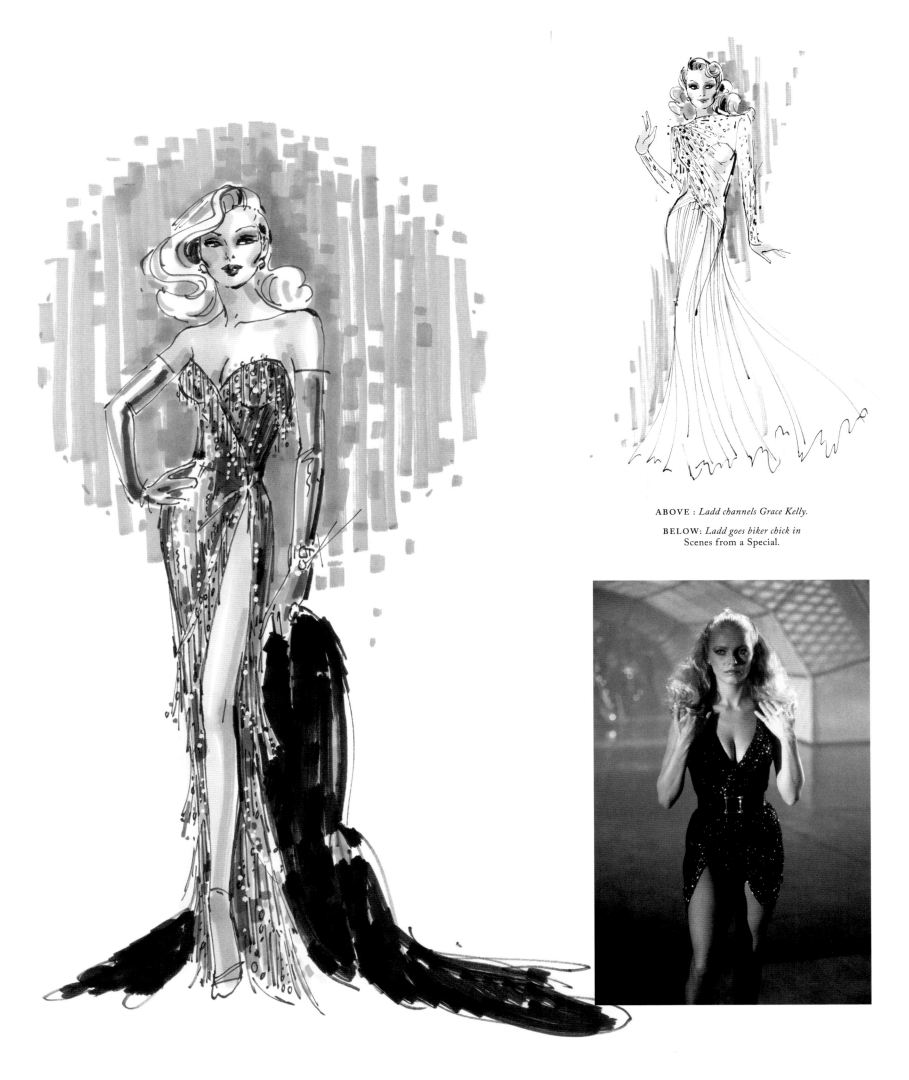

ABOVE : *Ladd channels Grace Kelly.*

BELOW: *Ladd goes biker chick in*
Scenes from a Special.

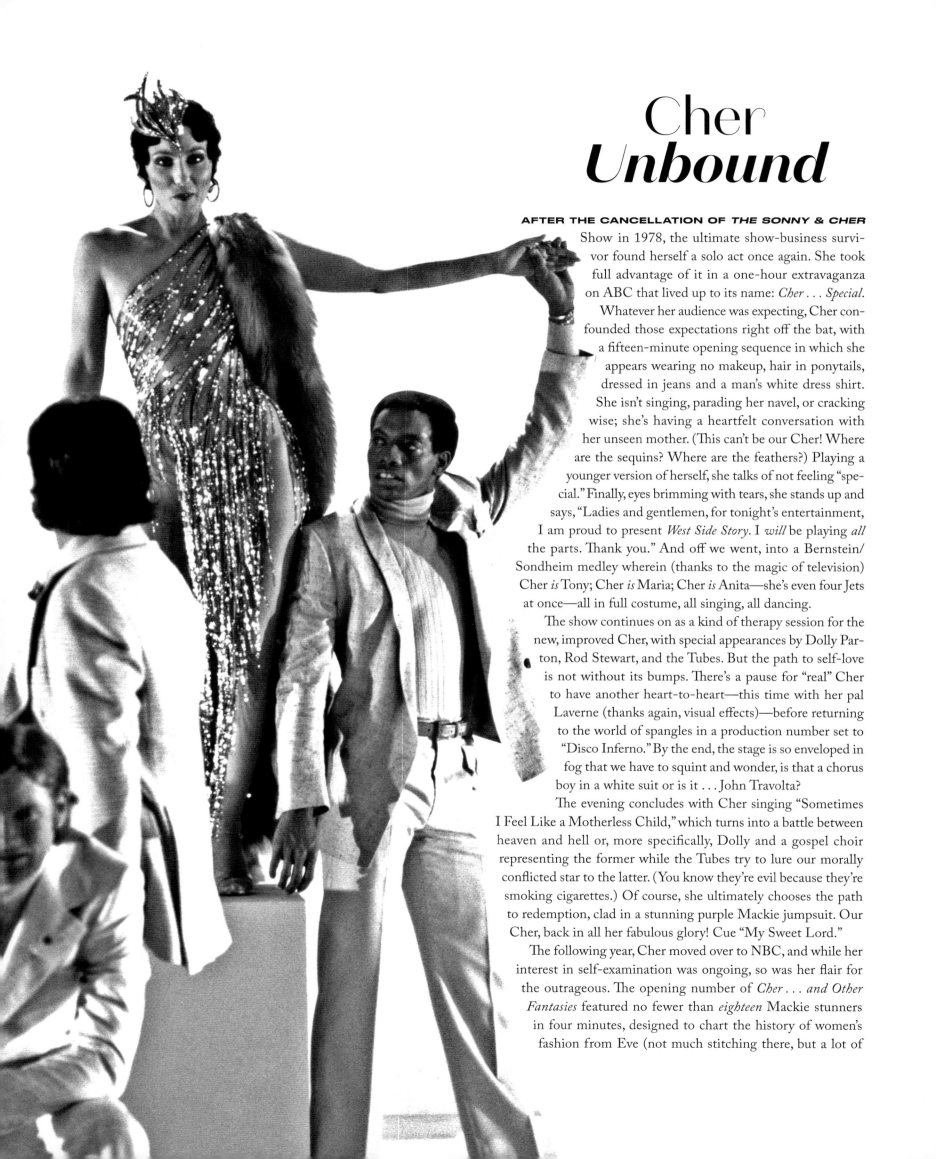

# Cher
# *Unbound*

**AFTER THE CANCELLATION OF** *THE SONNY & CHER*
Show in 1978, the ultimate show-business survivor found herself a solo act once again. She took full advantage of it in a one-hour extravaganza on ABC that lived up to its name: *Cher . . . Special.* Whatever her audience was expecting, Cher confounded those expectations right off the bat, with a fifteen-minute opening sequence in which she appears wearing no makeup, hair in ponytails, dressed in jeans and a man's white dress shirt. She isn't singing, parading her navel, or cracking wise; she's having a heartfelt conversation with her unseen mother. (This can't be our Cher! Where are the sequins? Where are the feathers?) Playing a younger version of herself, she talks of not feeling "special." Finally, eyes brimming with tears, she stands up and says, "Ladies and gentlemen, for tonight's entertainment, I am proud to present *West Side Story.* I *will* be playing *all* the parts. Thank you." And off we went, into a Bernstein/ Sondheim medley wherein (thanks to the magic of television) Cher *is* Tony; Cher *is* Maria; Cher *is* Anita—she's even four Jets at once—all in full costume, all singing, all dancing.

The show continues on as a kind of therapy session for the new, improved Cher, with special appearances by Dolly Parton, Rod Stewart, and the Tubes. But the path to self-love is not without its bumps. There's a pause for "real" Cher to have another heart-to-heart—this time with her pal Laverne (thanks again, visual effects)—before returning to the world of spangles in a production number set to "Disco Inferno." By the end, the stage is so enveloped in fog that we have to squint and wonder, is that a chorus boy in a white suit or is it . . . John Travolta?

The evening concludes with Cher singing "Sometimes I Feel Like a Motherless Child," which turns into a battle between heaven and hell or, more specifically, Dolly and a gospel choir representing the former while the Tubes try to lure our morally conflicted star to the latter. (You know they're evil because they're smoking cigarettes.) Of course, she ultimately chooses the path to redemption, clad in a stunning purple Mackie jumpsuit. Our Cher, back in all her fabulous glory! Cue "My Sweet Lord."

The following year, Cher moved over to NBC, and while her interest in self-examination was ongoing, so was her flair for the outrageous. The opening number of *Cher . . . and Other Fantasies* featured no fewer than *eighteen* Mackie stunners in four minutes, designed to chart the history of women's fashion from Eve (not much stitching there, but a lot of

strategically placed hair) up through the present. The penultimate look reprises Cher's nude-look Met Gala stunner, but it's just a prologue to number eighteen: the gold Viking jaw-dropper from the cover of her recently released album *Take Me Home*.

Going high concept yet again, Cher then finds herself in a blind alley behind an abandoned building. She meets a painter played by Elliott Gould (odd guest star number one), who guides her as she explores various doorways in an attempt to exit this dreamscape. One room she stumbles into is inhabited by a skate-maker who transforms her into a roller disco queen (she's very impressive on wheels, by the way); another door leads her into the Garden of Eden, where Andy Kaufman (odd guest star number two) portrays Adam to her snake. So, who plays Eve this time? Laverne, of course. Next, Cher encounters Shelley Winters (three for three) and, finally, a cleaning lady—played by Lucille Ball with several blacked-out teeth—who helps her see that the only kind of magic that matters in 1979 is . . . DISCO!

OPPOSITE: *Cher's "Take Me Home" gown, and some idol worship by the dance ensemble in* Cher . . . and Other Fantasies.

BELOW, LEFT AND RIGHT: *Cher as Roller Boogie Queen.*

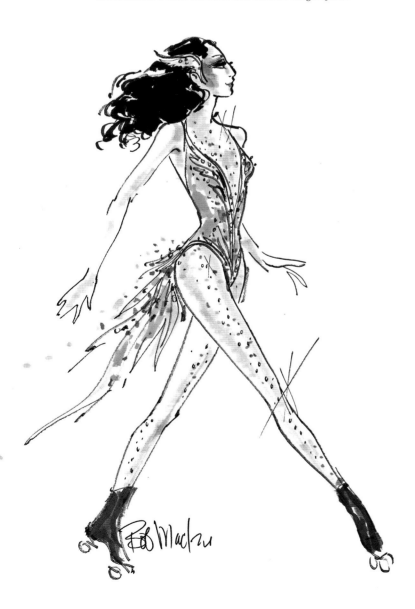

*The show continues on as a kind of therapy session for the new, improved Cher, with special appearances by Dolly Parton, Rod Stewart, and the Tubes.*

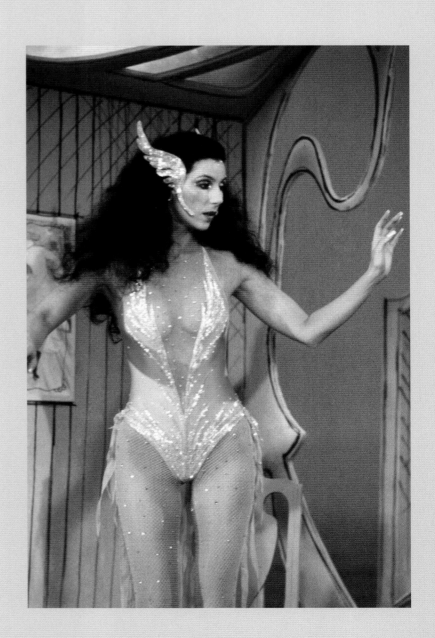

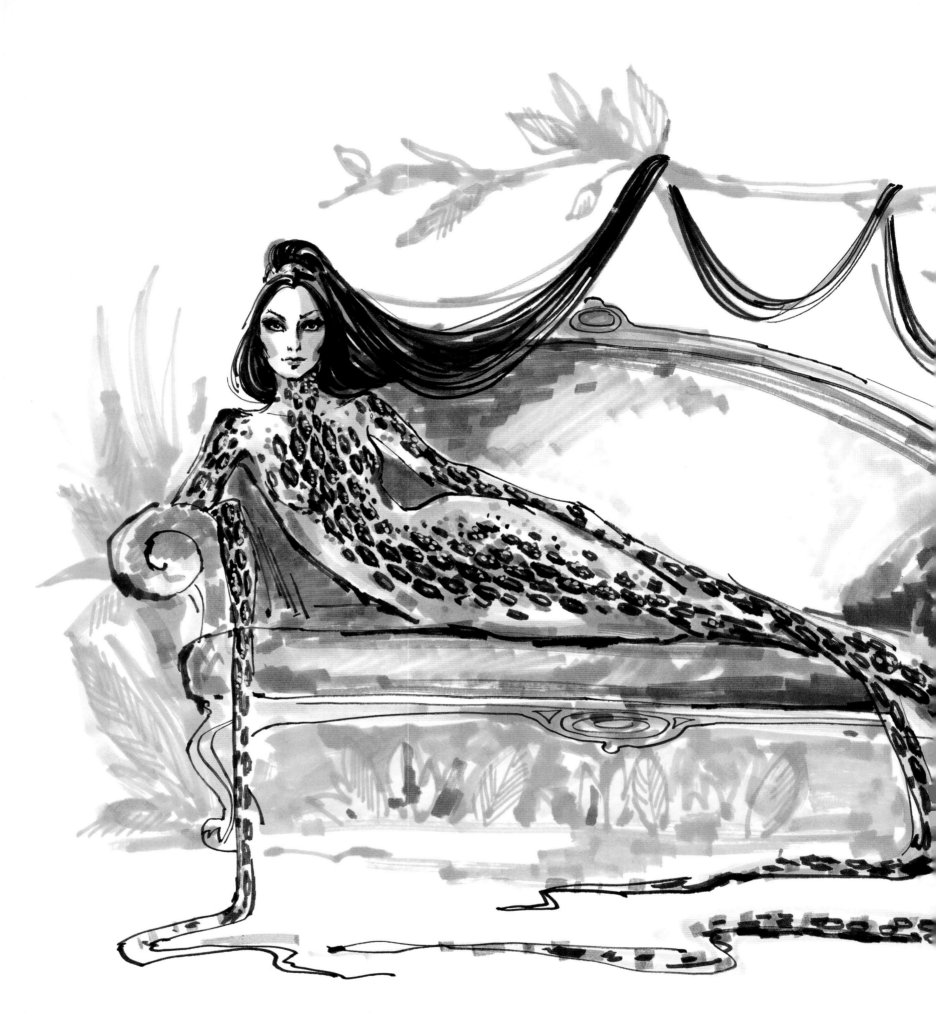

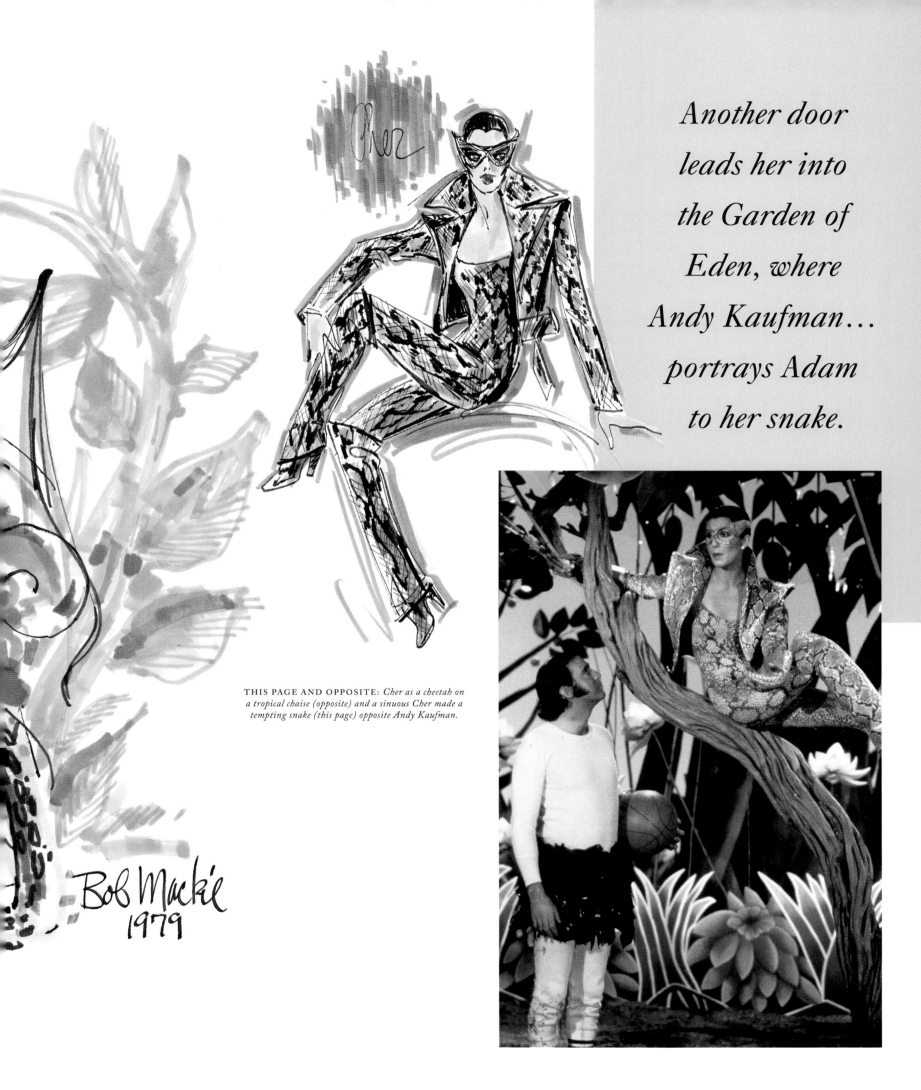

*Another door leads her into the Garden of Eden, where Andy Kaufman… portrays Adam to her snake.*

**THIS PAGE AND OPPOSITE:** *Cher as a cheetah on a tropical chaise (opposite) and a sinuous Cher made a tempting snake (this page) opposite Andy Kaufman.*

Bob Mackie
1979

# *Lynda* Struts Her Stuff

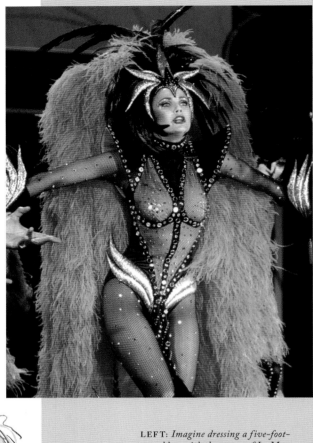

**TO AN ENTIRE GENERATION OF ADOLESCENT BOYS (AND** perhaps a few others), Lynda Carter will forever be synonymous with Wonder Woman, the iconic DC Comics crimefighter she played on TV for much of the 1970s. Less well known is her passion for singing everything from rock and roll and country-western to the Great American Songbook.

Between 1980 and 1984, Carter starred in five television specials, fielding such supporting talent as Tom Jones, Merle Haggard, Ben Vereen, Kenny Rogers, Ray Charles, and tennis legend Chris Evert, who showed viewers the finer points of her game while Lynda sang Pat Benatar's "Hit Me with Your Best Shot." Unlike other variety shows of the genre's golden age, Carter's tended to stick to the music, unspooling like hour-long concerts with minimal banter.

For her second, third, and fourth specials, she enlisted Mackie to create some truly stunning evening gowns for her, as well as a series of outfits for a fantasy sequence in which she portrayed three of her rock-and-roll idols: Tina Turner, Bette Midler, and Gene Simmons of KISS. To embody that last one, she descended from spiderweb scaffolding in full shock-glam mode, belting out the band's "I Was Made for Lovin' You." Thankfully, as this was the family hour, there was no blood-spitting.

Mackie recalled his collaboration with Carter fondly. "I love dressing a woman like Lynda. She's utterly gorgeous and looks fantastic in anything. The funny thing I'll always remember is that Walter Painter won an Emmy for his choreography of the second special I worked on [1981's *Celebration*]. Now . . . Lynda is a terrific singer, but I don't remember her ever really dancing, per se, in the way Ann-Margret would. She was more of a 'strutter,' like a curvy Mick Jagger. She'd just get out there and strut. And look fabulous doing it."

**LEFT:** *Imagine dressing a five-foot-ten goddess with the curves of Le Mans. Oh, the possibilities. Oh, the yardage.*

**ABOVE:** *Carter as a member of the rock group KISS in the "Rock and Roll Fantasy" sequence of* Encore.

**BELOW:** *Carter and jazz saxophonist John Phillips team up on a swinging version of "Cloudburst" in 1980.*

**OPPOSITE:** *The world's sexiest superhero swapped girl power for glamour in her three variety specials.*

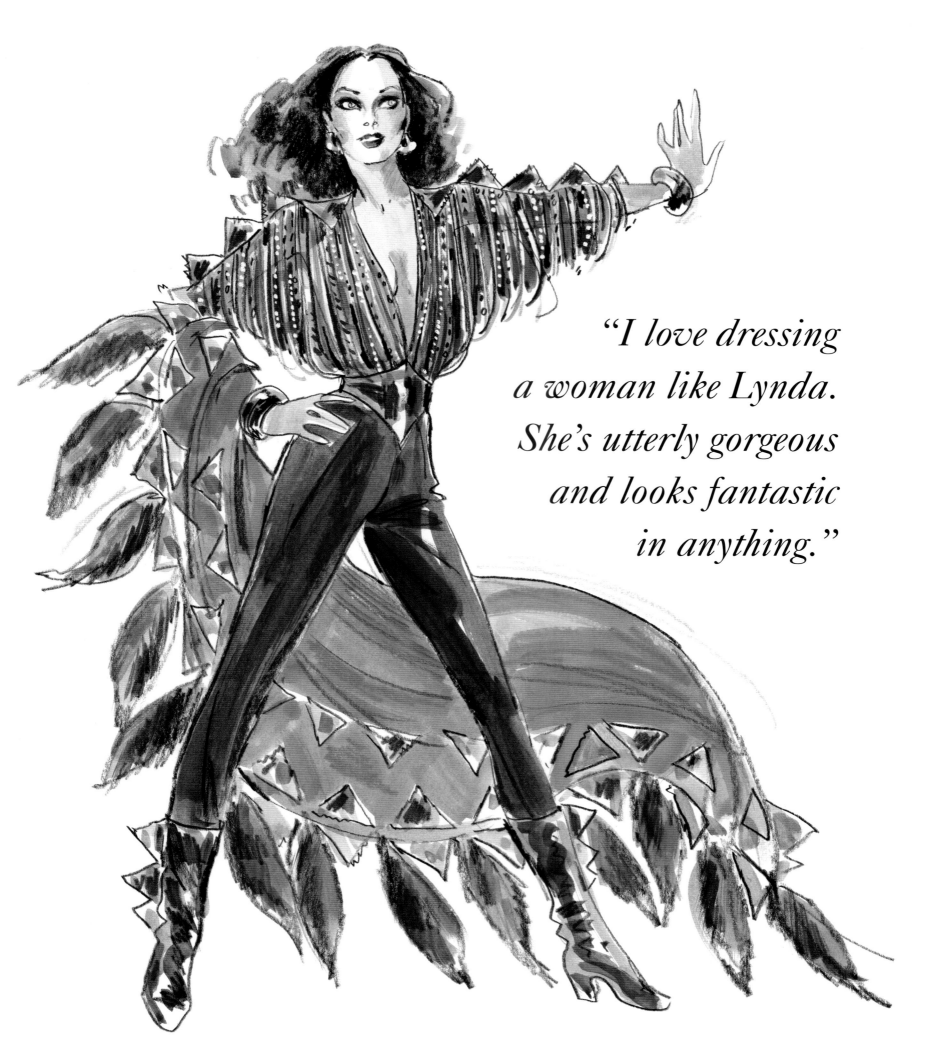

"I love dressing
a woman like Lynda.
She's utterly gorgeous
and looks fantastic
in anything."

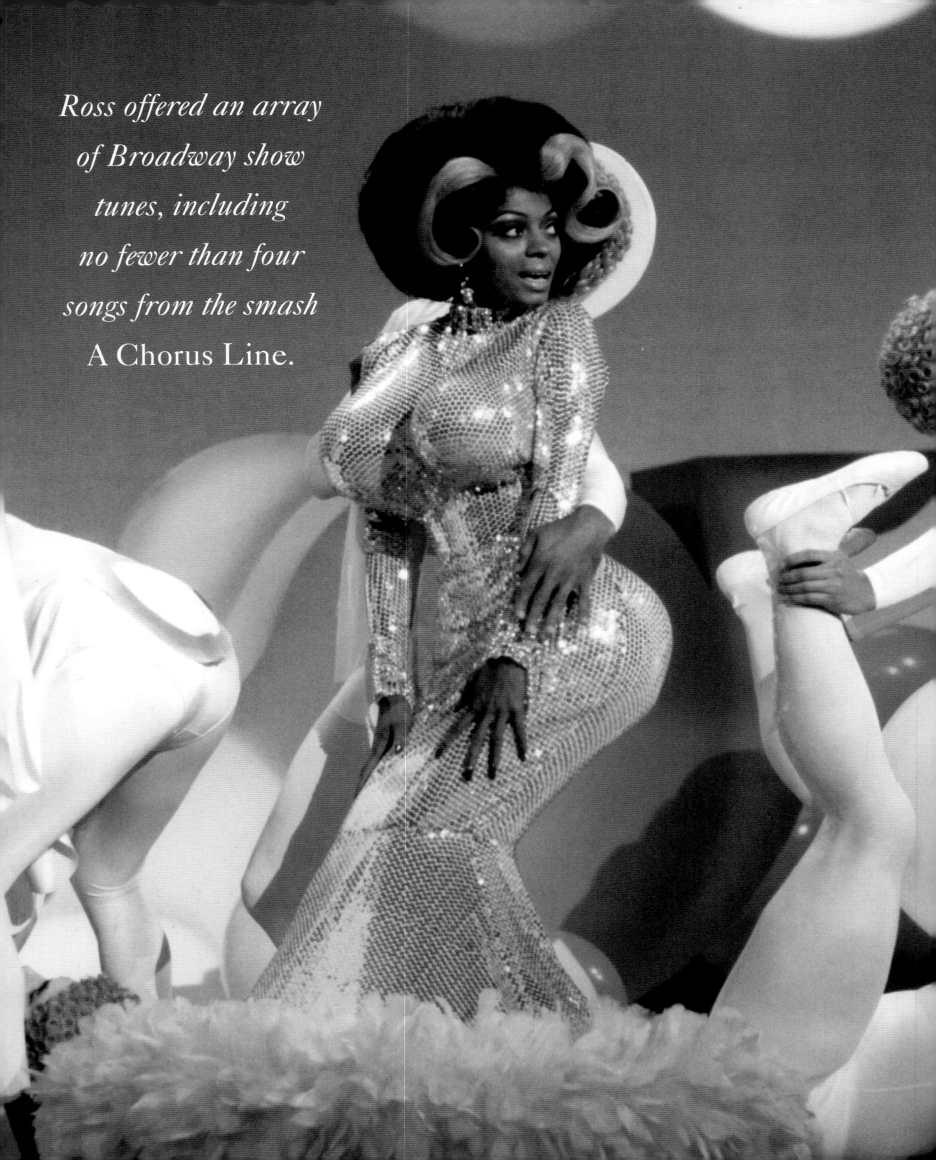

Ross offered an array of Broadway show tunes, including no fewer than four songs from the smash A Chorus Line.

# Diana *Transcendent*

**AN EVENING WITH DIANA ROSS, A TELEVISED VERSION OF** the by-then-Oscar-nominated superstar's 1976 one-woman Broadway concert, found the Motown diva at a crossroads. Ross was in the process of professionally separating from her former lover/producer Berry Gordy (they had separated romantically several years earlier), and her latest film, *Mahogany*, was a critical disappointment—though it did yield a number one *Billboard* hit in "Do You Know Where You're Going To?"

Filmed at the Ahmanson Theatre in Los Angeles the previous September, the ninety-minute special aired on NBC and consisted of equal parts concert footage and filmed sequences, which allowed Mackie to create yet more elaborate costumes for the star. In addition to the expected knockout gowns, he was tasked with transforming Miss Ross into some of the idols of her youth, from Billie Holiday singing "God Bless the Child" to Bessie Smith, Ethel Waters, and Josephine Baker. At one point, the four icons converse with one another, in dialogue written by Ntozake Shange, the Tony-nominated author of *For Colored Girls Who Have Considered Suicide / When the Rainbow Is Enuf.* The sequence is startlingly powerful, thanks to Mackie's work and that of makeup legend Stan

Winston (both would bag Emmy nominations), as well as Ross's superb acting. Trust us when we tell you that the star is completely unrecognizable from moment to moment.

In addition to performances of her own hits—including the most recent one (and thumbnail of her personal woes), "Love Hangover"—Ross offered an array of Broadway show tunes, including "The Lady Is a Tramp," "Send in the Clowns," "Home" (from *The Wiz*, the movie version of which she would soon start filming), and no fewer than four songs from the smash *A Chorus Line*. After strolling through the audience so she could "reach out and touch" every last hand, Ross offered a live rafter-raising finale of "Ain't No Mountain High Enough," signaling to viewers around the world that—whatever a few cranky movie critics might think—Miss Ross was definitely still boss.

---

RIGHT: *Diana Ross's 1976 TV special, along with a new album, a series of sellout Broadway concerts, and the film* Mahogany *(mixed reviews aside), proved there was no world the diva couldn't conquer—including that of high fashion.*

BELOW: *Looks for Ross's tributes to her show business forebearers (clockwise from right) Ethel Waters, Bessie Smith, and Josephine Baker. Just imagine what Mackie might have designed for the real Baker.*

OPPOSITE: *Ross in her* A Chorus Line *period, putting a comic twist on that show's "Dance: Ten, Looks: Three."*

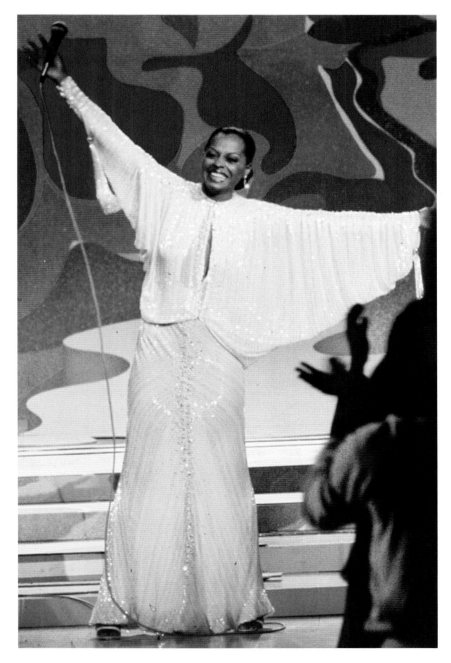

# *Goldie* Comes Home

**AFTER APPEARING IN SUCH FILMS AS** *THE SUGARLAND Express* and *Shampoo*, Goldie Hawn was drawn back to television for an hour-long variety special guest-starring John Ritter and Shaun Cassidy, then both A-list stars on ABC. The show aired in March 1978, and Mackie's work proved an indispensable element of its winning formula.

Hawn's persona now polished to perfection and her comic film chops and box-office appeal amply proven by the hit movie *Foul Play*, she wanted to remind audiences of her roots as a singer, dancer, and sketch comedienne. She opened with the Cy Coleman/Dorothy Fields song "Nobody Does It Like Me" from the Broadway musical *Seesaw* (she'd been one of the names bandied about when a movie version was briefly discussed), demonstrating that she had come a long way since the similarly themed number she'd demolished with her klutziness in her previous variety showcase.

Hawn was a mom now, having given birth to son Oliver Hudson two years earlier. (Daughter Kate was still in the wings.) She had earned a little time for self-reflection. After a sequence with George Burns, for whom she proved

the best comic foil since Madeline Kahn stole Gracie Allen's title in 1976, Hawn launched into the absolute highlight of the hour: a medley of pop songs of the 1960s bookended by the Beatles' "Yesterday." Paying tribute to her beginnings as a caged go-go dancer at the Peppermint Lounge in East Orange, New Jersey, the eight-minute song-and-dance delight showcased Hawn's still acute mastery of the twist, the Watusi, the monkey, the jerk, and the swim, as staged by *Grease* choreographer Patricia Birch. A fashion parade of five fabulously funky Mackie looks—one for each dance craze—was the height of "mod," as warped by the lens of the late 1970s and Mackie's wicked sense of satiric detail.

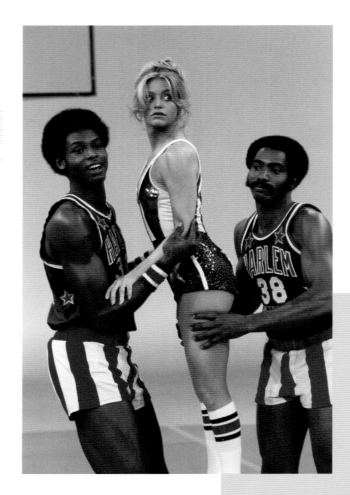

LEFT: *One of Hawn's costumes for the 1978 Goldie Hawn Special. Her guest stars included John Ritter, at that time the fastest rising comedy star on television, and Shaun Cassidy.*

RIGHT AND BELOW: *The design for Hawn's production number with the Harlem Globe Trotters, set to the Randy Newman hit "Short People."*

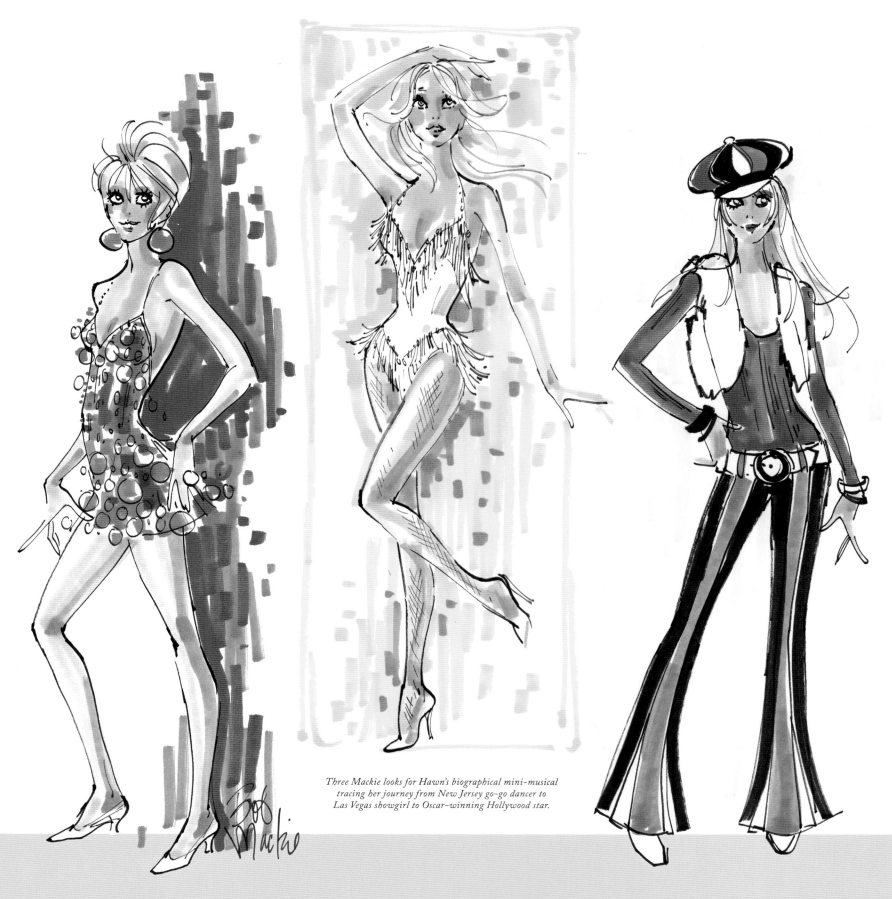

*Three Mackie looks for Hawn's biographical mini-musical tracing her journey from New Jersey go-go dancer to Las Vegas showgirl to Oscar-winning Hollywood star.*

*A fashion parade of five fabulously funky Mackie looks—one for each dance craze—was the height of "mod."*

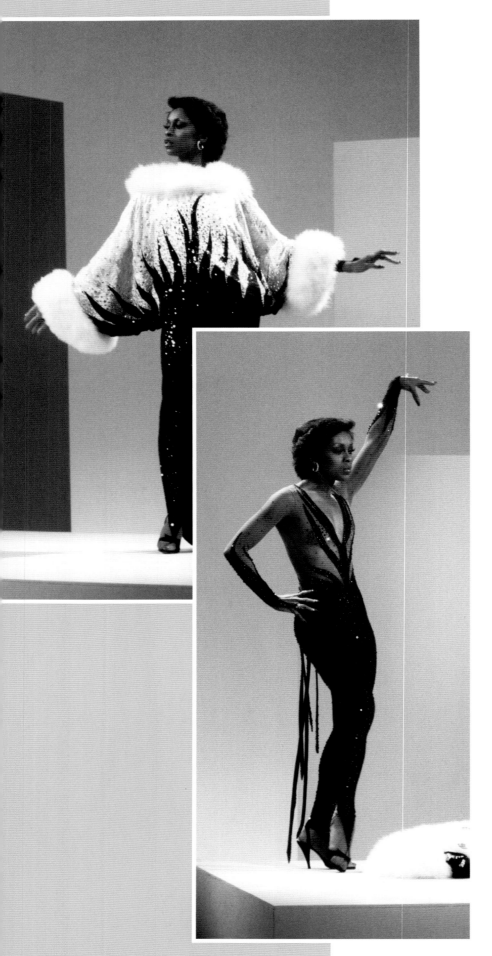

# Whatever *Lola* Wants

**THE FIREBALL OF TALENT KNOWN AS LOLA FALANA CAUGHT** a big break in 1964, while laboring in the chorus of the Broadway musical *Golden Boy*. Its star, Sammy Davis Jr., recognized her gifts and mentored her right into a recording contract the following year.

While rising to prominence in Italian cinema—where she became known as the Black Venus—and playing a few roles in American films and television shows, Lola continued to tour with Davis until 1969. At that point, although there was no love lost between them, the young dynamo felt she'd better strike out on her own or she'd be stuck in her mentor's shadow forever. It was off to Las Vegas, where she would become a major headliner for the next decade, thanks to her powerful voice and exhilarating dance routines incorporating Broadway, jazz, disco, and the African dance vocabulary she'd studied way back in her youth in Camden, New Jersey.

Mackie and Aghayan frequently worked in tandem on Lola's spectacular wardrobe, though the clothes for her eponymous 1975 variety series was all Ray ... Bob had a lot of other ladies on his to-do list that year.

The one creation that was pure Mackie was for Lola's turn in a 1980 reboot of the arts special *Omnibus*. Hosted by Hal Holbrook, the show's other acts included a segment of then-smash *Peter Pan* starring Sandy Duncan, live from the Lunt-Fontanne Theatre; and a tap duet by legendary MGM hoofer Gene Kelly and Pittsburgh Steeler Lynn Swann. As starry as the event was, every review spent some ink on the fashions by Mackie and his former boss, Edith Head. While Head's contributions consisted of re-creations of her famous costumes for Mae West and Ginger Rogers from the 1930s to '50s, Mackie brought a fresh and smashing design to the party, inspired by his muses du jour, Carol, Cher, and Ann-Margret.

At the show's climax, Lola appeared in a black beaded floor-length gown trimmed in white fur. Once the audience members' eyes had adjusted, she reached back and unhooked a tiny catch between her shoulder blades, and the dress dropped to the floor, revealing a daring, curve-clutching catsuit with every sequin strategically and perfectly placed.

Gasp.

Mackie explained his strategy with a question as rhetorical as they come: "Why design only *one* costume when I can design two?"

---

THIS PAGE AND OPPOSITE: *Lola Falana in her magical morphing outfit for* Omnibus *in 1980.*

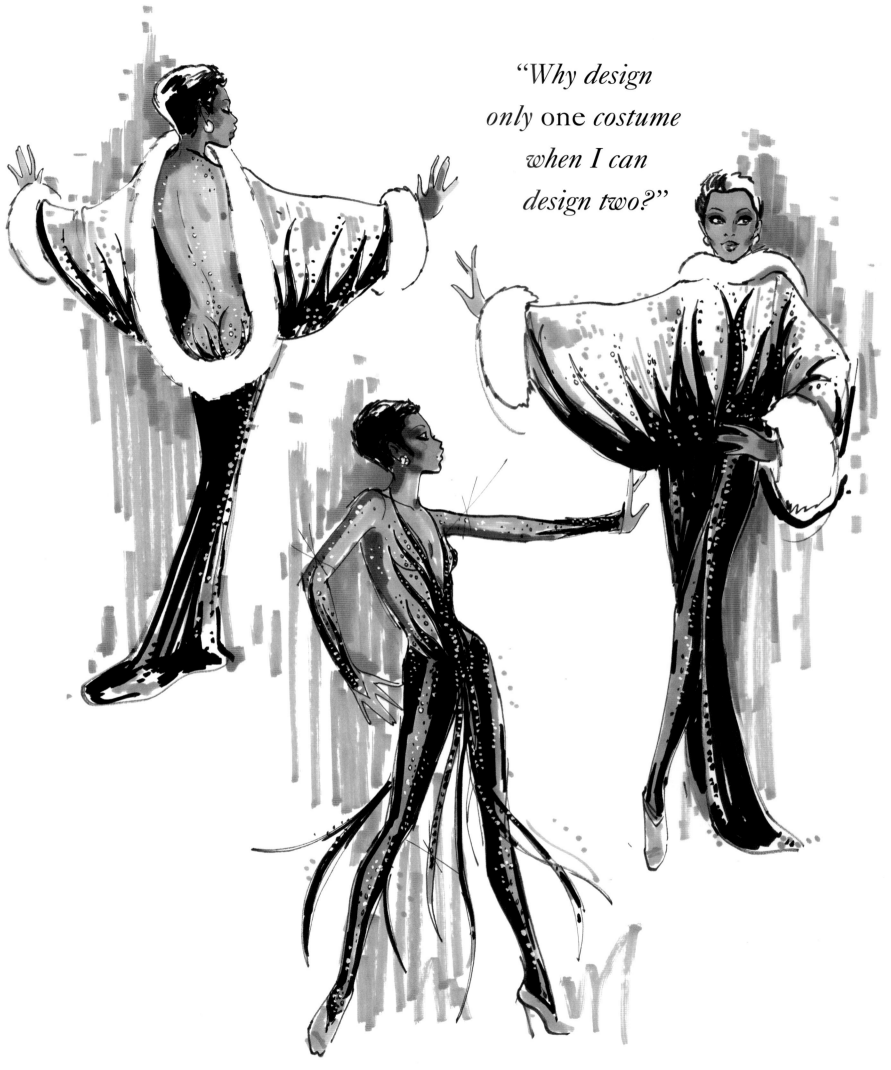

"*Why design only* one *costume when I can design two?*"

# Divine *Madness*

**THE 1977 NBC SPECIAL *OL' RED HAIR IS BACK* MARKED THE** introduction of everyday Americans to the high-energy, sometimes tasteless, but always entertaining and multitalented Bette Midler. Of course, she had appeared on *The Tonight Show Starring Johnny Carson*, *The David Frost Show*, and various awards shows by this time—and had made a legendary appearance on Cher's variety show (where she and fellow guest star Elton John first worked with Bob Mackie). She had also headlined her own special on what was then known as "Home Box Office," essentially a filmed concert stop in Cleveland. But the NBC special would be wall-to-wall "Divine Miss M" on the peacock network, for all those viewers who might have heard her top-selling record albums but had no idea about her rise as a replacement in *Fiddler on the Roof* on Broadway or her descent into the basement of New York's Ansonia apartments, where she held court among the towel-clad denizens of the Continental Baths accompanied by a skinny piano player from Brooklyn named Barry Manilow.

Like many specials of its era, *Ol' Red Hair* included both live performances in front of a studio audience and pretaped segments. It included many elements of Midler's regular act, softened for viewers who would have called the network in an uproar if Bette had launched into one of her classically explicit "Sophie" jokes.

Inspired by Midler's early life in Hawaii, the special kicks off with a group of fishermen on "a peaceful island somewhere in the South Pacific" who snag an enormous clam shell. It opens and—voilà—there she is, in a stupendously wacky Mackie, a bikini covered with strands of pearls. Instead of singing "Bali Ha'i," as might be expected, Midler launches into another Rodgers and Hammerstein classic, the title song from *Oklahoma!*—and the offbeat tone is set.

Thanks to a writing staff that included Bruce Vilanch, *Dreamgirls* book writer Tom Eyen, and Carson/*Get Smart* scribe Pat McCormick, the show was warped, fast-paced, and possibly mystifying to much of the mainstream viewing public. (In a coded message to hard-core fans, she demands at one point, "Pass the brownies, Harry!")

Guest stars included Dustin Hoffman, playing the piano like a virtuoso; sad clown Emmett Kelly; and, of course, Midler's naughty, bawdy backup singers, the "Staggering Harlettes." It could be said (so we are saying it) that the show was stolen by its unseen star, Bob Mackie, who turned the outrageous Midler into a bona fide swan in a stunning red floor-length gown, setting the mood for a completely straight—and completely captivating—rendition of "La Vie en Rose." This was a far cry from the performer whom Johnny Carson famously noted "dresses like a stolen car."

---

ABOVE: *Bette Midler in a "Galliano" bugle-beaded gown, with legendary clown Emmett Kelly.*

LEFT: *Midler in a cherry-strewn number from the Ray Aghayan/ Bob Mackie evening gown line from the 1970s.*

OPPOSITE: *Midler conjures up her childhood in Honolulu for the opening of her 1977 variety special* Ol' Red Hair Is Back.

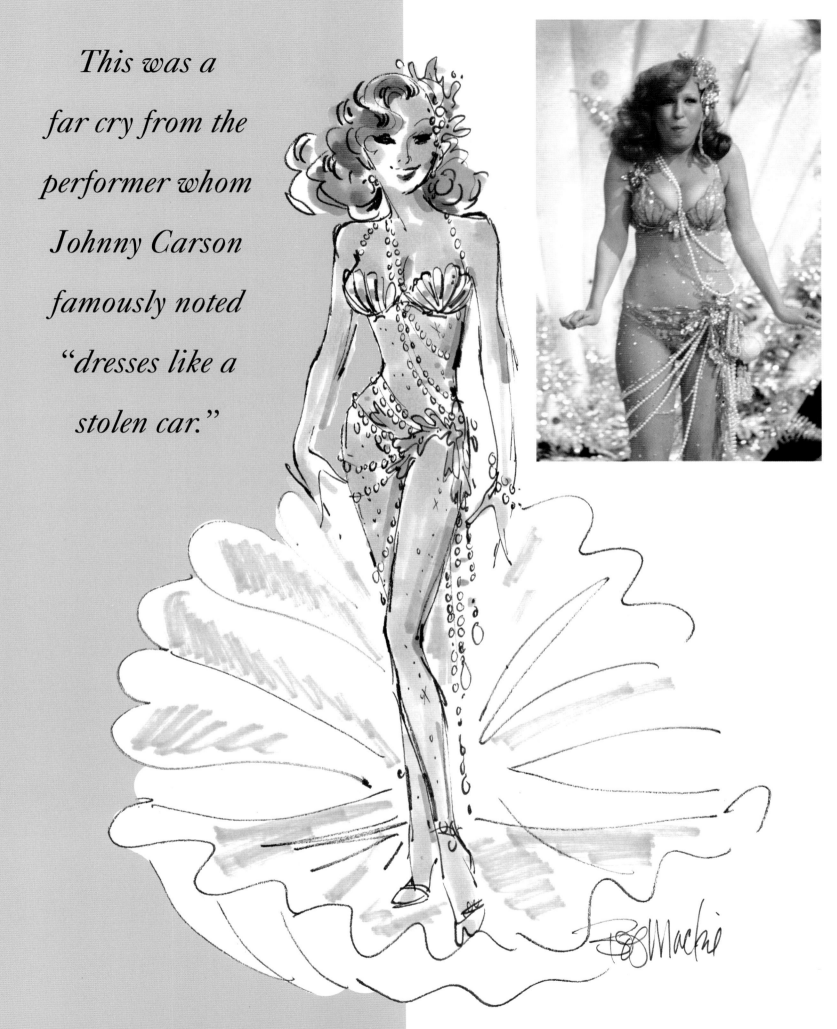

This was a far cry from the performer whom Johnny Carson famously noted "dresses like a stolen car."

# Songs of *Bernadette*

**WHEN WE ASKED BOB MACKIE HOW HE APPROACHES THE** curves of the ageless, adorable Bernadette Peters, he answered with one word: "Carefully."

Bernadette Lazzara, from Ozone Park, Queens—just a subway ride from Broadway—started her career at the age of three, soon took her father's first name as her stage surname, and by the time she was nineteen, was playing Joel Grey's kid sister on Broadway, in the musical *George M!* She followed that up with a true star-making performance Off Broadway in the 1930s musical spoof *Dames at Sea.* Her dancing, singing, and flair for period comedy attracted the attention of many people, including Carol Burnett—and that led her directly to Bob Mackie. As she described it, "I first met Bob when I was on the *Burnett Show* and fell in love with him. I was doing a lot of summer stock at the time, and as I was preparing to go off to do some show, Bob asked, 'What will you wear?' I said, 'Oh, they have wardrobe and seamstresses and things.' 'I think I'd better send you off with a few things,' he said—and thank goodness he did!"

Cut to the present and a working friendship spanning over fifty years. In fact, Bob has been designing for Bernadette longer than any other performer besides his two stalwarts, Carol B. and Mitzi G.

Said Bob, "I feel like I've designed for Bernadette in every medium there is: television, movies, Broadway, nightclubs, Carnegie Hall, Radio City, the Oscars. I even designed her wedding dress! She's just the kindest, most thoughtful person—and gorgeous, inside and out."

As much as Mackie adores designing the outrageous clothes for Cher, the wacky movie spoofs for Carol, and the glamorous yet indestructible dancewear for Mitzi Gaynor, he particularly relishes the special challenges of designing for Bernadette: her diminutive stature and Vargas-girl shape.

Peters: "I've heard people say that when I wear a dress designed by Bob, they like to take bets on whether or not it'll stay up. I have two reasons it will."

One of the last remaining true Broadway stars, Peters has been gracing its stages with her ineffable charm and multiple gifts for seven decades. She's a performer who can break your heart one second, then take a deep breath and, with one sultry pout, wrap the entire audience around her little finger. "Irresistible" isn't too strong a word.

Case in point: When Mackie was awarded the 2019 CFDA Geoffrey Beene Lifetime Achievement Award, he asked Peters to present it. She said she would be thrilled and honored, but she'd need something new to wear. The busy designer explained that he was completely exhausted, what with all of the Tony, Drama Desk, and Outer Critics Circle hubbub he'd been caught up in thanks to *The Cher Show.* (The Tony Awards were coming up a mere six days after the CFDA ceremony.) "But Booooooooob," Bernadette cooed, "I don't have anything to wear!" Getting the not so subtle hint, Mackie picked up his pen and began to sketch.

She looked exquisite, of course.

FAR LEFT: *Peters in the 1970s, giving them the old razzle dazzle in top hat and black sequined Mackie.*

LEFT AND OPPOSITE: *Some of the many sketches Mackie has done for his client and friend over five decades.*

OPPOSITE RIGHT: *Peters and Mackie in the late 1970s, doing a fitting for her nightclub act.*

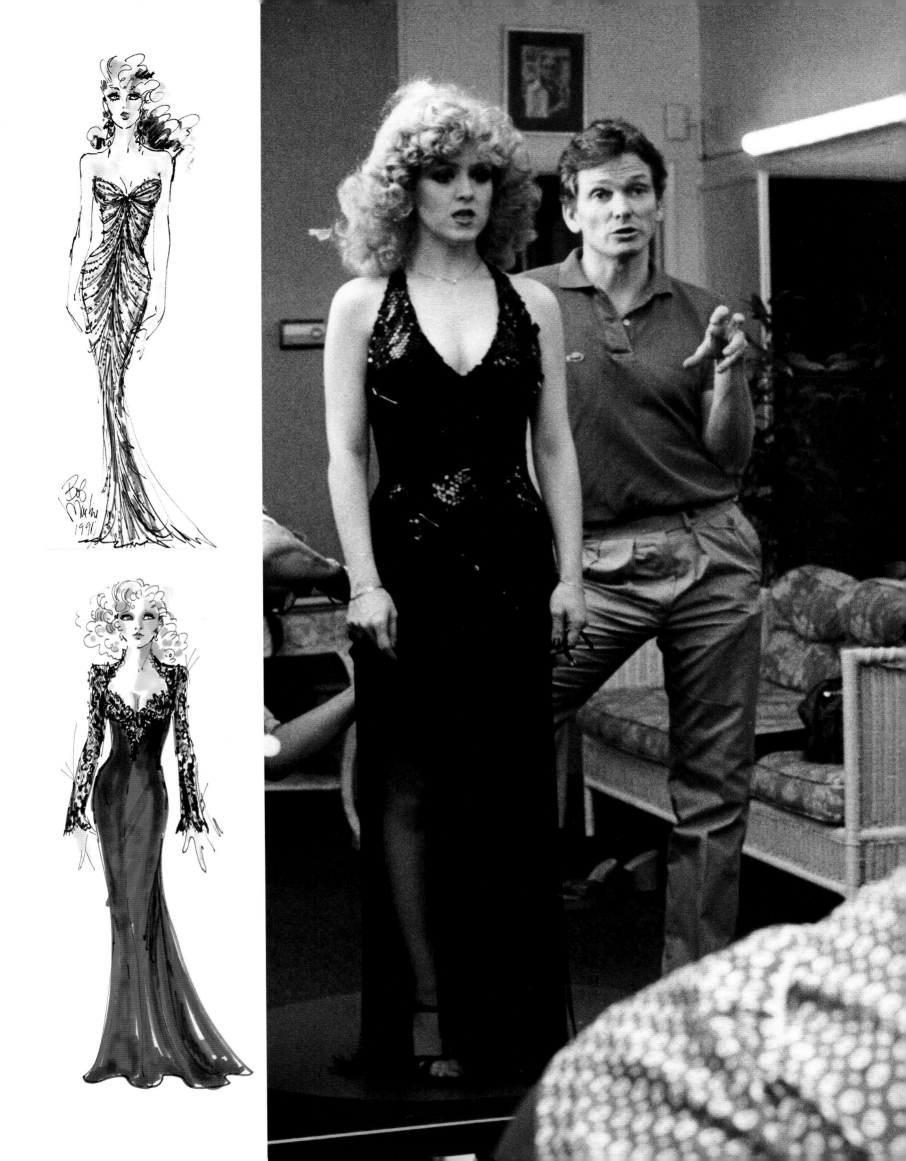

> *"I feel like I've designed for Bernadette in every medium there is: television, movies, Broadway, nightclubs, Carnegie Hall, Radio City, the Oscars. I even designed her wedding dress!"*

ABOVE, RIGHT, AND OPPOSITE LEFT:
*A trio of looks for Peters's 1981 nightclub act.*

TOP RIGHT: *An early 1980s portrait of the agelessly adorable Bernadette Peters.*

CENTER RIGHT: *Mackie executes a perfect Jack Benny "take" as he shares a laugh with Peters in the 1970s.*

BOTTOM RIGHT: *Now in her sixth decade of dressing in Mackie, Peters still dazzles.*

*"I've heard people say that when I wear a dress designed by Bob, they like to take bets on whether or not it'll stay up. I have two reasons it will."*

—Bernadette Peters

# Keeping It *Saucy*

**MACKIE: "BERNADETTE LOOKS GREAT IN CLOTHES FROM** another era. She's a modern woman, but she's not shaped that way. She can be a Kewpie doll, Carole Lombard, or a French tart."

When Peters was asked to pose for a spread in *Playboy* magazine illustrating the history of lingerie, she was insistent that Mackie join in the fun.

Peters: "I enjoyed that so much! I was never just standing there, posing. Each period had a separate ambience, so it was just like being onstage and acting!"

*Miss Peters in* Playboy, *wearing the prettiest unmentionables ever made.*

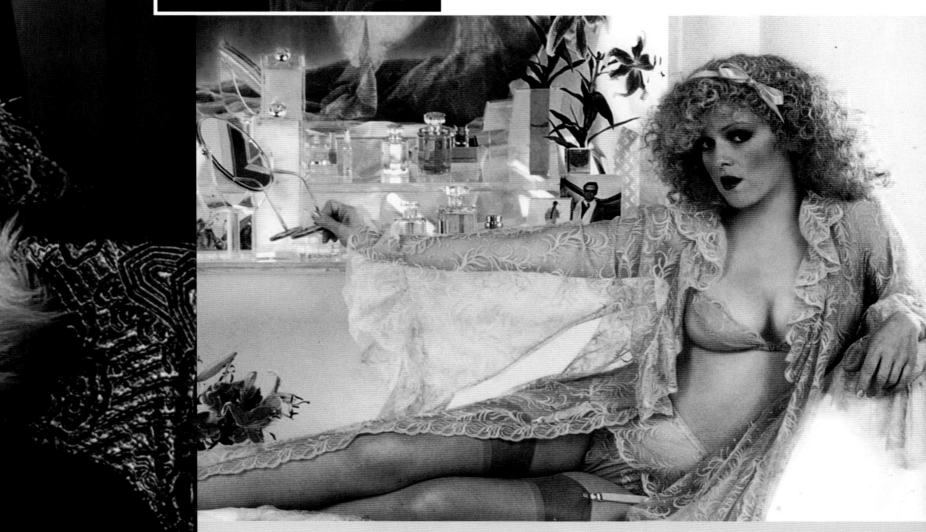

# Very Special *Mitzi*

**SAFELY ENSCONCED AT CBS BY THE MID-1970S, MITZI GAY-** nor continued her hot streak with a series of increasingly elaborate and glamorous specials, all directed and choreographed by a master of TV variety, Tony Charmoli, and designed by Bob Mackie with his signature flair.

One of the more peculiar in format was *Mitzi . . . A Tribute to the American Housewife,* consisting of skits about marriage in a high-brow vein. To perform songs from Stephen Sondheim's *Company,* Mitzi enlisted Ted Knight and Jerry Orbach, along with Suzanne Pleshette and Jane Withers—her first two female guest stars.

Mitzi's 1975 offering was called *Mitzi & 100 Guys,* and it was true to its name—sort of. The star-studded roster of gents enlisted for a classic "top hat and tails" number with Mitzi numbered only thirty-six, but another sixty-four specimens were corralled from the USC Trojan marching band. (What a missed opportunity for sponsorship by a condom company!) Along with veteran guests Mike Connors and Ken Berry, the special featured additional Mayberry residents Andy Griffith and Jim Nabors; the entire male contingent of *Mary Tyler Moore* (Ed Asner, Ted Knight, and Gavin MacLeod); the game show brigade (Allen Ludden, Monty Hall, Peter Marshall, and Tom Kennedy); and the classic song-and-dance team of Shatner and Nimoy. Live long, prosper, and step-kick.

The 1976 offering, *Mitzi . . . Roarin' in the '20s* (with guest stars Carl Reiner and . . . Ken Berry again, for the rare Gaynor triple), was state-of-the-art 1970s variety. Charmoli incorporated animation, green screen, and quick-cut editing, while Mackie, who never met a flapper he didn't like, went to town and won an Emmy. In *Mitzi . . . Zings into Spring* (1977), Gaynor was in classic form, but the threads were beginning to wear thin—on everything but the costumes, that is. Mackie would never allow that! Guest stars Wayne Rogers and Roy Clark were hardly on par with Carl Reiner, and the variety format itself was losing steam. Nonetheless, Mackie contributed some of his most amazing, jaw-dropping gowns and was deservedly awarded another Emmy.

Gaynor's final special, *Mitzi . . . What's Hot, What's Not,* proved prophetic. By now it was spring 1978, Carol Burnett and Cher were off the air, and CBS was about to prove incontrovertibly that variety was no longer "hot" by chalking up a colossal failure with a Mary Tyler Moore variety show. Mitzi's television career quietly came to a close after a very successful decade, but luckily for her and for us—and aided by stunning contributions from her friend Bob Mackie—she would continue to be a force in Las Vegas and nightclubs everywhere for the next forty years.

TOP LEFT: *Publicity shot for* Mitzi . . . A Tribute to the American Housewife.

LEFT: *The design for Gaynor's "Yankee Doodle Dandy" number.*

OPPOSITE: *Mitzi Gaynor, resplendent purple, in a publicity shot for her 1975 special,* Mitzi & 100 Guys.

OPPOSITE, INSET : *Mackie adjusts Gaynor's costume on the set of* Mitzi . . . Zings into Spring.

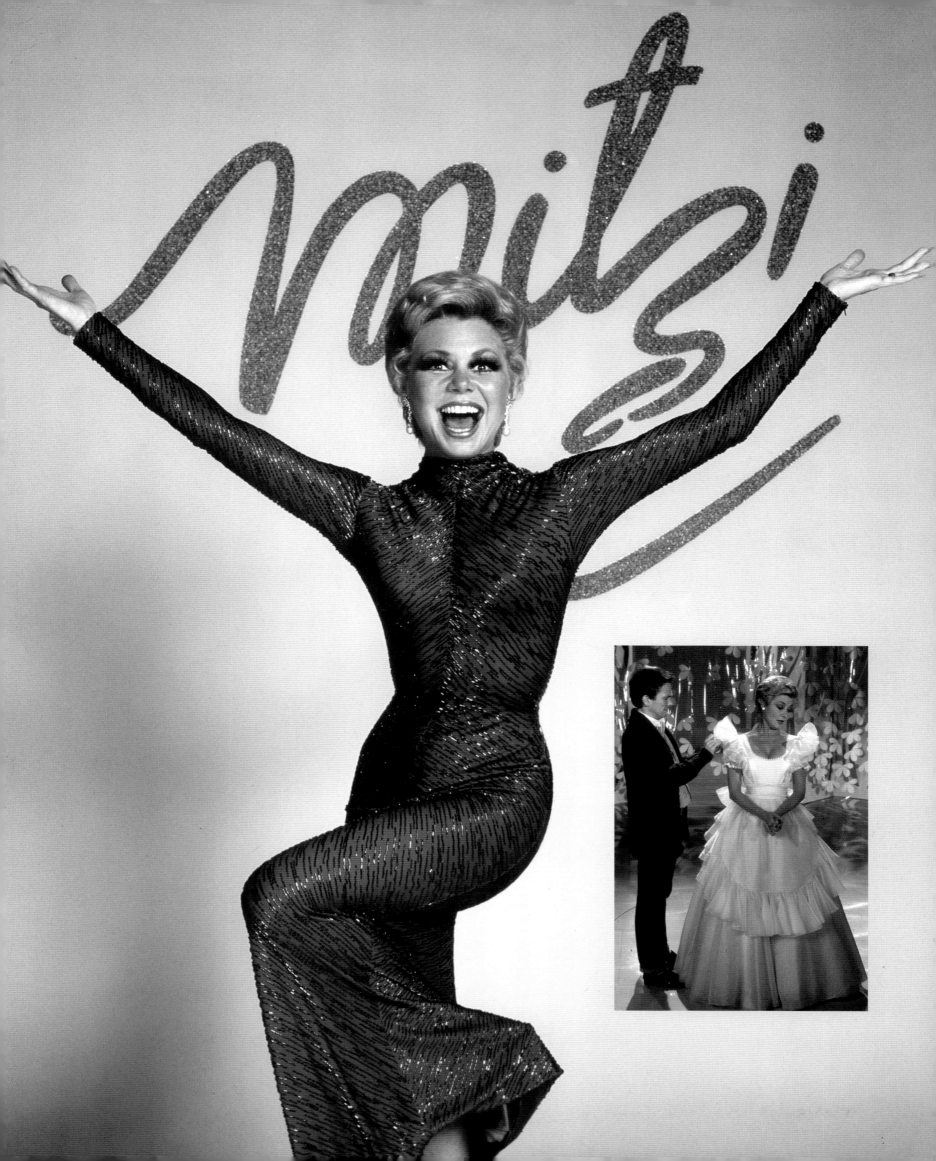

*Mackie contributed some of his most amazing, jaw-dropping gowns and was deservedly awarded another Emmy.*

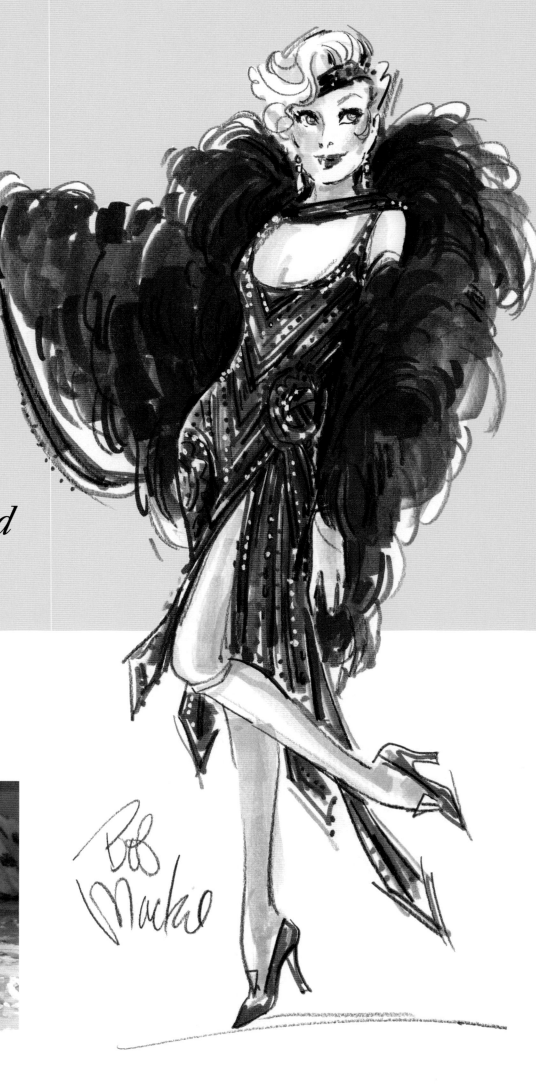

BELOW: Mitzi . . . Zings into Spring. *You don't want to know what that lamb did all over Mitzi's gown.*

RIGHT: *A particularly fabulous sketch for Gaynor's 1976 special* Roarin' in the '20s.

OPPOSITE TOP: *Fresh-as-a-daisy Gaynor and her boys in* Mitzi . . . Zings into Spring.

OPPOSITE BOTTOM: *Sketches for Gaynor's later specials.*

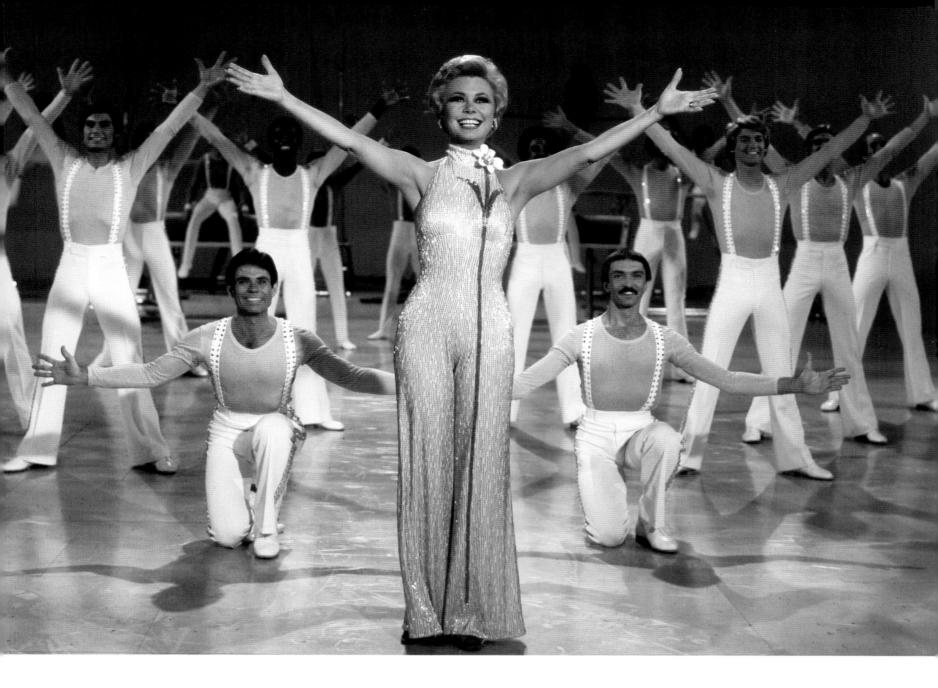

# *Odd* Couple

**THE 1980 CBS SPECIAL *GOLDIE AND LIZA: TOGETHER*** offered up an unlikely pairing, to say the least. Goldie Hawn was blond, goofy, and as perpetually sunny as the beach at Malibu, while Liza was a dark, dramatic denizen of the New York party scene, notorious for her all-nighters at Studio 54. The one thing they shared, beyond their supersized, mascaraed peepers, was the fact that they were both quadruple threats: Each of them could sing, dance, clown, and then turn on a dime to evoke great pathos with amazing ease. In the same way Julie Andrews and Carol Burnett had celebrated their differences in several successful specials, Hawn and Minnelli worked the contrast to dazzling effect.

"I've known Goldie since practically the day she arrived in California," Mackie recalled. "She was one of twelve girl dancers on a 1967 Andy Griffith special, and when they were dancing behind Andy, all you could see was Goldie Hawn. She was *so* unique and endearing, giggling and laughing and completely a star, and after one day of rehearsal, every writer and producer at CBS was saying, 'Hey, who's this new girl, Goldie?' Within a few months, she was a regular on a sitcom [the short-lived *Good Morning, World*], and you know what happened after that.

"As for Liza, I've known her since 1963, when she was seventeen and on her mother's show. She could sing and dance like a seasoned pro, of course, but in reality, she was just a little girl: insecure and unsure of herself. Of course, within a couple of years she became a huge star on Broadway. Next thing you know, I'm designing her wedding gown for her fourth marriage!"

The hour's finale gives the entire special its raison d'être and features Mackie at his best. Goldie and Liza step out in classic Mackie sequined flapper dresses and sing the hell out of "All That Jazz" from the Broadway musical *Chicago*. It was common knowledge at the time that both actresses were campaigning to do the film version of the Bob Fosse hit. The two dance and belt with such confidence that it's shocking one or the other didn't ink a deal the next morning. Of course, the film version of *Chicago* would circle the airport for another twenty years before it finally landed in theaters.

And regarding Liza's costume for the "All That Jazz" finale, as Facebook would say, "It's complicated." It actually *was* designed by Mr. Mackie, who has the sketches to prove it. Only the leotard underneath the bling was Halston's. But years later, when Minnelli auctioned off the creation, it was listed in the catalog as a Halston and Bonham's refused to issue a correction. Consider the record belatedly set straight.

*Believe it or not, Bob Mackie loves designing clown costumes—so he jumped at the chance to dress Goldie Hawn and Liza Minnelli for the Richard Maltby/David Shire show tune "One Step."*

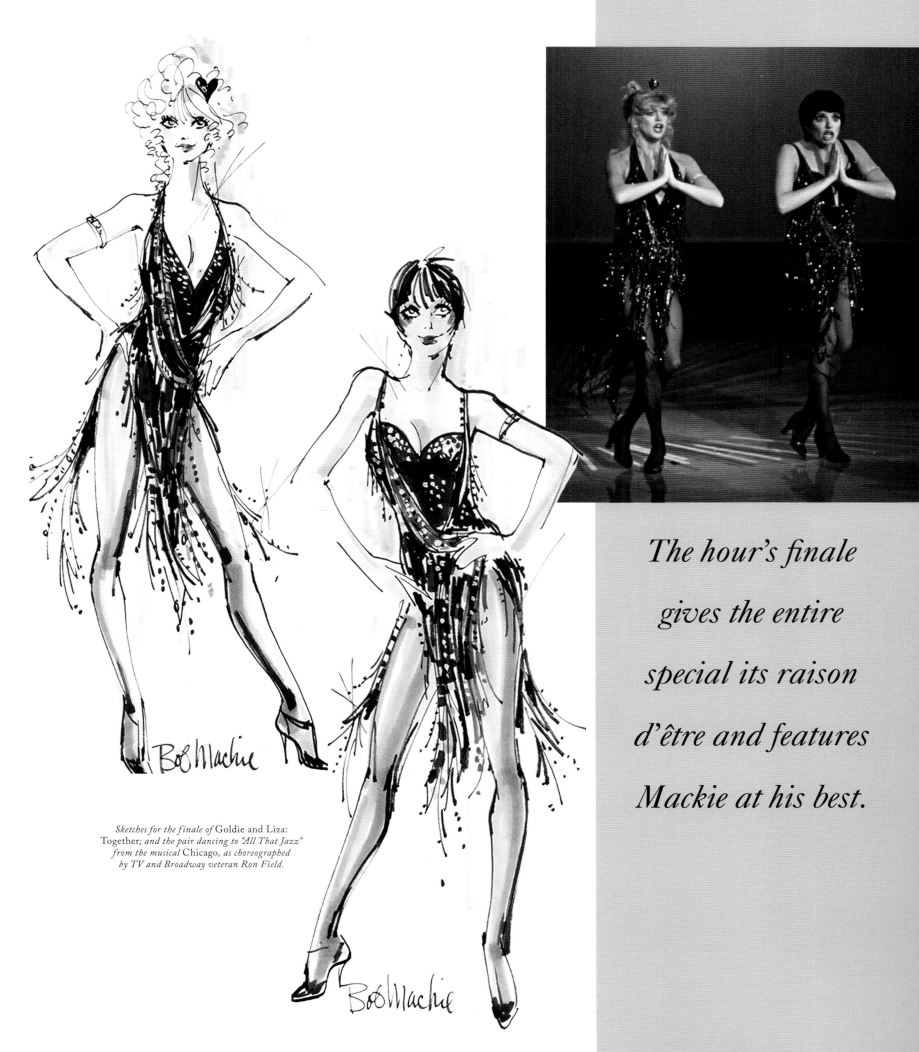

*Sketches for the finale of* Goldie and Liza: Together; *and the pair dancing to "All That Jazz" from the musical* Chicago, *as choreographed by TV and Broadway veteran Ron Field.*

*The hour's finale gives the entire special its raison d'être and features Mackie at his best.*

# *Bubbles* Meets *Burnett*

**JULIE ANDREWS AND CAROL BURNETT WERE GOOD FRIENDS** who happened to hold down opposite ends of the musical theater spectrum. Their pairing in two very successful TV specials got Beverly Sills thinking: "What if I reached out to that zany fellow redhead myself, and pushed the envelope a little farther?"

Sills (née Belle Silverman of Brooklyn, New York), was America's most famous and beloved soprano. She had been charming television audiences for years with her wit and warmth, guest-hosting *The Tonight Show Starring Johnny Carson* numerous times, and had finally made her Metropolitan Opera debut in 1975, after twenty years as the star of the New York City Opera. (The notorious Met general manager, Rudolf Bing, had snubbed the homegrown talent for nearly two decades in favor of European stars.) Perhaps as a Brooklyn version of a Bronx cheer aimed at the recently departed Bing, "Bubbles" pitched an idea to Burnett, whom she had never met: Let's team up for a TV special taped at the Met, with tickets priced from fifteen to twenty dollars and all proceeds going to the Met.

Carol, who had never met a challenge she didn't rise to, said yes—and the two immediately hit it off.

Since Burnett had a built-in comedy infrastructure, she brought along the team from her show: husband Joe Hamilton as producer, Dave Powers as director, Peter Matz on music, Ernie Flatt on dances, and—of course—Bob Mackie on costumes.

The result, *Sills and Burnett at the Met*, is one of the most delightful odd-couple pairings in TV variety history. Burnett and Sills are delicious together—perhaps even more so than Burnett and Andrews, but who's keeping score?—with Sills revealing her ability to clown with the best of them.

All variety shows succeed or fail on the quality of the material, and these two were fortunate enough to have four of the best writers on the case: the married team of Ken and Mitzie Welch on special musical material, and *Burnett Show* alumni Kenny Solms and Gail Parent on sketches. And then there was Mackie—whose wit and passion for detail provided the not so secret ingredient in the success of everything he worked on.

The best thing about doing comedy in a cavernous space like the Met—or doing it well, anyway—is that you can pull up a stool and milk a joke for all it's worth, then pause as the laughter rolls from the footlights all the way to the back of the house and back again. It's the comic equivalent of a "stand-up double" in baseball: Even as you're winding up to pitch your next line, you have to take another breath because the crowd . . . is still . . . laughing.

This is abundantly evident in the sketch where Sills plays "Barbara Bushkin," in a babushka and cloth coat, alongside Burnett's "Sheila Friebus," in a fur coat, oversized sunglasses, eight-inch heels, and a cigarette (on the stage of the Met! Take that, Rudolf!). The witty, over-the-top ensembles are ample proof—as if any were needed—that no one designs for comic contrast better than Mackie.

In a tip of the hat to the recent Broadway smash *A Chorus Line*, the two women are being auditioned by an unseen interviewer. When Sills's character is asked when she knew she wanted to sing opera, she deadpans, "Well, it might have been when my whole family was wiped out in the cyclone. Or when my legal guardian was struck by lightning. But I do remember there was a radio in the orphanage."

Burnett (eye roll evident even behind the shades): "Oh, brother . . ."

Sills: "No, we lost him, too."

Mackie went to town for every scene, providing gowns for a gonzo thirteen-minute torch song medley, appropriately glitzy garb for some opera takeoffs, and sequined bell-bottom pantsuits for a song-and-tap-dance finale featuring a twenty-man chorus line. The whole thing added up to sixty minutes of sheer joy and gave birth to a friendship that would endure for the next thirty-five years.

---

ABOVE: *Odd couple Carol Burnett and Beverly Sills became fast friends while doing* Sills and Burnett at the Met.

OPPOSITE TOP: *Designs for the ladies' classic tap dance finale.*

OPPOSITE BOTTOM: *An over-the-top opera spoof sent Mackie straight back into* Burnett Show *territory.*

Sills and Burnett
at the Met *is one of*
*the most delightful*
*odd-couple pairings*
*in TV variety history.*

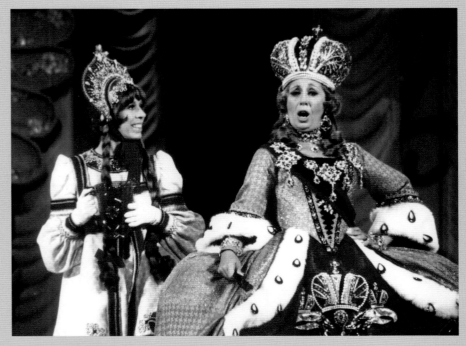

# Perfect *Harmony*

**OF ALL CAROL BURNETT'S INNUMERABLE GIFTS, IT MIGHT** be her musical dexterity that is most astonishing. For one thing, it is truly the exceptional singer who can harmonize by ear. On her show, Burnett sang with a wide range of artists—everybody from the Carpenters to opera divas Eileen Farrell and Marilyn Horne—and held her own with every one of them. When she was paired with fellow belters such as Ethel Merman, Eydie Gormé, and Liza Minnelli, her powerhouse voice was unleashed, but—like the gracious host she was—she always took the harmony line. (It's hard to imagine the Merm singing a third below *anybody*.)

Who else can list talents as varied as Bing Crosby, Cass Elliot, Ray Charles, and Petula Clark as duetting partners? Through every performance, Burnett remained attuned to (and in tune with) her costars. Her instincts never failed to inform her when to let it rip and when to hold back—and exactly how much comic gold she might mine or pathos she might extract from a number.

In her TV specials, Burnett paired with Julie Andrews three times, Neil Diamond, Beverly Sills, and two singers at polar extremes of the vocal spectrum: country music legend Dolly Parton and opera star Placido Domingo. In *Dolly and Carol in Nashville* (1979) and *Burnett Discovers Domingo* (1984), Burnett's versatility was on full display (plus, with Parton, she gleefully mined the comedy of their contrasting silhouettes). Each of her specials included a gonzo eight-minute medley that ran the gamut of the Great American Songbook. With Dolly, it was a mashup of love songs performed on the stage of the Grand Ole Opry in stunning red floor-length Mackie creations. (Dolly may have been just five-one, but the designer confirms that more fabric was used for her dress than for Carol's.)

On the Domingo special, he and Burnett played former opera stars now sleeping on the street, and her outfit called to mind a cross between her character Nora Desmond and Miss Hannigan from *Annie*. The two traded eights on songs of inspiration and survival, beginning and ending with Stephen Sondheim's anthem to show-business scrappiness, "I'm Still Here." Call it an audition: The following year, Burnett would be tapped to sing the song in the historic Lincoln Center concert version of *Follies*.

ABOVE: *Carol Burnett and her pal "Placi" in the "I'm Still Here" medley from* Burnett Discovers Domingo.

RIGHT: *Sketches for their "opera singers gone to seed" sequence.*

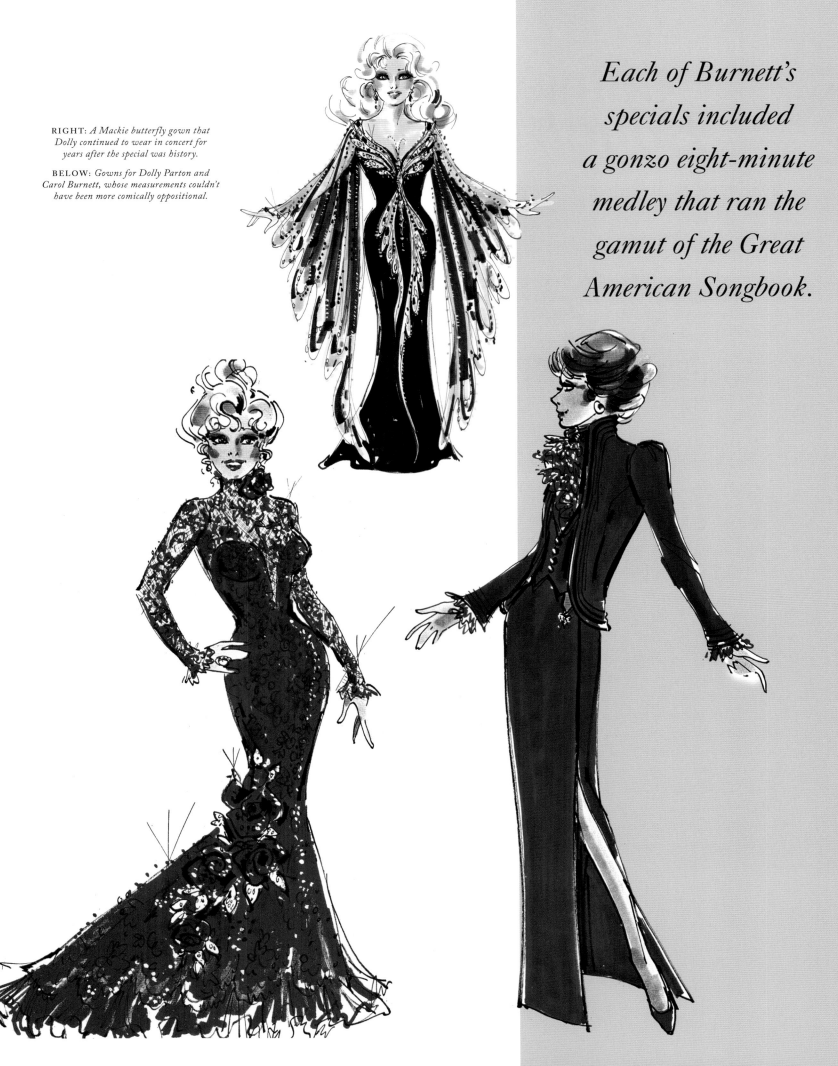

RIGHT: *A Mackie butterfly gown that Dolly continued to wear in concert for years after the special was history.*

BELOW: *Gowns for Dolly Parton and Carol Burnett, whose measurements couldn't have been more comically oppositional.*

*Each of Burnett's specials included a gonzo eight-minute medley that ran the gamut of the Great American Songbook.*

# Comic
# *Royalty*

**"STAR-STUDDED" IS AN UNDERSTATEMENT (AND UNFOR-** giveable cliché) for the confab of brilliant comedians who came together in 1987 for this very special Burnett special. No wonder they called it simply *Carol, Carl, Whoopi and Robin.* No more introduction needed.

The four greats kick off the hour standing at lecterns, mock-seriously examining the "primary root and cause" of laughter—and inspiring quite a lot of it in the process. Once the uproar dies down, more hilarity is elicited by:

- Carol as a grieving widow accosted at her husband's funeral by an obnoxious, loudly dressed man (Williams) who asks inappropriate questions about her spouse's death and insists she keen with him;

- The same sketch again, but with Williams's madcap gift for ad-libbing fully unleashed;

- A loony parody of Shakespeare in which Reiner impersonates Laurence Olivier and Williams adds his own spin on the Bard's greatest hits;

- Carol coaxing a self-conscious Whoopi into singing a duet called "That's a Friend"; and

- Williams as an uptight businessman whose wild side emerges with the help of a bongo-playing hipster (Goldberg).

Perhaps to give the audience's stomach muscles a break, the show ends on a more poignant note as Burnett and Goldberg explore the evolution of the mother-daughter relationship from the daughter's infancy to the mother's old age. As most of the sketches called for variations on everyday wear (although Mackie's widow's weeds were innately humorous), his only chance to insert some of his trademark Mackie glamour was for Carol's and Whoopi's opening gowns. It was one of just a handful of times Goldberg appeared in anything floor-length.

A very good time was had on screen and in living rooms.

*What Carol Burnett and Whoopi Goldberg would wear for the opening number in* Carol, Carl, Whoopi and Robin.

*The only chance to insert some of his trademark Mackie glamour was for Carol's and Whoopi's opening gowns.*

# Together
# Yet *Again*

**IN 1989, CLAD IN BEAUTIFUL RED-AND-BLACK MACKIE** gowns, two legends stroll onstage from opposite wings of the Pantages Theatre in Hollywood, embrace, then launch into Stephen Sondheim's "Old Friends." The lyrics are as heartfelt as they've ever been.

Of course, the friends are Julie Andrews and Carol Burnett, back on television for their third hour of music and comedy—*Julie & Carol Together Again*. It has been seventeen years since their previous special, recorded live at Lincoln Center, and twenty-seven years since their premier outing at Carnegie Hall. Written by Burnett stalwarts Ken and Mitzie Welch, the show is simultaneously a trip down memory lane and a desperately contemporary take on what musical variety can be—and the fashions are integral to both effects. The title could have been *Julie & Carol: Together Again . . . This Time They RAP!*

The comedy here is broader than before (yes, even broader than when Carol tore off Julie's skirt at Lincoln Center). One sketch opens upon the ladies having a "veddy English" tea that devolves into a food fight, with Carol squeezing an éclair into Julie's cleavage; another, "The Phantom of the Opry," is a country-western riff on the smash Andrew Lloyd Webber musical (Mackie's costumes definitely elevate this one); and yet another features a mega-medley of songs recorded since 1971. While there are assuredly wonderful songs from the era, watching two fiftysomething legends sing "Feelings" (Burnett trivia fans will remember that this is a reprise of Eunice's performance on *The Gong Show*), "Stayin' Alive," "I'm So Excited," and "Bad" is . . . awkward at best.

Never fear, though. The two beloved entertainers recover handily from their foray into pop music, overalls, and flying whipped cream. In closing, they emerge from the wings again, this time in glorious black-and-white sequined Mackies, singing Barry Manilow's "All the Time" and a reprise of "Old Friends." To paraphrase Mr. Sondheim:

> *Here's to them.*
> *Who's like them?*
> *Damn few.*

---

*Mackie provided smart, glamorous gowns for the onstage reunion of Carol Burnett and Julie Andrews after seventeen years.*

*The title could have been* Julie and Carol: Together Again… This Time They RAP!

LEFT: *Burnett and Andrews in the spoof "Phantom of the Opry."*

ABOVE AND OPPOSITE: *Mackie's sketches for Andrews and Burnett as rappers, which, thanks to some well-placed Velcro, would get torn away to reveal four of the greatest gams in the business, descending from colorful sequined mini-dresses. Opposite top: Chums Carol and Julie sing "All the Time," the finale of their special* Together Again.

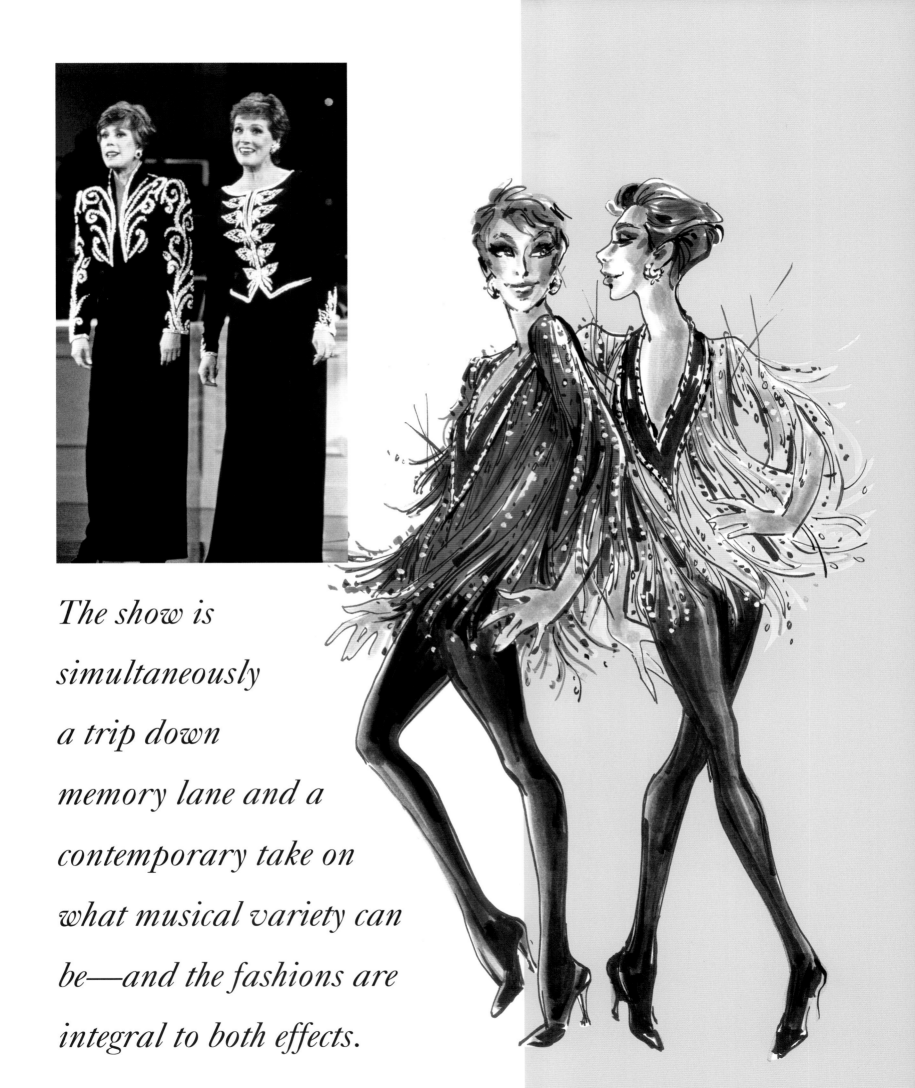

The show is simultaneously a trip down memory lane and a contemporary take on what musical variety can be—and the fashions are integral to both effects.

# Raisin *Hell*

**IT'S DIFFICULT TO SATIRIZE A GENRE THAT IS, IN ITSELF, SO** over the top that it defies parody. Mel Brooks succeeded in his films *Young Frankenstein, Blazing Saddles,* and *High Anxiety,* and the 1980 movie *Airplane!* brilliantly skewered the disaster-film form. By 1986, with shows such as *Dallas, Dynasty,* and *Knots Landing* soaring up the Nielsen charts, the prime-time soap opera was as ripe as the grapes on *Falcon Crest* for comic trouncing. Thus, the one-of-a-kind satiric miniseries *Fresno* was born.

Created by Barry Kemp, the warped comic mind behind *Newhart* (then halfway through its smash eight-season run), *Fresno's* intention was to "rip apart the surface gloss and glitter of the nation's sixty-fourth largest city to reveal the sun-ripened passions and freeze-dried hearts of wealthy raisin tycoons as they wage a life-and-death battle for money, power, and control of the vital raisin cartel." Or so the press release insisted.

Who better to star as the matriarch in this tongue-in-cheek endeavor than the mistress of showbiz spoofing herself, Carol Burnett? She had, after all, already lampooned every possible Hollywood archetype on her own show, from Joan Crawford to Esther Williams to Doris Day.

And who better to create the women's costumes than Bob Mackie, who had elevated and enlivened every one of Burnett's satiric sketches for eleven seasons? In a brilliant takedown of his fellow designer Nolan Miller, who had created the looks for both *Dynasty* and its spinoff *The Colbys,* Mackie made sure every shoulder pad was an inch or two wider, every neckline an inch or two lower, and every picture hat wide enough to require landing lights. In a classic case of biting the hand that feeds you, the show was telecast over five consecutive nights on CBS, the network responsible for the trifecta of prime-time soap, *Dallas, Falcon Crest,* and *Knots Landing.* For his witty, spot-on designs, he notched a well-deserved Emmy nomination.

Burnett played Charlotte Kensington as a comically exaggerated cross between Joan Collins and Jane Wyman, and was joined in the send-up by some brilliantly subtle comedians including Dabney Coleman, Teri Garr, Charles Grodin, and Valerie Mahaffey. Somehow, perhaps aided by the pitch-perfect clothes they wore, they all managed to walk the tightrope between sly winks and outright camp without once falling into the net.

---

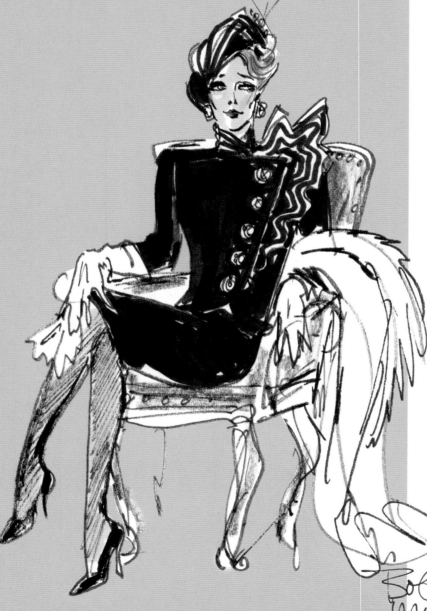

TOP LEFT: *Charlotte gives Torch, the mysterious new stranger in town played by Gregory Harrison, the once over. Okay, maybe twice over.*

LEFT: *Even at the reading of a will, fashion came first in* Fresno.

OPPOSITE, TOP: *Be it court, jail, or her boudoir, wherever Charlotte Kensington went, she went in Mackie.*

OPPOSITE, BOTTOM LEFT: *Burnett channels Scarlett O'Hara one more time at Fresno's annual Raisin Festival Ball.*

OPPOSITE, BOTTOM RIGHT: *Carol Burnett and Charles Grodin as mother and son. Actual age difference between mummy and junior? One year, eleven months, and twenty-five days.*

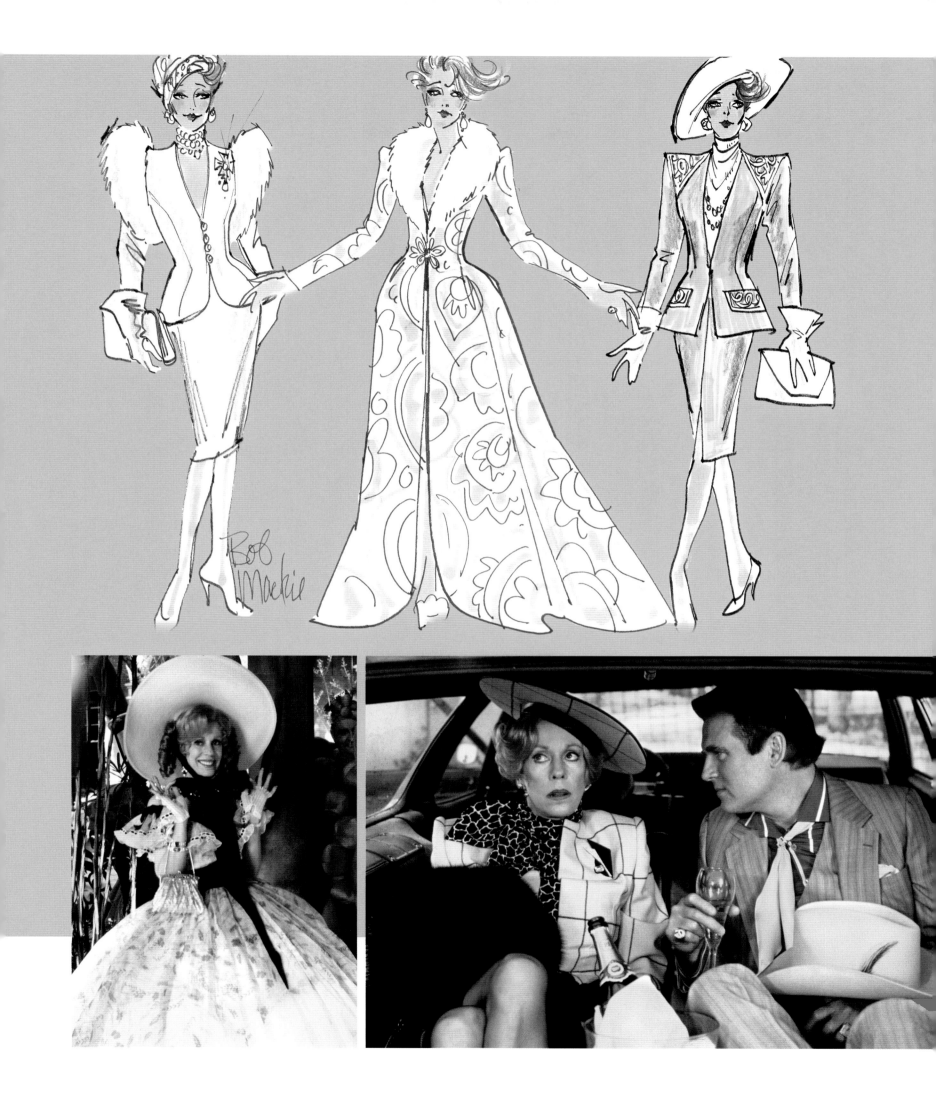

# Let Me *Entertain* You

**THE 1993 TELEVISION VERSION OF THE JULE STYNE/**
Stephen Sondheim/Arthur Laurents musical *Gypsy*, starring Bette
Midler, marked Mackie's return to television musicals for the first
time since the 1972 version of *Once Upon a Mattress*. Its costars
included Peter Riegert, Cynthia Gibb, Ed Asner, and—as the three
strippers—Broadway's Christine Ebersole, Linda Hart, and Anna
McNeely. Dish: 1960s Broadway stars and Tony winners Barbara
Harris and Robert Morse were originally cast as stripper Tessie Tura
and Uncle Jocko but were both fired after the first day of rehearsal.
(Ebersole moved up to Tessie from the role of the deadpan secretary
Miss Cratchitt, making room for the irresistible Andrea Martin.)

Mackie said of the experience, "It's one of my favorite shows,
and I never thought I'd get the opportunity to do it, so I jumped
at the chance. It was like a gift. I wasn't working on anything else
at the time, so I was able to be on set every day, give myself over to
it, and watch every minute, and I think it looks quite good. I was
nominated for an Emmy for it, but I didn't win; I got it for *Mama's
Family* . . . go figure! But I had a great time. That's all you can hope
for when you work on something; make friends, make something
together, and stand back and say, 'Yes!'"

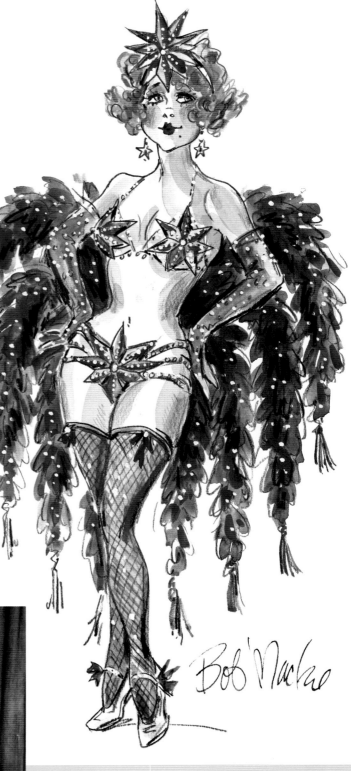

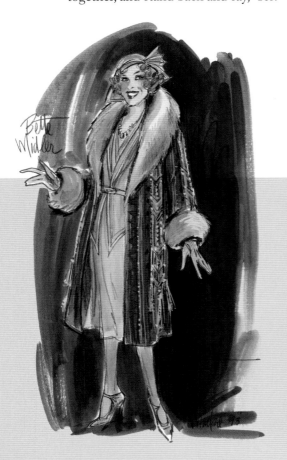

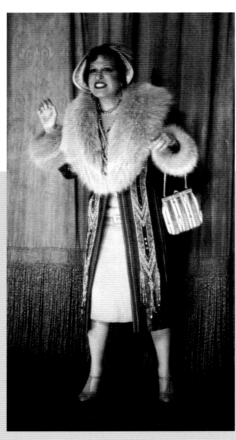

**LEFT:** *Bette Midler as Rose Hovick,
the Medea of musical theatre.*

**ABOVE AND OPPOSITE:** *Sketches for Anna McNeely
(re-creating her role from the 1989 Tyne Daly Broadway
revival) as Electra, Christine Ebersole as Dressy Tessie
Tura, and Linda Hart (a former Bette Midler "Harlette")
as Miss Mazeppa—the three strippers who inform the
future Gypsy Rose Lee that she's "Gotta have a gimmick."*

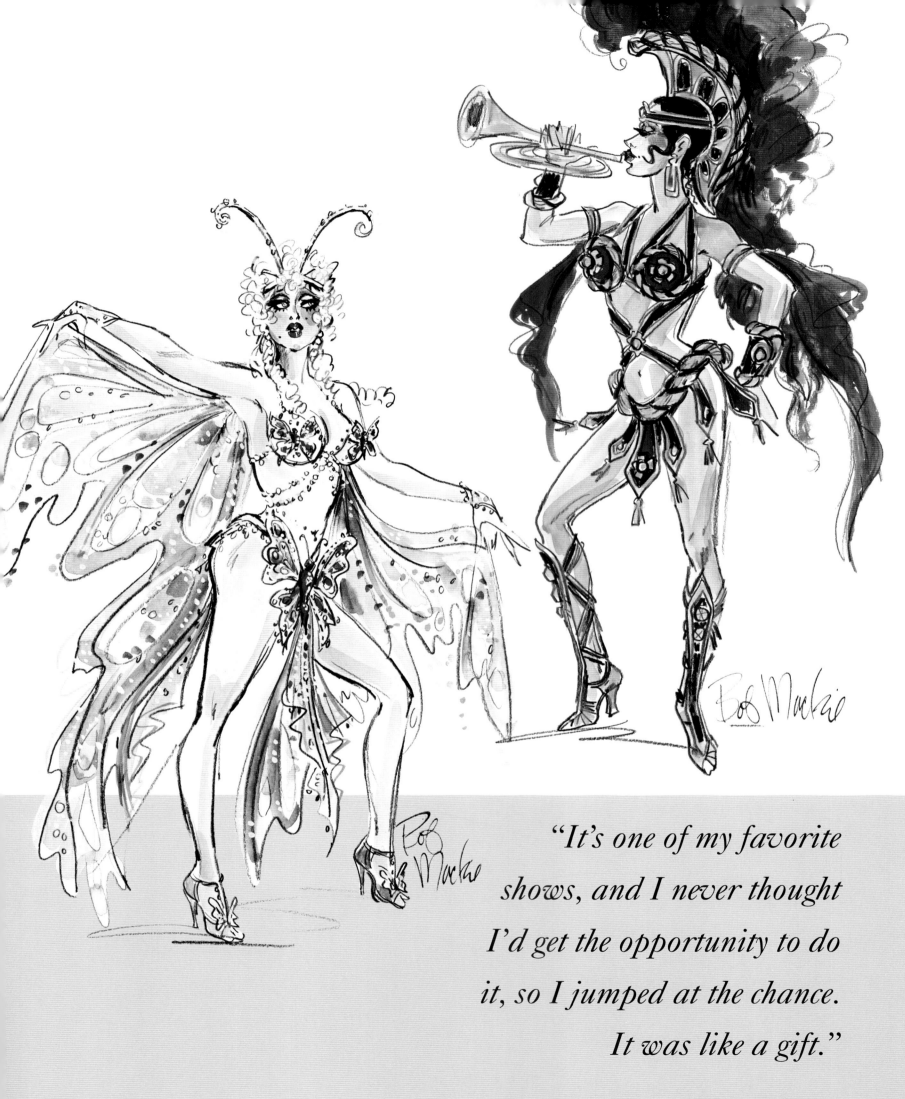

"It's one of my favorite shows, and I never thought I'd get the opportunity to do it, so I jumped at the chance. It was like a gift."

# Here Comes (*Mrs.*) Santa Claus

**WHEN IT CAME TIME FOR ANGELA LANSBURY TO STAR IN** her first television musical, who else but Bob Mackie—who had dressed her so beautifully for her three-year stint as host of the Tony Awards in the 1980s—to create the costumes? Doffing her trench coat and putting down her magnifying glass for the moment, CBS's beloved *Murder, She Wrote* sleuth took on the role of Mrs. Santa Claus in the eponymous 1996 Hallmark special. The production also marked the reunion of Lansbury and Jerry Herman, the composer who had helped make her a Broadway star thirty years earlier in the hit musical *Mame*.

For the Tonys, Mackie had created appropriately chic and glamorous looks for Lansbury. Here, he was confined to the parameters of the rather unconventional Christmas story at hand. It's 1910 at the North Pole, and Anna Claus feels ignored by her famous husband—played by the only man for the job, Charles Durning. She decides to take the sleigh out for a joy ride, and when one of the reindeer sprains a hoof, she makes an emergency landing on New York City's Lower East Side. Going undercover (because you just can't keep a good detective down), Anna moves in with a Jewish family, gets woke about the city's abusive labor practices, and joins the beginnings of the women's suffrage movement—all to the accompaniment of eleven bouncy Herman tunes.

In the full spirit of the season, Mackie created pitch-perfect costumes for Lansbury and an enormous cast; it was probably the largest scale on which he had worked since *Pennies from Heaven*. And naturally he buttoned it all up with his trademark flair, kitting Lansbury out in a glorious floor-length red-sequined coat with white fur trim for her final sleigh date through the night sky.

As Mackie remembered, "It was fun! Actually, scratch that, it wasn't fun, because we were trying to re-create December in New York in 110-degree heat on the Universal back lot in August, and everyone was sweltering in wool and tweed. But . . . you just do the best you can, and I was working with wonderful, cheery people: Charles, Michael Jeter, Jerry Herman, and Angela. Angela is *always* a breath of fresh air."

TOP LEFT: *The legendary Angela Lansbury, perfectly cast and clad as Mrs. Claus.*

BOTTOM LEFT: *Beloved character actors Charles Durning and Michael Jeter as the workshop boss and his right-hand elf.*

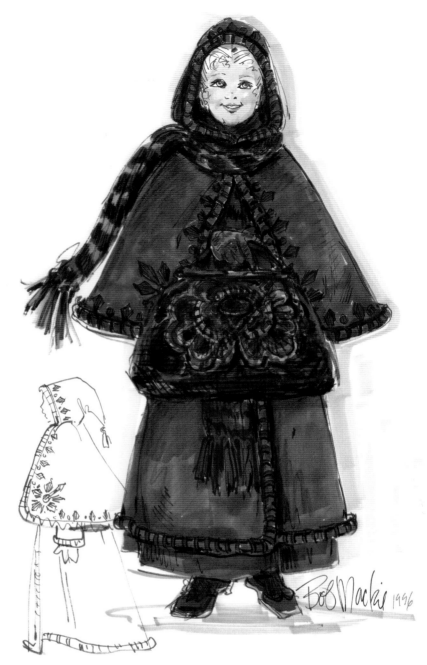

ABOVE: *Lansbury and Mackie on the set. He'd previously designed her gown for the opening number of the 1973 Academy Awards.*

RIGHT: *Mackie's sketch for Anna Claus, crusader for women's rights.*

BELOW: *Santa's workshop, Mackie style. Michael Jeter is second from left.*

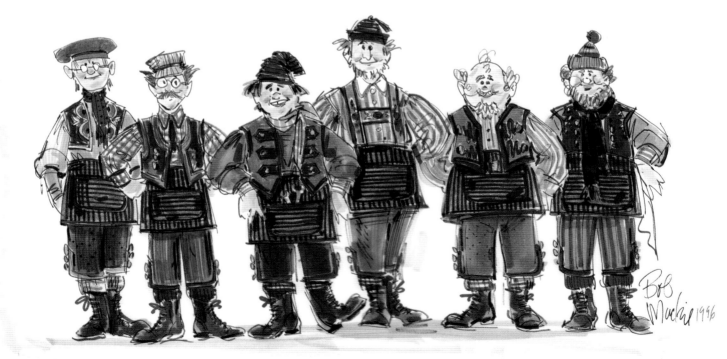

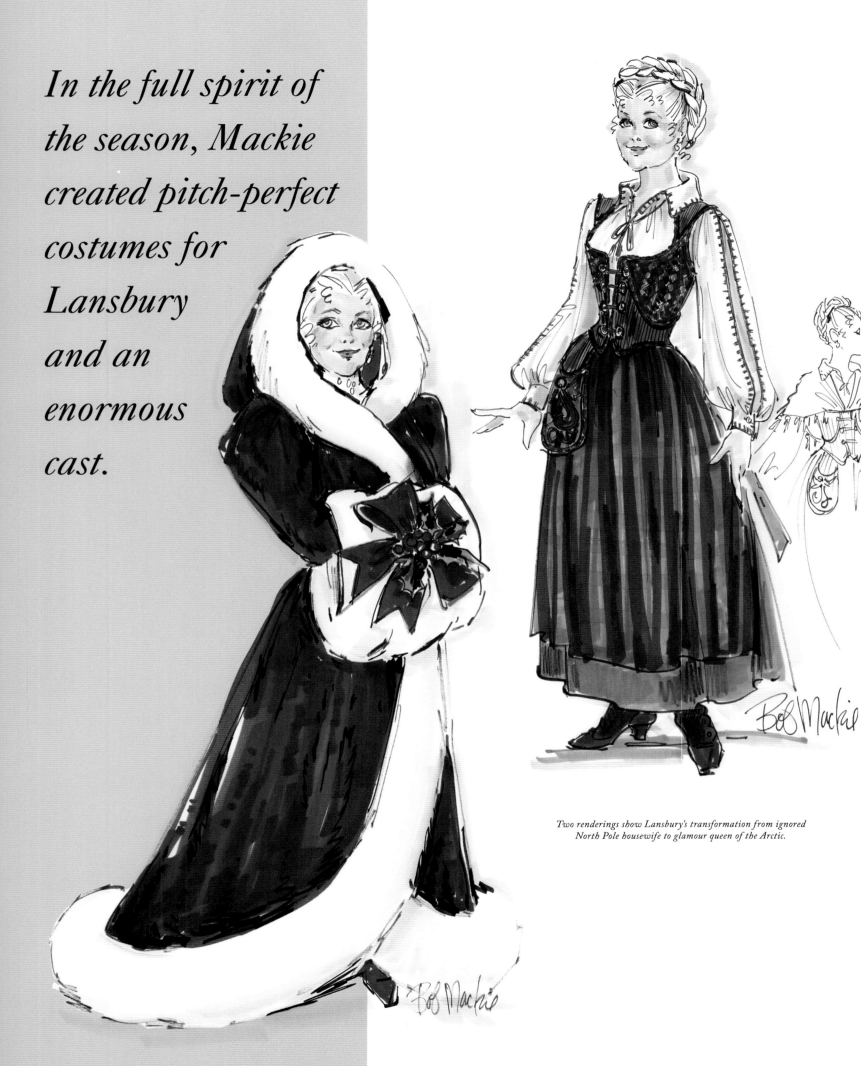

*In the full spirit of the season, Mackie created pitch-perfect costumes for Lansbury and an enormous cast.*

*Two renderings show Lansbury's transformation from ignored North Pole housewife to glamour queen of the Arctic.*

# "A long time ago, in a galaxy known as *Hollywood* . . ."

**SURE, IT WAS A BOX-OFFICE SMASH THAT WOULD LAUNCH** the most successful film franchise in history—but whose idea was it to build a holiday variety special around *Star Wars,* and what were they smoking at the time?

The 1978 CBS event featured nearly all the major players from the sci-fi blockbuster and (believe it or not) told the loose story of Chewbacca's family awaiting his return for "Life Day"—presumably his planet's version of either Thanksgiving or Christmas. Responsible for this epic were some heavy hitters, including Oscar ceremony scribe Bruce Vilanch and *Carol Burnett Show* special material writers Ken and Mitzie Welch.

Highlights of the two-hour head-scratcher were Burnett veteran Harvey Korman as a four-armed Julia Child parody named Chef Gormaanda; Bea Arthur as Ackmena, the proprietress of the Mos Eisley Cantina, singing the disco hit "Star Wars Theme/Cantina Band") with parody lyrics; and a special performance by Jefferson Starship.

It's no secret (and no surprise) that ever since the special aired, *Star Wars* creator/director George Lucas has actively sought out and burned every master tape. Harrison Ford, whose turn as Han Solo in the film vaulted him to full-fledged stardom, took a different approach. When, on talk shows, he was shown clips from the two-hour train wreck, he said simply, "Oh. That isn't me."

For his part, Mackie has nothing to destroy or disavow. His major contribution was a stunning gown for his longtime friend Diahann Carroll, who played a seductive hologram named Mermeia. The virtual underwater goddess sang a song called "This Minute Now" to a *very* content Grandpa Wookie named Itchy, who happened to be lounging in his recliner on the planet Kashyyyk. It truly is a beautiful costume for a beautiful lady, but we must disclose that Carroll wasn't the first choice for the role. That honor—and the probable explanation for Mackie's involvement in this dubious project—was Cher's.

ABOVE AND LEFT: *Two of the characters that appear on little Lumpy's holographic table in* The Star Wars Holiday Special: The Ringmaster *and a gymnast known as* The Great Zorbak—*though the name was deleted from the final shooting script.*

BELOW: *"I have a bad feeling about this . . ." Left to right: Anthony Daniels, Peter Mayhew, Carrie Fisher, a profoundly mortified Harrison Ford, and Mark Hamill celebrate Life Day. One-of-a-kind Chewbacca ceremonial robe by Mackie.*

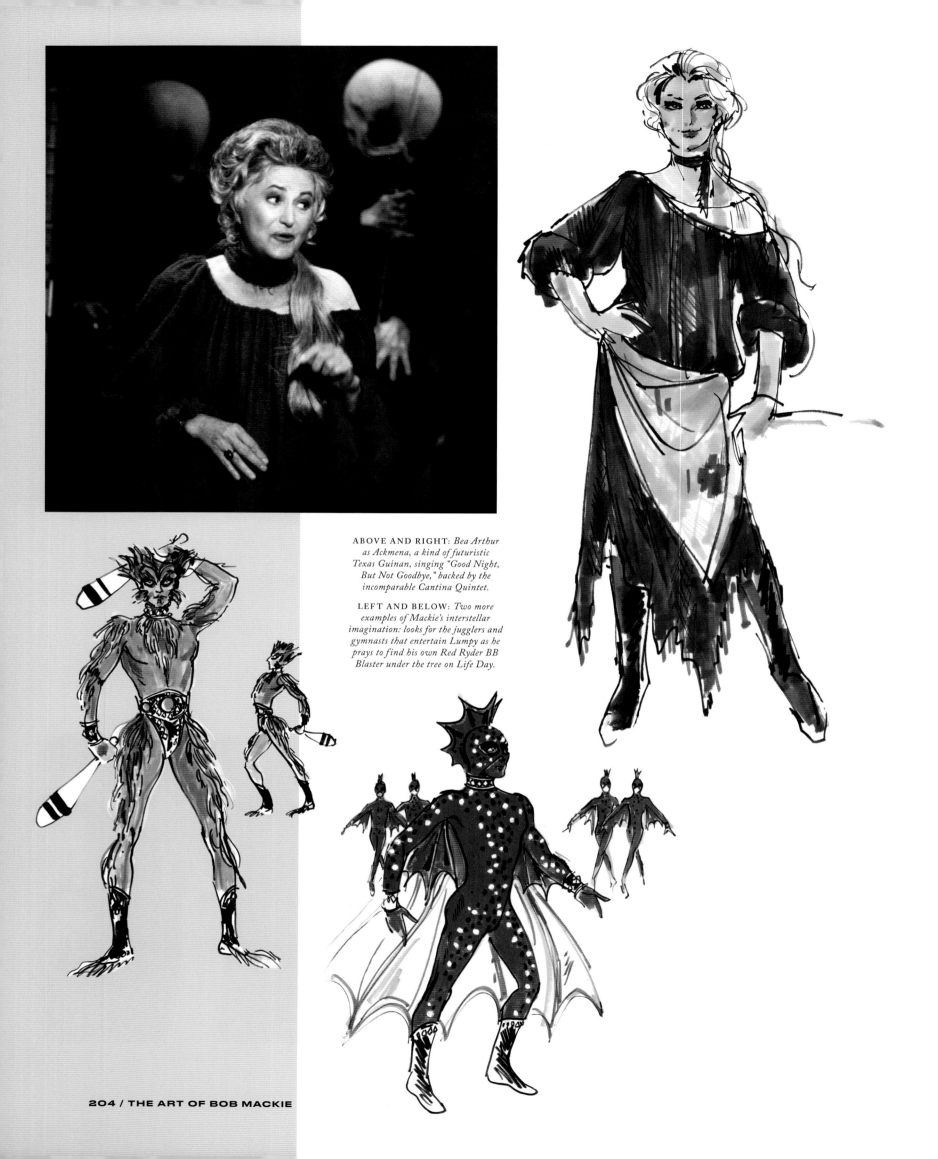

ABOVE AND RIGHT: *Bea Arthur as Ackmena, a kind of futuristic Texas Guinan, singing "Good Night, But Not Goodbye," backed by the incomparable Cantina Quintet.*

LEFT AND BELOW: *Two more examples of Mackie's interstellar imagination: looks for the jugglers and gymnasts that entertain Lumpy as he prays to find his own Red Ryder BB Blaster under the tree on Life Day.*

Diahann Carroll as the singing hologram Mermeia.

*Whose idea was it to build a holiday variety special around Star Wars, and what were they smoking at the time?*

# More Than Once Upon a *Mattress*

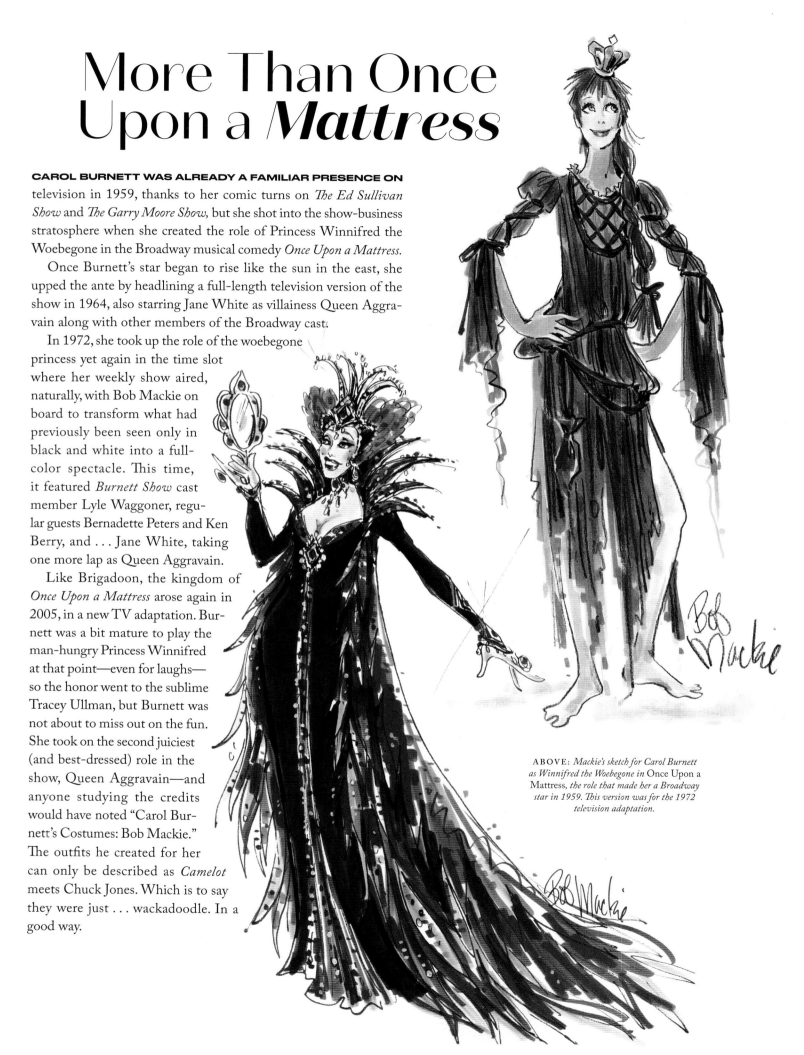

**CAROL BURNETT WAS ALREADY A FAMILIAR PRESENCE ON** television in 1959, thanks to her comic turns on *The Ed Sullivan Show* and *The Garry Moore Show,* but she shot into the show-business stratosphere when she created the role of Princess Winnifred the Woebegone in the Broadway musical comedy *Once Upon a Mattress.*

Once Burnett's star began to rise like the sun in the east, she upped the ante by headlining a full-length television version of the show in 1964, also starring Jane White as villainess Queen Aggravain along with other members of the Broadway cast.

In 1972, she took up the role of the woebegone princess yet again in the time slot where her weekly show aired, naturally, with Bob Mackie on board to transform what had previously been seen only in black and white into a full-color spectacle. This time, it featured *Burnett Show* cast member Lyle Waggoner, regular guests Bernadette Peters and Ken Berry, and . . . Jane White, taking one more lap as Queen Aggravain.

Like Brigadoon, the kingdom of *Once Upon a Mattress* arose again in 2005, in a new TV adaptation. Burnett was a bit mature to play the man-hungry Princess Winnifred at that point—even for laughs—so the honor went to the sublime Tracey Ullman, but Burnett was not about to miss out on the fun. She took on the second juiciest (and best-dressed) role in the show, Queen Aggravain—and anyone studying the credits would have noted "Carol Burnett's Costumes: Bob Mackie." The outfits he created for her can only be described as *Camelot* meets Chuck Jones. Which is to say they were just . . . wackadoodle. In a good way.

ABOVE: *Mackie's sketch for Carol Burnett as Winnifred the Woebegone in* Once Upon a Mattress, *the role that made her a Broadway star in 1959. This version was for the 1972 television adaptation.*

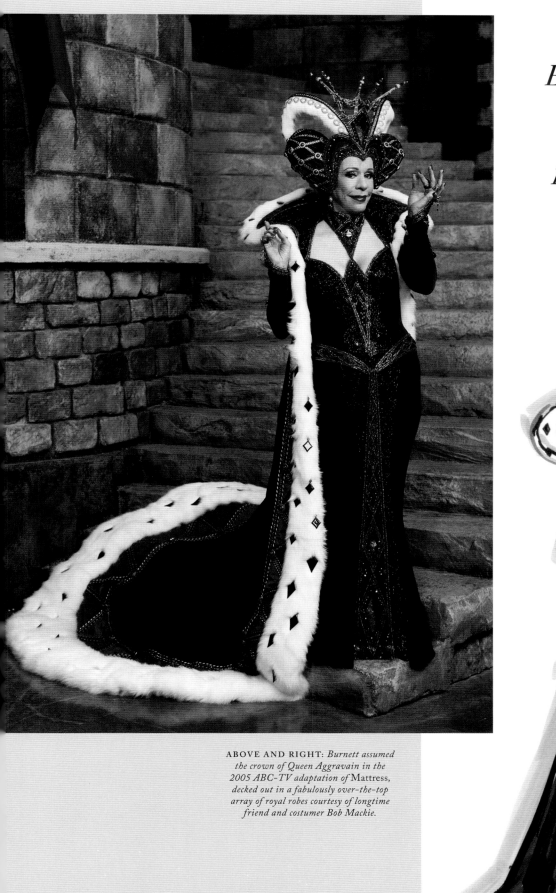

*Bob Mackie* was *on board to transform what had previously been seen only in black and white into a full-color spectacle.*

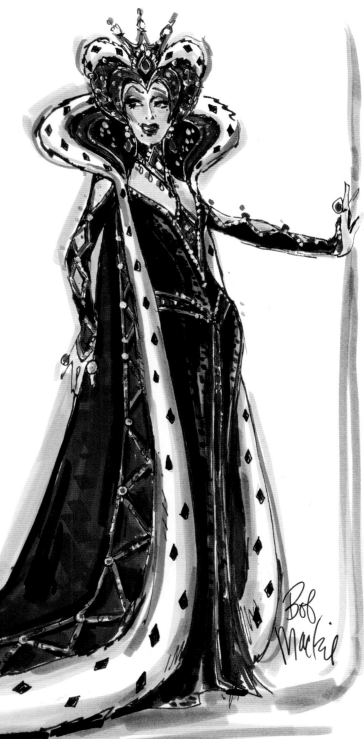

**ABOVE AND RIGHT:** *Burnett assumed the crown of Queen Aggravain in the 2005 ABC-TV adaptation of* Mattress, *decked out in a fabulously over-the-top array of royal robes courtesy of longtime friend and costumer Bob Mackie.*

# MACKIE ROCKS

**AS THE 1960S "FLOWER CHILD" LOOK OF FOLK STARS**
Joni Mitchell, Janis Ian, and Judy Collins began to lose traction—along with the slightly rougher but still homespun getups of "rock chicks" Janis Joplin, Grace Slick, and Stevie Nicks—Bob Mackie found a new avenue for his decidedly glam designs: the world of popular music.

Costuming for a range of performers, from Toni Tennille to P!nk, Mackie made forays into contemporary music that inspired him to push the boundaries of his imagination well beyond the confines of a television screen or even a Broadway stage. His new clients needed clothes that would make them feel and look larger than life to patrons in the nosebleed seats of twenty-thousand-seat arenas like Madison Square Garden. It was Mackie who moved Cher out of fur vests and onto the cover of *Time*, turned Tina Turner from a supporting performer into a full-fledged solo superstar, and transformed Elton John's virtuoso singer-songwriter act into one lengthy, over-the-top carnival ride. To be sure, this was a world away from the soundstages of MGM where young Bobby had dreamed of making his mark; but it was an apt new canvas for the endlessly inventive designer with the vision to turn musicians into rock-and-roll gods and goddesses. Cue the pyrotechnics.

THIS PAGE: *Mackie's Cubist sketch for Elton John.*

OPPOSITE: *The artist formerly known as Alecia Moore makes her entrance through the stage floor at the beginning of her record-breaking "Funhouse" tour.*

# Fuel for *Rocketman*

**MACKIE MET MANY STARS DURING HIS YEARS DESIGNING** for television's most successful variety shows, but even the less successful ones yielded some important new connections for the influential designer. Cher's self-titled solo effort lasted just one and a half seasons, but over the course of it, Mackie met three superstars of the contemporary music scene: Tina Turner, Bette Midler, and Elton John.

Other than their navel-baring hostess—and perhaps Liberace—there was no star working in any genre more intent on pushing the envelope of glamour, spectacle, and yes, good taste, than the singer born Reginald Kenneth Dwight. For him, nothing was off-limits; the bigger and gaudier, the better. Who but Mackie to provide him with exactly that?

"Elton was very appreciative of the things I designed for him on Cher's show and asked me to create some things just for him. 'What are you looking for?' I asked, and he immediately said, 'I want the things you do for Cher!' So I treated him like a showgirl. I did these sequined jumpsuits with a bare midriff and fur coats that stretched all the way across the stage . . ."

The designer went on to explain that John didn't understand the concept of a designer pitching sketches so that the client could select his or her favorites. "If I showed him ten sketches, he'd order all ten. And want them by Monday! If I'd shown him forty, he would have ordered all forty!"

Mackie was the man behind Elton as Donald Duck; Elton in a sequined baseball uniform for a concert at Dodger Stadium; and Elton as Satan in an enormous, heaven-scraping headdress, among other eye-poppers. The rock star often wore a look just once before retiring it—all the better for the man tasked with keeping him dressed to the nines (tens, elevens, twelves . . . ).

The 2019 Elton John biopic *Rocketman* credits Julian Day with costume design, but many of the performance outfits are re-creations (or, at a minimum, reimaginings) of Mackie. Julian may have swapped out the sequins on the Dodgers costume for 140,000 Swarovski crystals, but there's no mistaking who came up with the concept.

---

BELOW: *Elton John shakes a Mackie tail feather.*

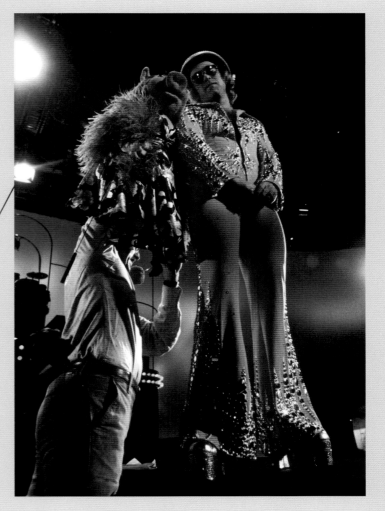

*For the three of you who don't remember the occasion, Elton John dueted with Miss Piggy on "Don't Go Breaking My Heart" in this fabulous jumpsuit on* The Muppet Show, *circa 1977.*

"'What are you looking for?' I asked, and he immediately said, 'I want the things you do for Cher!' So I treated him like a showgirl. I did these sequined jumpsuits with a bare midriff and fur coats that stretched all the way across the stage…"

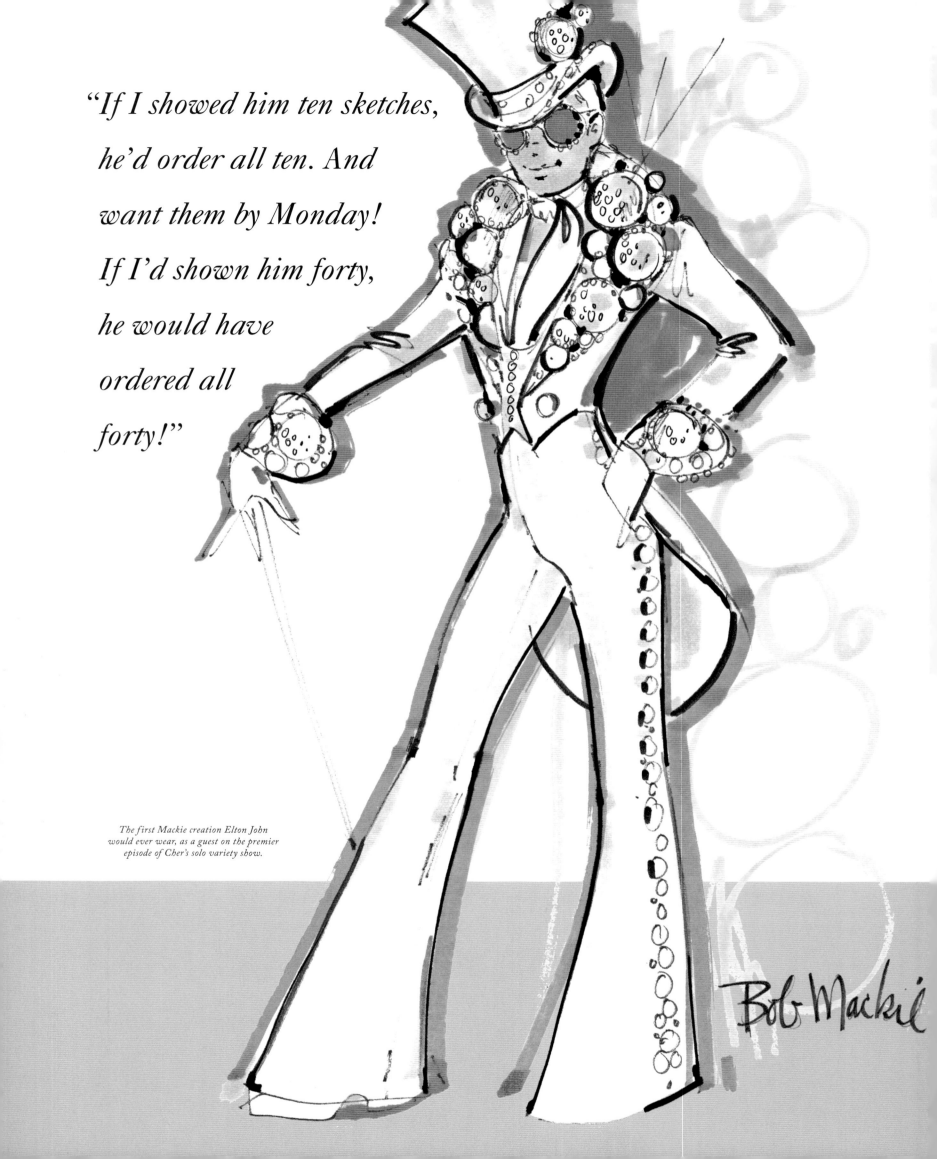

*"If I showed him ten sketches, he'd order all ten. And want them by Monday! If I'd shown him forty, he would have ordered all forty!"*

The first Mackie creation Elton John would ever wear, as a guest on the premier episode of Cher's solo variety show.

Bob Mackie

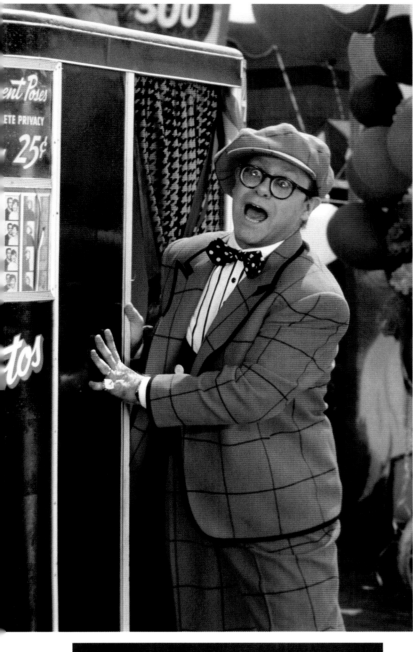

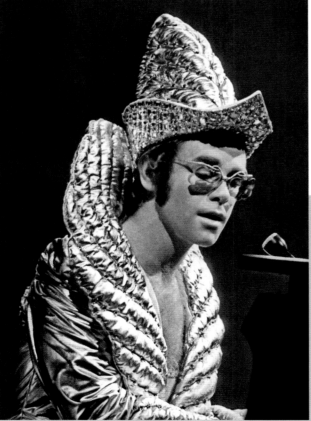

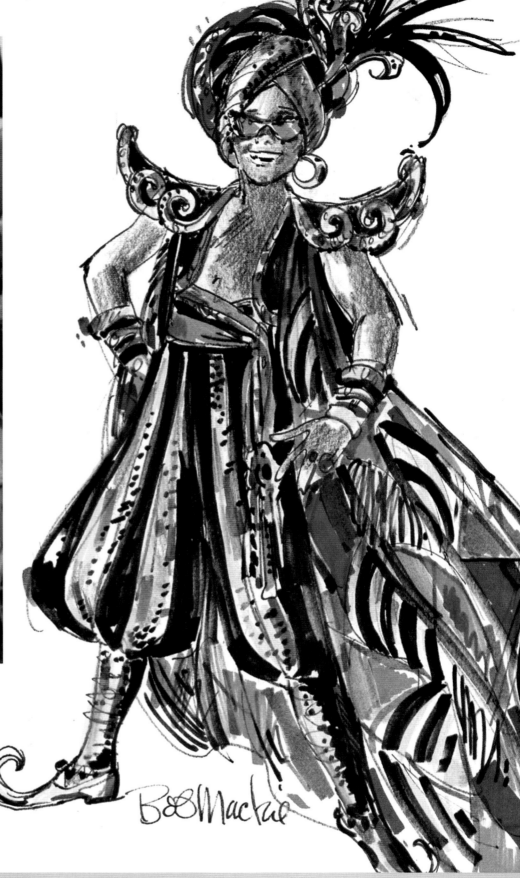

TOP LEFT: *Elton John on the 1988 TV special* Totally Minnie, *where he sang "Don't Go Breaking My Heart" with yet another plush costar: Minnie Mouse.*

ABOVE: *A 1978 genie costume for Sir Elton.*

LEFT: *On Cher, Elton sang "Lucy in the Sky with Diamonds" clad in silver Mackie.*

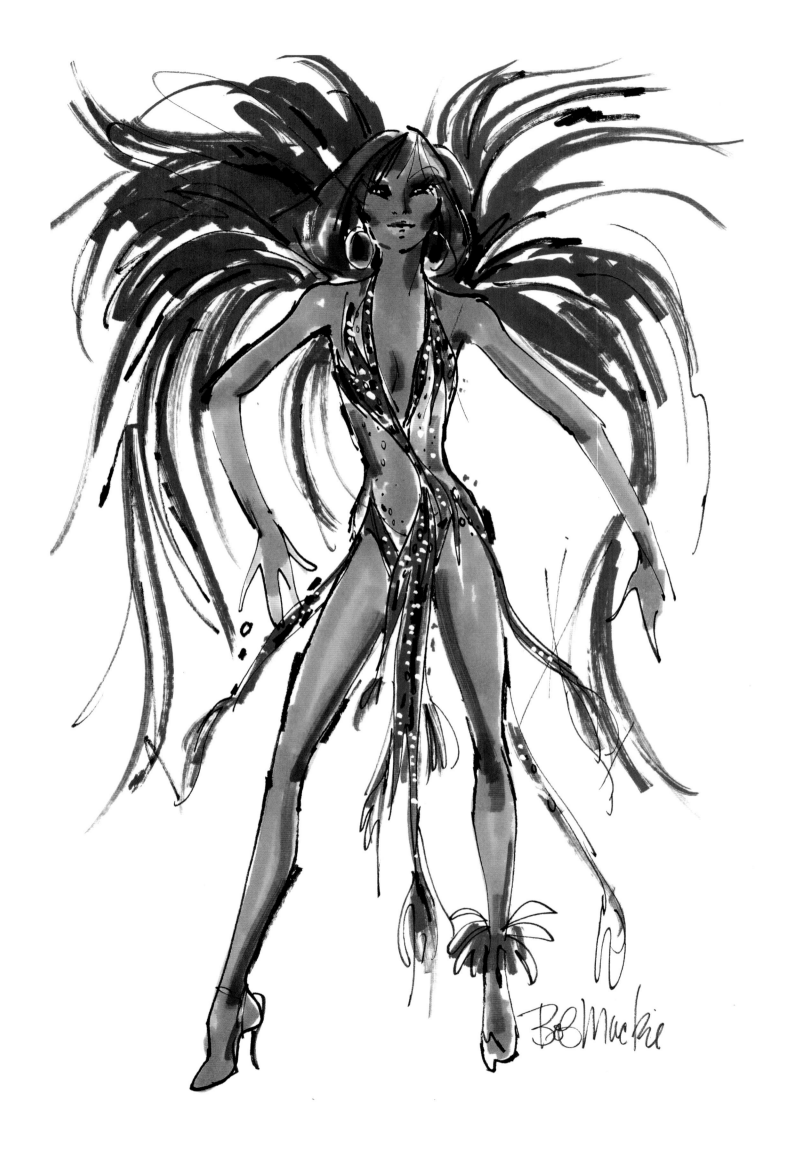

# Tina *Triumphs*

**THE FIRST TIME BOB MACKIE MET TINA TURNER, THE** hardest-working woman in rock and roll, was when she guest-starred on the *Cher* solo variety series in 1975. He recalled, "I had always loved her. I thought she was special and kind of dangerous. Then she walked in wearing a beautiful man's silk blouse, gabardine pants, and alligator loafers. It was completely the opposite of how anyone thought of Tina Turner at the time."

At that point, the former Anna Mae Bullock of Nutbush, Tennessee, had climbed her way to the brink of superstardom. Turner was in the process of splitting from her controlling, abusive husband, Ike—in fact, she was actively hiding from him at the time she appeared on *Cher,* so that even the crew didn't know exactly where she was living—and was eager to work while she reinvented herself as a solo act. Over the next two years, she would guest-star on everything from Dick Van Dyke's short-lived *Van Dyke and Company* to *The Brady Bunch Variety Hour.*

In 1975, Cher herself was in the process of disentangling from a controlling husband, and she and Tina clicked immediately; their chemistry on-screen was undeniable (if slightly dimmed when they performed a Beatles medley with fellow guest star Kate Smith).

Mackie: "While she was doing the rounds appearing on all these shows, Tina brought me some old dresses she'd bought in Paris. And she put them on and asked me to do something with these simple cocktail dresses. She said, 'I've always wanted to look like Raquel Welch in *One Million Years B.C.*' So I started doing cutouts and turning the bottom into strips, and it looked terrific. Then Raquel was doing her nightclub act and said, 'Can you do one of those ragged things like you do for Tina Turner?' So I did, and suddenly, she was on the cover of the French magazine *L'Express.* Tina came to see me, pulled out the magazine, and said, 'Bob, you *have* to make one of these for me!' And I said, 'Okay, I'll do it . . . Actually, I already *did*!' And that's when I realized that everyone is watching everyone else and doesn't realize when they were the inspiration in the first place."

In 1977, Turner appeared on country singer Lynn Anderson's TV show wearing the equivalent of "baby's first flame dress," and Mackie embarked on a steady working relationship with her that would last until her final, fiftieth-anniversary tour in 2008. For that swan-song outing, he created eight showstopping looks, including a riff on the costume she'd worn as Aunty Entity in *Mad Max: Beyond Thunderdome.*

Turner said of her relationship with the designer, "No one does concert wear like Bob. *No one.* The only restriction I've ever given him is that I have to be able to move easily. If I have to worry about a sleeve or a sequin or 'things' coming out that shouldn't, that's a problem."

Mackie: "They may look like something that she could wear to a party, but these are work clothes. You have to make them like iron but make them look like they're made out of butterfly wings."

---

THIS PAGE: *Assorted looks for Turner's record-breaking Fiftieth Anniversary Tour, which kicked off in 2008.*

OPPOSITE: *Mackie made this sketch in 1977, early in his working relationship with Tina Turner.*

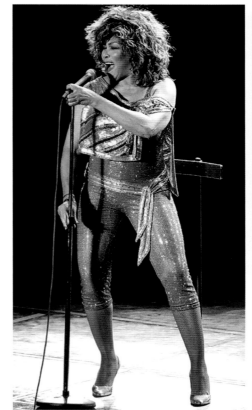

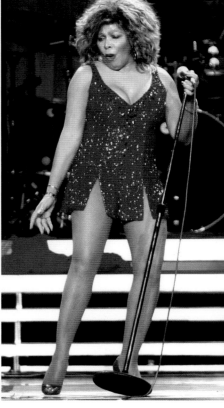

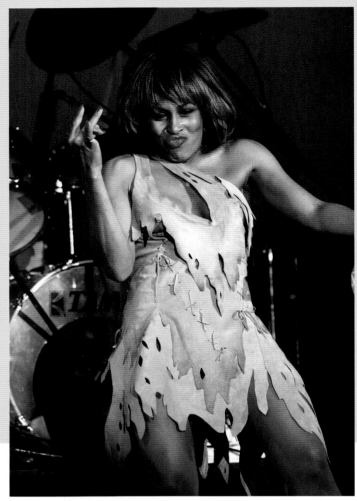

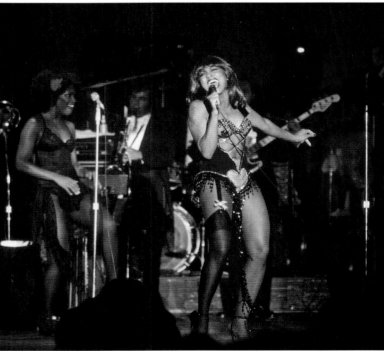

*Turner's costumes were integral to her transformation from front woman to solo artist in the late 1970s.*

"*They may look like something that she could wear to a party, but these are work clothes. You have to make them like iron but make them look like they're made out of butterfly wings.*"

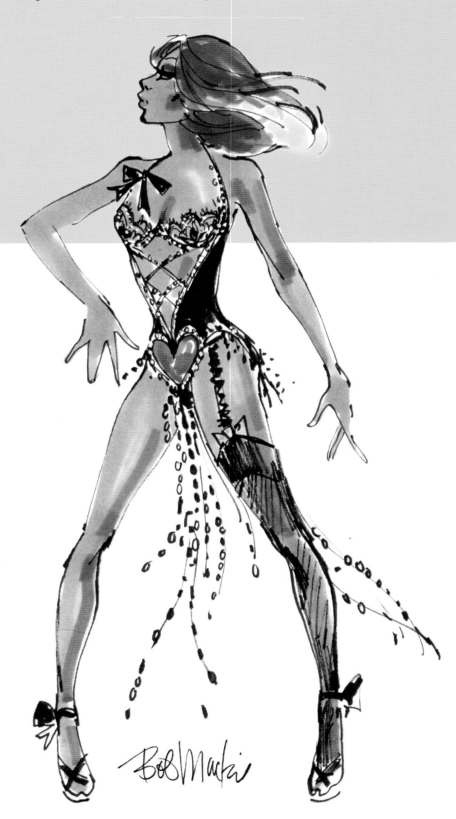

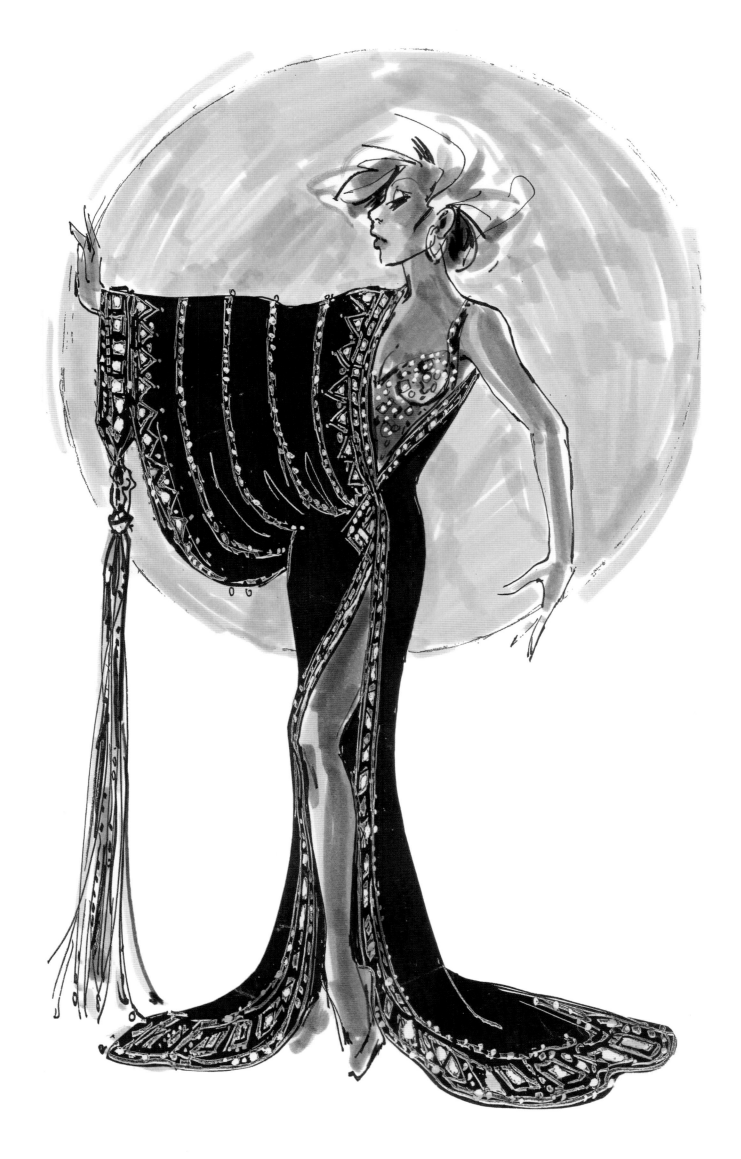

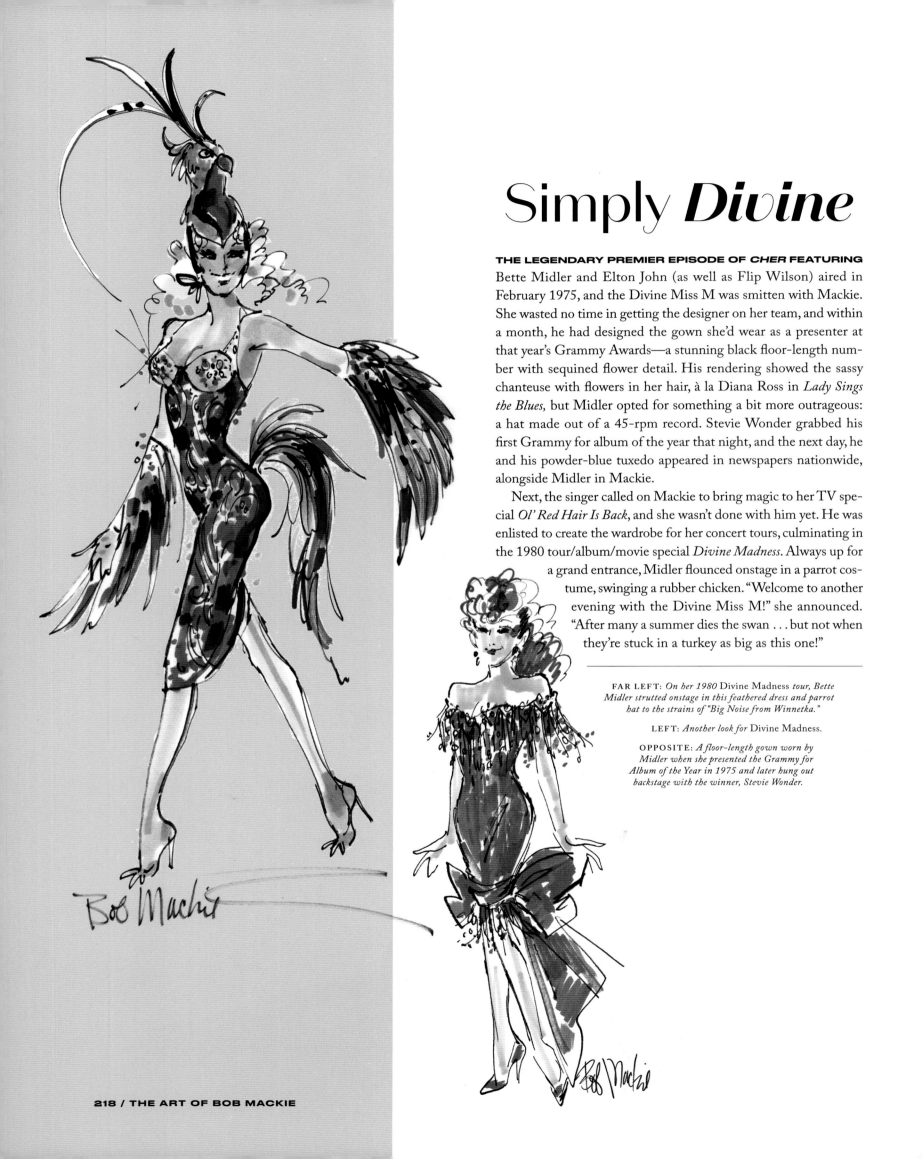

# Simply *Divine*

**THE LEGENDARY PREMIER EPISODE OF *CHER* FEATURING** Bette Midler and Elton John (as well as Flip Wilson) aired in February 1975, and the Divine Miss M was smitten with Mackie. She wasted no time in getting the designer on her team, and within a month, he had designed the gown she'd wear as a presenter at that year's Grammy Awards—a stunning black floor-length number with sequined flower detail. His rendering showed the sassy chanteuse with flowers in her hair, à la Diana Ross in *Lady Sings the Blues,* but Midler opted for something a bit more outrageous: a hat made out of a 45-rpm record. Stevie Wonder grabbed his first Grammy for album of the year that night, and the next day, he and his powder-blue tuxedo appeared in newspapers nationwide, alongside Midler in Mackie.

Next, the singer called on Mackie to bring magic to her TV special *Ol' Red Hair Is Back,* and she wasn't done with him yet. He was enlisted to create the wardrobe for her concert tours, culminating in the 1980 tour/album/movie special *Divine Madness.* Always up for a grand entrance, Midler flounced onstage in a parrot costume, swinging a rubber chicken. "Welcome to another evening with the Divine Miss M!" she announced. "After many a summer dies the swan . . . but not when they're stuck in a turkey as big as this one!"

FAR LEFT: *On her 1980* Divine Madness *tour, Bette Midler strutted onstage in this feathered dress and parrot hat to the strains of "Big Noise from Winnetka."*

LEFT: *Another look for* Divine Madness.

OPPOSITE: *A floor-length gown worn by Midler when she presented the Grammy for Album of the Year in 1975 and later hung out backstage with the winner, Stevie Wonder.*

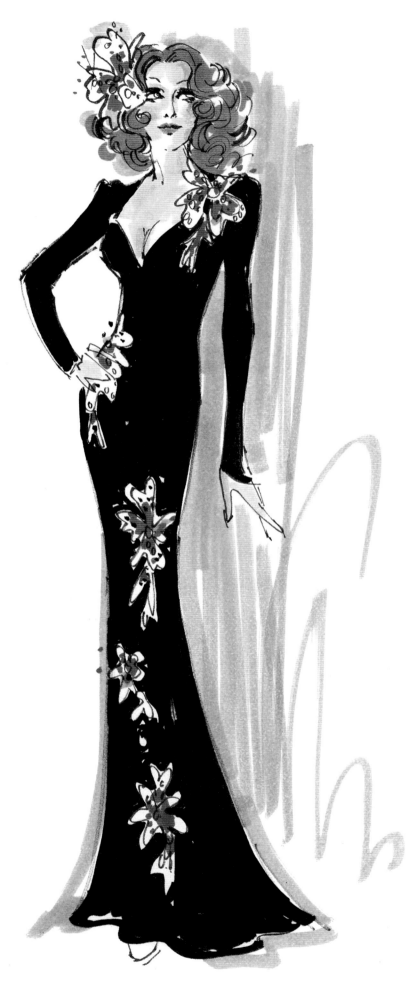

His rendering showed the sassy chanteuse with flowers in her hair, *à la Diana Ross in* Lady Sings the Blues, *but Midler opted for something a bit more outrageous: a hat made out of a 45-rpm record.*

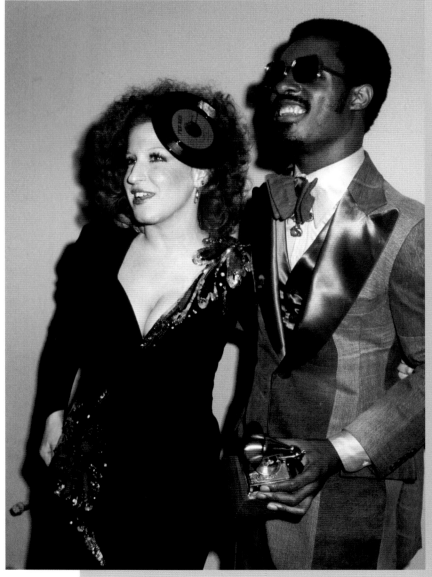

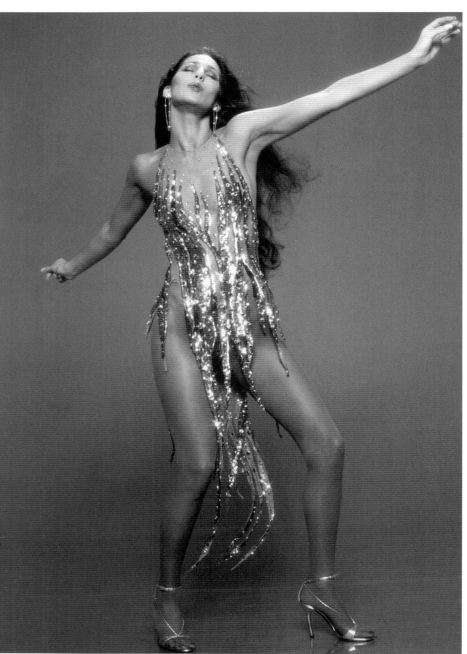

# Out in *Flames*

**WHEN IT COMES TO BOB MACKIE'S TRADEMARK FLAME** dress, the question isn't "Who wore it better?" but "Who wore it *first*?"

Many rock fans would insist the answer is Tina Turner. They'd be surprised to find out that Turner had specifically asked Mackie to re-create a gown he had designed for Raquel Welch that landed her on the cover of a Paris magazine. Once Tina stepped out in flames, though, it was just a matter of time before the look became sought after and ultimately iconic. Artists as diverse as Lynda Carter and RuPaul have worn versions of the dress, as has Beyoncé— most notably in her salute to Turner at the Kennedy Center Honors.

Ann-Margret has worn one; Cher, of course; Diana Ross. Even the eleven-and-a-half-inch "Flame" Barbie doll got in on the act by sporting a flame back pack.

We are aware that we still haven't answered the question posed above. If you really want to know who wore the first flame dress, you have to turn back time (hat tip, Cher) to 1968. That's when Mackie created the mini-est version of them all for dancer Barrie Chase to wear on *The Fred Astaire Show*. Check it out on YouTube, but wear oven mitts: The girl in the flames is definitely smoking hot.

*A sketch for the never-produced "Flame" Barbie.*

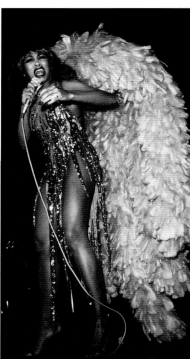

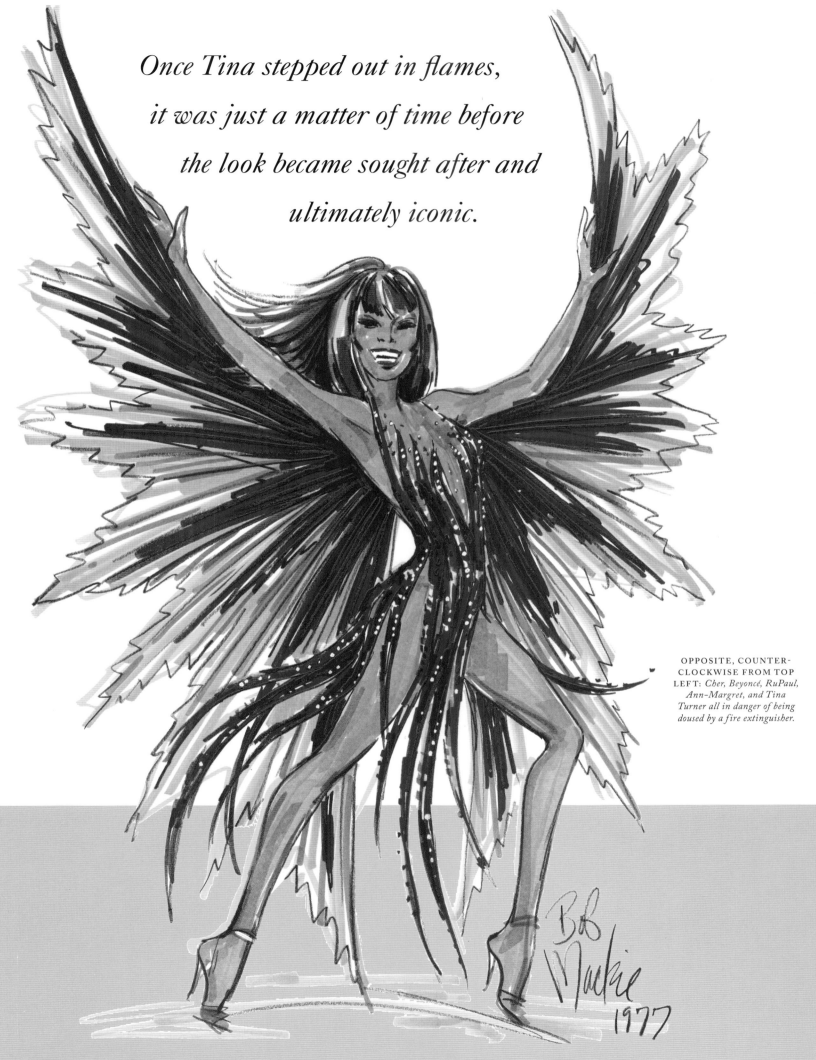

*Once Tina stepped out in flames, it was just a matter of time before the look became sought after and ultimately iconic.*

OPPOSITE, COUNTER-CLOCKWISE FROM TOP LEFT: *Cher, Beyoncé, RuPaul, Ann-Margret, and Tina Turner all in danger of being doused by a fire extinguisher.*

# When Rock Stars *Fly*

**TAKING HER STAGE NAME FROM A CHARACTER IN THE QUEN-**tin Tarantino film *Reservoir Dogs,* Alecia Beth Moore, aka P!nk, spent her childhood juggling competing aspirations: to be a competitive gymnast and a rock singer. Anyone who knows her work—even if from just a random performance on the Grammys—can tell you she has managed to blend those dreams and spin them into gold.

By the time she was fourteen, Moore was performing in clubs around her hometown of Philadelphia, first in the girl group Basic Instinct and then as part of the R&B trio Choice. At sixteen, she was offered a solo recording contract; when she was twenty-one, her debut album, *Can't Take Me Home,* went double platinum.

Not wanting to be thought of as just another cookie-cutter packaged pop star, P!nk began to incorporate her gymnastic skills into her performances as a full-fledged touring headliner. Adding trapeze and aerial silk routines to her concerts definitely upped the energy and excitement level—her own as well as audiences'. By the time she was ready to launch her fourth tour in early 2009, to coincide with the release of her album *Funhouse,* she wanted to push the envelope even further—so she approached Bob Mackie about designing the costumes.

Mackie on P!nk: "I try to keep up-to-date with music trends, and I was delighted to work with P!nk. She's an amazing performer, and of course, the aerial work was just an additional challenge. I mean, she sings while hanging up there in the air, and she is absolutely fearless! Luckily, today we have these amazing stretch fabrics that we didn't have years ago. P!nk is different from anyone I've ever dressed—a true showperson who really *gets* it."

Australia, in particular, went absolutely bonkers for the singer during her three months Down Under. She played sixteen sold-out concerts over six different engagements in the city of Melbourne alone, filling the sixteen-thousand-seat Rod Laver Arena with throngs of adoring attendees, many of whom came back multiple times. She followed that up with a performance on the 2009 MTV Video Music Awards that stopped the show cold. She performed her number one hit "Sober" while flying on a trapeze, and she sang it live; no lip-synching ever for the gal from Doylestown, PA.

Then, in what has been called one of the greatest live performances of the twenty-first century (so far), P!nk finished her eleven months on the road at the Grammys in L.A., where she sang her hit "Glitter in the Air" in a Mackie floor-length hooded robe. Halfway through the song, she doffed the garment to reveal a nude body stocking covered in white straps. Thus (un)dressed, she finished her work hanging *upside down* from aerial silks and spinning as she was lowered into a tank of water, then raised again to spin some more and drench the first six rows of the orchestra. We hope little Alecia Beth Moore would have considered the ensuing standing ovation every bit as satisfying as a row of perfect tens from the judges.

---

THIS PAGE: *Mackie's renderings for the first two of P!nk's looks in* Funhouse: *a Napoleonic uniform and a scorching leopard-print beaded silk scarf top and metallic pants ensemble.*

OPPOSITE: *P!nk, flawless from any angle.*

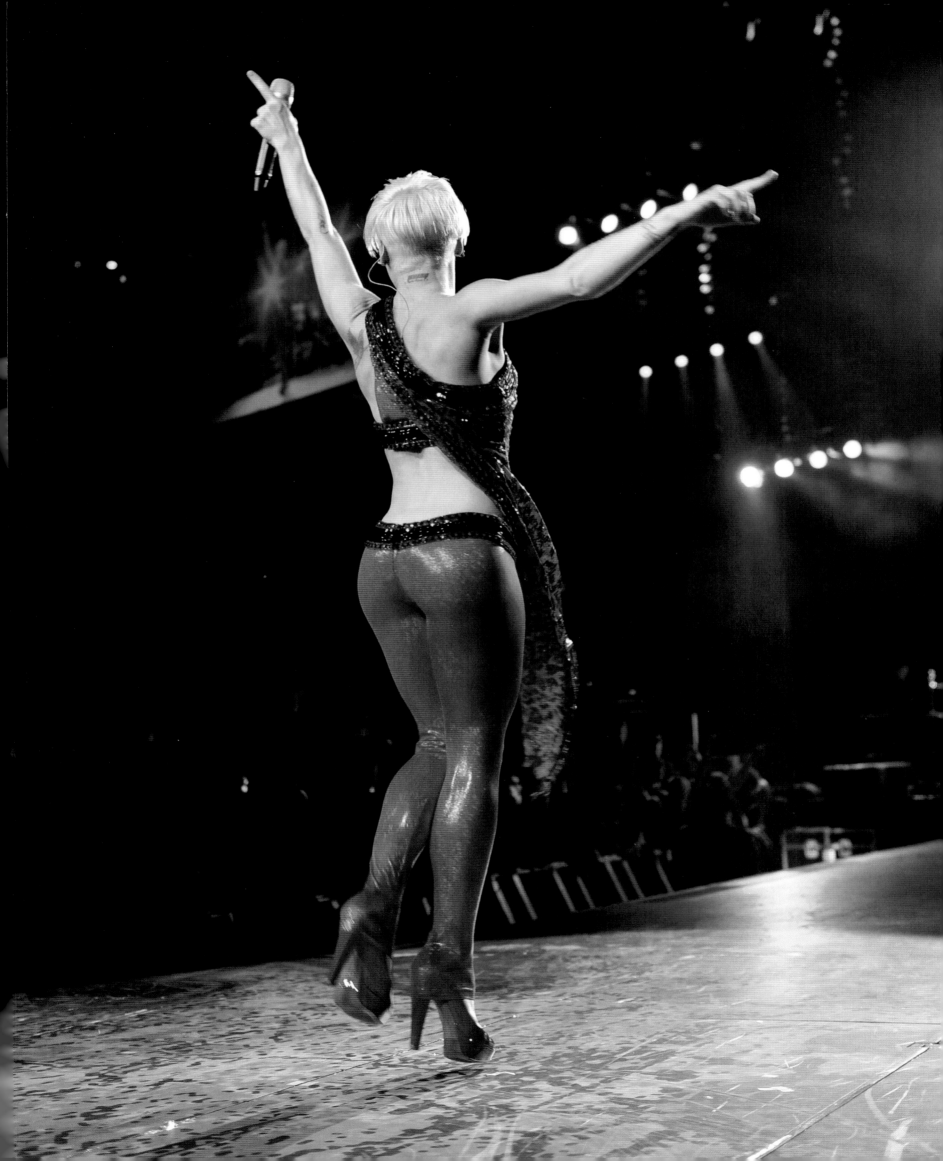

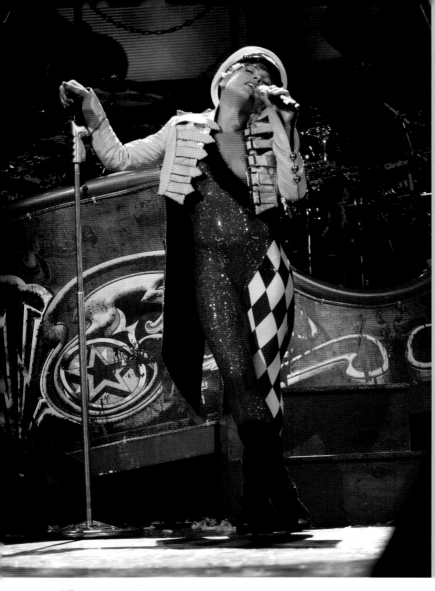

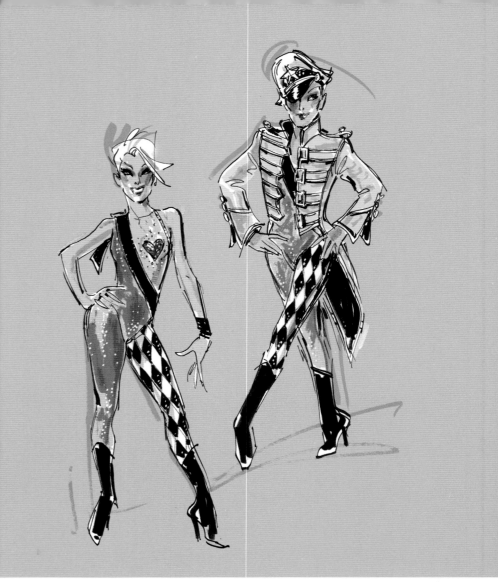

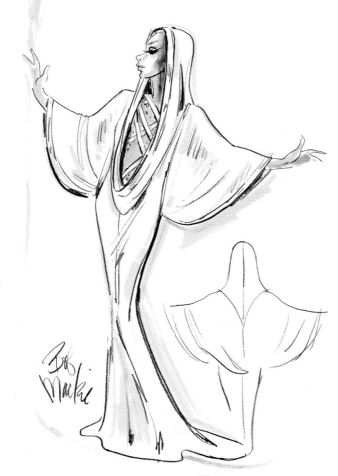

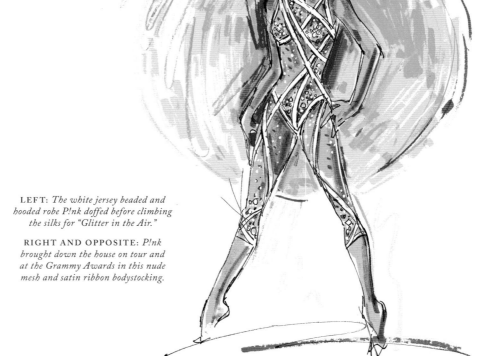

LEFT: *The white jersey beaded and hooded robe P!nk doffed before climbing the silks for "Glitter in the Air."*

RIGHT AND OPPOSITE: *P!nk brought down the house on tour and at the Grammy Awards in this nude mesh and satin ribbon bodystocking.*

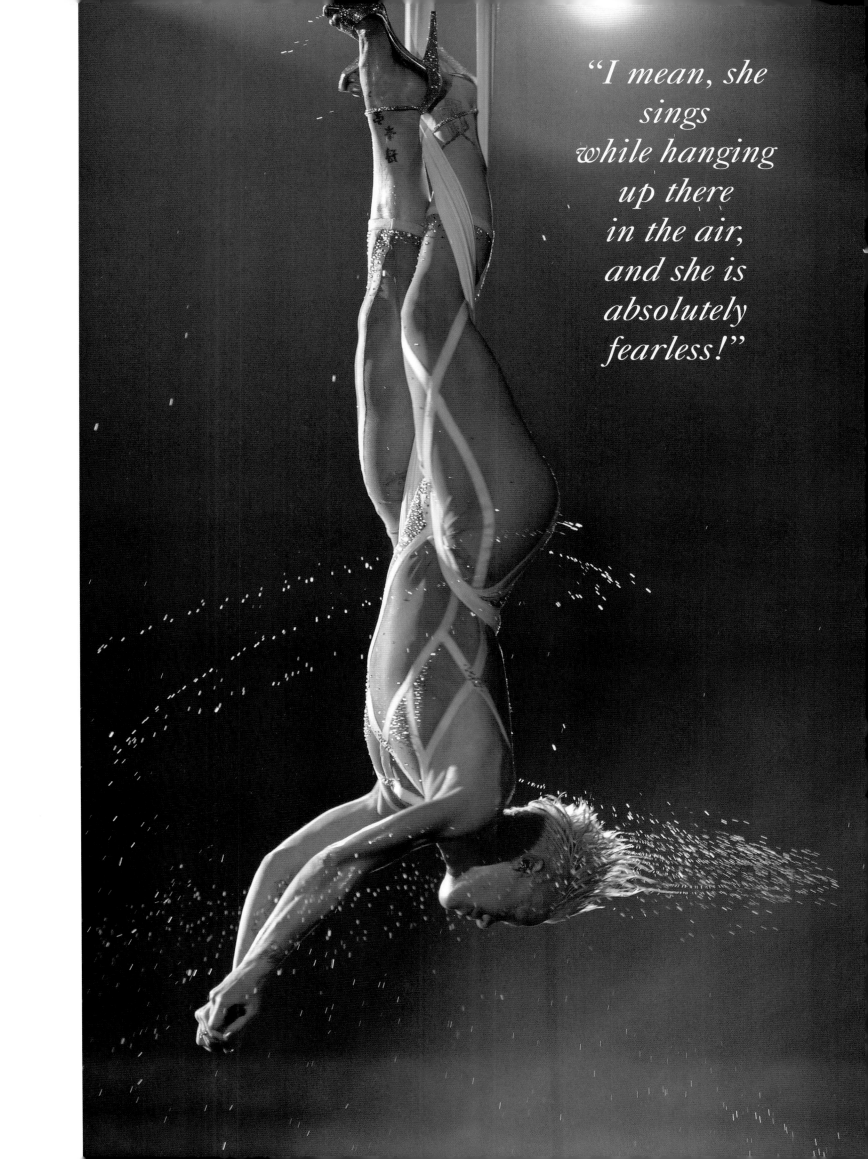

"I mean, she sings while hanging up there in the air, and she is absolutely fearless!"

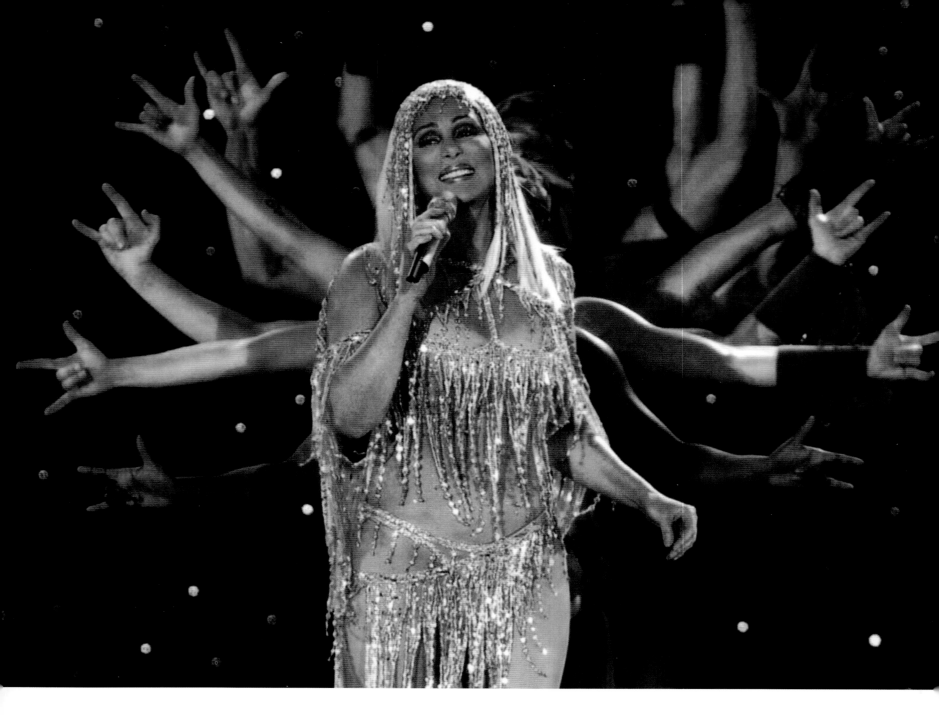

# *Cher* Magic

**AFTER A DECADE OF WEEKLY TELEVISION SHOWS AND VARI-**ety specials, Cher moved into the 1980s with another goal in mind: conquering the world of film. And that she did, earning respect for her roles in *Silkwood* and *Moonstruck,* among others. With a best-actress Oscar safely stashed on her mantelpiece for the latter, she returned to the concert stage in 1989, with the hard-rocking *Heart of Stone* tour.

Over the next two decades, while her shows became more and more elaborate and her fan base expanded exponentially, Cher grew into an arena icon in the same league as her friends Tina Turner and Elton John, racking up record sales with such hits as "Just Like Jesse James," "If I Could Turn Back Time," "Strong Enough," and "Believe."

Cher's *first* farewell tour, *Living Proof,* was a marathon comprising 326 concerts over three years—from June 2002 through April 2005.

So that was that, right? Wrong. Although the star was sneaking up on sixty and had earned the right (and the money) to kick back and relax, she continued to be lured by the siren song of the live audience. She said farewell to "farewell" and took up residency at Caesars Palace in Las Vegas from 2008 to 2011. That gig would net her a $60 million paycheck and seventeen brand-new Mackie looks to showcase as no other diva could.

As of this writing, Cher is still rocking the house rather than cleaning it, alternating between farewell tours and Vegas residencies and proving the veracity of one of her hits from Sonny-er days: "The Beat Goes On."

*Cher in a gold Mackie designed for her first farewell tour in 2002.*

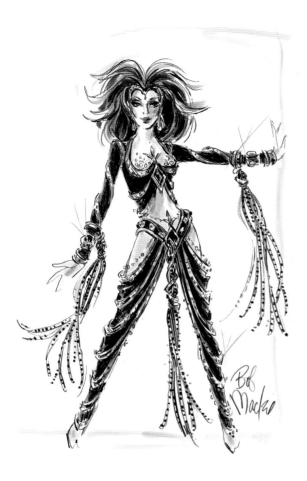

ABOVE AND BELOW: *Sketches for Cher's 2008–11 residency at Caesars Palace.*

RIGHT: *Cher's entrance costume, featuring red pheasant feathers and French chain, for her premier appearance at Caesars in 1980.*

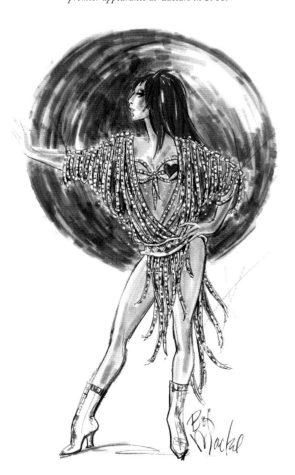

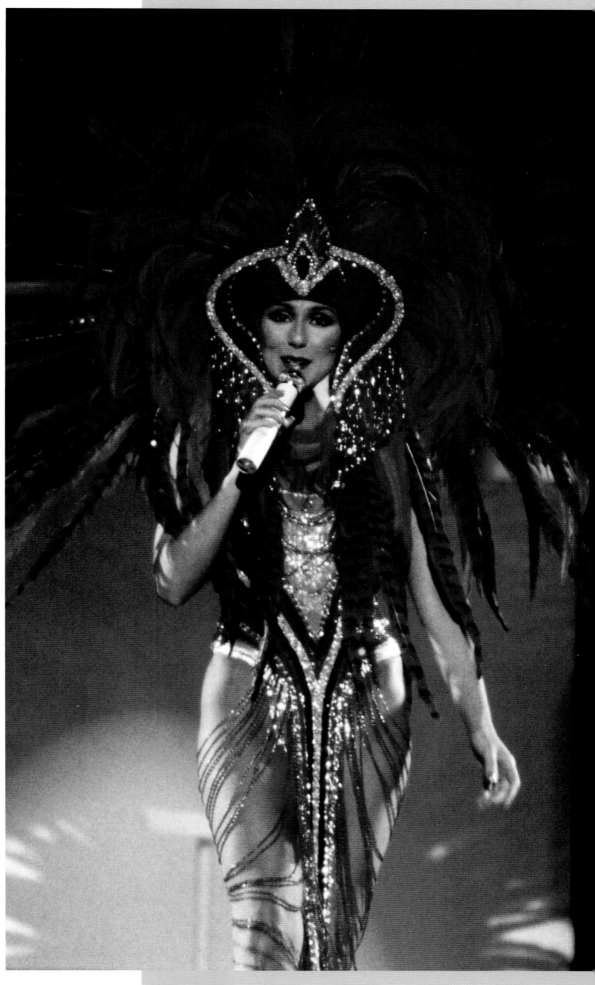

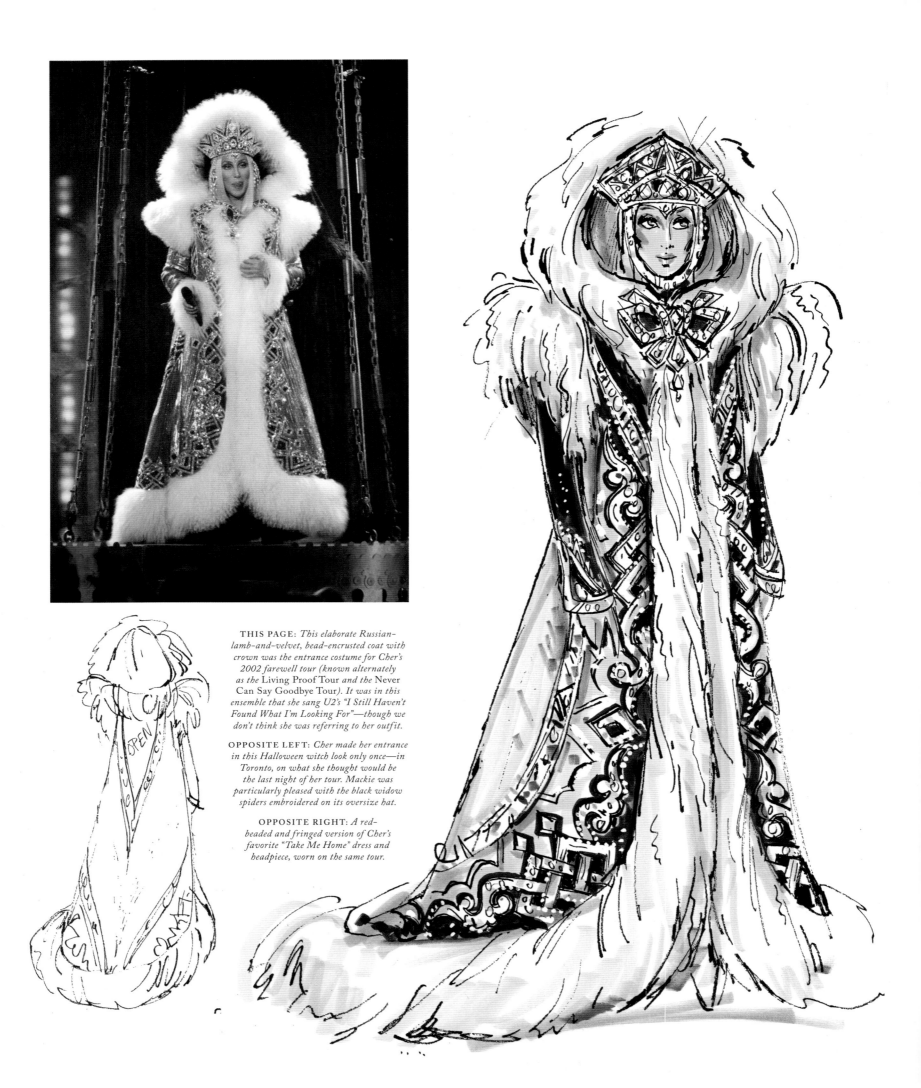

THIS PAGE: *This elaborate Russian-lamb-and-velvet, bead-encrusted coat with crown was the entrance costume for Cher's 2002 farewell tour (known alternately as the* Living Proof Tour *and the* Never Can Say Goodbye Tour). *It was in this ensemble that she sang U2's "I Still Haven't Found What I'm Looking For"—though we don't think she was referring to her outfit.*

OPPOSITE LEFT: *Cher made her entrance in this Halloween witch look only once—in Toronto, on what she thought would be the last night of her tour. Mackie was particularly pleased with the black widow spiders embroidered on its oversize hat.*

OPPOSITE RIGHT: *A red-beaded and fringed version of Cher's favorite "Take Me Home" dress and headpiece, worn on the same tour.*

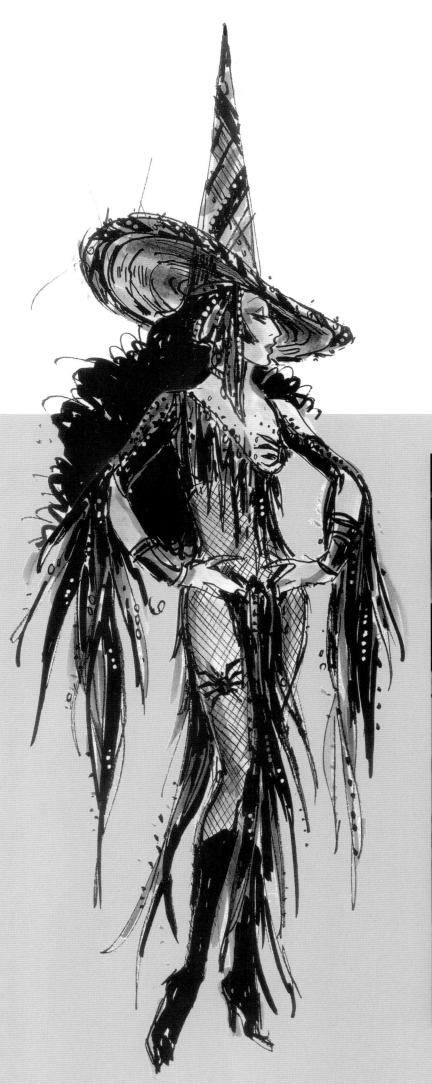

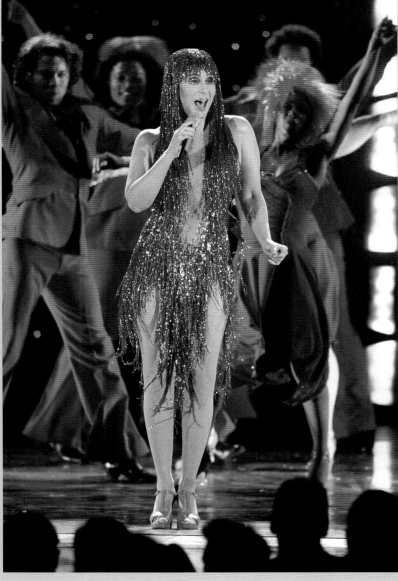

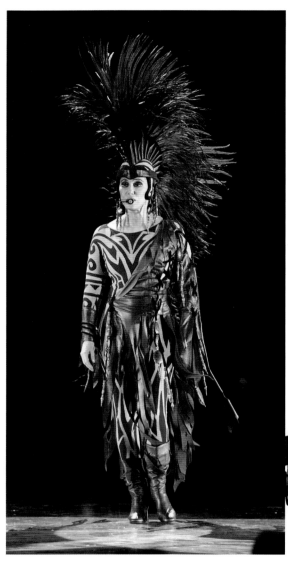

As of this writing, Cher is still rocking the house rather than cleaning it, alternating between farewell tours and Vegas residencies.

ABOVE AND RIGHT: *Cher in sketch and flesh, singing "Bang, Bang" during her 2002 farewell tour.*

OPPOSITE: *The African-inspired three-piece entrance costume for Cher's 2016 residency at the Park MGM Theater in Las Vegas.*

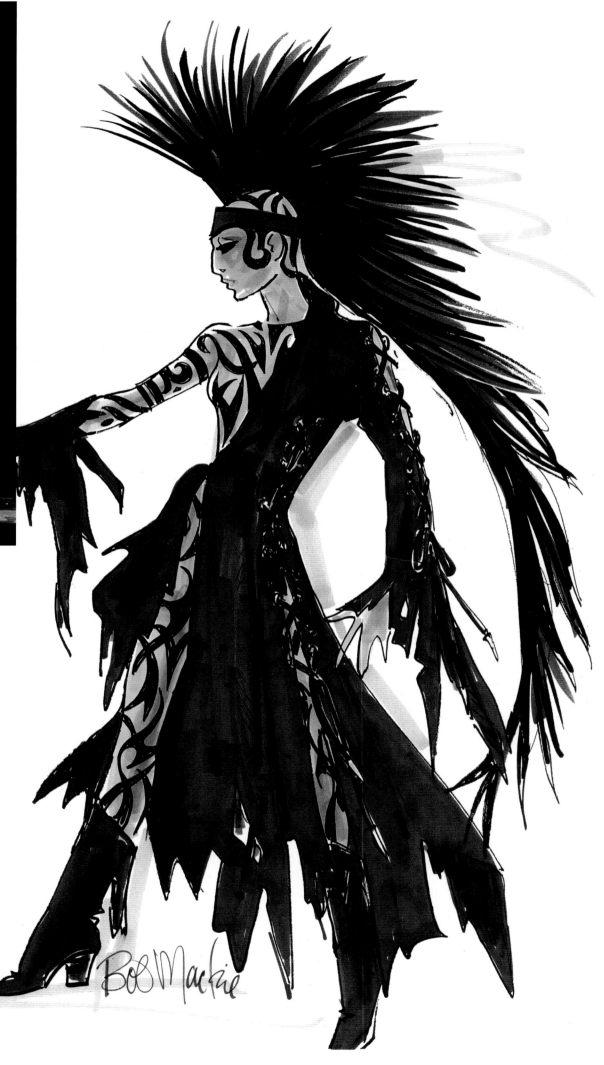

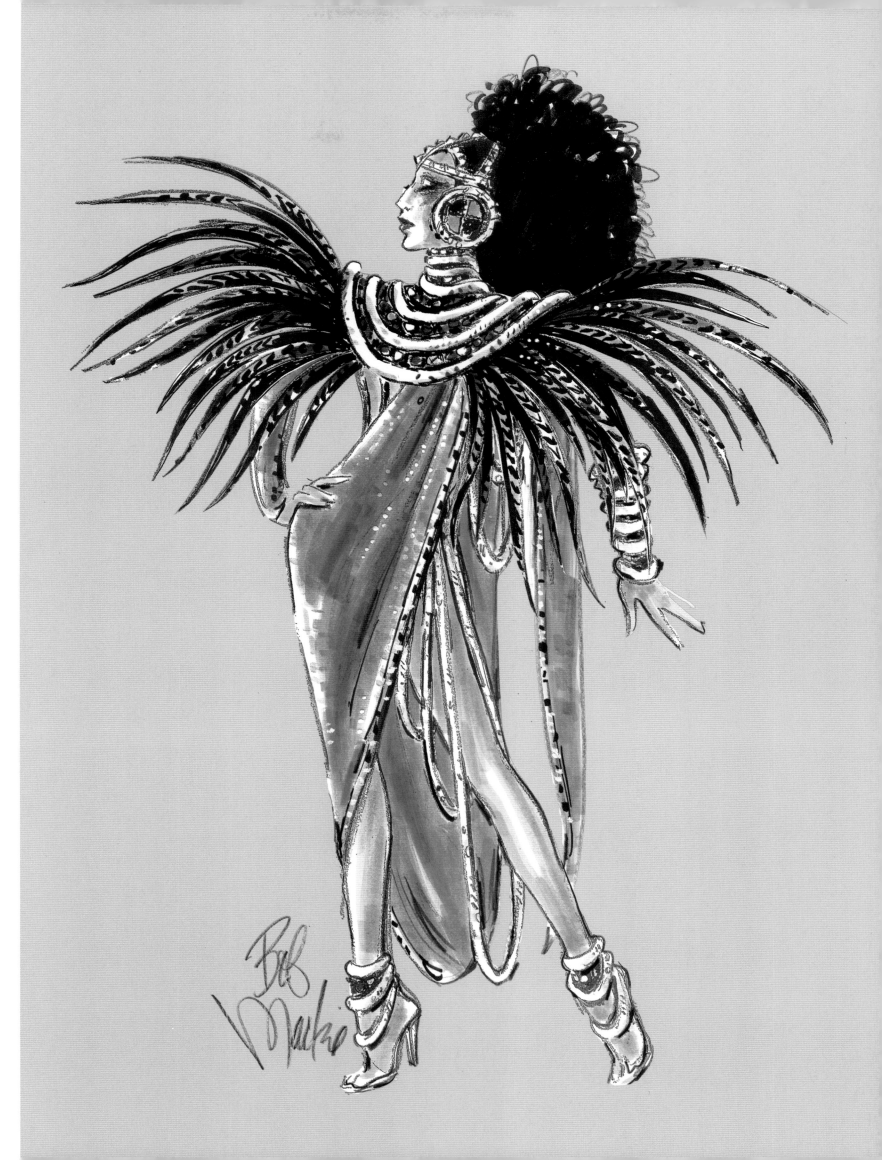

# ON BROADWAY AND OFF

**"I WAS ALWAYS BOUND TO DESIGN FOR BROADWAY,** because by the time I graduated from design school, the movie musical was dead!"

Mackie made it to the Great White Way at the ripe old age of thirty, after almost a decade in Hollywood. His first outing was a collaboration with Ray Aghayan on the costumes for the 1971 revival of the Leonard Bernstein/Betty Comden/Adolph Green classic, *On the Town*.

But . . . let's be real. He'd already been designing the equivalent of twenty-six Broadway musicals a season for four years on *The Carol Burnett Show*.

Although his duties have tended to keep him on the West Coast most of the time, Bob has always grabbed every chance he could get to design for theater, be it Broadway, Off Broadway, or the stages of L.A.

Behold, a tribute to Bob Mackie's first passion, one that finally paid off with a well-deserved Tony Award in 2019 for his witty reimagining of diva style for *The Cher Show*. If you think he pulled these astonishing creations out of his trunk—or Cher's— think again. The clothes that got standing O's all on their own were nothing less than a history of Mackie couture from 1966 to the present.

In case you're counting, that's fifty Mackie years in the theater.

---

LEFT: *Now it can be told. Bob Mackie designed (without credit) several costumes for Ann Miller in the 1980 Broadway Musical Sugar Babies.*

RIGHT: *Tony winner Donna McKechnie, pretty in pink in the 1971 Broadway revival of On the Town.*

OPPOSITE: *Mackie's rendering for the legendary Angela Lansbury's return to Broadway, as host of the 1987 Tony Awards. Glorious in black and white, she would find herself somewhat incongruously surrounded by six of Miss Mona's "girls" from The Best Little Whorehouse Goes Public.*

Bob Mackie

# Helluva *Town*

**WHEN MACKIE FIRST SAW HIS WORK ON A BROADWAY STAGE,**
it was in collaboration with his partner, Ray Aghayan, who'd been hired to design costumes for the 1971 revival of the Leonard Bernstein/Betty Comden/Adolph Green musical *On the Town*. A smash-hit revival of the 1925 musical *No, No, Nanette* had taken New York by storm earlier that year, and nostalgia was *in*.

The big-budget revival, directed and choreographed by Ron Field (who had won two Tony Awards the previous season for the Lauren Bacall vehicle *Applause*), was beset by troubles from the beginning. Two of the three male leads had to be replaced out of town, including the role originally played by co-author Adolph Green. The bar to play Green's role was set pretty high, as the actress playing opposite was the Tony-winning Phyllis Newman, who also happened to be Mrs. Green.

While the show was not successful, and Field's new choreography was largely dismissed, he did get two things exactly right: the casting of the female leads and the hiring of Aghayan and Mackie. Newman

as the man-hungry anthropologist Claire de Lune and Bernadette Peters as the man-hungry cabdriver Hildy Esterhazy were joined by sublime dancing actress Donna McKechnie as Gaby's dream girl, Ivy Smith. The fiercely talented trio (all eventual Tony winners) handily upstaged the male contingent—in part because they got to wear infinitely more memorable costumes than the fellas. (In fairness, there's not much even the most inventive designer can do with a sailor suit beyond making sure it's a perfect fit.)

Aghayan and Mackie totally captured the spirit of this nonpareil musical love letter to New York City. The clothes were colorful, character revealing, and designed with just enough of a sly wink to enhance the comedy of the ladies' performances. Looking back, they easily could have been designed for one of Carol Burnett's 1970s spoofs of vintage movies.

Although *On the Town* lasted just two months on Broadway, people who saw it still talk about its costumes fifty years later. The major miscalculation may have been counting on audiences' hunger

for the good old days. While theatergoers had exhibited sentimental affection for the tap dancing employed in *Nanette*, they weren't necessarily itching for the jitterbug. As they say, timing is everything, and tastes were changing at a mind-blowing rate. Three seasons later, the Andrews Sisters musical *Over Here!* would open, and thanks to a variety of factors—including Bette Midler's chart-topping cover of "Boogie Woogie Bugle Boy"—the big-band sound would once again ring out on Broadway.

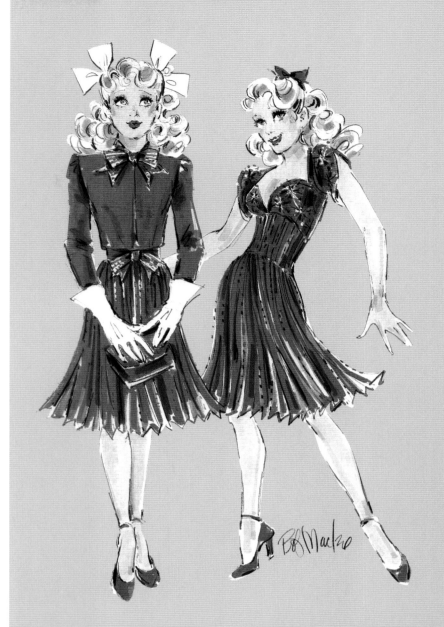

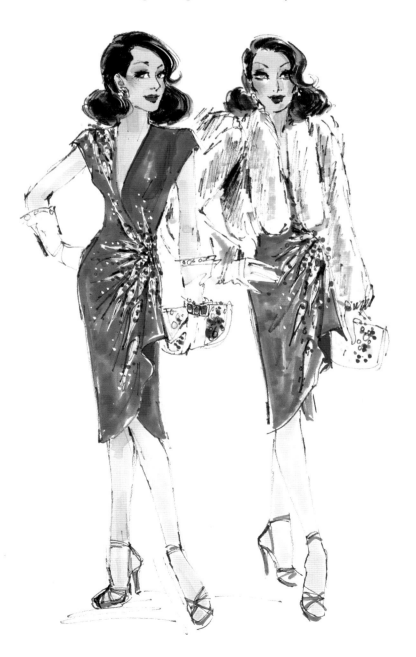

*The clothes were colorful, character revealing, and designed with just enough of a sly wink to enhance the comedy of the ladies' performances.*

OPPOSITE: *Sketches for Donna McKechnie's Miss Turnstiles.*

TOP LEFT: *In this very rare color photo of the curtain call of* On the Town, *leading man Ron Husmann (far left) takes his bow as Donna McKechnie, Fran Stevens, Phyllis Newman, Remak Ramsey, Bernadette Peters, and Jess Richards look on.*

ABOVE AND LEFT: *Sketches for Bernadette Peters's Hildy and Phyllis Newman's Claire de Loone, respectively..*

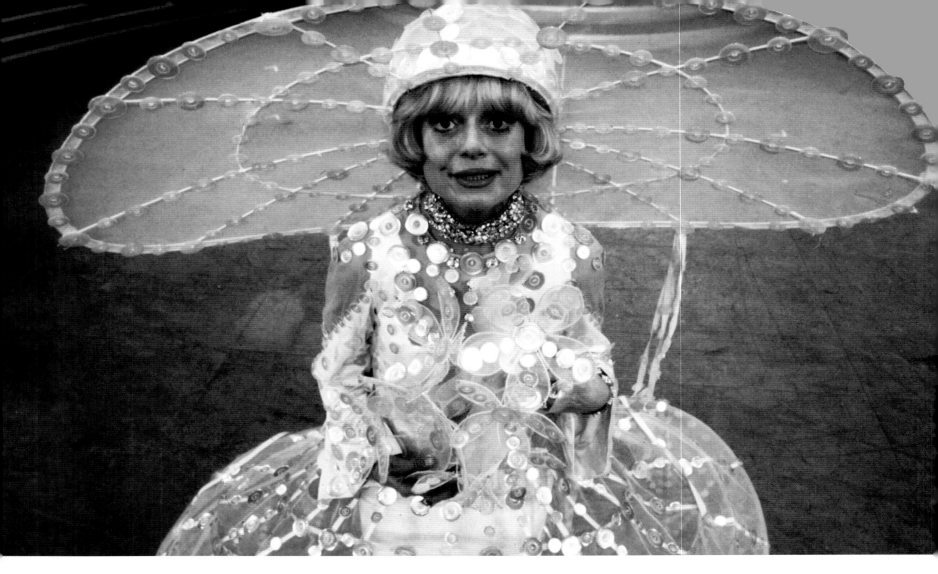

# Just a *Little Girl* from *Little Rock*

**LORELEI WAS A 1973 "REVISAL" OF THE 1947 SMASH** *Gentlemen Prefer Blondes*, the show that made Carol Channing a star. It was produced with the best of intentions but fraught with headaches.

With a new book by Mackie's *Carol Burnett Show* collaborators Kenny Solms and Gail Parent, additional songs by the show's original composer, Jule Styne, and lyrics by the legendary Betty Comden and Adolph Green, *Lorelei* set off on an eleven-month national tour, with Channing reprising the title role, before heading to Broadway. Solms and Parent, two directors, and countless choreographers were asked to hit the road while *on* the road.

While most of the costumes were the handiwork of Alvin Colt, Mackie was tapped to create the bedazzled designs for Channing. Let's face it: In 1973, if you were going to sing "Diamonds Are a Girl's Best Friend," who better than the "sultan of sequins" himself to deck you out? As he recalled, "Carol was a windup doll, larger than life but with *very* specific ideas about what she would wear."

Mackie had worked with Channing on a Danny Thomas burlesque special in 1966, and when she was a guest on the *Burnett Show*. He'd go on to design many red-carpet and day-wear looks for the five-ten wide-eyed naïf.

The show finally landed at New York's Palace Theatre in 1974, ran for a very respectable 321 performances, and issued *two* cast albums—one early on and one incorporating the myriad changes made during the show's pre-Broadway trial by fire. By the time it hit the Great White Way, it was nothing more than a thinly veiled revival of *Blondes*. Only four of Comden and Green's songs made it into the final *Playbill;* at least ten others had bitten the proverbial dust during the extended tryout. But Channing was thrilled when she and her fabulous wardrobe were welcomed back to Broadway after a decade away. Her many accolades included a curious Tony Award nomination. Not that she didn't deserve it . . . but the rules clearly state that no actor may be nominated for a role she has already played between Fortieth and Fifty-seventh Streets.

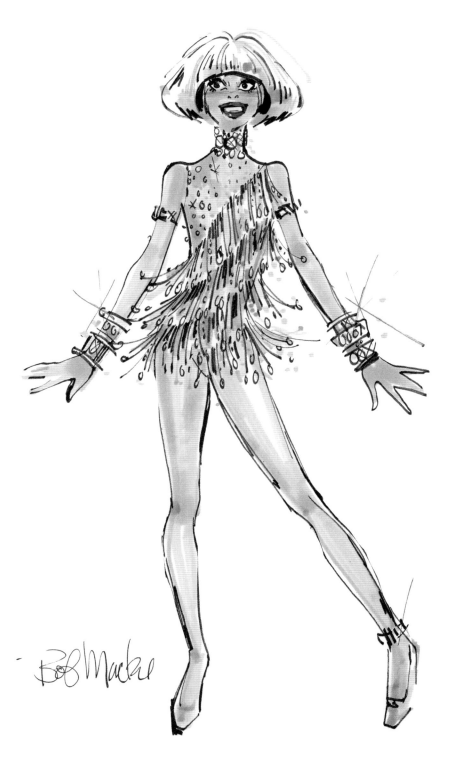

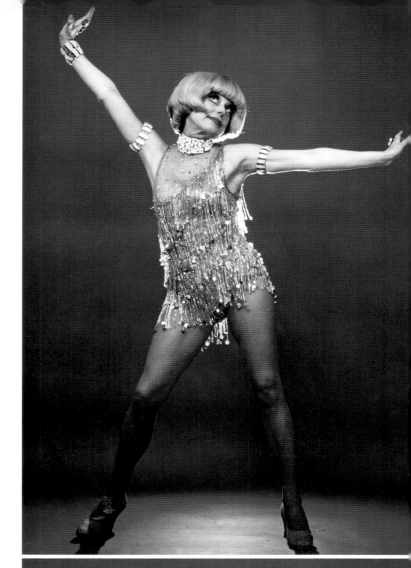

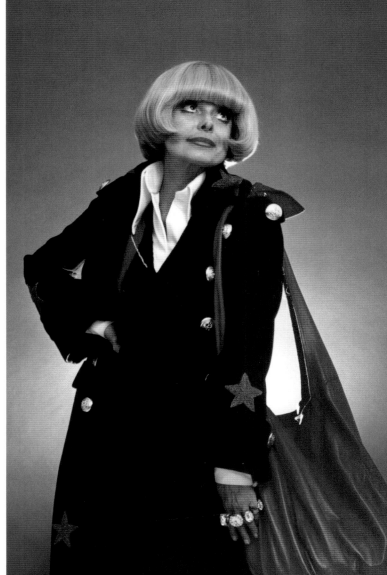

— Bob Mackie

*"Carol was a windup doll, larger than life but with very specific ideas about what she would wear."*

OPPOSITE, BOTTOM: *Carol Channing's look for the opening scene of* Lorelei, *as a flapper in mourning who sings the newly written Jule Styne/Comden and Green song "Looking Back."*

ABOVE, LEFT AND RIGHT: *Diamonds may be a girl's best friend, but gold is right up there on Lorelei Lee's wish list as well. She performed the showstopper "Mamie Is Mimi" in this beaded minidress.*

RIGHT: *"I made a navy blue full-length version of a peacoat for her to wear in public, and she trucked it out for the next forty years!"*

# Platinum *Dreams*

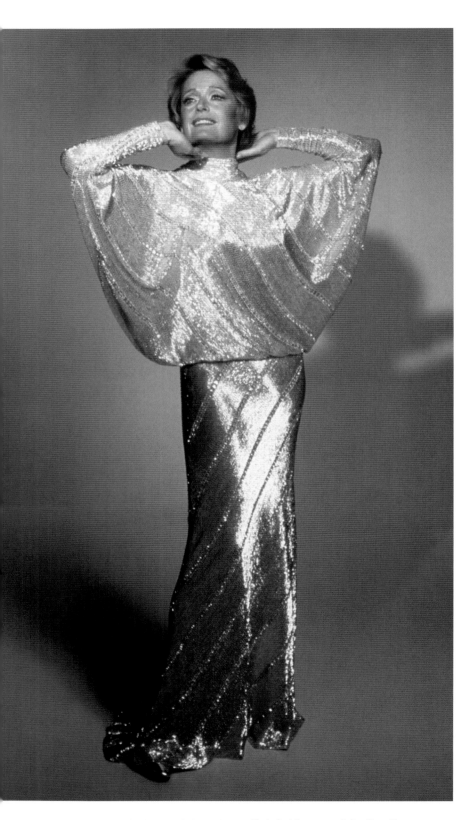

ABOVE AND OPPOSITE: *Alexis Smith recaptured the glitz of her career as a movie siren in the 1940s and '50s in her final* Platinum *costume.*

**MACKIE RECALLS: "OH, ALEXIS'S CURTAIN-CALL DRESS! I** loved designing it, and she looked stunning in it, but it was so heavily beaded that the thing weighed about fifty pounds. If she'd ever fallen over onstage, she'd never have been able to get up!"

Mackie got to work with another Hollywood legend from his moviegoing youth when he designed the costumes for the 1978 Broadway musical *Platinum*. The star was Alexis Smith, a statuesque glamour gal of the 1940s and '50s who'd launched a new career in the theater earlier in the decade with her Tony-winning turn in Stephen Sondheim's *Follies*. Smith's singing and dancing had stopped that show and landed her on the cover of *Time* magazine. Long-legged, soigné, and exhibiting a saunter that could conquer the catwalk of any fashion show in Paris, she was a perfect muse for Mackie, epitomizing his particular sense of elegance.

Under its initial title, *Sunset, Platinum* had started its journey the previous year at the Studio Arena Theatre in Buffalo, directed by Tommy Tune, who would go on to work with Mackie several times over the next two decades—though not this time, as he'd abandoned the project in favor of *Best Little Whorehouse in Texas* before Mackie came on board. In a sense, the show was an example of art imitating life. Smith played Lila Halliday, a 1940s movie star attempting a comeback by recording a rock album (shades of the notorious *Ethel Merman Disco Album* that would be released in 1979, shortly after *Platinum* closed). By the time the show hit Broadway, it had a new title, a new director (Joe Layton, who had helmed the 1968 hit *George M!* and would go on to shepherd *Barnum* into the win column), and a new book writer (Bruce Vilanch, now best known for writing awards-show "ad-libs"). It would also have an entirely new cast, save Smith and Lisa Mordente, the daughter of Broadway legend Chita Rivera and a talented singer/dancer in her own right.

*Platinum* opened at the Mark Hellinger Theater in November 1978, having grown to mammoth proportions. Film sequences were incorporated into the action (gotcha, Ivo van Hove), and an entire recording studio occupied the stage, along with a pinball machine and—this being the 1970s—a working hot tub. For Smith, Mackie created a wardrobe of leather pants and satin blouses, cashmere sweaters, and a silver curtain-call dress featuring bugle beads in a groove pattern reminiscent of a vinyl record. It weighed a ton and became the stuff of legend. For Mordente and the rest of the younger generation, it was an array of outrageous glam-rock attire. Leading man Richard Cox, who played a sexier, less extreme version of Alice Cooper named Dan Danger (you knew he was Dangerous because his act incorporated a whip), had the most memorable costume in the show, although Mackie can't claim responsibility for it. It appeared when the actor stepped out of the aforementioned hot tub in his birthday suit, demystifying his name change from Zuckerman to Cox. The matinee ladies were mortified, and many of them made numerous return visits to show their disgust during the show's monthlong run, sitting closer and closer each time!

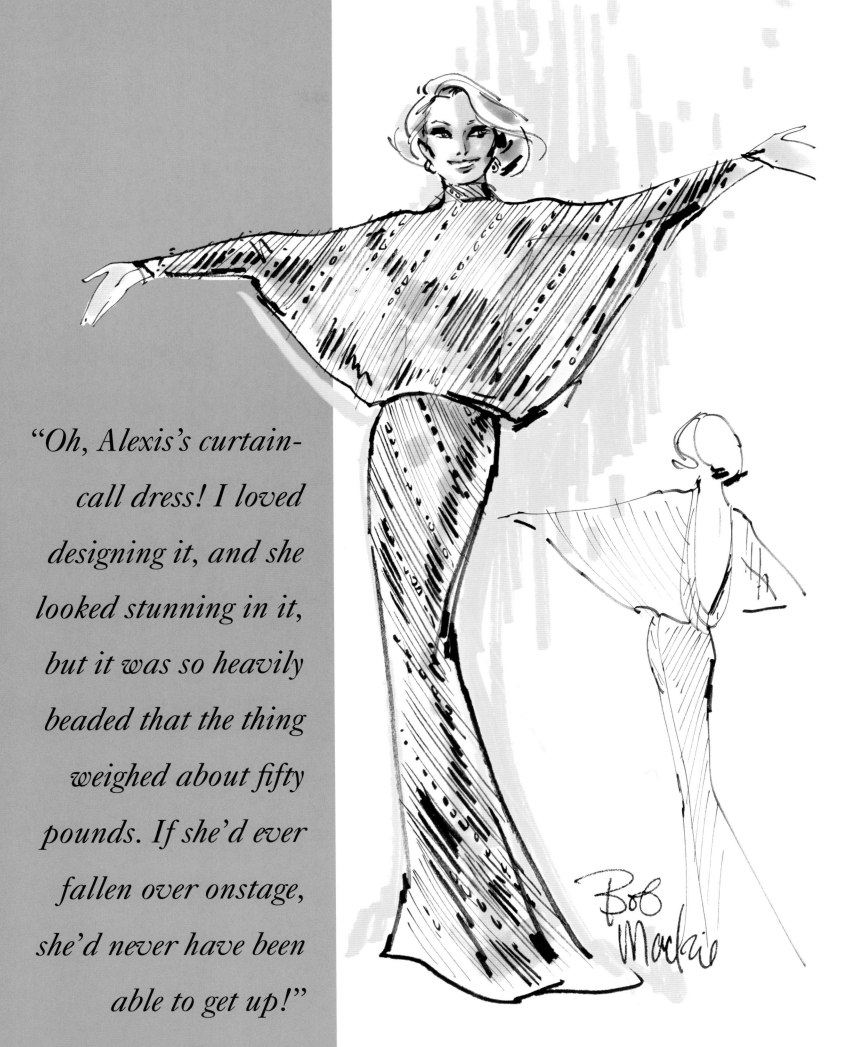

*"Oh, Alexis's curtain-call dress! I loved designing it, and she looked stunning in it, but it was so heavily beaded that the thing weighed about fifty pounds. If she'd ever fallen over onstage, she'd never have been able to get up!"*

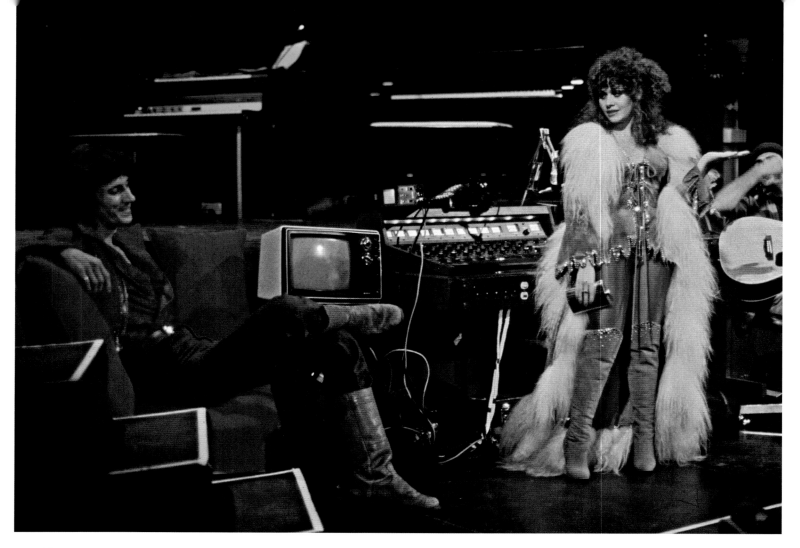

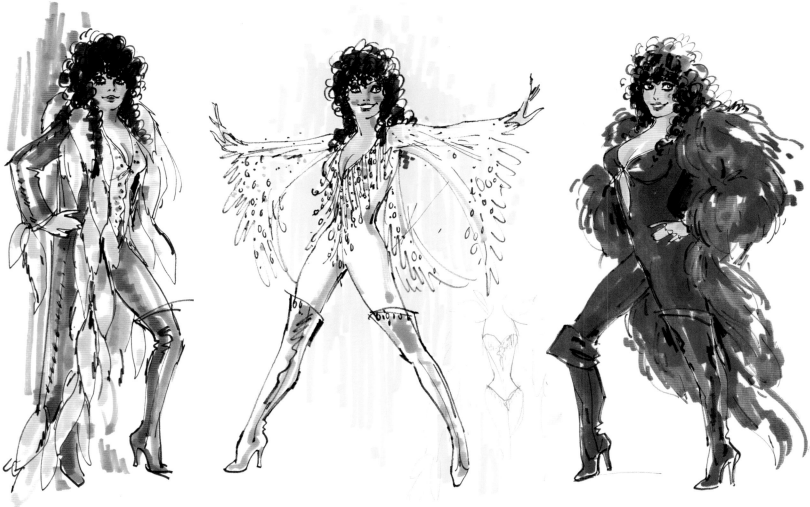

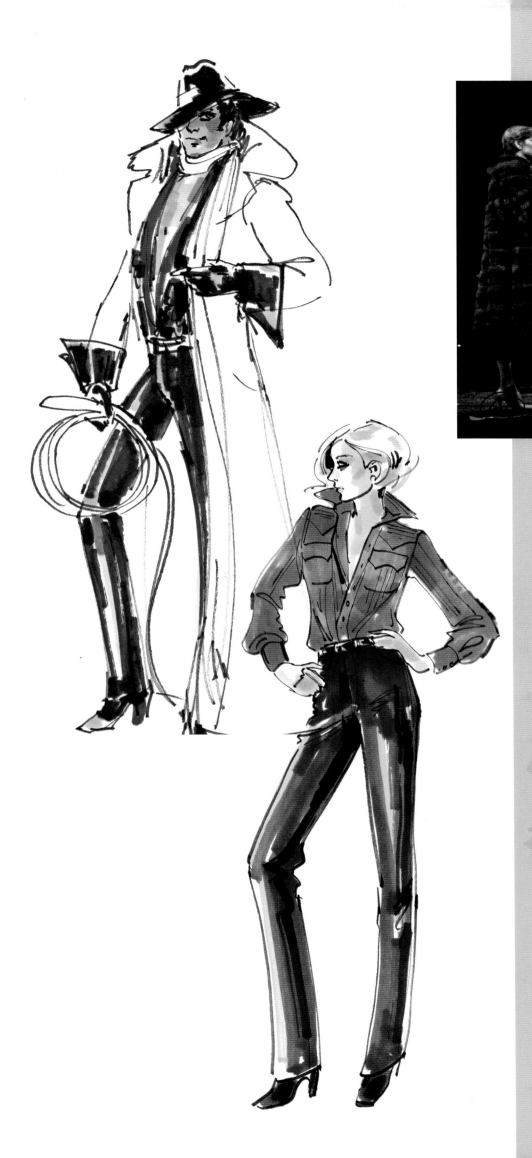

*The matinee ladies were mortified, and many of them made numerous return visits to show their disgust during the show's monthlong run, sitting closer and closer each time!*

OPPOSITE, TOP: *The very tall Richard Cox and the very wee Lisa Mordente hope for a hit record as characters and a hit musical as performers.*

OPPOSITE BOTTOM AND LEFT *In his designs for Lisa Mordente, Mackie drew upon his experience designing for real-life pop stars Elton John, Bette Midler, and Tina Turner.*

ABOVE: *"Mr. Danger, I believe you dropped your whip!" Generations clash as Alexis Smith goes high heel to high heel with Richard Cox, observed by Damita Jo Freeman, John Hammil, Ronnie Baker, Lisa Mordente, and Avery Sommers.*

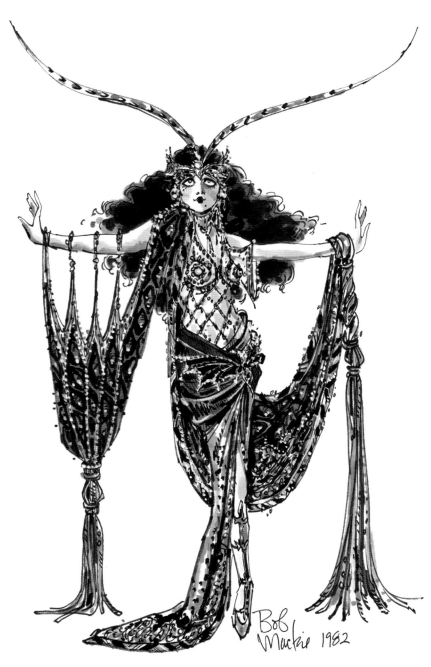

# Let's Put on a *Show!*

**YOU COULD CALL *MOVIE STAR*, A MUSICAL REVUE THAT** scored a hit at Los Angeles's Westwood Playhouse in 1982, a bit of a family affair. It was co-created by Ray Aghayan (who also directed) and Bob Mackie (who designed the absolutely outrageous costumes) and featured songs by master of the form Billy Barnes—with whom Mackie had collaborated for over twenty years, starting with Barnes's 1963 revue, *Billy Barnes L.A.*

The left-coast version of Julius Monk, whose New York revues skewered politics, society, and cultural trends, Barnes began writing satirical musical material in the mid-1950s. His sly work reached its apotheosis in 1959, when his *Billy Barnes Revue* transferred to Broadway. Barnes would go on to write specialty material for *Rowan & Martin's Laugh-In*, *The Sonny & Cher Comedy Hour*, and Academy Awards telecasts through the 1970s.

Perhaps the thing that cemented the collaboration of Aghayan, Barnes, and Mackie was their shared adoration of the movies, stretching back to their respective childhoods. It was only logical that they'd whip that passion into a love letter to the industry and the town where they'd chosen to live and work.

While the writing in *Movie Star* was clever and the cast fantastically talented, Mackie's costumes received the biggest bouquets in the reviews—for good reason: They were the wildly inventive result of the designer's years honing his skills in variety television, only this time he wasn't working on a weekly-TV-style deadline. This was Mackie on acid, and every lucky patron of the intimate 650-seat Westwood Playhouse walked out humming the costumes.

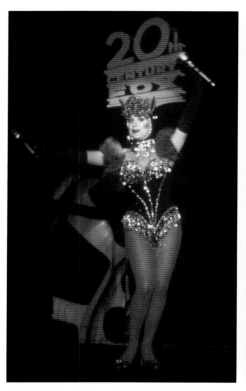

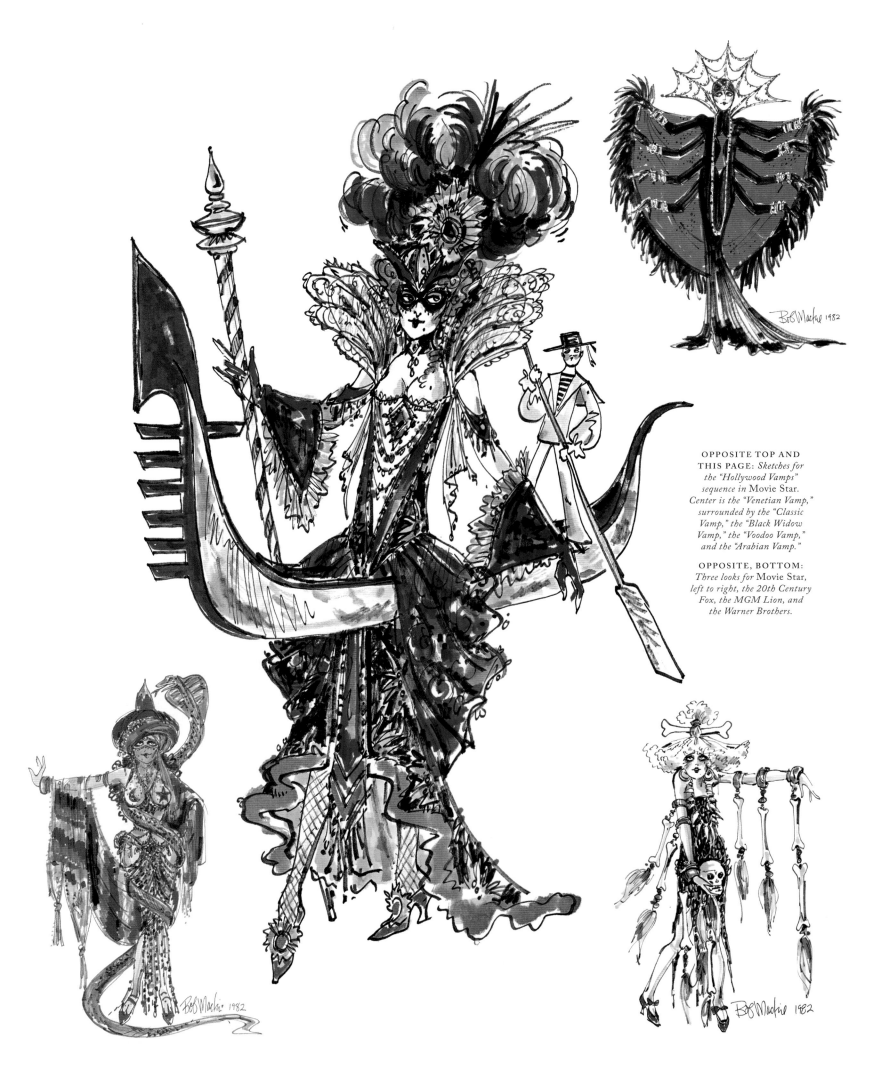

OPPOSITE TOP AND THIS PAGE: *Sketches for the "Hollywood Vamps" sequence in* Movie Star. *Center is the "Venetian Vamp," surrounded by the "Classic Vamp," the "Black Widow Vamp," the "Voodoo Vamp," and the "Arabian Vamp."*

OPPOSITE, BOTTOM: *Three looks for* Movie Star, *left to right, the 20th Century Fox, the MGM Lion, and the Warner Brothers.*

# Fresh *Follies*

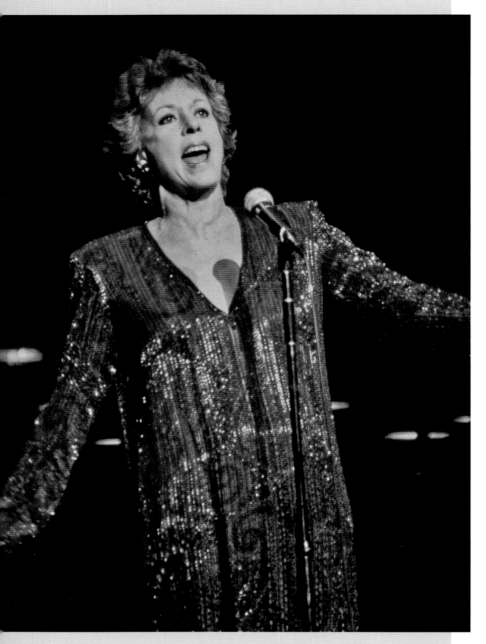

ABOVE: *Carol Burnett nails "I'm Still Here" in the historic 1985* Follies in Concert.

BELOW: *At the dress rehearsal where this shot was taken, Liliane Montevecchi was still reading the Sondheim lyrics to "Ah, Paree!" from a scrap of paper. By performance night, she had committed most of them to memory, but just for safety she pulled a Sarah Palin and wrote them all over her hands.*

*Leaving behind only a severely truncated cast album for devotees to cling to in the night, the show cried out for a revival for almost fifteen years.*

**THOSE LUCKY ENOUGH (AND OLD ENOUGH) TO HAVE SEEN** the original 1971 Broadway production of the Stephen Sondheim/James Goldman musical *Follies*, co-directed by Hal Prince and Michael Bennett with choreography by Bennett, still talk about it to this day. Fans returned to the Winter Garden Theatre over and over, haunted by the show's complex message of longing and regret, conveyed via a time-looping story of theatrical colleagues attending a reunion of a *Ziegfeld Follies*–style show.

The original production conveyed a physical opulence not seen since the days of the original *Ziegfeld Follies,* augmented by the unparalleled genius of its "dream team" of creators. In spite of its grandeur, bracing originality, and devoted cadre of fans, *Follies* was never a box-office smash. Some explain this by insisting it was ahead of its time or too cynically on the nose to satisfy the theater party crowd. Whatever the case, the passage of time would vindicate it as one of the undisputed all-time greats.

Leaving behind only a severely truncated cast album for devotees to cling to in the night, the show cried out for a revival for almost fifteen years. Finally, fans' prayers were answered when a concert version was announced for September 1985, to be performed at New York's Avery Fisher Hall with the New York Philharmonic. Tickets were immediately snapped up for what promised to be an event for the ages. (Thankfully for the majority of humans on the planet who hadn't a prayer of snagging a seat, the concert was filmed by PBS for an hour-long documentary.)

Re-creating Boris Aronson's amazing sets from the original production was out of the question, and Florence Klotz's costumes, well . . . why even try? But the actors had to wear something, and that something had to rise to the level of the material, the assembled performers, and the long memories of the show's staunchest acolytes. Enter Bob Mackie with his customary sparkle.

Designing gowns for chum Carol Burnett, who belted out the anthem "I'm Still Here"; Tony-winning French chanteuse Liliane Montevecchi, who is still trying to master the tricky Sondheim lyrics to "Ah, Paree!" up in that great Moulin Rouge in the sky; and his friend of twenty years Lee Remick, for whom he had designed since before he met Burnett, Mackie brought the elegance. For Remick, he designed two classic gowns, one in black for her turn as the brittle, acerbic Phyllis Rogers Stone, and another in fire-engine red for her eleven o'clock patter song, "The Story of Lucy and Jessie."

With only five days of rehearsal and the show's legacy on the line, the entire company felt the weight of the task—a burden made decidedly lighter by Mackie's pitch-perfect evocations of the show's timeless splendor.

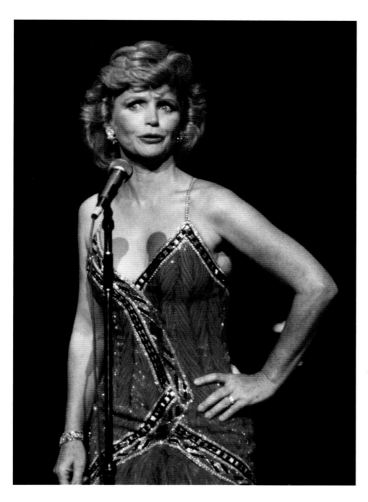

ABOVE AND RIGHT: *Reznick onstage at Avery Fisher Hall, and the newly drawn sketch of the "Lucie and Jessie" gown.*

BELOW: *Remick in a slip-top Mackie, singing "Could I Leave You?"*

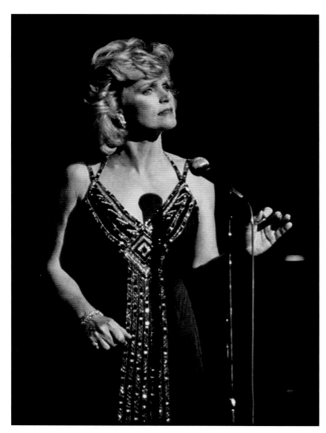

# Carrying a *Tune*

**DIRECTOR/CHOREOGRAPHER/HOOFER TOMMY TUNE** won a Tony for *The Will Rogers Follies*, but it was *The Best Little Whorehouse in Texas* that cemented his reputation as one of the most creative geniuses in the American theater. Then in 1994 came its sequel, *The Best Little Whorehouse Goes Public*—and Tune chalked up one of Broadway's legendary flops.

The original *Whorehouse* had unfolded in Texas, but *Public* moved the action to Las Vegas, city of glitz and a perfect fit for set designer John Arnone and costume designer Bob Mackie, who had conquered Sin City with the hit revues *Hallelujah Hollywood!* and *Jubilee!* Would the audience have to don sunglasses when Jules Fisher's lighting hit Mackie's baubles and beads?

The opening number was populated with impersonators of Elvis Presley, Ann-Margret, Liza Minnelli, Liberace, Siegfried and Roy, and Sonny and Cher. Needless to say, Mackie fulfilled his contract with panache.

But brilliant, witty costumes do not a show make, and Tune's magic touch was curiously lacking. (The show would mark his last director credit on Broadway; the following season's revival of *Grease* would list him as "Production Supervisor.") The writing didn't help, either. The most notorious number in the show, "Call Me," featured the ladies of the house spread-eagled in Plexiglas cubes that careened around the stage while pudgy, middle-aged men in bathrobes and boxer shorts sat atop the cubes engaging them in phone sex. Appropriately enough, *TBLWGP* was the first Broadway musical to spawn its own infomercial.

By the time the show's talented leading lady, Dee Hoty, entered for her curtain call wearing a smashing Mackie—a white fringe suit and cowboy hat—riding a white horse that had been dutifully waiting for hours in an alley off Forty-sixth Street, all class and sense had long departed, along with some of the audience. The show closed after two weeks, but every costume was a hit.

---

**LEFT:** *He may not have designed for Dolly (yet), but Mackie provided this pitch-perfect look for a Parton impersonator with all the requisite assets.*

**BELOW:** *One of the most intentionally tacky production numbers in Broadway history.*

**OPPOSITE, TOP:** *The fabulous Dee Hoty netted a Tony nomination for her thoroughly valiant effort to make* The Best Little Whorehouse Goes Public *work. In retrospect, she deserved a Purple Heart.*

**OPPOSITE, BOTTOM:** *Mackie's witty designs for "The Moral Majority."*

*By the time the show's talented leading lady, Dee Hoty, entered for her curtain call wearing a smashing Mackie…a white fringe suit and cowboy hat—all class and sense had long departed, along with some of the audience.*

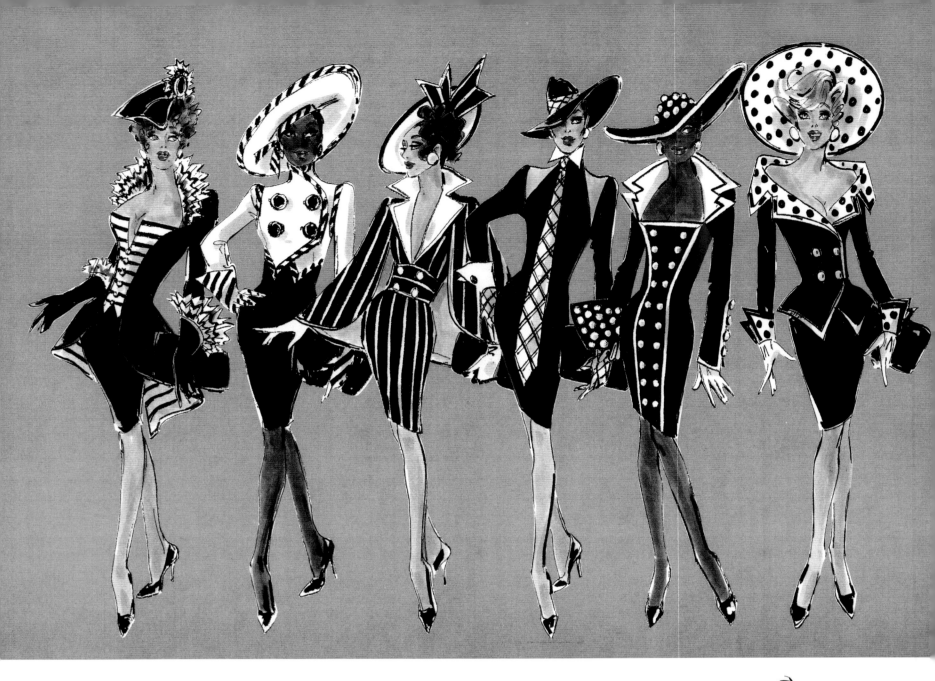

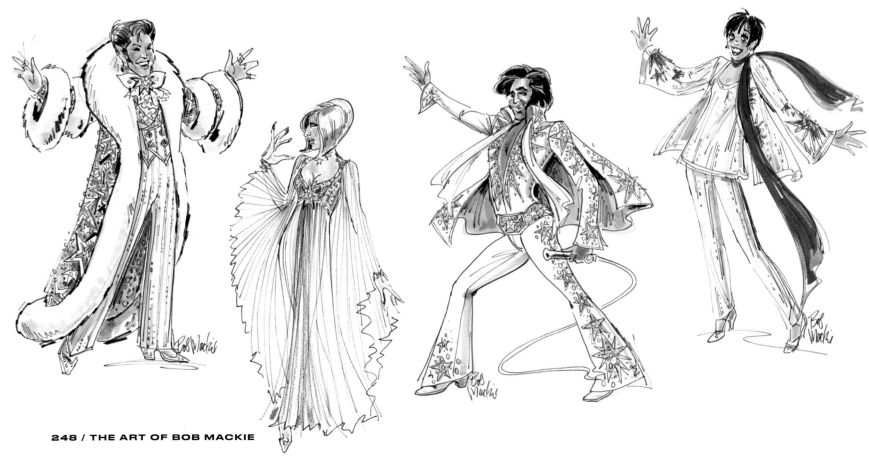

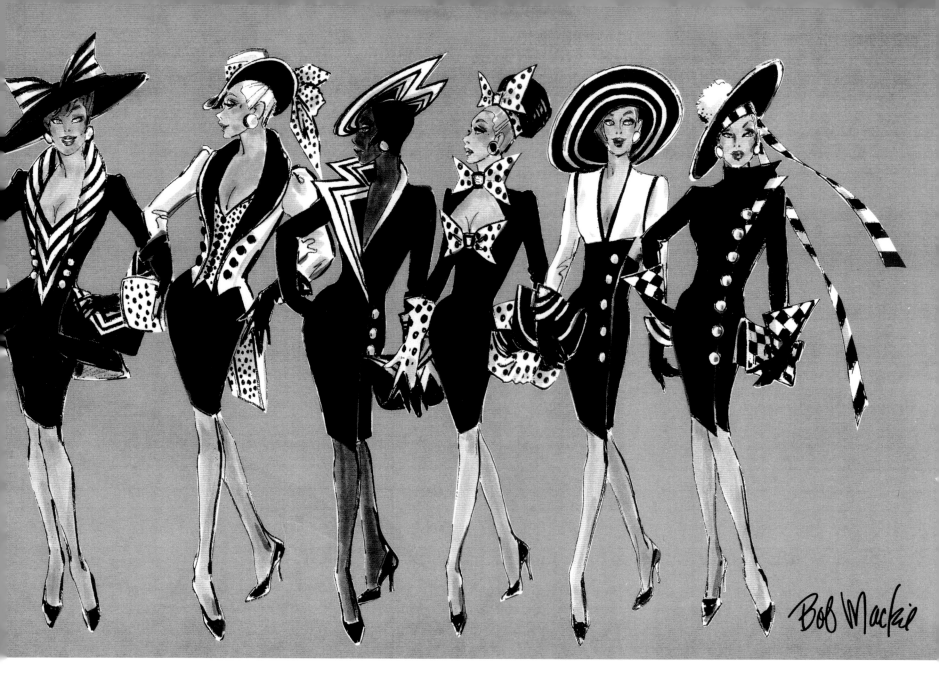

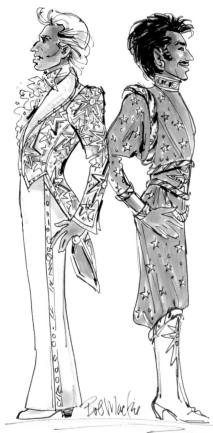

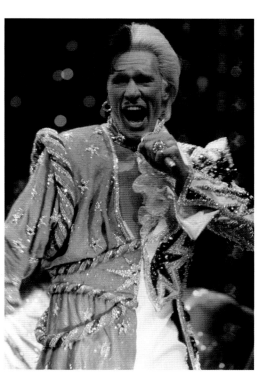

ABOVE: *What Mona Stangley's "girls"
would wear to court.*

OPPOSITE: *Mackie's designs for the Vegas impersonators
are as witty as any he ever did for TV. Left to right:
Bob's versions of Liberace, Barbra, Elvis, and Liza.*

RIGHT: *In a wicked riff on a half-man, half-woman
sideshow act, Mackie designed a half-Siegfried,
half-Roy costume for actor William Ryall.*

# *Moon* Man

**TWENTY-EIGHT YEARS AFTER SHE STARRED IN THE MUSICAL**
*Fade Out, Fade In,* Carol Burnett returned to Broadway in the Ken Ludwig farce *Moon Over Buffalo.*

Ludwig had scored wins with a similarly madcap play, *Lend Me a Tenor,* and the book for the musical comedy *Crazy for You.* Like its predecessors, *Moon* relies on mistaken identities for its laughs, as well as mistaken infidelities, excessive drinking, and liberal amounts of slapstick—all in a show-business setting. It revolves around a second-tier Lunt-Fontanne-type acting couple—Philip Bosco and Burnett—finishing up a run of *Cyrano de Bergerac* and Noël Coward's *Private Lives* in repertory.

Despite the rock-solid credentials of the cast, director, and designers, the play experienced some bumps on its journey to Broadway. During the Boston tryout, it became apparent that the playwright had gone to the same comic well one too many times, and the show was distinctly short on jokes. As punch lines were written and rewritten to little effect, the producers' faith in the show began to slip. (At one point, there was even talk of bringing in a joke-writing dentist from Long Island.)

The one thing that was never second-guessed was the costume design. Of course, Carol had called on her old partner in crime to bring that Mackie magic to her 1953 fashions, as well as her play-within-a-play costumes for Roxanne and Amanda Prynne. In fact, one of the biggest audience reactions of the evening came after a lightning-fast costume change by Burnett, who appeared at the top of a staircase in a completely new head-to-toe look—shades of the beloved "Starlet O'Hara" moment she and Bob had pulled off to hilarious effect on her television show.

---

BELOW AND OPPOSITE LEFT: *Mackie provided his old friend with a stunning circa-1953-style wardrobe.*

OPPOSITE RIGHT: *Burnett and Philip Bosco as a legendary acting couple well past their finest hour.*

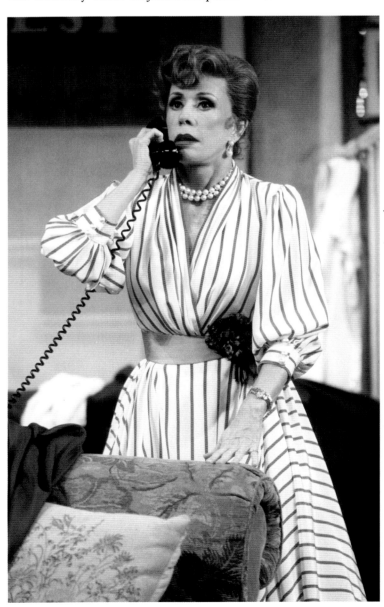

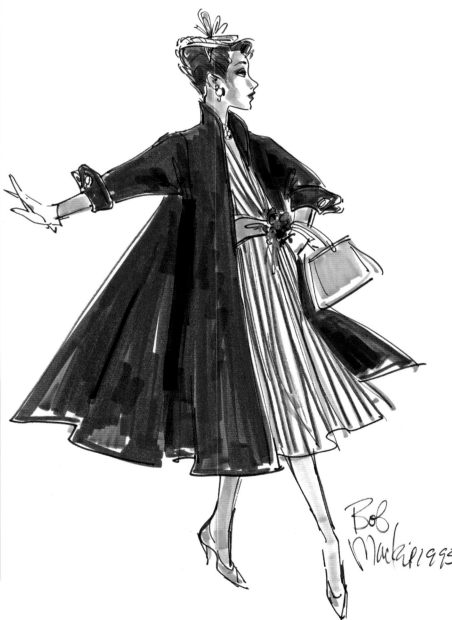

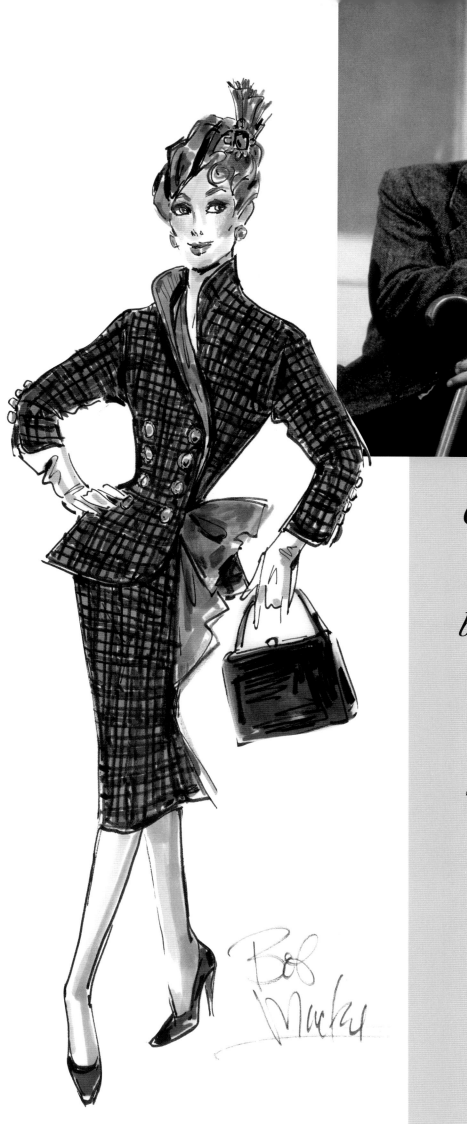

*Carol had called on her old partner in crime to bring that Mackie magic to her 1953 fashions, as well as her play-within-a-play costumes for Roxanne and Amanda Prynne.*

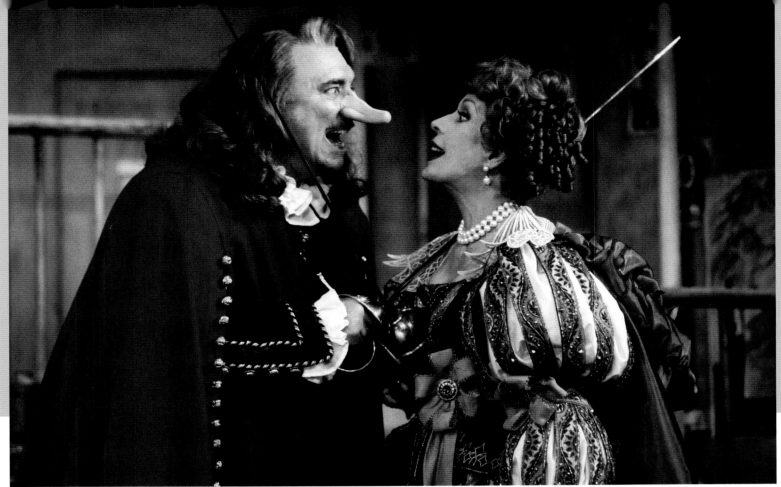

THIS PAGE: *Burnett and Bosco as a bickering Roxanne and Cyrano.*

OPPOSITE: *Mackie's creation for one of Burnett's play-within-a-play turns, as Amanda Prynne in* Private Lives.

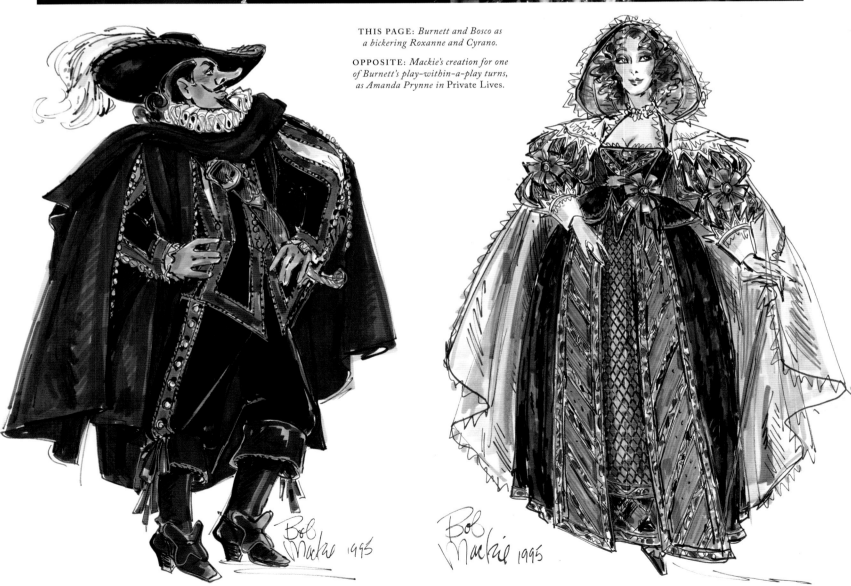

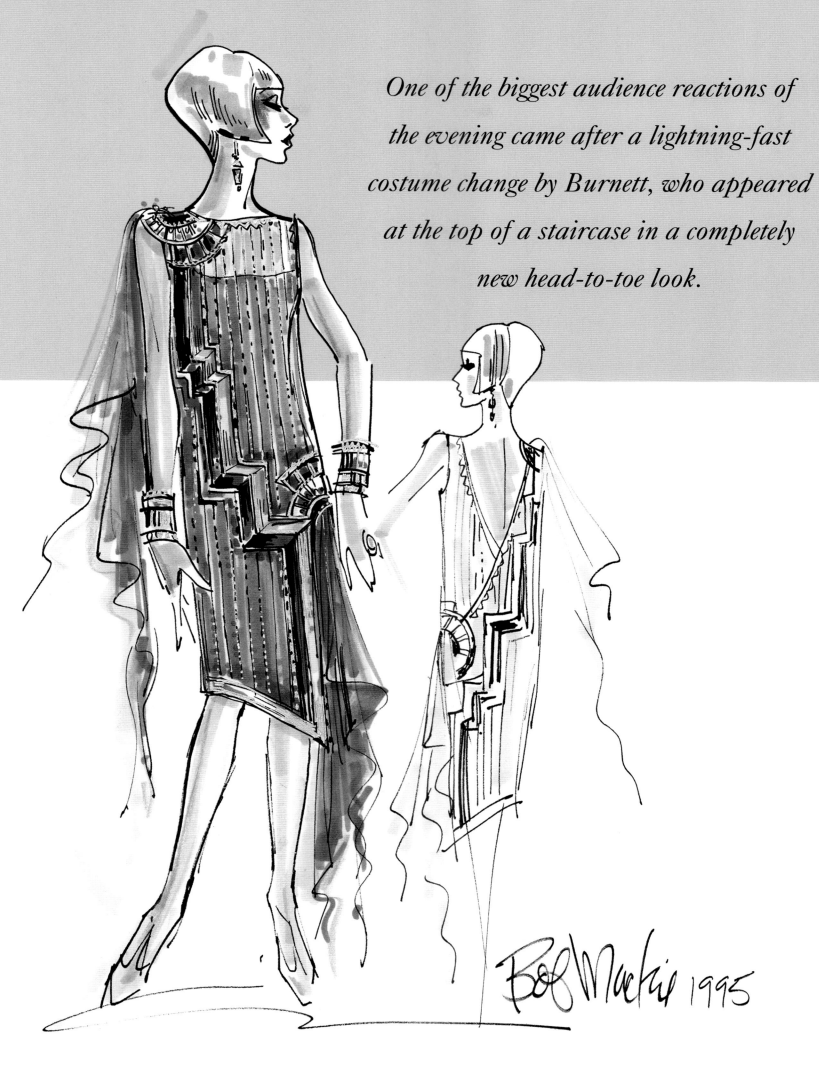

*One of the biggest audience reactions of the evening came after a lightning-fast costume change by Burnett, who appeared at the top of a staircase in a completely new head-to-toe look.*

Bob Mackie 1995

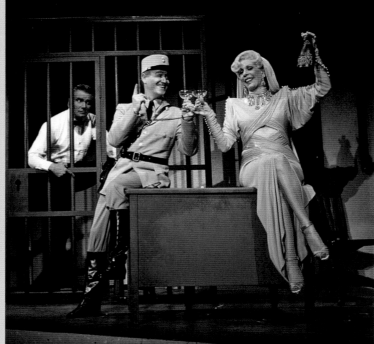

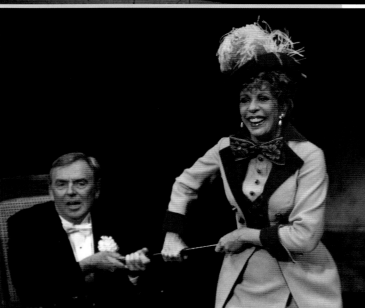

# Let's *Revue*

**BOOKENDING HER RETURN TO BROADWAY IN 1995, BUR-**
nett appeared in two musical grab bags in Los Angeles, both costumed by Mackie. The latter would transfer to Broadway.

*From the Top*, presented by the Long Beach Civic Light Opera in 1993, was a lengthy compilation of tributes to specific composers that Burnett had first performed on her TV show. Each of the three segments—paying homage to Irving Berlin, Cole Porter, and Ira Gershwin, respectively—included dozens of songs (which is why many of the original medleys were omitted from the home-video versions of the Burnett show; music licensing fees can be astronomically expensive).

The Berlin segment, a World War I–era piece titled "The Walking Stick," costarred Burnett's old pal, singer/dancer Ken Berry. The Cole Porter medley was a *Casablanca* takeoff called "One Night in Marrakech," featuring John McCook. Then came intermission, after which the show never managed to come back to life. The final offering, featuring songs with lyrics by Ira Gershwin and costarring the Broadway comedian Gary Beach, was called "That Simpson Woman." It took as its subjects the Duke and Duchess of Windsor, hinging on the idea that Wallis Simpson (the aforementioned Duchess) never cracked a smile. That's right. For one hour, one of the greatest clowns in the business went completely deadpan. A bit like that might have worked for the duration of a brief TV sketch, but it tried the live audiences' patience—as well as the critics'—and other than the usual raves for Mackie's costumes, the show landed with a thud.

In 1998, a revised version of the Stephen Sondheim revue *Putting It Together* opened at the Mark Taper Forum in Los Angeles, starring Burnett, George Hearn, TV actor Bronson Pinchot, and British musical performers Ruthie Henshall and John Barrowman. Its paper-thin plotline involved the unhappy marriage (a Sondheim staple) of Burnett and Hearn. The show transferred to Broadway a year later, where it ran for four months and offered Burnett the opportunity to perform some of Sondheim's most iconic showstoppers, including "Could I Leave You?" from *Follies* and "The Ladies Who Lunch" from *Company*. When eight shows per week proved too grueling for the star, Kathie Lee Gifford got to make her Broadway debut as Burnett's pinch hitter.

---

TOP LEFT: *John McCook, David Eric, and Carol Burnett in the "One Night in Marrakech" segment of* From the Top.

CENTER LEFT: *Burnett reunited with Ken Berry, who'd made some twenty appearances on her variety show, in the curtain-raiser, "The Walking Stick."*

BOTTOM LEFT: *A stone-faced Burnett and the brilliant Gary Beach perform the somewhat misguided second-act number, "That Simpson Woman."*

OPPOSITE, LEFT: *Burnett in the Los Angeles run of* Putting It Together.

OPPOSITE, RIGHT: *Carol Burnett's looks for the 1999 Broadway transfer of the Stephen Sondheim revue* Putting It Together.

*The show… offered Burnett the opportunity to perform some of Sondheim's most iconic showstoppers, including "Could I Leave You?" from* Follies *and "The Ladies Who Lunch" from* Company.

# *Liza* with a Bang

**IT'S THE RARE STAR WHO WARRANTS HER OWN CONCERT**
on the Great White Way—but long before there was a *Bruce Springsteen on Broadway*, there was *Minnelli on Minnelli*, starring the ultimate show-business survivor paying musical tribute to her father, film director Vincente Minnelli. Appropriately, it was staged at the historic Palace Theatre, the site of the triumphant 1951 comeback of the star's mother, Judy Garland. (Judy had been booked initially for four weeks and stayed nineteen.)

Liza, now fifty-three, was not in top shape vocally or physically and needed a little assistance from her friends. Mackie dutifully provided glamorous camouflage (glamo camo?) in the form of sequined pantsuits with figure-flattering tunic overlays. Backing up the main attraction were some of Broadway's finest male singer/dancers, who provided a lift for the star—quite literally at one point, when they pulled Minnelli around the stage on a rolling chair—as well as vocal enhancement. (To be fair, it is difficult to sing "Triplets," from Papa Minnelli's hit *The Band Wagon*, as a solo.)

A seventeen-city tour had been planned post-Broadway, but it had to be canceled when Liza needed a hip replacement (thus the rolling chair) and then suffered a near-fatal bout of encephalitis.

True to her brand, Liza overcame—but none of the drama that had surrounded *Minnelli on Minnelli* could compare to the pomp and spectacle of Liza and Mackie's next collaboration.

In 2002, Liza offered the tabloids their dream come true when she announced that on March 16, she intended to marry producer David Gest at the Marble Collegiate Church on Manhattan's Fifth Avenue. Would her fourth trip down the aisle prove the charm? Clearly, she wanted the festivities to communicate as much.

Exclusive rights to the first "event wedding" of the twenty-first century were sold to the British rag *OK!* Elizabeth Taylor was pressed into service as matron of honor, and Michael Jackson was best man, in front of a celebrity grab bag of guests that included Gene Simmons of KISS, Paul "Pee-wee Herman" Reubens, and Martha Stewart. In the run-up to the occasion, details—most especially any news about the bride's gown—were as closely guarded as the landings at Normandy. It turned out there would be two of them—gowns, not landings—and both were designed by one Robert Gordon Mackie, Crown Prince of the Imperial Monarchy of the Isle of Bling.

Mackie recalled, "It was nuts, frankly. Joe [McFate, Bob's design director for two decades] and I arrived via car service with the dresses and it was absolute pandemonium at the church."

Thirteen bridesmaids (including singer Mya, who admitted she'd met Liza only twice in her life) awaited the blushing bride, who walked down the aisle as Natalie Cole sang "Unforgettable." (An A-list talent, for sure, but Cole was actually filling in for Whitney Houston, who'd canceled at the last minute.) The bride wore a stunning gown of ivory satin laden with princess and marquise-cut crystals, with a bodice featuring pearl and teardrop beading. If all that sounds shiny, we assure you, it was.

Keep in mind, one dress is never enough for a bona fide superstar. Liza sauntered into the reception at the Regent Wall Street Hotel in a floor-length white fur coat that dropped to the floor on cue, revealing a sparkly red minidress topped by a pink and red ostrich feather coverup. The ensemble was pure Mackie, and the perfect thing for boogying the night away to a sixty-piece orchestra fronted by a hit parade of vocalists including Tony Bennett, Donny Osmond, Stevie Wonder, Andy Williams, the Brothers Doobie, and the Sisters Pointer. Oh, yes . . . and Gloria Gaynor blew the roof off the joint with Liza's very unofficial theme song, "I Will Survive." Sadly, the same could not be said for the marriage, which lasted just sixteen months. Don't fret, though. The divorce battle endured for years.

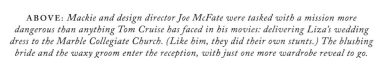

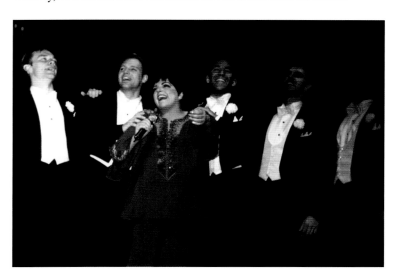

---

**ABOVE:** *Mackie and design director Joe McFate were tasked with a mission more dangerous than anything Tom Cruise has faced in his movies: delivering Liza's wedding dress to the Marble Collegiate Church. (Like him, they did their own stunts.) The blushing bride and the waxy groom enter the reception, with just one more wardrobe reveal to go.*

**LEFT:** *Minnelli in Mackie, backed by four of the six singer-dancers who supported the star in her return to Broadway: left to right, Billy Hartung, Jim Newman, Sebastian La Cause, and Stephen Campanella.*

**OPPOSITE:** *Minnelli's gown for her wedding to David Gest, her fourth marriage and THE show-business social event of 2002.*

"It was nuts, frankly. Joe… and I arrived via car service with the dresses and it was absolute pandemonium at the church."

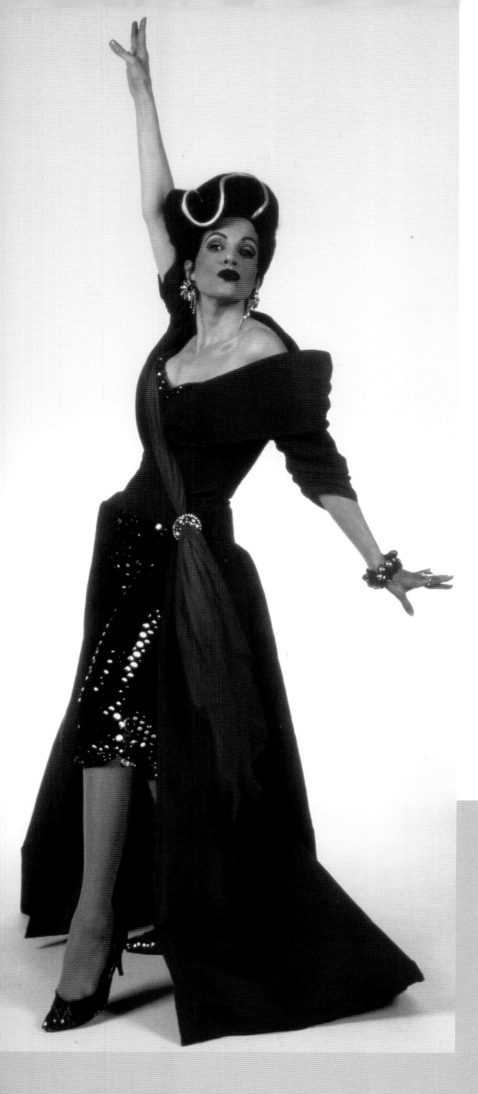

# Ruthless
# *Babes*

**THE 1992 OFF BROADWAY MUSICAL *RUTHLESS!*, WHICH WAS** a respectable hit during its New York run, got a big boost for its 1993 L.A. production when Bob Mackie was brought on board to take the costumes from "humorous on a budget" to "no-holds-barred hilarious." Working with a wild abandon he hadn't permitted himself since the Carol Burnett soap opera spoof *Fresno*, Mackie intercepted the spangled football and ran it ninety-nine yards for a touchdown.

Written by lyricist/director Joel Paley and composer Marvin Laird (Bernadette Peters's longtime conductor, who had known Mackie since the 1964 Los Angeles revue *Billy Barnes' Hollywood*), *Ruthless!* is a wickedly funny showbiz riff on such quotable movies and Broadway shows as *The Bad Seed*, *Gypsy*, and *All About Eve*. Unspooling the story of the murderous showbiz-obsessed tot Tina Denmark, the show appealed to both diehard camp lovers and fans of the kind of slapstick parody that had been in short supply since Burnett hung up her curtain rod. Just one highlight (or low-light?) was provided by comedienne Rita McKenzie, notable for her remarkable resemblance to Ethel Merman in both look and voice, as theater critic Lita Encore, belting out a showstopper called "I Hate Musicals." (Rule number one, Rita: Know your audience.)

In the lead role of Tina in New York was up-and-comer Laura Bell Bundy, understudied by (get ready for it) eleven-year-old Natalie Portman and eleven-year-old Britney Spears. In L.A., the team found a firecracker named Lindsay Ridgeway, only eight but with the voice and timing of a pint-size Bernadette Peters. The L.A. company was so on point that it was ultimately rewarded with a cast recording. The artwork on the CD? By Bob Mackie, of course.

*Super belter Joan Ryan as Judy Denmark, the meek,*
*vacuous housewife who lets her inner diva out in* Ruthless!

*The show appealed to both diehard camp lovers and fans of the kind of slapstick parody that had been in short supply since Burnett hung up her curtain rod.*

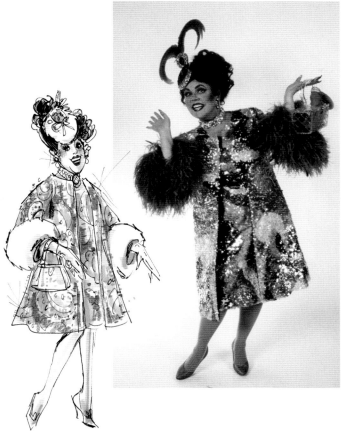

ABOVE: *Rita McKenzie as the poisonous theater critic Lita Encore.*

RIGHT: *Fabulously campy renderings for Judy, who rises to become the imperious Broadway star Gina Del Marco; and woman of mystery Sylvia St. Croix.*

BELOW: *Eight-year-old Lindsay Ridgeway, as the truly ruthless Tina Denmark, is never too far from the clutches of Loren Freeman as her agent, Sylvia St. Croix.*

# Marital *Mayhem*

**MACKIE HAD DESIGNED MANY OUTFITS FOR STEVE LAW-**rence and Eydie Gormé—the legendary husband-and-wife singing duo who were frequent guest stars on *The Carol Burnett Show*—so it was only fitting that he'd be the one to dream up the clothes for the Off Broadway musical spoof featuring a similar duo, *Pete 'n' Keely*.

Conceived by the deliciously clever James Hindman, directed and with lyrics by Mark Waldrop and new tunes by the medley-happy Patrick Brady, the show told the story of former musical marrieds Pete Bartel and Keely Stevens, reunited on a live TV special after an acrimonious public split at Caesars Palace five years earlier.

Played by the multitalented George Dvorsky and Sally Mayes, the couple sang, cracked wise, and relived every minute of their unhappy marriage in front of Mr. and Mrs. America. Oh, and changed costumes. A lot. Which was just fine, as Mackie went wild creating clothes reminiscent of his stint on *The Hollywood Palace* and his early days with Burnett. His wide-lapeled tuxes and feathered gowns easily could have been worn by Robert Goulet and Carol Lawrence (whose marriage the show mirrored more closely than Steve and Eydie's; Dvorsky's cheesy mustache was a pure Goulet), singing such classics as "Besame Mucho," "Fever," and the Lawrence/Gormé classic, "This Could Be the Start of Something Big." Mackie was especially in his wheelhouse in the sequence where the duo recalled their failed Broadway show *Tony and Cleo*, a musical version of *Antony and Cleopatra* straight outta Burnettland.

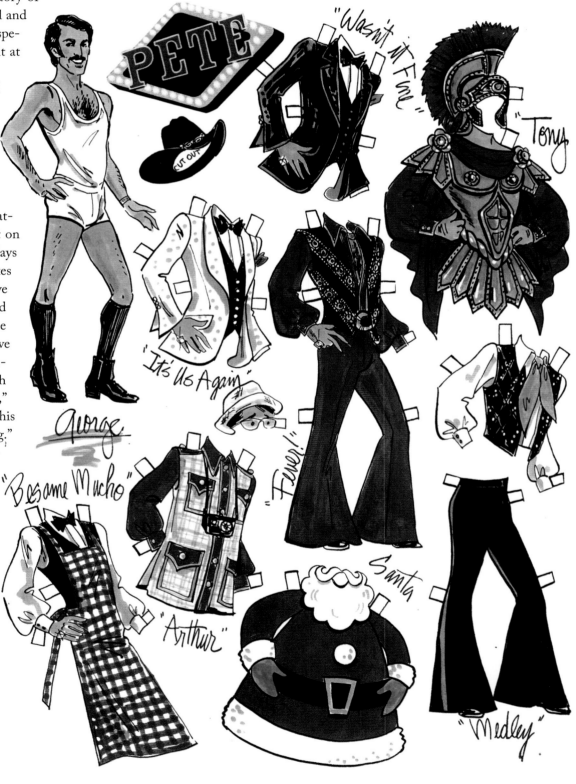

Mackie's inventive opening-night gift to the cast, crew, and creative team was a hand-drawn set of Pete and Keely paper dolls, complete with costume changes.

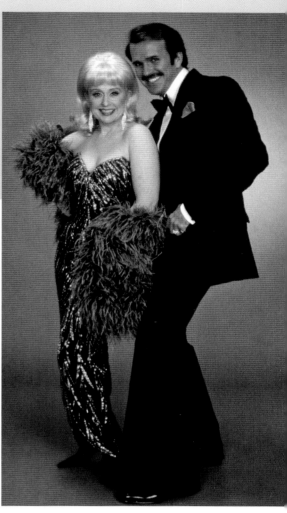

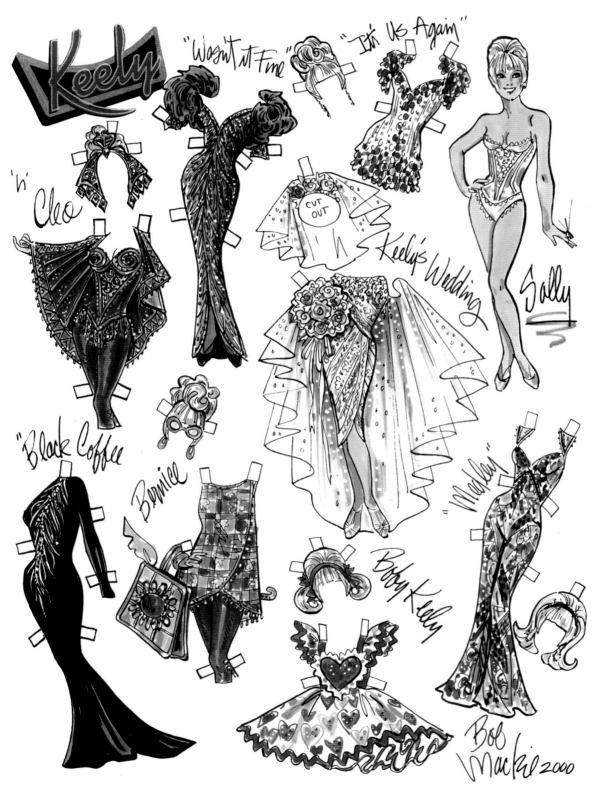

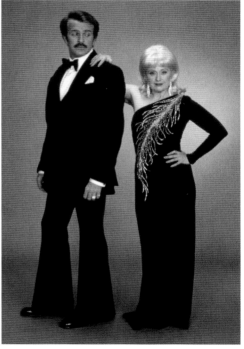

# Cher and *Cher-Alikes*

**TWO QUESTIONS. FIRST, HOW DO YOU DISTILL, TRANSFORM,** reinvent, and translate the hundreds of costume designs created over a fifty-year collaboration into the clothes for a two-hour Broadway musical? And second (if less pressing), how do you design costumes for an actor who's portraying *you*?

Bob Mackie faced both challenges when he undertook the Herculean task of designing 680 costumes for the 2018 Broadway musical *The Cher Show*. The prospect of telling the life story of that most mercurial of Mackie muses was a tricky one, to say the least. How to portray the many guises of Cher? In the end, the show's creators decided that a sole actress could never do the diva full justice. Ergo, three singing actresses were hired to embody Cher at different stages in her career: nineteen-year-old Micaela Diamond as the bell-bottomed young Cher, called "Babe" in the *Playbill* (as in "I Got You . . ."); Teal Wicks as "Lady" (the dark Cher who "danced and sang and lit the candles one by one" [Clap! Clap!]); and Tony winner Stephanie J. Block as "Star" (self-explanatory).

Never mind the fact that Mackie hadn't designed a Broadway show on this scale in fifteen years; that fazed no one, including him. "It was always clear to me what looks we had to include in *The Cher Show*," Mackie recalled, "like the Met Gala dress. Some, we modified as far as the cut, but the Oscar dress in the show is identical to the one Cher wore. You couldn't tell the difference if you saw them side by side."

But inevitably, there were challenges, and one of them came to light during tryouts in Chicago. A sequence set to the song "Ain't Nobody's Business if I Do" (but always referred to by the company as the "Bob Mackie Number") was a fashion parade of Cher's most outrageous looks, modeled by the three Chers and the ladies of the ensemble. Quite simply, it drove the dressers crazy. "We had dozens of split-second changes into clothes that had literally taken Cher hours to get into. And no matter how fast the changes were made, the director wanted them faster!" Somehow, the number was in shape by the New York opening—and we're reassured that no ostriches were harmed in the process.

Ironically, the same song and gambit had been used as the opening number of Cher's 1979 special *Cher . . . and Other Fantasies*,

during which she was seen in eighteen looks over the course of four minutes. But that was TV, and everybody knows TV is magic. Theater is all too real.

Back to that thing about Bob designing for "Bob." In contemplating the portrayal, Mackie had but one request: "'Just don't play me like I'm a flaming old queen,' I told them. The first actor they hired was bouncing off the walls with these grand gestures!" The very tasteful and Tony-nominated actor-director Michael Berresse took over the role for Broadway, to everyone's satisfaction. Mackie dresses in blazers, button-downs, and loafers, so he gave Berresse a heightened Broadway version of the look. "I'd never wear anything like it in real life," he confessed in reference to the skintight pants and snakeskin-print sport coat worn by his alter ego. "But it's Broadway! You've got to make it a *little* theatrical."

Comments Berresse, "It took me a while to understand that Bob is essentially a magnificent show-off trapped inside a truly shy man. His designs allow him to say, 'Look at me, without looking at me.' Playing a singing and dancing 'show-biz Mackie' was a living paradox, but it was also an opportunity for Bob to turn himself into a design. I like to think that seeing 'himself' center stage at the end of that staggering parade of his most iconic Cher get-ups let the show-off and the shy man both feel seen."

And now we reach the finale. Mackie's ability to design on the fly came in handy when, at the last minute, director Jason Moore asked for a new set of looks for the show's ending, set to the 1999 hit "Believe." Tapping into his bygone experience of designing for Cher and Burnett simultaneously, at age seventy-nine, Mackie created brand-new "warrior goddess" costumes that went into the show just before it was "frozen" (not the Disney musical but a theatrical term for the day when no more changes can be made).

Who's to say whether three Chers are better than one . . . but they certainly require more yardage.

---

ABOVE: *Mackie and his muse on opening night.*

OPPOSITE: *The young, fur vest version of Sony and Cher.*

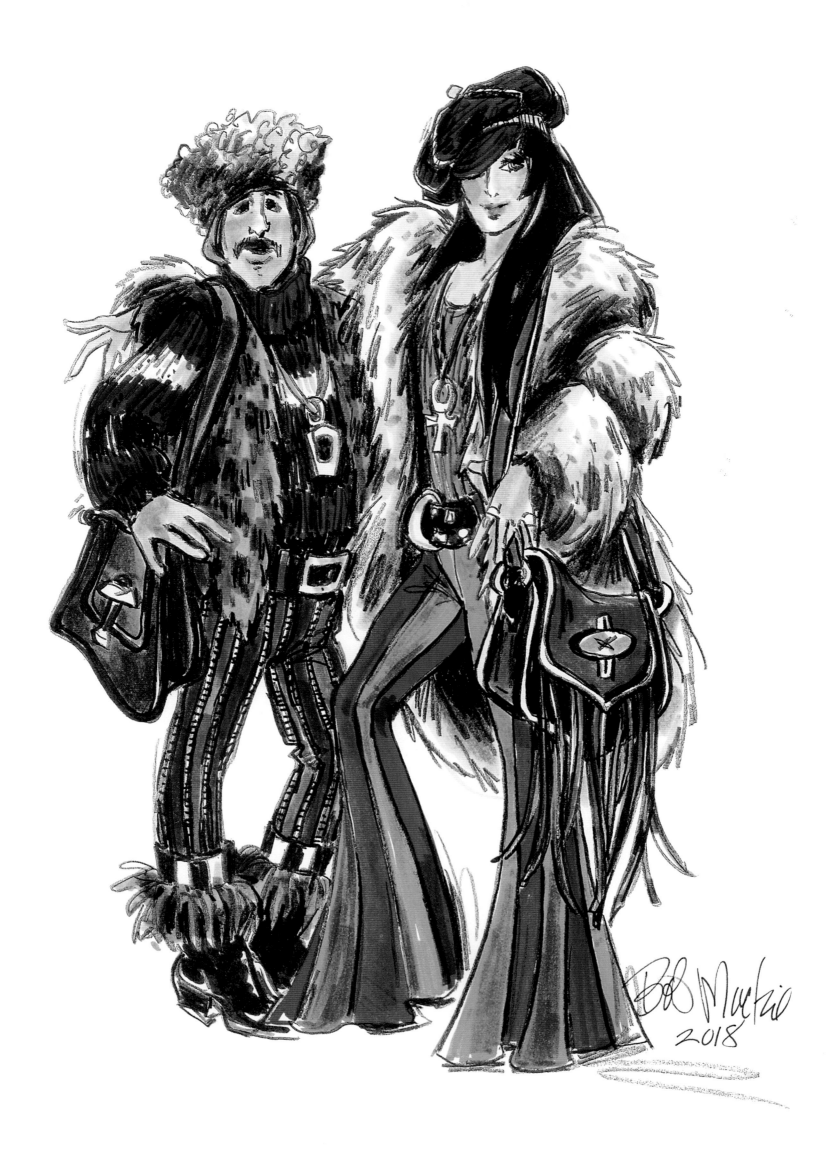

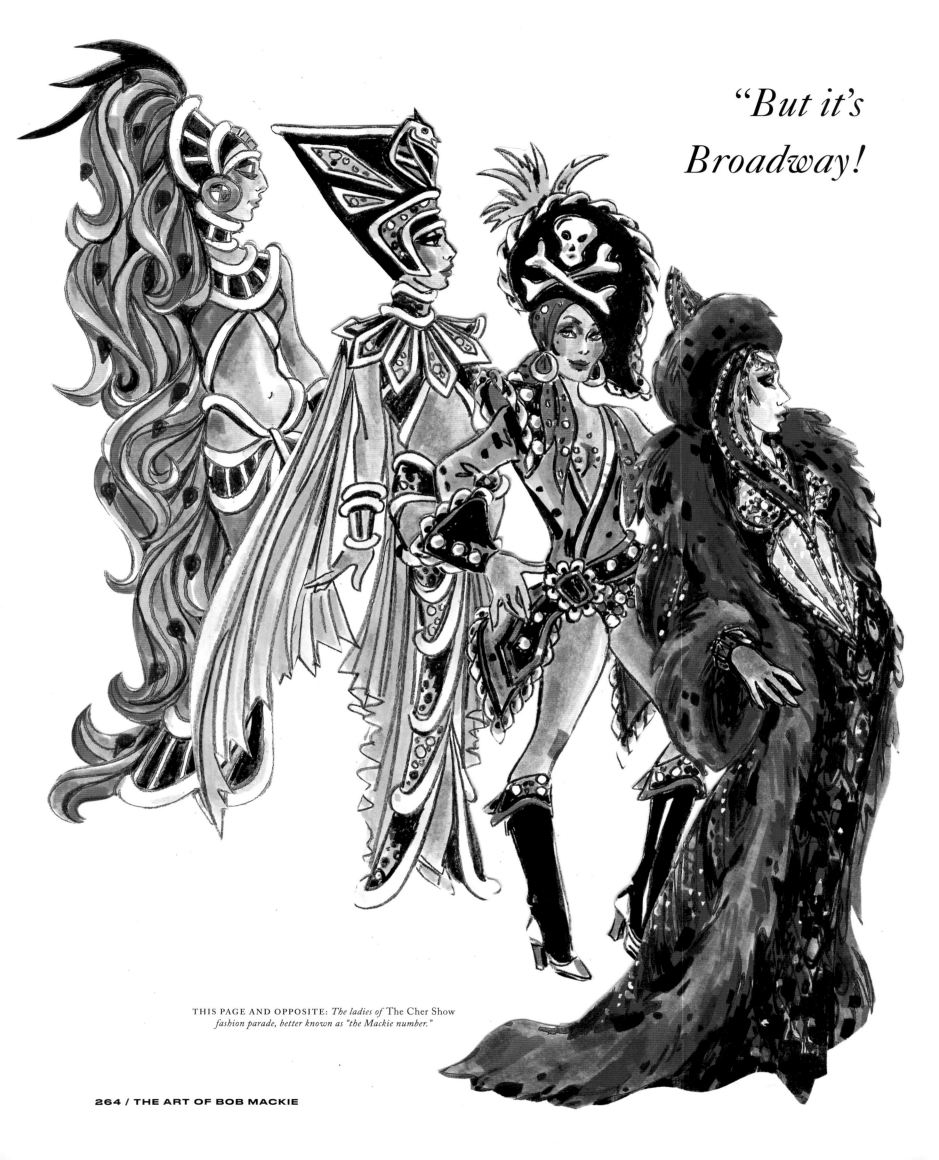

THIS PAGE AND OPPOSITE: *The ladies of* The Cher Show *fashion parade, better known as "the Mackie number."*

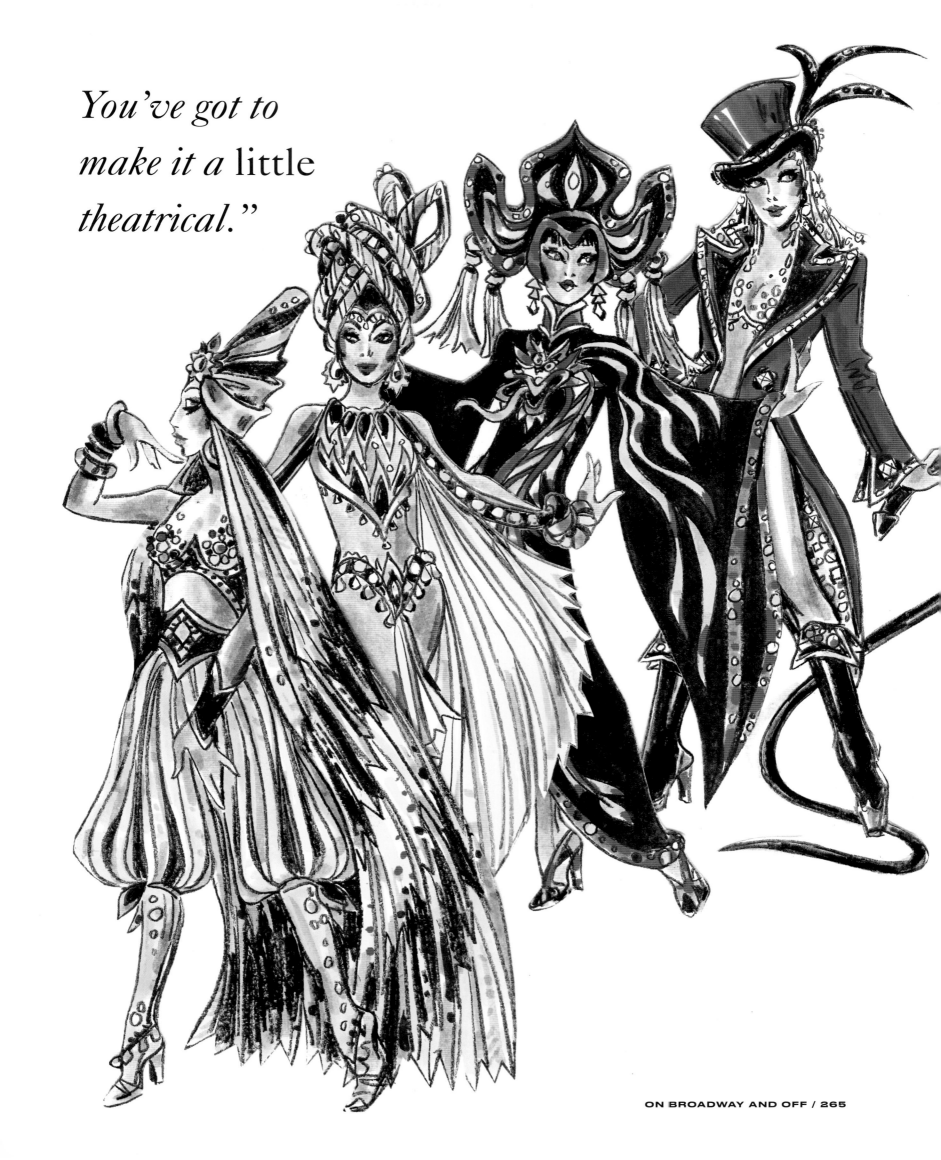

*You've got to make it a little theatrical."*

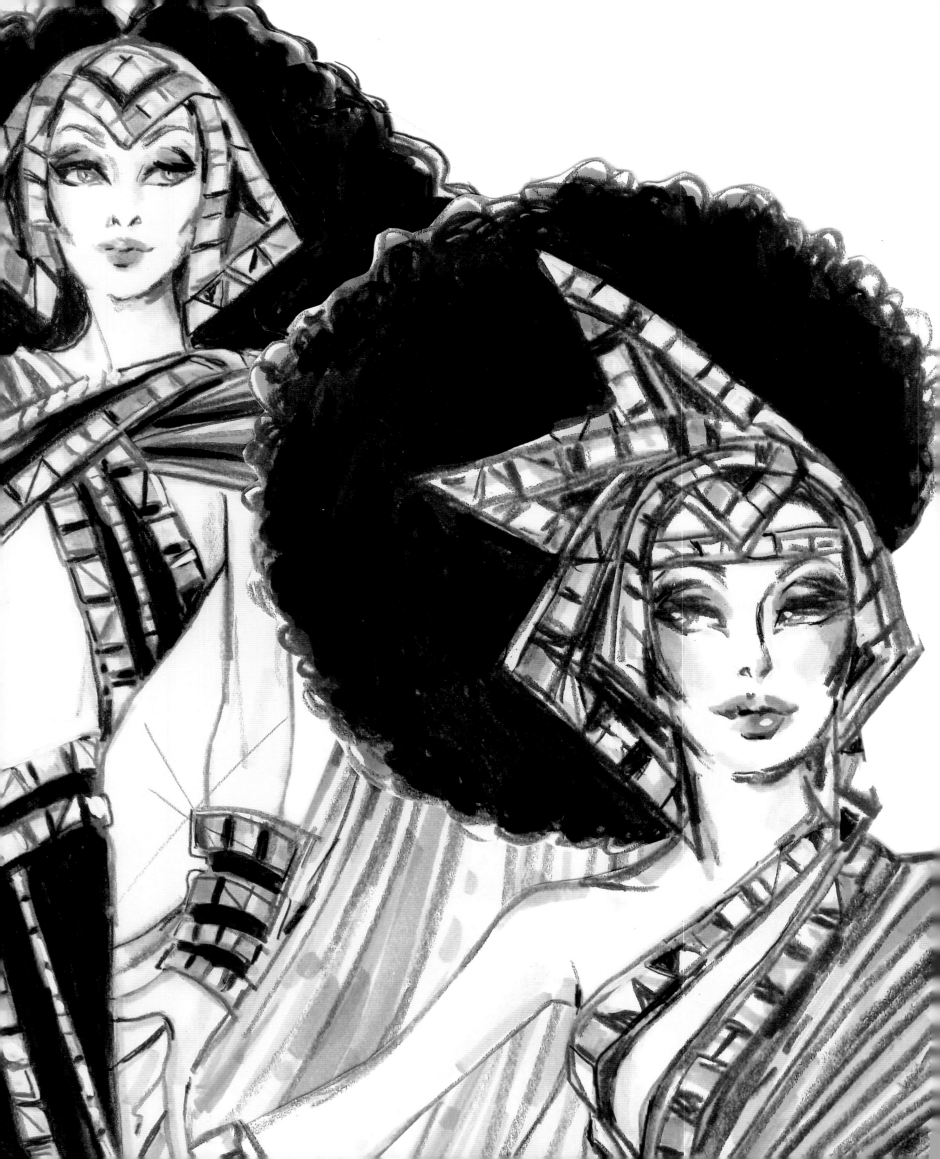

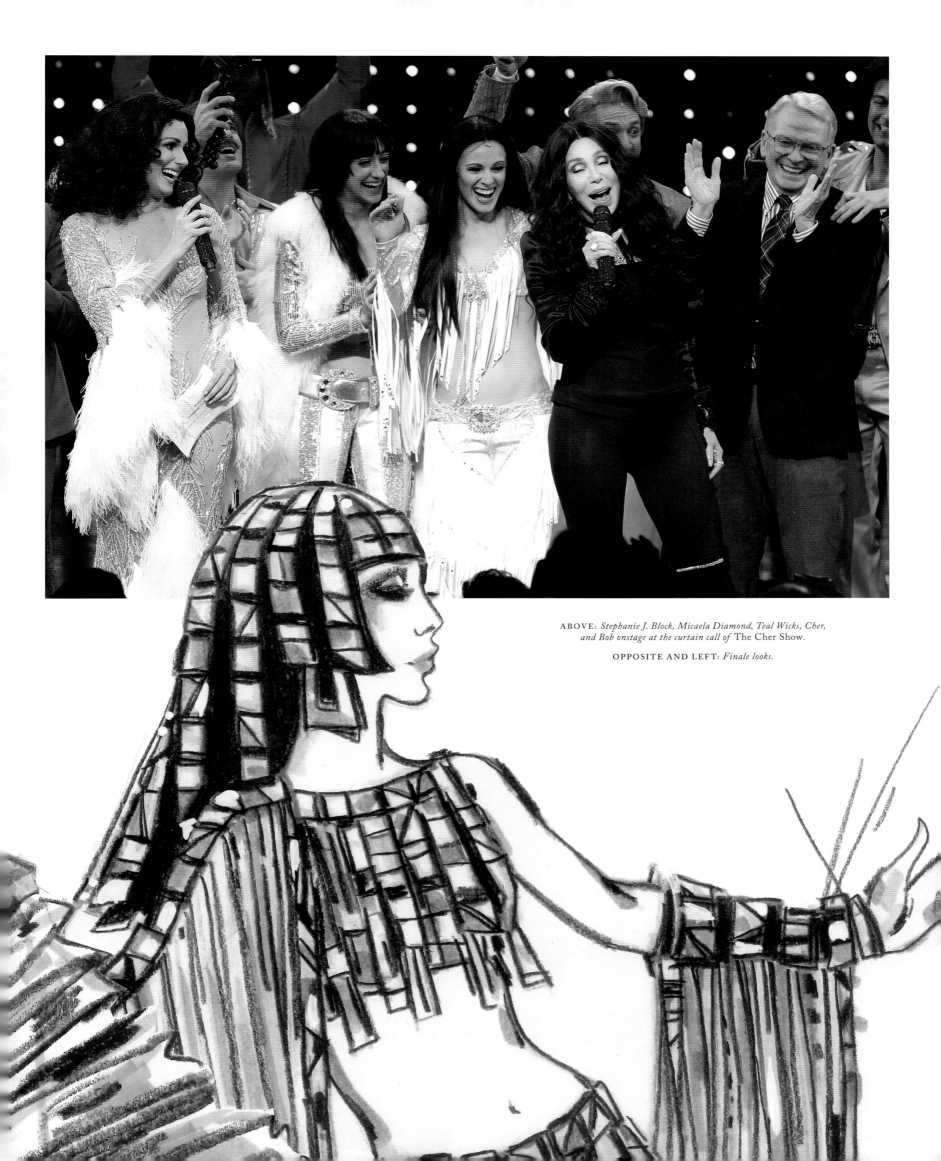

ABOVE: *Stephanie J. Block, Micaela Diamond, Teal Wicks, Cher, and Bob onstage at the curtain call of* The Cher Show.

OPPOSITE AND LEFT: *Finale looks.*

# CONSTANT REINVENTION

**IN ONE OF HIS MOST INSPIRING SONGS FROM** *SUNDAY IN the Park with George* (originally sung, coincidentally, by beloved Mackie muse Bernadette Peters), Stephen Sondheim admonished, "Stop worrying where you're going, *Move On*."

As Mackie entered his fourth decade as a costume designer, his name—spoken for years in the same breath as Carol Burnett, Cher, and Mitzi Gaynor—became the basis of a self-sustaining industry.

Mind you, Mackie had leveraged his personal brand before, launching eponymous fashion collections in the 1970s and '80s with varying degrees of success. But beginning in 1990, with the launch of the Bob Mackie Barbie line, he began branching off in every possible direction—stepping into the worlds of jewelry, fragrance, luggage, and home furnishing. Most notably, he provided women around the world with an opportunity they'd clearly been yearning for, whether they realized it or not: a chance to purchase glamorous, wearable pieces for their own wardrobes, casually styled, affordably priced, but 100 percent Bob Mackie (with all the bling that implies).

It was the explosion of the televised home-shopping industry that made this possible, but it was Mackie's personal charisma and peerless understanding of "his woman" that turned him into a household name and indisputably successful brand ambassador on QVC.

Once Mackie had carved a spot for himself in the living rooms of America, it was just a matter of time before he was called upon to lend his style, experience, and wisdom to another TV phenomenon: reality television. Enter Bob Mackie, fashion contest judge extraordinaire.

*Mackie and the gal who introduced a whole new generation of little girls and boys to his magic.*

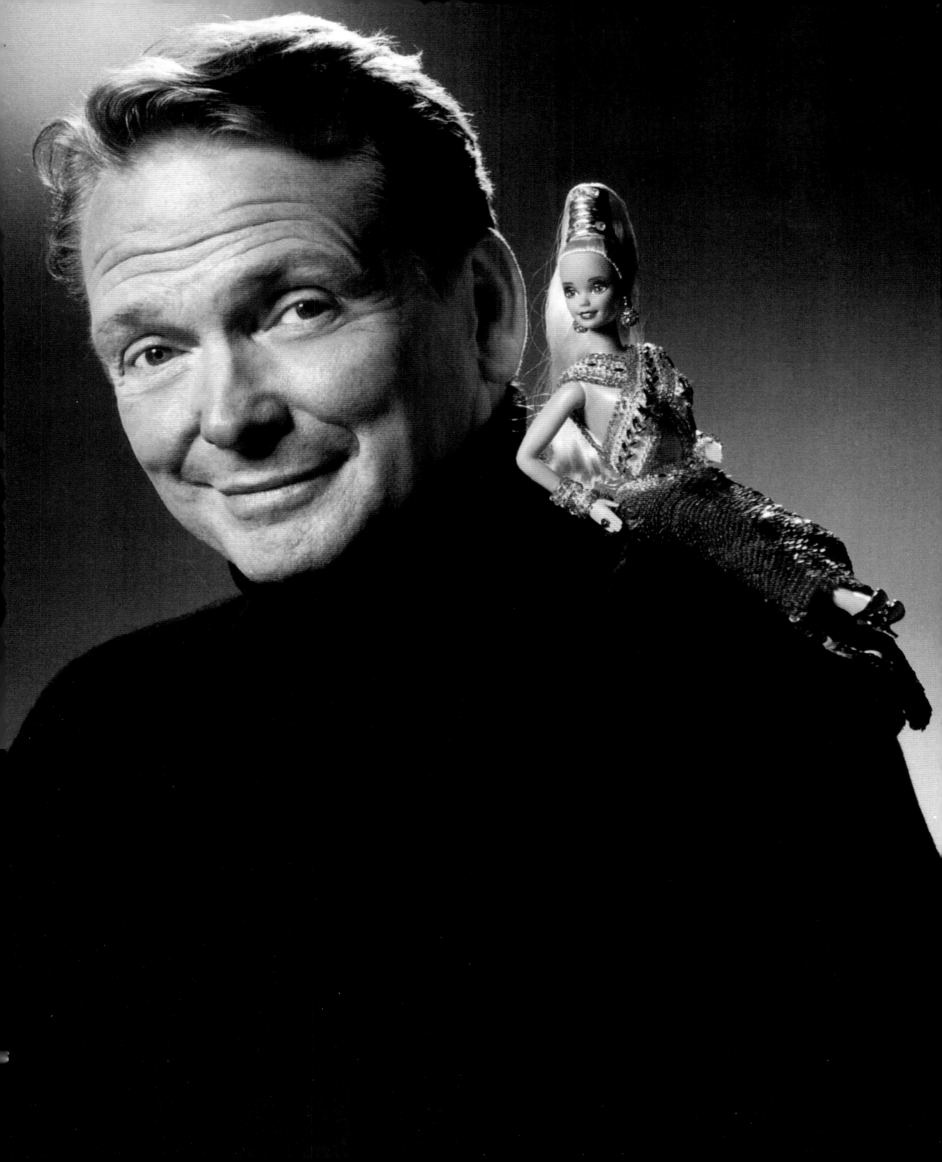

# It's a *Barbie* World

**ELEVEN AND A HALF INCHES OF WHOLESOME BEAUTY AND**
always dressed to the nines. There's no question that Barbie the original "fashion doll" looks amazing for her age. It was in 1990 that her world collided with Bob Mackie's, to spectacular results.

The Bob Mackie Gold Barbie was introduced by Mattel that year and became an immediate best seller. By 1992, with the release of his Neptune Fantasy Barbie, Bob had further transformed the legend by creating a new face for his creations. Called the "Mackie Face," it was soon adopted for use on other collectible Barbies as well.

Never one to shy away from a theme, Mackie went on to design the Barbie Goddess Collection, which included such extravagant, brilliantly detailed international fashion dolls as Goddess of the Arctic, Goddess of Africa, Goddess of Asia, and Goddess of the Americas.

Next came a look backward for inspiration. In a salute to childhood idol Carmen Miranda, he created the highly alliterative Brazilian Banana Bonanza Barbie—and scored an instant hit. (We suspect it wasn't just little girls—or even grown-up ones—purchasing these pint-size beauties.) Then, with a tip of the hat to the spectacular Las Vegas showgirls he'd clothed for the finale of the extravaganza *Jubilee!*—Mackie created tributes to his four favorite gemstones: emerald, ruby, amethyst, and sapphire. (Keep in mind that, while the *Jubilee!* showgirls had been topless, the Barbie versions were tastefully covered, thank you.)

No way Bob could quit on Barbie before he'd designed doll-size versions of three of his legendary clients, Cher, Diana Ross, and Carol Burnett. Representing Burnett is the Starlet O'Hara Barbie—curtain rod included. If it isn't displayed in the Smithsonian alongside the full-size gown, it certainly ought to be.

After a decades-long partnership full of feathers, gemstones, artistry, and excess, one thing is crystal clear: It take an icon to style an icon.

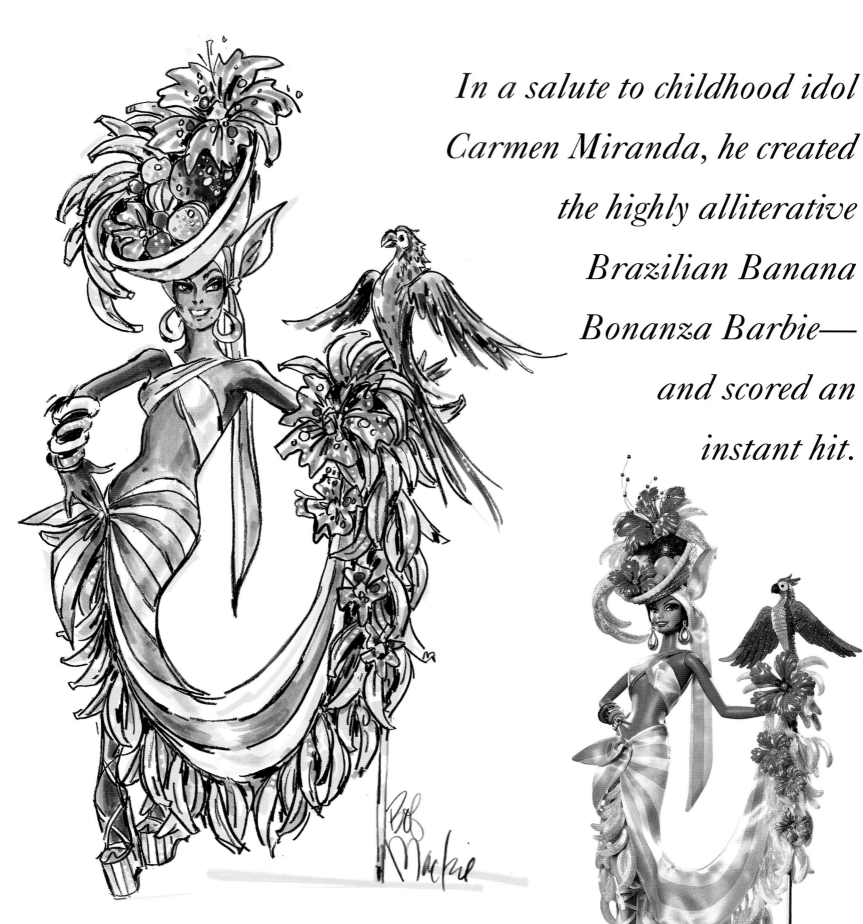

*In a salute to childhood idol Carmen Miranda, he created the highly alliterative Brazilian Banana Bonanza Barbie— and scored an instant hit.*

OPPOSITE, TOP LEFT: *One-of-a-kind Evil Madame du Barbie, auctioned at the 1997 "Dream Halloween" charity benefit.*

OPPOSITE, TOP RIGHT: *One-of-a-kind Cher Barbie, dressed in her 1999* Believe *tour costume, auctioned at the 1999 "Dream Halloween" charity benefit.*

OPPOSITE, BOTTOM: *Rendering for the Princess Stargazer Barbie, the last doll Mackie designed for Mattel, released in 2013.*

ABOVE AND RIGHT: *The marvelous Brazilian Banana Bonanza Barbie, released in 2012.*

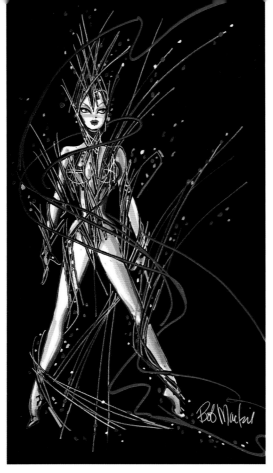

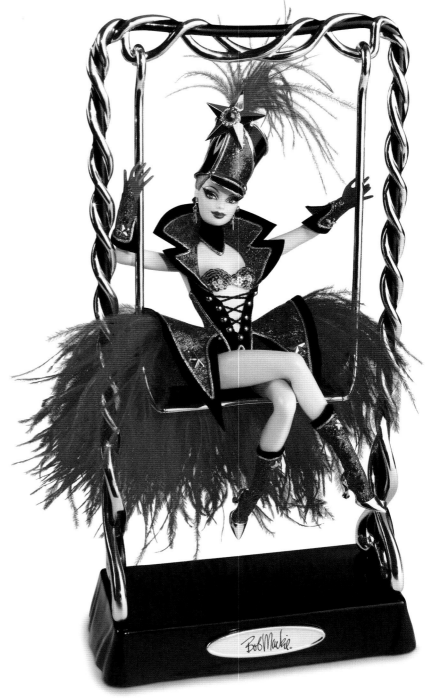

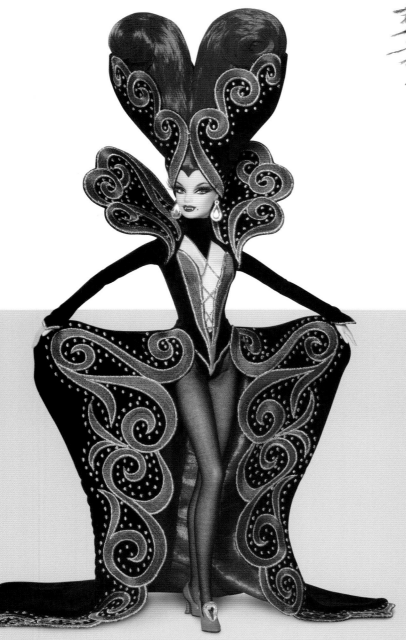

ABOVE: *Circus Barbie on her swing.*

TOP LEFT: *Mackie's rendering for a feature in* Paper *magazine, where he was given the challenge to design a "futuristic Barbie."*

LEFT: *It isn't shown here, but Countess Dracula Barbie comes with her very own coffin.*

OPPOSITE TOP LEFT: *One-of-a-kind Showgirl Barbie, auctioned at a "Dream Halloween" charity benefit.*

OPPOSITE TOP RIGHT: *"Goddess of the Unicorns" Barbie.*

OPPOSITE BOTTOM RIGHT: *Cher as Goddess of the Cockatiels— another one-of-a-kind doll for a "Dream Halloween" benefit.*

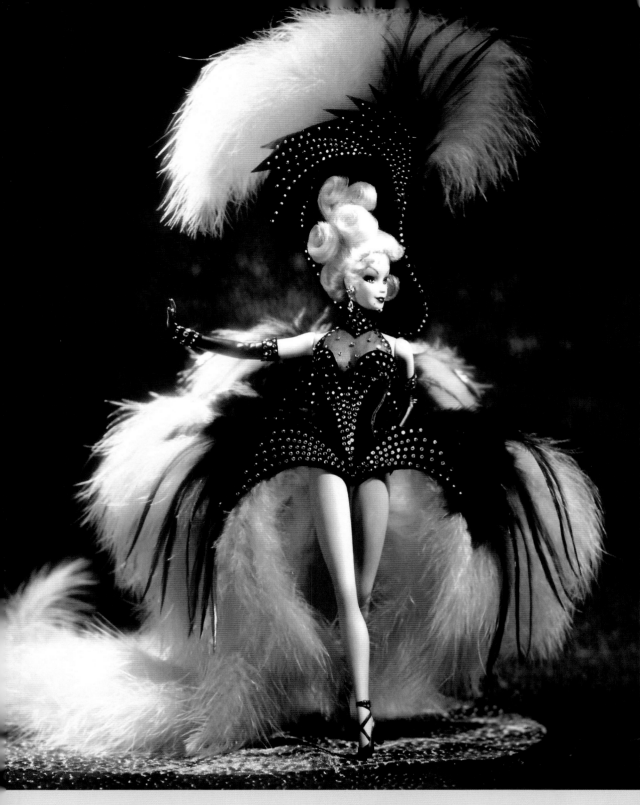

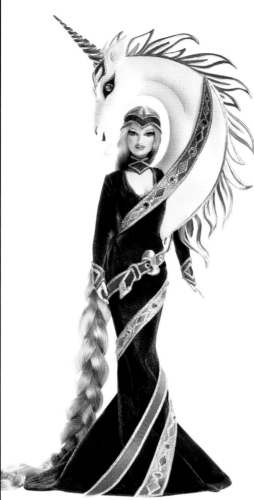

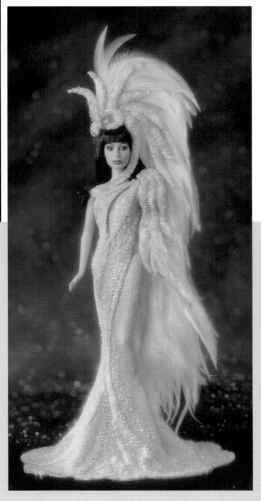

*After a decades-long partnership*
*full of feathers, gemstones, artistry,*
*and excess, one thing is crystal clear:*
*It takes an icon to style an icon.*

# Mighty *McFate*

**HIS OFFICIAL TITLE IS DESIGN DIRECTOR, BUT FOR THE PAST** twenty years, Joe McFate has been involved in every aspect of Bob Mackie's business—his second set of eyes, extra pair of hands, and all-around logistical miracle worker and problem solver. If he looks familiar, you probably know him from his on-air appearances alongside Bob on QVC, representing the Bob Mackie Wearable Art Collection.

Like Bob, Joe has his roots in live theater; over the course of his long theatrical career, he performed in, directed, and designed dozens of productions in regional theater and summer stock. As associate costume designer for the legendary Alvin Colt, he worked on several Broadway shows, including *Waiting in the Wings*, starring Lauren Bacall and Rosemary Harris; and the long-running Off Broadway smash *Forbidden Broadway*. Loyal, tireless, always helpful, and a walking encyclopedia of everything Mackie, Joe keeps the Mackie machine oiled and running. It's safe to say that this book wouldn't exist without his patient guidance and support.

TOP: *Joe McFate and Bob Mackie on Tony night 2019, when Bob brought home the big prize.*

ABOVE: *The dynamic duo flank Carol Burnett as Nora Desmond.*

RIGHT: *Mackie and McFate.*

# King of QVC

**"THESE DAYS, FASHION MEANS COMFORT."**

So proclaims Bob Mackie quite frequently in the process of presenting his affordable, accessible Wearable Art line on the QVC network. And clearly, he understands exactly what women—real, everyday women—want: the glamour and style associated with his name in wearable form at a reasonable price. Is it any surprise that the line, as well as his other offerings on QVC, have been a continuing success for over two decades?

Mackie's journey into the world of retail sales began before the concept of home shopping was even a glimmer. In the early 1980s, he designed a line of dazzling crystal-studded costume jewelry, including earrings, necklaces, and an array of whimsical brooches that have become collector's items. In 1991, it was on to the Bob Mackie fragrance collection—perfume and cologne for both men and women. And finally, in 1998, he launched the Bob Mackie Home Classics Furniture Collection by American Drew, featuring mahogany and walnut pieces with his signature attention to detail.

But wait—as they say in the home-shopping game—there's more. In the past twenty years, Mackie has also released eponymously branded rugs, handbags, scarves, eyewear, watches, and yet more jewelry through partnerships with Kas Rugs, Premium Bag, Horizon Beauty Group, Glance Eyewear, and the Bradford Exchange. His latest collaboration is with Nigaam Jewels of New York on a new line of high-end jewelry that marries his love of glamour with Nigaam's precious-stone expertise.

*Mackie and McFate with their ever-elegant QVC models, from left: Chantal Marmula, Angela Izzo-Sink, Kate Coll, Maria Costa, and Maria Balle. (Missing from the roll call were Stacey Dickerson and Katia Biassou.)*

# My *Faux* Ladies

**CALL THEM WHATEVER YOU CONSIDER POLITE: FEMALE** impersonators, gender illusionists, or just plain drag queens. Whatever the term, these literally larger-than-life entertainers need a closet full of bling—and who better to supply it than Bob Mackie? After all, he's spent decades dressing the very icons they so memorably interpret, from Cher and Tina to Diana and Bette.

The superstar born RuPaul Andre Charles made television history and racked up supersized ratings with his reality show *RuPaul's Drag Race*. On the judges' panel for the premier episode? Robert Gordon Mackie. Seven feet tall in heels, Ru stopped traffic at the 1995 VH1 Fashion and Music Awards wearing a winged Mackie creation that transformed him into a cross between Julie Newmar and Mothra.

The brilliant playwright and performer Charles Busch was another benefactor (-factrix?) of an original Mackie design, for his 2005 Actors' Fund of America benefit, *Charles Busch and Julie Halston: Together on Broadway*. As he tells it, "When Margot Harley from Juilliard's Acting Company asked me to emcee their fall gala in 1995, she cannily threw in as an incentive, 'And we'll have Bob Mackie design you a costume and Barbara Matera will build it.' 'I'm in,' I said. I knew Bob socially but we'd never worked together. We had the best time being inspired by various images, including a jacket designed by Travis Banton for Marlene Dietrich. The velvet skirt and beaded top were things Bob himself might've worked up for Judy Garland. For the next ten years, I mixed and matched those three beautiful pieces for stage, film, and cabaret until I could no longer squeeze myself into them."

And we can't close the beaded curtain without mentioning one of the most beloved recurring characters on *The Carol Burnett Show*. Brought to life by the brilliant Harvey Korman, Mother Marcus was the brimming-bosomed yenta who liked to drop by Marian Clayton's house in the recurring soap opera parody "As the Stomach Turns." Mother M. proved so popular that she began popping up in other settings as well, most memorably as Fairy Godmother Marcus in the classic "Cinderella Gets It On." The Pointer Sisters were the guest stars, but the Mackie masterpiece on Harvey stole the show.

---

ABOVE: *A look for playwright and drag legend Charles Busch.*

BELOW: *RuPaul spreads his Mackie wings at the 1995 VH1 Fashion and Music Awards.*

OPPOSITE: *The newly created sketch that simply* had *to exist: Harvey Korman as Fairy Godmother Marcus and Carol Burnett in the* Burnett Show *sketch "Cinderella Gets It On."*

# Bobby's *Angels*

**IN THE EARLY 2000S, BOB MACKIE TOLD THE STORY** of twentieth-century women's fashion through a collectible line of ten-inch figurines designed for American Greetings (opposite). Below: Three never-before-seen sketches for a proposed line of Mackie Glamour Angels that, alas, went unproduced. Each one of the limited-edition Bob Mackie's Glamour Angels represents a decade from 1900 onward. Immaculately crafted with his trademark attention to detail, the series is valued by collectors worldwide.

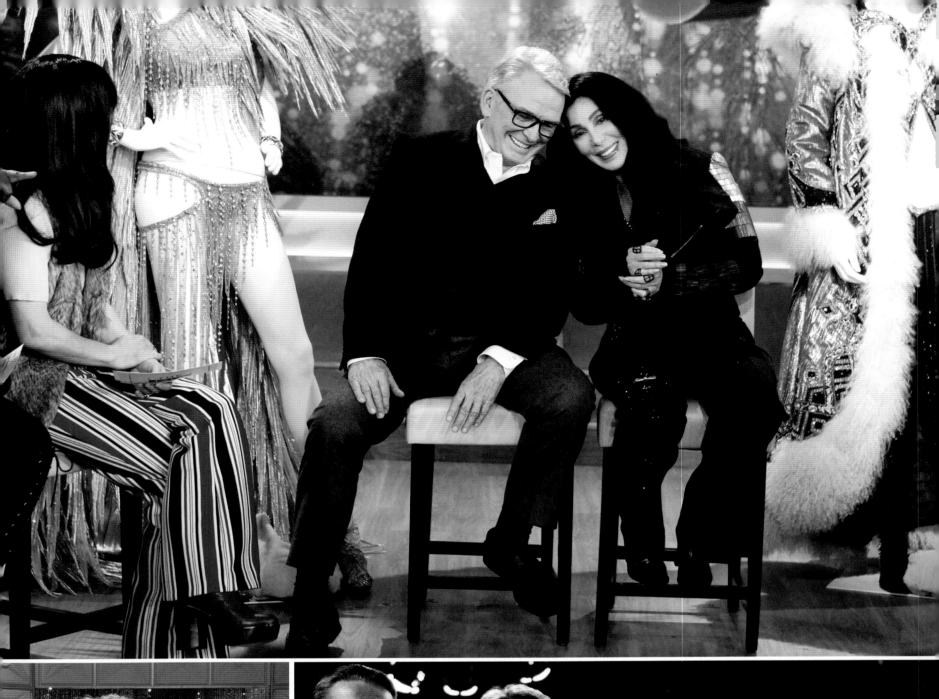

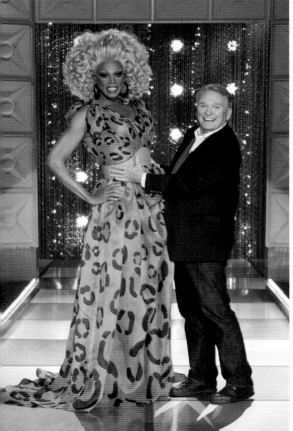

# Ready for His *Close-up*

**BEHIND THE SCENES, HE WAS A LEGEND OF STAGE AND** screen—especially that small screen in the living room. But Bob Mackie's presence in front of the camera was minimal through the end of the twentieth century. Minimal—but not nonexistent. In a memorable two-part episode of *The Love Boat* in 1981, Mackie appeared alongside fellow designers Gloria Vanderbilt, Halston, and Geoffrey Beene—whose eponymous lifetime achievement award he'd win some forty years later. The three romantic subplots (featuring Anne Baxter, Cristina Ferrare, Jayne Kennedy, and Elke Sommer, all of whom knew how to rock the runway) included fashion shows in their plotlines.

That appearance, plus an interview on *The Mike Douglas Show* in 1979, were the extent of Mackie's screen time until 1993, when he flexed his muscles a bit further by playing Richard Evan Hampton—i.e., someone not named Bob Mackie—on two episodes of the TV miniseries adaptation of Armistead Maupin's *Tales of the City*.

Then came a new century and a higher profile. As the Mackie brand developed momentum, the designer made many talk show appearances, proving himself charming company. And with the advent of reality television, he was in demand for his expertise as well as his affability, becoming a sought-after guest judge on such shows as *Project Runway* (where he rivaled Tim Gunn for most blazing blazer wearer), *Fashion Police*, and *RuPaul's Drag Race*.

And then there was—and is—QVC, where Mackie reigns over his affordably glamorous product line like the first-class pitchman he has turned out to be.

In 2020, as part of the long-running *Wheel of Fortune*'s "Great American Cities" tour, Mackie designed gowns for everyone's favorite letter turner, Vanna White. Throughout the show's San Francisco residency, White made an entrance in a different spectacular Mackie each night, and Vanna and Bob's immediate rapport as two salt-of-the-earth personalities made for great television. Right before viewers' eyes, Vanna became yet another very happy Mackie client—and if there is any other kind out there, our investigations have not brought her to light.

OPPOSITE, TOP: *Mackie and Cher on a 2018 episode of* The View.

OPPOSITE, BOTTOM LEFT: *Doing the honors as the very first guest judge on* RuPaul's Drag Race.

OPPOSITE, BOTTOM RIGHT: *Halston, Bob Mackie, Gloria Vanderbilt, and Geoffrey Beene grace the deck of the* Love Boat *in 1981.*

RIGHT: *Mackie and the letter-turning legend Vanna White on the set of* Wheel of Fortune *in 2020.*

*Throughout the show's San Francisco residency, Vanna White made an entrance in a different spectacular Mackie each night.*

# Highest *Honors*

**SO, WE'RE TOLD IT TOOK GOD SIX DAYS TO CREATE THE** universe, and He rested on the seventh. Well, a certain design god we know rarely rests—and the proof of that came in June 2019, when the eighty-year-old fashion icon racked up so many awards in the span of a week that he had to install a second mantelpiece to hold them all.

The Geoffrey Beene Lifetime Achievement Award from the Council of Fashion Designers of America—arguably fashion's highest honor—was particularly meaningful, for, although the CFDA had honored him in 2001 for his "fashion exuberance," Mackie had never felt truly appreciated by the fashion community as a whole. What could be more appreciative than an acknowledgment of his five decades of groundbreaking work?

In introducing Mackie at the ceremony, his great friend and longtime client Bernadette Peters said, "I can't even begin to tell you what Bob has meant to me throughout my life. When I was doing my first nightclub act, I didn't have money for a dress, and Bob said, 'Wait, wait, wait, wait . . .' and he went into his stock and pulled out a gown and remade it for me on the spot. And then he added a boa. And a turban. And it was *red*. He really knows how to give a girl *pizzazz*. Bob, for half a century, you've made me stand out, sparkle, and shine."

In accepting the award, Mackie said, "I got a call from Diane von Furstenberg, and she said, 'Darling, you're receiving the Geoffrey Beene Award for Lifetime Achievement.' And I thought, 'Really?' You see, I still think I'm thirty-five. Then I realized I had just turned eighty. All these years, I've just been doing my job, filling the orders, doing what was required of me, never thinking about a legacy or the future. So, thank you for making me take a look at the last fifty years."

Bookending this great honor, in what must have been one of the most dizzying weeks of Mackie's life, were three awards for his work on the Broadway hit *The Cher Show*. First came the Outer Critics Circle Award, next, the Drama Desk Award and finally, six days after that, the Tony. Working gracefully within the egregious time limits of the Tony ceremony, Bob kept his remarks short but sweet: "As Ruth Gordon said at the Oscars many years ago, this is very encouraging for an eighty-year-old."

TOP LEFT: *Mackie accepts his Tony Award.*

LEFT: *Actor Michael Berresse and the man he portrayed in* The Cher Show.

OPPOSITE: *Joe McFate, Bernadette Peters, and Bob Mackie at the 2019 CFDA Awards.*

# THIS MAY SOUND STRANGE TO SOME,

**BUT OF ALL THE MEN IN MY LIFE, BOB MACKIE HAS BEEN ONE** of the most important, hands down.

In 1967, I was standing in a fitting room at Berman's costume house looking into a three-way mirror. I was nineteen or twenty and VERY shy.

The longer I stood there, the more nervous I became. All of a sudden, the door opened and a young, handsome man with an unbelievable smile (and great hair) walked in and said, "You're smaller than I thought you'd be!" I replied, "You're younger than I thought you'd be!"

We both laughed, and that was the beginning of a friendship and collaboration that has lasted from 1967 thru 2021, and still counting!

Even though I met Bob only twice in those first five years, I KNEW that someday we would work together. That day came when *The Sonny & Cher Comedy Hour* debuted as a summer replacement series. We didn't have ANY budget for our first eight shows, so Bob made one perfect white dress for me that he magically transformed each week.

He promised me that if we got picked up, there would be "millions of beads," and, true to his word, there have been GAZILLIONS of them, sometimes with just a tiny bit of fabric, for the past fifty years!

He has such a timeless fashion sense that the best of today's designers are copying his looks for every top female artist. Bobby, you are brilliant.

**LOVE FOREVER,**
**CHER**

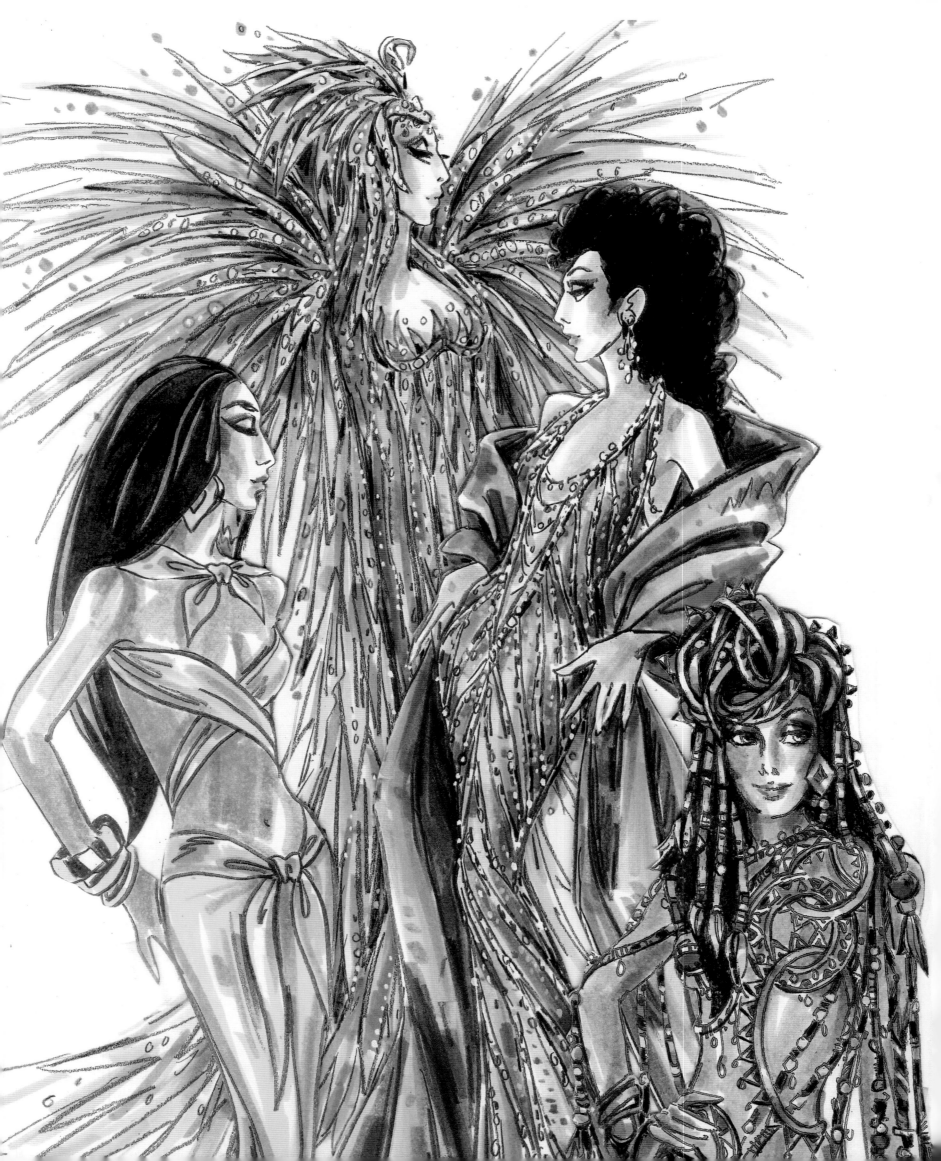

"He promised me that if we got picked up, there would be 'millions of beads,' and, true to his word, there have been GAZILLIONS of them."

# ACKNOWLEDGMENTS

**FRANK:** It takes a village, said the characters in Shirley Jackson's *The Lottery*. I first and foremost must salute the constant and unflagging support of two wonderful, generous friends: my brilliant photographic editor Matt Tunia, who was always a phone call away and one step ahead of me, finding images that constantly amazed everyone connected with this book; and the unparalleled expert Manoah Bowman, who truly IS Hollywood history. They are two of the best people in the business.

To the helpful and generous photo agencies who made Bob's sketches come to life: Michelle Press at Getty Images, Howard Mandelbaum at Photofest, and, above all else, Andy Howick at MPTV, who went above and beyond the call of duty. Great thanks to Mitzi Gaynor's right-hand men, Rene Reyes and Shane Rosamonda at Polly O. Entertainment; Shady Farshadfar from P!nk's team; and Steve Sauer, Carol Burnett's manager, for being so supportive and helpful.

To photographers Joan Marcus, Michael Childers, and to collectors and fellow authors Jay Jorgensen, David Wills, and Tom Wilson, who generously provided photographs and sketches.

To the wonderful Carol Burnett, Cher, Bernadette Peters, Kenny Solms, Daniel Orlandi, Charles Busch, Michael Berresse, and Carole Cook for their reminiscences about working with Bob. To my pals John Sala, David Standish, John Schroeder, Carl Einbeck and Michael Kane, Ellen Gibson, and especially my dear Bill Damaschke, who gave me pep talks when I could barely put one foot in front of the other. To Zack Knoll, our wunderkind editor and our ROCK, who kept us laughing yet always on task during impossible circumstances; and to everyone else at Simon & Schuster, notably Jackie Seow and Ruth Lee-Mui, as well as designer Jason Snyder, who executed the design of this beautiful book.

To my partner in crimes against the written language, Laura Ross, who pitched this book to Bob one night after a Ted Firth jazz concert and got us an agent, the FABULOUS Alison Fargis, within forty-eight hours; and to everyone at Stonesong, especially Ellen Scordato and designer Jessica Musumeci, who created the template from which the design team at S&S took off. Forever grateful, Laura.

And finally, to the two people without whom this book would never have happened: The man of this and any hour, the brilliant, funny, and kind Robert Gordon Mackie, and his Design Director and aide-de-camp for more than twenty years, Joseph McFate, who talked me off of many a ledge during this journey. Getting to know Bob and Joe over the last three years has been a dream come true. Thank you both for trusting me. As Joe would say, "Smooches."

**LAURA:** As usual, my brilliant wellspring of a partner has covered a lot of ground succinctly and left nary a footprint, so allow me to ride his coattails (a not unfamiliar mode of transport) and second his thanks to all the aforementioned.

I'll add my own heaping helping of personal gratitude to Alison Fargis and Zack Knoll, whose enthusiasm is rivaled only by their professionalism; and also mention the painstaking, perfectionist, and patient copy and production team of Samantha Hoback, Kimberly Goldstein, Allison Har-zvi, and Samantha Cohen. I like to think that marketing this book will be the most fun that Heidi Meier and Elizabeth Breeden have ever had, but I've been in their shoes and I know how challenging their jobs are. Special props to them for creativity and persistence.

For Bob and Joe, a deep, seam-splitting curtsy of gratitude, respect, and admiration. Thanks to both of you for trusting both of us to do you proud—and for helping us and remaining positive every single step of the way. Thanks also to the redoubtable Marc Schwartz for keeping us kosher, and to the elegant Jenelle Hamilton for your great ideas and for coordinating Bob's eventful life and myriad endeavors with the budding life of our book.

Leslie Ben-Zvi, in addition to *everything . . .* thank you for introducing me to Bob Mackie and Joe McFate, and for encouraging me to untie my tongue and chat with them about a little idea I had.

Finally, deepest thanks of all to you, Frank Vlastnik. You are nothing short of superhuman in your ability to get the job done on all fronts (and all coasts)—in a pandemic, no less. Your unstinting perfectionism, deep knowledge, and abiding love of all things theatrical have propelled this project forward and made it all I hoped it could be and much more.

# INDEX

OPPOSITE: *Four sketches for the 2017 Off-Broadway revival of the brilliant Howard Crabtree/Mark Waldrop revue* When Pigs Fly, *which was canceled at the last minute. What a shame that New York audiences were denied the chance to marvel at these wacky Mackies, inspired by the over-the-top hilarious designs of Howard Crabtree for the original production.*

# PHOTO CREDITS

# ABOUT THE AUTHORS

**FRANK VLASTNIK** is an author, actor, photo editor, and Broadway, television, and pop culture historian. After working for four years as an archivist/researcher in the Time & Life Picture Collection, Frank acted as photo editor for heavily illustrated books such as *A Chronology of American Musical Theater*, *The American Songbook*, and *Jerry Herman: The Lyrics*. His first book, *Broadway Musicals: The 101 Greatest Shows of All Time*, coauthored with Ken Bloom, was awarded the George Freedley Memorial Award by the Theatre Library Association for its "outstanding contribution to the literature of the theatre." He lives in New York City.

**LAURA ROSS** is an author, editor, and publishing consultant who has served as editorial director at Black Dog & Leventhal Publishers and Theatre Communications Group; vice president/director of marketing at Pocket Books; and director of advertising and promotion at Simon & Schuster and Penguin Books. Her attributed works include a series of annotated classics, a wellness book, and several works of history, including *Traveling the Silk Road: Ancient Pathway to the Modern World* and *A Passion to Lead: Theodore Roosevelt in His Own Words*. She lives in New York City.

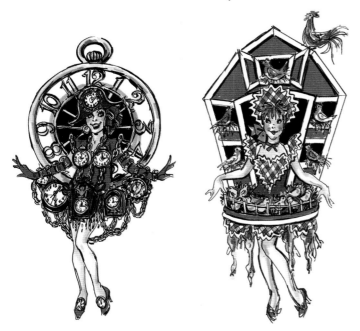